THE WILCOX

GUIDE

TO THE BEST

WATERCOLOR
PAINTS

by Michael Wilcox

COLOUR SCHOOL PUBLICATIONS

INFORMATION TO THE ARTIST

Acknowledgements

This book is an honest attempt to put right the muddle of centuries. It has only been made possible by the hard work, expertise and dedication of those who have worked with me.

I would particularly like to thank Carol Ann Smith for her strenuous efforts in obtaining the necessary samples and background information, a difficult and often frustrating task.

Joy Turner Luke, one of the world's leading experts on artists' paints has given valued support. Her vast knowledge and dedication to her subject, have put my mind at rest on many of the technical aspects of this book.

Franka Yarrick and Sean Elsegood worked tirelessly at compiling and presenting the information. A difficult and exacting task.

Anne Gardner gave encouragement and support during the difficult up-dating stage for this version of the book. Her help is greatly appreciated.

Desmond Heng, of Imago Productions, organised the colour separations and printing. A nightmarish job at times as the colour reproduction was so critical. Every aspect of the production was handled in a most professional way.

Finally I would like to thank my wife Dawn for her valuable contribution and enduring patience. Her wide range of skills were applied to the fullest.

With time, we will all become normal again.

ISBN 0 89134 409 8

Research:
Michael Wilcox
Carol Ann Smith
Paul Harris
Lyndel D'Arche
Peggy Lang
Phillipa Nikulinsky
Dawn Wilcox
Denver Wilcox

Technical consultant:
Joy Turner Luke

Picture research:
Dawn Wilcox

Page compilation:
Franka Yarrick

Page layout:
Sean Elsegood
Susan Meese

Photography:
Murray Simon

Design, text, and illustrations:
Michael Wilcox

Published by :
Colour School Publications
P.O. Box 3518 London SE24 9LW

Printed in Singapore through
Imago Productions (F.E.) Pte. Ltd.

Colour separations by Bright
Arts (H.K.) Ltd.

Text, Illustrations and
Arrangement, Copyright
Artways 1991

First published in 1991. Reprinted 1993 and 1995.

Foreword

This is a landmark book for artists. It contains a surprising amount of information that is not available elsewhere. Equally important, the information is presented in a handsome, easily referenced format. No matter how knowledgeable you are as an artist, you are going to be surprised by some of the facts in this book. It is the first publication to cover the wide range of pigments currently used in artists' watercolours, many of them almost unknown in the art community. In fact, it is the first to completely document the pigments used in any artists' medium.

This book summarizes what is known about these pigments and gives the watercolours that contain each pigment. The major watercolour manufacturers around the world are covered, along with a thumbnail sketch of the individual companies. No matter where you live some of the brands described in the book will be available. Colour reproductions of each watercolour, coupled with a description of its handling qualities, add another essential piece of information. The guidance on colour mixing is a bonus.

It was a herculean task to gather, evaluate and compile this information, and even more difficult to present it in a practical form, as Michael Wilcox has done. When I heard his plan for this book I realized how valuable it would be, but wondered if it would be possible to acquire the necessary information and put it together in one manageable book. It is a great pleasure to see what can be accomplished through courage, determination and skill.

The pigment used in a paint determines how long the colour will last. It is also the most expensive ingredient in a paint, so there is a strong economic incentive for companies to use the less expensive pigments. Sometimes this works to the artist's advantage since the best pigments are not always the most expensive ones, but it can also lead to use of inferior pigments. Knowledge on the part of artists counterbalances this pressure. The more knowledgeable you are, the better supplies you will have.

Many books on artists' paints are based on obsolete reference sources. A few recent books contain an accurate pigment section, but do not cover all the pigments in use nor indicate which watercolours contain a particular pigment. In the last 50 years there has been a revolution in both the development of new pigments and their introduction into artists paints. Two engines have driven this revolution, One has been the need to develop pigments for use in automobile paints, where the colour must endure for years in direct sunlight. This market has led to the introduction of families of pigments that surpass in permanence and sometimes in brilliance, many, but certainly not all, traditional artists' pigments. The second impetus for the development of new pigments was not so favourable. The biggest market for pigments is in the printing industry, where permanence is not a major concern since most printed material is closed away from light in books or magazines.

Taken together these two factors have greatly expanded the number of pigments offered. At the same time, since the art material industry represents a very small part of pigment sales, those traditional pigments not used in other industries are disappearing from the market (even if their names linger on), or are becoming ever more expensive. Another factor affecting art materials is that, with the exception of a few newly formed smaller companies, independent art material companies are also disappearing. Most major companies are now divisions of large corporations, some changing hands several times in the last few years. Corporations are interested in the hobby, craft and school markets because they represent a larger volume of sales than the fine art market.

Because these changes have been taking place in the industrial world they are relatively invisible to artists. Established companies resort to fancy, but meaningless names: or rely on historic but obsolete names, to sell more paints. As Wilcox points out, many manufacturers do not identify the pigments in their watercolours on the container, or in their literature. Even in the case of companies that do identify pigments on the tube, in conformance with the labelling requirements of the American Society for Testing and Materials Specification D 5067 for watercolours, there is still a problem because the Common Name and Colour Index Name for the newer pigments are unfamiliar to artists.

The art teacher and the artist buying paints, have been looking at a giant jigsaw puzzle with most of its pieces missing. Michael Wilcox has supplied those pieces. This book provides the tools to safeguard your work and to reform the industry. Companies will supply what artist will buy.

Joy Turner Luke

Chairwoman, Artist Equity Association Materials Research Committee. Former Chairwoman, American Society for Testing & Materials Subcommittee on Artists' Paints. Former member of U.S. Bureau of Standards Committee on Artists' Paints. Past President Inter-Society Colour Council.

Contents

Introduction

The thoughts behind this book came together gradually over many years. Like countless other painters, I have spent many hours wandering around art material shops looking blankly at the wide array of colours on offer. The choice can be bewildering.

Books which offered advice invariably promoted one brand or the other. Conflicting snippets of information about colours which faded, or were in some other way unsuitable, added to the confusion. Much of the manufacturers' literature seemed to be little more than sales hype.

Most fellow painters seemed to stick to a certain brand, often without sound reason, apart from hearsay. I eventually ended up with a mish-mash of colours which I hoped would be suitable. I never once purchased with absolute confidence.

One thing was very clear in my mind, I wanted to know more about the materials that I used.

If you feel as I once did, you are not alone. There is enormous confusion amongst artists when it comes to the selection of paints.

My interests turned towards the history of artists' pigments and I spent many years researching this fascinating subject. My search for information showed very clearly that confusion has always existed when it comes to the selection of paints and pigments.

The cave painter probably had the best deal, colouring matter which came to hand was used without a care in the world. Ironically, the materials that they used, coloured earths and soot in the main, have turned out to be the most reliable of pigments.

Artists ever since have been prepared to try any material, from whatever source, in the quest for colours to suit particular needs. Countless thousands of substances have been tried, from the mundane to the bizarre, with varying degrees of success.

High prices were paid for particularly bright pigments. Prepared colorants became a valuable part of commerce. With human nature being what it is, many substances were adulterated or imitated. False descriptions abounded. The naming of colours added to the confusion, often several substances would have the same title. Poor communication added to the muddle.

This situation existed until the emergence of the colourmen in the mid 1800's. Since then it has become worse! Pigments and paints are still adulterated and imitated, false descriptions still abound and colour names are as misleading and confusing as ever. I say that the situation has become worse, because we do not now have the excuse of poor communication.

When I first started to research this book I had little idea of the actual situation. At one stage I wondered if it were even required. Could one not simply be guided by the available literature?

As work progressed and an overall picture started to emerge, my attitude changed. Keeping in mind always that there are paint manufacturers doing a superb job, it has to be said that, overall, confusion is still the order of the day.

The difference of approach taken by the Colourmen varied dramatically. Some offered samples and information readily, others had to be persuaded, some simply refused.

Attitudes varied from full co-operation and encouragement to the threat of legal action from one of the larger and better known companies. The threat was made in case I should find myself unable to recommend any of their products. As certain of their watercolours are unreliable and I have said so, I await the reaction.

Being able to select with confidence from the manufacturers' literature, I now know is impossible. Very few companies publish reliable information. The lists of pigments provided vary from being accurate to hopelessly incorrect. One company could only provide hand written notes and another openly admitted to being unsure of the pigments used.

After many years of research and the help of some very talented people I can now go into an art shop and select with confidence. I hope that this book will enable you to do likewise.

Let me quickly add (and stress) that there are, fortunately, producers who put the interest of the artist as a first priority, but they often work at a disadvantage. It has never seemed right to me that expensive materials, of the highest quality, have had to compete with low grade, inexpensive colorants, sold under the same or a very similar name.

Such conscientious manufacturers should be encouraged to the fullest, they are certainly out there.

It is intended to update this book regularly. Manufacturers have been invited to supply information on any changes that they make to their watercolour ranges.

In time, perhaps, we will end up with a much slimmer volume, recording a reduced number of colours, each of a high quality.

All proceeds from the sale of this book will go towards further research.

Built in Confusion

Prior to the emergence of the 'Artists Colourman' during the 1800's, there was incredible confusion, almost chaos, surrounding the naming and make-up of artists' paints and pigments.

This earlier muddle is perhaps understandable, there were countless people preparing pigments and paints, many Guilds intent on keeping formulas and techniques secret and poor communication in general.

Pigment names often changed places with each other, sometimes in a quite random fashion. A particular material often had a variety of names. Alternatively, several quite different substances might share the one title. Poor quality or adulterated products were sold by dealers and substitutes offered under misleading names.

MANGANESE BLUE ___ CINNABAR GREEN **** MORDANT ORANGE 77205:1 +++ CONFORMS TO 2961 PG23 ○III 552 VERMILION HUE F3RK-70 NAPTHOL PIGMENT COPRECIPITATED **** *** PHTHALOCYANINE BLUE ☐ AZO YELLOW VAT DYE 66 ARYLIDE YELLOW 266 PR 108:1 CYANIN GREEN 943667 PRUSSIAN GREEN PR83:1 A T S2 CADMIUM SULFOSELENIDE ☐ (ST) BITUME LIGHTFASTNESS II XXX (T) 223 ISOINDOLINE DURABLE BARIUM SULFATE NATURAL EARTH PIGMENTS 622 TERRE VERTE AA○ ROSE DORE BOSI ASTM D 4320 C.I.NUMBER STIL DE GRAIN PIGMENT XX CHROME ORANGE AS1 ☉(6529) ARYLIDE FUGITIVE LIGHTFASTNESS CATEGORY II LAKE ++C QUINACRIDONE ++ NICKEL AZO YELLOW PR170 F3RK PERMANENT SCARLET ⬮ II (94) 229 COBALT VIOLET S7 PERMANENT BLUE PR122 MAGENTA PURPLE MADDER 8884676 TS IIICOBALT TURQUOISE 118 INDIGO 119 ST 9 AZO RED 069 XXX TYRIAN ROSE ⊖ VAT GREEN 3 BENZIMIDDAZOLONE CARMINE PR176 CARBON BLACK 7735 GREEN LAKE DEEP 518 WARM SEPIA 227 DAVY'S GREY 217 PY119 (99387) BROWN MADDER PRUSSIAN GREEN HUE 338 88R MAUVE 771 XX ⊤ANTHRAQUINONE ** COBALT VIOLET HUE 339 HANSA ZINC RED ROSE DEEP AZO PGT 884 CHROME YELLOW GREEN PINK 577 ST9 VIOLET CARMINE 445 (092) ROSE CARTHAME 12 BAYEUX VIOLET THIOINDIGOID VIOLET PR88 MRS (XX)

Since the arrival of the Colourmen, the situation, to my mind, has hardly changed. If anything, it has become worse, not in effect but in manner. Full advantage has been taken by certain manufacturers of the trust placed in them by the artist.

The vast majority of painters have little understanding of their materials, through teaching methods, (which have placed little credence on the craft of the artist) and the lack of opportunity to become involved in the practical side of paint-making. The available information and range of colours is now so confusing that few could ever hope to even partly grasp the situation.

Many cling to the belief that the excellence of the work of the earlier masters was in some way due to the materials at their disposal. This, unfortunately, has led to the retention of many romantic but non-sensical paint names. Thus we have a situation whereby many recent and excellent additions to the range are marketed under often quite meaningless names. The descriptions employed, in many cases, relate to pigments which were either discarded by earlier artists as being unreliable or tolerated by them as they had little alternative.

But the names do sound nice

Van Dyke Brown

Sap Green

Caput Mortuum

Stil De Grain

Rose Madder

Carmine

Indigo

Dragon's Blood

Bitume

Tyrian Rose

and reassuring. If the information provided by the Colourman is also well packaged, and every effort made to convince of the highest integrity and tradition, few will notice the emptiness behind certain product descriptions.

This does not of course apply to all colourmen, there are those who have the interests of the artist as a first priority, but few have resisted the temptation to hard sell tradition, or rather, our concept of tradition.

Another temptation hard to overcome is the ease with which pigments can be adulterated or imitated.

Many of todays' pigments are particularly powerful and **require** a certain amount of 'letting down' with an inert filler. When it comes to an expensive pigment, the choice is often to unnecessarily adulterate it, (particularly if little change is caused to the colour), or to approximate the colour with cheaper materials and retain the name of the more expensive.

My research has led me to believe that there have been and still are, too few honest or competent manufacturers.

In an effort to obtain a share of the market, paint manufacturers in general have caused a lot of unnecessary confusion, they offer many quite useless colours and simple mixes and are often guilty of being less than straightforward. In the naming of colours there is a definite advantage in misleading the artist, and it has been all too easy.

Much of this is understandable, there have, unfortunately, been too few areas of common understanding in product description and labelling.

The ASTM Standards

In 1977, Artists Equity Association, a major organisation representing American visual artists, together with certain manufacturers approached the American Society of Testing and Materials (ASTM), with a view to developing new standards. Other manufacturers were informed of the proposals and some contributed, others have joined since the completion of the main work.

Subcommittee D01.57 of the ASTM was formed. It consisted of representatives of artists organisations, manufacturers and independent technical experts.

The New Standards

New standards have been written and published which are of particular importance to the artist.

New and explicit labelling requirements are described, covering the **Common** name of the pigment, the **Colour Index Name** and other pertinent information that will identify the materials used.

Also covered are the requirements for lightfastness.

Of particular value is a list of pigments which have passed stringent lightfastness tests.

Only pigments that are rated as being in:

Category I (*excellent lightfastness*) or

Category II (*very good lightfastness*)

are included on this list of approved pigments.

Manufacturers, artists, retailers, and wholesalers are, through this specification, provided with a basis for common understanding as to nomenclature, performance and composition of artist's watercolours.

As far as the artist is concerned, all manufacturers labelling their products as conforming to ASTM D 5067 are offering paint that has been formed to meet the very exacting standards of the ASTM Subcommittee. Further, the paint will be accurately named and the ingredients fully disclosed.

What the specifiacation does not in any way do is restrict our choice. There will still be variation in manufacturing processes which will give paints produced by the different colourmen subtleties of chemical and physical make-up. We will still have every reason to prefer one brand over another, or one particular colour over alternatives.

Effects of the New Labelling

The standards written by the ASTM subcommittee, will, it seems certain, eliminate a lot of the nonsense as far as the labelling of artists paints is concerned.

Although still few, there are sufficient manufacturers, at the time of writing, adopting the ASTM standards to make a significant difference to the way in which we decide between one product and another.

This new approach to labelling encompasses the following:

- *Common Name*
 This will identify the established and commonly used name of the principal pigment, for example:

CADMIUM YELLOW

- *Hue Name*
 If a manufacturer wishes to use substitute pigments in order to **Imitate** the colour of the **Common Name**, then the word **Hue** must be added in the same size letters as the name of the pigment being simulated.

If for example, Arylide Yellow G was being used in a paint to give a colour which closely resembled **Genuine** Cadmium Yellow, then the main name on the tube would read:

CADMIUM YELLOW HUE

Under this name would appear the common name for the pigment being used, in this case:

> CADMIUM YELLOW HUE
> ARYLIDE YELLOW G

This secondary name, which in this case is the one to take notice of, must be in letters which are no smaller than the next size of print down.

▪ *Trade Names*

Where neither the **Common** nor the **Hue** name appears, but a **Trade Name** is given in their place, for example,

> SMITHS YELLOW

the dominant pigment used must be identified clearly, directly under the **Trade** name. In letters no smaller than the next size print down, must appear the **Common** name for the actual pigment used. In this case it might be:

> SMITHS YELLOW
> ARYLIDE YELLOW G

Added to these three categories: **Common Name, Hue Name** and **Trade** (or propriety name), there is another; the **Mixed Pigments Name.**

▪ *Mixed Pigments*

In the case of a paint containing a mixture of two or more pigments, the ASTM ruling is that all ingredients must be on the suitable pigments list. Furthermore, the lightfastness rating given on the tube must be that of the contributing pigment with the **lowest** lightfastness rating.

If, for example, a mixed green was composed of Arylide Yellow G and Prussian Blue, the label might read:

> PERMANENT GREEN
> ARYLIDE YELLOW 10G
> AND PRUSSIAN BLUE
> LIGHTFASTNESS II

The Arylide Yellow 10G has been given a lightfastness rating of II and Prussian Blue is rated I, on the list of suitable pigments. The rating for the mixed colour is therefore II, that of the Arylide Yellow 10G.

▪ *Colour Index Names*

As a Further means of identifying the pigment used in a paint, the Colour Index Name will be printed, probably on the back of the tube. This is a particularly vital part of the new labelling. It will identify very precisely the pigments used, in a way that no Common or Trade Name could.

The Colour Index Names are a type of international shorthand for identifying colorants. The name consists of three parts:

1) The category and type of dye or pigment.
2) General hue.
3) Assigned number.

For example: Cadmium Yellow Light is, **Pigment Yellow 35.**

The word **Pigment** identifies the type of colorant, **Yellow** the hue and **35** the assigned number. This may be further abbreviated to **PY 35.**

Other examples:

Cobalt Blue is **Pigment Blue 28** or **PB28.**

Viridian is **Pigment Green 18,** or **PG18.**

The main abbreviations used for Colour Index Names are:

PY	Pigment Yellow
PO	Pigment Orange
PR	Pigment Red
PV	Pigment Violet
PB	Pigment Blue
PG	Pigment Green
PBr	Pigment Brown
PBk	Pigment Black
PW	Pigment White
NR	Natural Red

and so on.

▪ *The Colour Index Numbers*

You may also find a five digit number in the literature. This number identifies, very precisely, the chemical composition of the colouring. There is no obligation to print this number on the product.

You should be aware of its existence as it often appears in manufacturers literature.
As examples:

Cadmium Yellow Light (PY35) has as its Colour Index Number, **77205**
Phthalocyanine Blue (PB 15) is **74160**

▪ *Chemical Description*

A simple chemical description of the dominant pigment may also be included on the label, this is not mandatory as far as ASTM D4302 is concerned.

The Standard does encourage the inclusion of this further description, where space on the label allows.

Examples:

Aureolin, would be further described as:

Potassium Cobaltnitrite.

Cobalt Blue:
Oxides of Cobalt and Aluminum.

- *Lightfastness*

The ASTM Standards apply only to **Artists' Quality** paints. It has at last been recognised as a contradiction in terms to have a fugitive colour described as an Artists' Quality. Only pigments found to have a lightfastness rating of **I** (Excellent Lightfastness), or **II** (Very Good lightfastness), are to be used in paints conforming to ASTM requirements. The word Lightfastness followed by the appropriate rating will be given. For example: **Lightfastness II.**

- *Toxicity*

If applicable, a warning and safe handling statement will be printed on the label. This information will be more explicit and more carefully researched than ever before. A statement to the effect that the health labelling is certified by The Arts and Craft Materials Institute will be carried .

If, however, the product has been found to be safe (based on current knowledge) by an approved toxicologist, it will carry the seal of The Art and Craft Materials Institute, which will declare it to be **Non-Toxic.**

- *Statement of Conformance*

The wording will be similar to:

> **Conforms to the Quality and Health Requirements of ASTM Standard D 5067 and D 4236**.

The Significance of the New Labelling

From the manufacturer's point of view, the work of the ASTM subcommittee will lead to fairer competition and a rationalisation of nomenclature. It will certainly be of benefit to those companies producing a quality product.

It has never seemed right that expensive materials, of the highest quality, have had to compete with low grade inexpensive colorants, sold under the same or a very similar name.

As for the consumer, the ASTM Standards are like a breath of fresh air. Not only will we be able to know exactly what we are buying, but we can be certain that the product has passed many very stringent tests. Paints conforming to ASTM D 5067 will have met exacting standards of composition, performance and labelling. A paint made with pigments included in the **Suitable Pigments List** of that standard, will fully justify being described as **Artist Quality**.

There will be long term benefits to be enjoyed by the discerning artist. As, hopefully, more and more manufacturers become involved, we shall see the removal of many of the poor pigments from paint ranges. At the time of writing there are still many fugitive and otherwise worthless pigments, being made up into paint described as being of 'Artists' Quality'.

With an unravelling of the incredible muddle that we are slowly emerging from, will come a new awareness of materials and hopefully a return of artists also wishing to understand their craft.

ASTM Subcommittee DO1.57 Artists' Paints

The members of the Committee are owed a debt by artists that will probably take a long time to be realised. Their work and that of others before them, is leading to the most important breakthrough in the history of the materials of the artist.

Special mention should be made of the immediate past Chairperson of the Subcommittee, Mrs. Joy Turner Luke. Joy has put in an enormous effort over many years, so that you, the artist, can purchase and use your materials with confidence. If the art world needs a folk heroine, it should look no further.

The immense workload has now been taken over by Mr. Mark Gottsegen, another person with a genuine interest in the needs of the artist. Mark works long, hard, unpaid hours for your benefit.

Mention must also be made of the invaluable work of Henry Levison. Henry undertook the immense task of testing the majority of the pigments for the standards. He worked largely at his own expense.

Behind the scenes there has been a lot going on.

Many artists, by their very nature, shy away from details, facts and figures. I can fully sympathise with this. However, a glance through the pages of this book will convince most that coming to terms with the new labelling will be more than worth the effort.

It should not be thought for one moment that the Standards apply only to North American paints and artists. Manufacturers from around the world are becoming involved.

The new Standards will only become fully effective if artists make sure that manufacturers have an incentive to become involved. *That incentive will be linked directly to sales.*

See the opportunity for what it is and do not let it slip away.

Impermanent Colours

Countless paintings have been ruined because unreliable paints have been employed. This need no longer happen.

In the majority of cases the artist will not have realised the limitations of his or her materials.

It is not only the cheaper ranges that are at fault. Many 'Artist Quality' paints are also unreliable.

The usual reason given for the inclusion of impermanent colours in a particular range is 'demand'. To quote one leading manufacturer, *'We do not put ourselves in the position of dictating to artists what materials to use and if there is a demand for particular impermanent colours we will continue to supply'.*

This is all very noble and suggests the existence of a core of artists who demand certain colours despite having full knowledge of the way in which they will deteriorate.

Can there really be painters with such refined tastes as to insist on using a particular colour, with the full knowledge that it will have the shortest of lives. It all has a delicious air of decadence

about it, *particularly when virtually all impermanent colours have a reliable alternative or are easily matched through mixing.*

In truth, such artists would be hard to find. Impermanent colours are in 'demand' because many of the purchasers are not well informed. They are not well informed because of the very sophisticated smoke screen that has been thrown up by colourmen over the centuries.

During the course of a year I give many seminars and talks to artists. Of the many thousands of painters that I have spoken to I have yet to find one who is not horrified by the way many of the fugitive colours deteriorate. The word 'demand' can have several meanings.

Such colours are in 'demand' because they can be sold.

There is of course a place in art for short lived materials and colours, as there is a place for everything. If you are looking for such paints in watercolour then I have identified them for you.

My real interest however, is towards those whose work has more of a purpose.

In time it will be realised that the artist has a most valuable place in society. That place, I feel, is to help in the interpretation of the world for others. It will indeed be tragic if much of the work of our generation should be unavailable, through deterioration, for the future.

About This Book

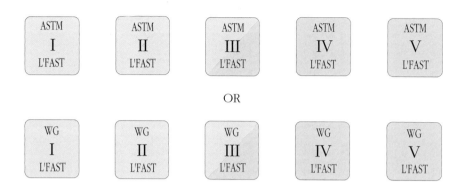

Lightfastness

Impermanence is not just to do with fastness to light. Certain colours are damaged by weak acids, alkalis and impurities in the atmosphere. Such weaknesses have been noted in the sections on modern pigments.

Exposure to light is the major concern as it can cause change over a wide selection of hues. Watercolours are at most risk as they do not have the protection of the binder enjoyed by pigments bound in oil or acrylic.

Many pigments are reasonably lightfast at full strength but fade when in a tint.

Watercolours, of course, are usually applied in thin films. This exposes the pigment to increased radiation and leads to damage to the colour.

These factors put watercolours at the forefront where damage from light is a concern.

Lightfast Ratings

Wherever possible I have used the results of ASTM testing when giving lightfast ratings. The testing procedures are very exacting and the findings are reliable.

The descriptions that I have used are:

ASTM I (Excellent lightfastness).

ASTM II (Very good lightfastness).

ASTM III (Not sufficiently light-fast to be used in paints conforming to the specification). Such colours can fade rather badly, particularly the tints.

ASTM IV Pigments falling into this category will fade rapidly.

ASTM V Pigments will bleach very quickly.

Where the pigment has not been tested as a watercolour, I have given a WG, (Wilcox Guide) rating. Wherever possible this rating is backed up by the results of ASTM testing in other media. Very occasionally a pigment is rated which has not been subjected to any recognised testing for which I have results. In almost every case the pigment has

clearly indicated its reliability.

In every instance the rating is based as far as possible on the known performance of the pigment. It is very difficult to be absolutely exact in some cases and I have always erred on the conservative side.

In-house Testing

Every pigment discussed has been subjected to our own con-trolled lightfast testing. Every manufactured colour has also been tested. Although carefully controlled, these tests have been carried out **only** to confirm the results of previous testing. If, for example, I point out that the blue and yellow in a particular green will fade, I will have first tested both the blue and the yellow indi-vidually to confirm previous find-ing. The resulting green was also exposed so that the actual changes could be discussed.

I wish to make it very clear that I have offered the light-fast ratings only after careful and thorough research of all available information. More work needs to be done in this area.

Paint Assessments

As much information as possible has been condensed into the space allocated for each colour.

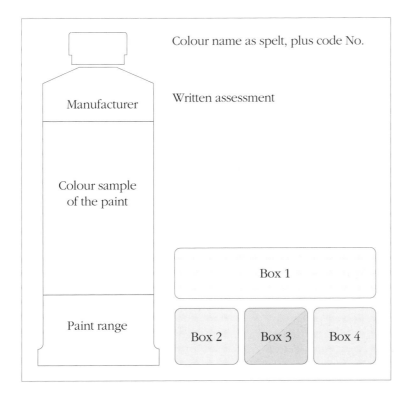

Colour name as spelt, plus code No.

Manufacturer

Written assessment

Colour sample of the paint

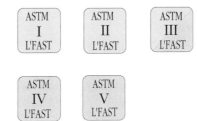
Box 1

Paint range

Box 2 Box 3 Box 4

Additional printing inks were used in the production of this book and every care taken to match the manufacturers colour. It must be borne in mind however that printed colours can never quite match the actual paint.

Box 1:

PR 106 VERMILION (P. 91)

The **Colour Index Name** and **Common Name** are given, together with the page number for further reference.

Box 2:

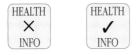

If the actual tube or pan gives either a health warning or carries a 'non toxic' label, this will be indicated. By an ✗ for 'no information' or by a ✓ for pertinent information. More on health labelling on the next page.

Box 3:

| ASTM I L'FAST | ASTM II L'FAST | ASTM III L'FAST |

| ASTM IV L'FAST | ASTM V L'FAST |

The overall lightfastness rating is given here. The lightfastness category is that of the least reliable pigment. If a paint contained, say, four pigments and three were lightfast I (excellent) and one was lightfast III (unsatisfactory) the entire paint would be classified as lightfastness III. The single unreliable pigment will tend to spoil the colour as it deteriorates.

Box 4: The ratings given here are based on several factors:

1) The reliability of the pigment.
2) The suitability of the pigment for the particular hue.
3) The qualities of the paint, how it brushed out, whether it was overbound with gum etc.

The ratings, **which are based purely on my own assessments,** are:

RATING ★★ ★★

An excellent all round paint, highly recommended.

RATING ★ ★★

A perfectly good watercolour, recommended.

RATING ★★

This paint has serious drawbacks for artistic use.

RATING ★

Most unsuitable.

RATING

An assessment could not be given for one reason or another.

Overall Assessments

I should like to make the following absolutely clear:

The information on the pigments used, (given in box 1) was supplied by the manufacturers. Every possible effort was made to ensure accuracy. Much of the detail was provided in a very confusing manner, with many changes being made at the last moment. Whereas I feel that the final information is as accurate as possible, I cannot be absolutely certain in every case.

The lightfast ratings are as accurate as existing information allows. W.G. Ratings are my own assessment and should be treated as such.

The ratings in Box 4 are my own assessment and are offered as guidance only. I have tried to keep personal preferences to one side by always seeking the opinions of others.

My written assessments of the paints are necessarily subjective and should be regarded as such.

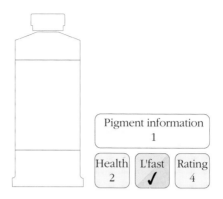

Where a paint has been described as gummy or overbound, the opinion of others was always sought for confirmation.

Some pigments are naturally difficult to use in watercolour paints. This is due to the very nature of the colorant. It may well be the case that manufacturers resist adding thickeners or extenders so that such differences are a feature of the particular colour.

I can only point out the characteristics of the paint as I see

them. If an artist wishes to use very gummy paints, for example, I have identified them.

Every attempt has been made to ensure fairness to both manufacturer and consumer. In the main, tubed paints were supplied and examined. Several companies also produce their colours in pan form.

In just about every case the same pigments are used in the pans as in the tubes. The main difference between the two lies in the make-up of the binder.

Health Information

I feel that sufficient information is already available on the possible hazards associated with art materials.

There are very few watercolours which warrant warnings. Little or no hazard is presented when they are used in a normal way. The possible dangers occur when the colours are applied with an airbrush, allowed onto food or ingested in some other way.

Certainly some pigments can be dangerous. But so is battery acid if made into a cocktail. This does not stop us using batteries. Common sense and care are all

that is needed.

I do feel however, that all watercolours should carry a label outlining possible health hazards or, equally useful, a label declaring the contents to be non toxic. It can be just as important to know that a paint is non toxic as it is to know of any possible dangers. This is particularly so if the substance should be eaten by a child or a mentally handicapped person.

Seals and statements to cover all aspects of health labelling are in use world wide. Different systems operate in the USA and Europe.

All companies, I believe, should ensure that an appropriate statement is given on each product.

An indication (in box 2) is given for every colour presented for our examination. Certain of these might now be correctly labelled where they were not before.

Several companies report that they are waiting for precise instructions before printing health labels and plan to introduce the practise in the near future. Perhaps in the next issue of this book each box will carry a ✓

The Colourmen

I have been very direct about some of the practices of certain of the Colourmen or paint manufacturers. Most, if not all, have come in for criticism one way or another.

This has come about, in part, due to practices which have been handed down over the years. I have been direct because I feel strongly that major changes are required and required urgently.

It must be borne in mind however, that this book has only been made possible because of the vital assistance that has been given by the vast majority of the manufacturers.

The participating companies each supplied a full range of product samples and comprehensive technical information. They also answered a constant stream of questions. I hope that this book will be seen as an attempt to rationalise the situation as it exists and to encourage a new spirit of openness. The paint manufacturers have played their part in this new approach and I thank them for it.

Da Vinci (USA)

Da Vinci Co. is a family owned and operated manufacturer of artists' colours, mediums and varnishes.

The company was founded in California in 1975. Experience in artists' paint manufacturing dates back some 60 years to work in Northern Italy.

A limited range of watercolours (45 in all) are sold under the description 'First Quality'.

It is often a good sign when a manufacturer limits the number of colours on offer. Others cannot resist adding one pre-mixed colour after another, often regardless of quality.

DVP tubes are of a generous size and are well made. A large cap, together with a strong neck and shoulders on the tube make for easier removal of a stuck cap.

The labelling is very good. The Colour Index Number, ingredients, and binder are given. Health information is also often provided. It makes a refreshing change to see pigments described correctly.

This company has my vote for offering the most improved range in the USA since the last edition. All colours are now lightfast.

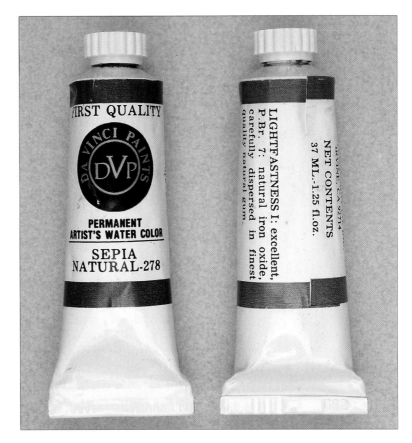

A well presented range of watercolours.

Available in 'Studio" size tubes of 1·25 Fl. oz. (37ml.)

Grumbacher (USA)

An American manufacturer. I cannot give details of the history of the company as our requests for information were not responded to.

Two watercolour ranges are produced : 'Finest Professional Artist Watercolours' and 'Academy Watercolours'.

Now in aluminium tubes with paper labels. The label design has recently been improved.

The caps and tubes are well designed and produced.

Large caps are a definite advantage should sticking occur. Strong necks to the tubes will resist twisting in this event.

The main catalogue gives good examples of the colours and, most importantly, full Colour Index Names and Numbers in the technical section.

The second range, 'Academy Watercolours' are very well labelled, giving pigment description, the Colour Index Number, vehicle and health information.

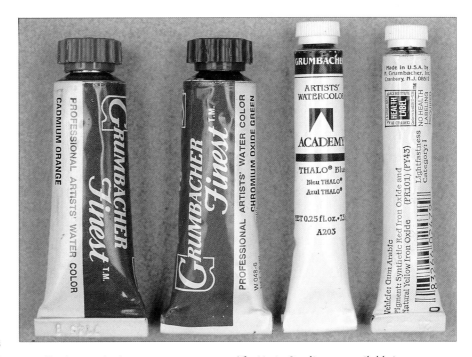

All colours in both ranges are now labelled to ASTM D-0567 requirements. Substitute pigments are now properly labelled as 'Hues' and lightfastness ratings have been re-evaluated. *A much improved range.*

The 'Artist Quality are available in tubes of ·54 Fl.oz. (16ml), as shown here, or ·18 Fl.oz. (5·3ml).

'Academy' watercolours are in tubes of ·25Fl. oz. (7.4ml). At right.

Martin/F. Weber Co. (USA)

(Permalba)

Founded in 1853, Martin/F. Weber Co. claim to be the oldest manufacturers of artists' supplies in the United States. They were the first Colourmen to develop Titanium White as an artist pigment.

A range of 36 watercolours is offered under the name 'Permalba'. The tubes are well produced and reasonably strong. Serrations on the edge of the cap ease removal and sticking is not really the problem that it is with some makes.

Useful information is given on the tube. Pigment descriptions plus Colour Index Names are printed very clearly. Each tube also carries pertinent health information. We were given every possible assistance in the compilation of information.

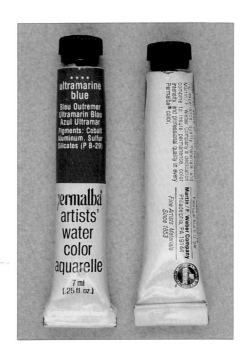

Details of the new range of Susan Scheewe watercolours are given on page 289. They will be covered thoroughly in the next edition.

Available in tubes of ·25 Fl.oz. (7ml). As shown here.

Royal Talens (Holland)

Martin Talens started the company in 1899 with a range of watercolours and drawing inks. Manufacture started at his villa in the quiet Dutch town of Apeldoorn. Four generations later the company has expanded considerably and production is carried out in a well equipped, very modern colour-works.

Two watercolour ranges are offered. Rembrandt are the 'Artist Quality' range and are available in 72 tube colours and 36 pan. The 'second range' offers 40 colours.

The tubes are particularly soft and weak. A stuck cap can cause serious problems as the tube will twist with the slightest pressure.

Labelling is very poor with no indication being given as to the ingredients. Health information is also not given.

A new 2nd range will be introduced in 1995 under the

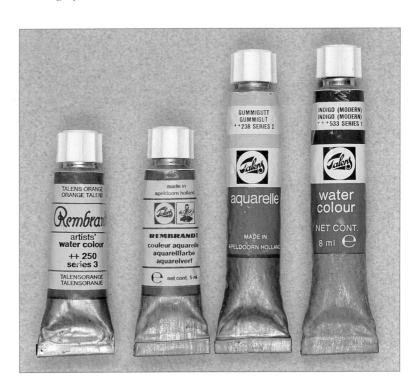

name 'Van Gogh. These will replace the 'Talens Watercolours' now being phased out.

The 'Rembrandt' range is avalable in 5ml tubes. Certain colours are also in 17ml tubes. The 'second' range is in 8ml tubes only.

Blockx (Belgium)

Founded in the 1860's by Jacques Blockx. A chemist by profession, he was persuaded by his many artist friends to produce a range of paints comparable to earlier products.

Traditional Blockx tube watercolours have a high honey and glycerine content. This, it is claimed, assists with the creation of free flowing washes and interesting colour mixing effects.

The drawback to this approach is that the paint does not dry out when applied at all heavily. Blockx report that whilst sales of the 'moist' watercolours are buoyant in France, they sell less well in other countries.

To overcome consumer resistance, an alternative tube formula has recently been introduced.

The 'moist' colours have a black cap, the new formula

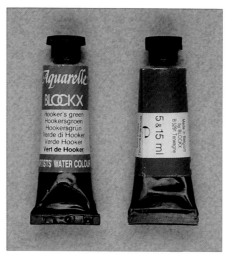

Available in 5 and 15 ml tubes. Also in pans using same pigments.

(which behaves like other watercolours) has a white cap. You now have a choice not offered by any other manufacturer.

Blockx have been particularly helpful, supplying samples and full information. Their literature gives a good colour example of each paint, but is limited in pigment description.

Colour Index names and numbers are not given. Vague descriptions such as 'Azo pigment' find their way in amongst the more accurate nomenclature.

Lightfast ratings are not given by the company. They state : *'We do not, and never have done, prepare transient or unstable shades. A classification by degree of stability would therefore be out of place'.* Not all of their colours bear this statement out however.

The drawbacks associated with true Vermilion are pointed out and I am informed that the intention is to replace Alizarin by Quinacridone.

Lefranc & Bourgeois (France)

The company trace their origin back to 1720. An ancestor of the Lefranc family, a Mr. Laclef, had a spice shop beneath the studio of Jean - Baptiste Chardin. Laclef was requested to grind pigments for Chardin and the foundations were laid for the present company.

In 1836, the great grand nephew of Mr. Laclef took over the company and opened a factory, business expanded rapidly. A Mr. Bourgeois formed a similar company in 1867 which was in direct competition. In 1965 the two amalgamated.

Available in both tube and pan, the Linel range of watercolours are well presented and packaged. The tubes are strong, particularly at the shoulders. Ingredients are given on the tube

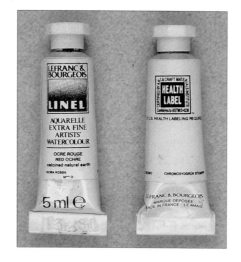

Available in 5·5 ml tubes. Also in pans.

and in the literature. The value of the information varies from being accurate to vague. Meaningless terms such as 'Azo pigment' find their place. Lightfast Raw Umber is described as 'Natural Earth' the same description given to the fugitive Van Dyke Brown. The all important Colour Index Numbers are not given.

The Linel range replaces the earlier '600' series. Lefranc & Bourgeois were particularly helpful in the compilation of information and the supply of samples.

Binney & Smith (USA)
(Liquitex)

Joseph Binney established the Peekskill Chemical Co. in 1864. Based in New York, he produced and sold charcoal and Lamp Black, the latter made by burning whale oil.

Over the years other lines such as shoe polish, crayons and pencils were introduced. The company became known as Binney & Smith in 1885.

Further lines were included such as tempera, finger paint and watercolours in 1948. A major break through came in 1964 when Permanent Pigments Inc. was acquired. This brought into the company the now familiar Liquitex lines. The President of Permanent Pigments had been Henry Levison, on his retirement Henry set about testing many of the pigments featured in the ASTM listing. He received the co-operation of Binney & Smith in this invaluable work.

The watercolour tubes are reasonably strong and well made.

The labelling is excellent. Full information on the vehicle and ingredients is given, including the Colour Index Name. The labelling conforms

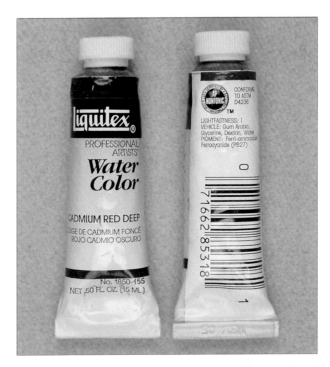

to ASTM standards.

Binney & Smith have made a valuable contribution to the vital work of the ASTM in drawing up the new standards.

Available in 5Fl.oz.tubes (15ml.).

Lukas (Germany)

Stephan Schoenfeld opened a business supplying artists' requirements in 1829. It was ideally located opposite the famous Art Academy of Düsseldorf.

Stephan's son, Franz, went on to form Dr. Fr. Schoenfeld & Co., a company specialising in the manufacture of artists' colours. At the turn of the century the patron Saint of painters, 'Saint Lukas' gave his name to all artists' colours produced by Dr. Fr. Schoenfeld & Co. The company and trade name have continued to the present day.

Lukas watercolours are available in both pan and tube. We examined only the tubed colours. The tubes are well made, being soft enough to collapse under light pressure but strong enough at the shoulders to resist twisting.

The ingredients are given on the tube labels but a magnifying glass is required (literally) in order to read them. Vague, meaningless terms such as 'Monoazo pigment' are amongst the more accurate descriptions. The important Colour Index

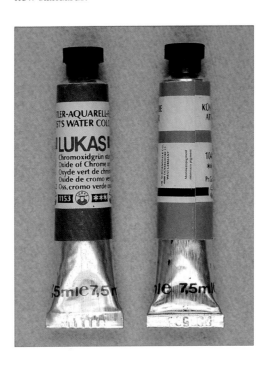

Numbers are given in the literature.

We were given every assistance in the compilation of information. The full range of colours was provided for examination. *The labelling is to be changed by the end of 1995.*

Available in 7·5 ml. tubes, (shown here). Certain colours are also produced in 24 ml. tubes. 1/2 and full pans are also available.

Holbein (Japan)

This leading Japanese company, based in Osaka, was formed in 1900. Holbein have been very successful in marketing their products to a world wide audience.

The development of their paint making techniques was largely independent of European and American influence. Japan of course, has a long history of producing pigments and paints.

The watercolour range is presented in tube form. These used to be rather basic in appearance and tended to twist. Now very much improved.

The labelling has been very much improved since the last edition. Conformance to ASTM D-4236 and health warnings (which were only given on tubes for the North American market) are now in use world wide.

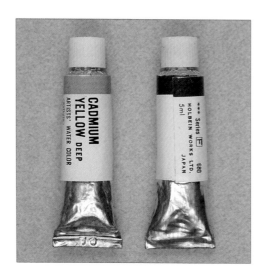

Available in 5 and 15 ml. tubes. The 5 ml. tubes are shown here.

The colours are produced without the use of wetting agents. This allows , it is claimed, for improved brushing technique. Adequate water must be used or the paint will seem rather opaque at first.

Holbein have been particularly helpful in the compilation of this book. They have supplied samples, full technical information and answers to all questions.

Pebeo (France)

Despite many requests we were not provided with information on the history of the company.

A range of 48 colours are produced and are available in both pan and tube. We examined only the tubed colours, but the pans have exactly the same ingredients.

The information provided on the labels and in the literature is excellent. Lightfast ratings conform to ASTM standards. This should be noted as some might think that the ASTM Standards apply only to certain companies based in the USA. They are in fact spreading worldwide, albeit slowly.

Another point worth noting is the fact that the all important Colour Index Numbers are given on the product and in the literature.

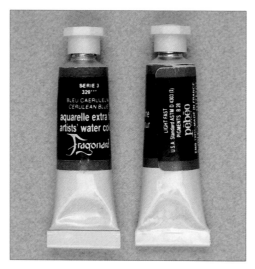

Produced in 5ml. tubes and 1 ml. 1/2 pans. Both contain the same pigments.

Pigment descriptions are accurate and meaningful.

This approach is to be encouraged as it marks a major breakthrough from the past. As artists become more aware and informed, they will seek out companies who give clear and concise information on the ingredients of their products. Increased sales will not only reward such manufacturers but will encourage others.

Schmincke (Germany)

The artists' colour manufacturer H. Schmincke & Co. was founded in 1881 by Hermann Schmincke and Josef Horadam. Four generations later the company is run by the direct descendants of the founding families.

Operating from a modern factory near Düsseldorf, they produce a wide range of artists' colorants.

Their 'Artist Quality' Horadam watercolours are available in both tube and pan. Great pride is taken in the fact that pan colours are poured rather than pressed when dry. The colour picks up well from the pans as they are slightly moist. The paint is ground on slow turning stone mills.

The tubes are strongly made and resist twisting should the cap stick. An inherent weakness in the caps caused them to fracture easily. This has now been overcome with a new, shorter design. By now the earlier tubes (with very tall caps) will probably have been largely replaced with new stock.

Produced in 5 and 15 ml. tubes. The 5 ml. is shown here. Also available in 1/2 and full pans.

It is impossible to be sure in every case just what the ingredients are. Vague terms such as 'Permanent Organic Pigment' appear on both the product and in the literature. Colour Index names are not given.

We were provided with full and accurate information on all ingredients.

Winsor & Newton (UK)

Two young painters with a scientific background, William Winsor and Henry Charles Newton founded Winsor and Newton in 1832.

In 1892 they became the first Artists' Colourmen to publish a complete list of colours, together with details of their chemical composition and permanence.

A booklet giving such information is still published. It is most useful and carries full information on the ingredients, including the vital Colour Index Name and Number. The booklets are not always readily available in art stores.

Winsor and Newton watercolours are available in both tube and pan. We only examined the former in detail. The tubes are strong and well produced, the caps resist sticking.

Surprisingly the 'Artist Quality' tubes do not give any indication as to the ingredients used. Although the company has worked with the ASTM, they do not seem to have adopted the labelling practices.

Many of the 'second' range colours provided were well labelled, particularly those intended for the USA market.

Fuller health information will be given on the products in the near future.

Winsor and Newton were most helpful in the supply of technical information.

The 'Artists Quality', shown on the left are available in 5 and 14 ml. tubes. Also in 1/2 and whole pans. 'Cotman colours', on the right, are produced in 8 and 21 ml. tubes. The 'Cotman' colours for the USA market are in 8ml. tubes.

Sennelier (France)

The company was founded by Gustave Sennelier in 1887. His sons, Charles and Henri eventually took over the running of the business. Today his grandson, Dominique Sennelier, manages this well established paint company.

Large granite mullers were used originally to grind and blend the pigment and binder. Today, slowly turning granite rollers have taken over the job.

Watercolours are produced in both pan and tube. We examined the latter.

The tubes are well produced and strong. If anything they are a little too strong and take quite a pressure before they collapse.

Eighty colours are offered. Information on the tube is very

Produced in small, 1·2 Fl. oz. (3·5 ml) and 2·8 Fl.oz. (8·5ml.) tubes, as shown here Also available in 1/2 pans

limited. No indication is given as to the ingredients used, either on the label or in the literature.

Sennelier were most helpful in the supply of samples and technical information.

This company have made many significant improvements since the last edition of this book. Colours have been re-formulated and fugitive paints replaced by lightfast examples.

Old Holland (Holland)

Established in 1664, this company has had a long and steady history. It is probably the oldest artists' paints factory in the world. It is claimed that the company was established by artists and is still under the control of artists, not business people.

Slow, stone mills are still used to grind the paints rather than the faster steel rollered variety. This, it is claimed, helps to preserve the colour.

The packaging is unique in that the tubes have a sample of the colour from the actual batch. This is painted out and stuck around the tube. It is a much better indication of the colour than a printed band.

The lead tubes are rather soft. If a cap should stick the shoulders of the tube should be held during its removal rather than the body.

Little, or no information is given as to the contents on the tube label. The literature is also rather vague in this respect. Quite meaningless terms such as 'Permanent Azo' find their way into the pigment lists.

Although I cannot be certain, it would appear that the tubes are available in 6 and 25 ml. sizes.

Sorting out the actual ingredients that were used was rather uphill work.

The company failed to confirm the list of ingredients when requested to do so. I cannot therefore be abso-

lutely sure that the pigments as shown in this book are correct.

Old Holland are a small company who take pride in following the methods of the colourmen of yesteryear.

Maimeri (Italy)

The Maimeri brothers Gianni and Carlo founded the company in 1923. They made a good combination, Gianni being an artist and Carlo a research chemist.

Their factory, located at Barona was destroyed in an air raid towards the end of the Second World War. It was rebuilt in 1946 and relocated to Milan in 1968.

Maimeri produce a wide range of colorants and other art materials.

Two watercolour ranges are offered, 'Artist Quality' and a 'second range' known as Studio Acquerello. Both are available in tubes, the 'Artist' range is also produced in pan form.

The tubes are well produced. They are strong enough to resist twisting yet collapse readily. An interesting feature on the 'second' range caps are slots in the cap. These will take a coin to help ease a sticking cap.

Full information, including the vital Colour Index Name is provided in the literature. Unfortunately it has not found its way onto the actual product. Neither tube or pan give any indication as to contents.

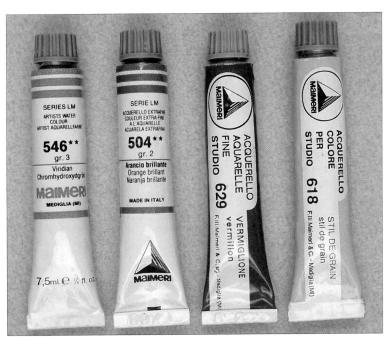

Maimeri rendered every possible assistance in the compilation of this book. *They have made many improvements to their colours since the last edition of this book.*

Both ranges are produced in 7·5 ml. tubes. The 'Artist Quality', shown on the left, also comes in 1/2 and full pans.

Daler Rowney (England)

The brothers Thomas and Richard Rowney started preparing and selling artists' colours a little over 200 years ago. Their products were sought after by notable artists of the time such as Constable and Turner. Rowneys merged with the canvas board manufacturers, Daler Board, in 1983.

Rowney watercolours are available in two ranges - Artists' Quality and Georgian, their 'second' range. Available in both tube and pan.

The tubes are reasonably strong and well made. General information on the pigments used in the Artist Quality is available in the main catalogue. The vital Colour Index Names are not given. Vague terms such as 'Arylamide Yellow' are included amongst more accurate descriptions.

No information on ingredients is given on the tubes of the Artists' Quality or Georgian ranges.

Having visited the colour works, I know that a lot of care is taken in the preparation of the paint. It is a pity that pertinent information on the pigments used is not more widely

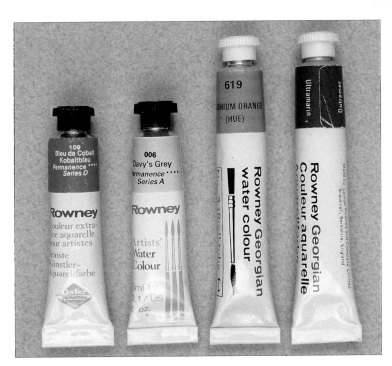

available, particularly on the actual products.

Daler Rowney have been very helpful in supplying samples and technical information. All questions were answered frankly.

The 'Artist Quality' range, shown on the left, is available in 5 ml. tubes, 1/2 and whole pans.

Georgian colours are produced in 8ml. tubes. Certain of them are also available in 1/2 pans.

Hunts (USA)

I am afraid that I do not have a lot to report on this company.

Hunts International Co., based in Philadelphia, manufacture a range of tubed watercolours described as 'Speedball Professional Watercolours'. Several samples and a limited amount of information were sent to us. When a request was made for the very important Colour Index Names and Numbers of the ingredients we received the following, and I quote. 'We consider the Colour Numbers you are requesting as privileged, confidential manufacturer's information and we are unable to provide such information'.

I did not take this rebuff personally. It had been pointed out to all manufacturers that this book was intended as an opportunity for them to assure their customers that earlier, restrictive and confusing practices were no longer being followed. Hunts have not refused me vital information, but they might have refused you.

Trade secrets as far as the use of pigments is concerned no longer exist. Other companies have been very free with their details.

It may well be that the marketing division have overridden the technical personnel, as can so often happen.

It should be recorded that Mr. Al Spizzo, the chemist at Hunt's, has put an enormous effort into the work of the ASTM Subcommittee. He is known and respected for his expertise.

If the company change their attitude, I will document their products fully in the next edition.

This has not happened. Presumably they are happy with the situation.

Paillard (France)

I can tell you very little about this company. Paillard, who produce a range of pan colours, are part of the Lefranc and Bourgeois group.

Intended for the student, the range is reasonably extensive and quite widely available. For these reasons I wanted to provide full coverage.

Samples and limited information were provided initially and the range was included in the book. Despite promises of further information it never materialised. No indication whatsoever is given in the literature or on the pan as to the ingredients used. Perhaps in the next edition I will be able to tell you more.

Reeves (UK)

The Reeves company, under the same ownership as Winsor and Newton, was formed in 1766. A very old company, Reeves joined the Winsor and Newton group in 1976.

The policy on labelling and product information is identical to that of the parent company.

There are many similarities between this range and 'Cotman' the Winsor and Newton 'second' range. However I am informed the two paint ranges are not identical.

Available in tubes only, these are strong and well produced. Information on the ingredients is limited, with many general terms such as 'Azo red' being used.

The tubes carry carry this limited information.

It must be remembered however that the range is intended more for the beginner, where perhaps less detail is required.

Twenty seven colours are on offer. Reeves gave every assistance and a full range of samples. All questions of a technical nature were answered without delay.

THE ENTIRE RANGE HAS NOW BEEN DISCONTINUED. DETAILS ARE PROVIDED IN THIS EDITION AS MANY ARTISTS WILL HAVE THE PRODUCT.

Produced in 7·5 ml. tubes

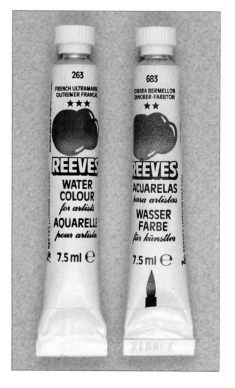

YELLOWS

Brief History of Yellow Pigments

The main requirement of a yellow pigment during ancient and Medieval times was to imitate gold. To a lesser extent, yellows were used to modify other colours, still less important seems to have been the representation of yellow objects.

A freer use was made of yellow in paintings by Renaissance artists and many new pigments were introduced.

It was fully realized that overuse of a bright yellow could quickly disturb the balance of a painting For this reason, yellow ochre was usually thought of as being strong enough for most purposes.

The book illustrator however, required much brighter yellows. Orpiment, an orange - yellow of some brilliance found favour with the illuminator as it closely resembled gold in colour. Unfortunely it caused problems in mixes. Yellows produced from fish and animal bile, gall stones and various vegetable extracts were >

employed. Many of them tended to fade quickly, especially the vegetable yellows.

Other imitations of gold were used by artists in the middle ages. Mercury was whipped into egg yolk and a yellow dye such as bile or saffron was added. This gave a metallic but short - lived effect. Gold was also depicted by glazing over powdered tin with a transparent yellow paint.

Many of the earlier yellow pigments have been replaced on the artists' palette by recent, more permanent yellows. Occasionally we have lost a particularly useful colour and have had to make do with a less than perfect replacement.

There were a few problems associated with the earlier Cadmium Yellows, the paler varieties particularly being less than lightfast. However the modern Cadmiums, offered by reputable manufacturers, are extremely permanent, very bright and opaque.

Arylides are recent additions >

Modern Cadmium Yellows are superb pigments with outstanding qualities.

to the range of available yellows. Originally known as Hansa Yellow they vary widely in reliability. >

Genuine Indian Yellow was produced from concentrated cows urine.

The urine was mixed with mud and sent to London for refining.

The resulting pigment was valued for its hue and transparency.

The modern synthetic dye - stuffs will, we hope, provide us with an ever widening range of yellows that promise to remain permanent even when diluted or reduced with white.

Most of the earlier transparent yellows such as Indian Yellow and Gamboge have been replaced by imitations bearing the same names. Many of these replacements are based on inferior pigments and are not worth considering. Of real value however, is the very delicate, transparent Aureolin, also known as Cobalt Yellow. Only of use in thinly glazed layers, for when it is applied heavily it is dull and leathery in appearance.

Genuine Gamboge is taken from the bark of a tree native to several East Asian countries.

The sap is often collected in short lengths of bamboo, these act as moulds.

Despite the romance and tradition of it all, Gamboge fades rapidly.

Arylides have withstood the severest of testing procedures and have found a permanent place on the palette of many an artist. >

A wide range of Arylides are available. Unfortunately they are often poorly described. A variety of meaningless terms are in use. >

Descriptions such as 'Hansa Pigment' or 'Arylide Base' give no indication at all of the actual pigment used.

We have a wide range of yellows at our disposal, from the absolutely reliable to the fugitive. It has become more important than ever to have a clear understanding of the pigments that are used in their make-up.

If the actual pigments which have been used to produce the paint cannot be accurately identified - either from the tube or pan, or from the literature - the colour is not worth considering.

You could be spending more to purchase a less than reliable paint.

MODERN YELLOW PIGMENTS

ARYLIDE YELLOW G

A bright transparent to semi-transparent yellow.
Possessing a high tinting strength, PY1 can quickly influence other colours in a mix. Compatible with all other pigments. Covering, or hiding power is moderate. The drawback to this very popular pigment is that it fades rapidly, rated only V in ASTM testing. Relatively cheap, it is used as a substitute for Cadmium Yellow or is blended into other colours which it will eventually spoil.

Our sample was quickly on its way back to white paper when applied as a wash and exposed to light. Darkened at full strength. Unsuitable for artistic use.

COMMON NAME

ARYLIDE YELLOW G

COLOUR INDEX NAME
PY1

COLOUR INDEX NUMBER
11680

CHEMICAL CLASS
**MONOARYLIDE OR
MONOAZO:ACETOACETYL**

Also called Hansa Yellow Light

ARYLIDE YELLOW G

A bright semi-transparent orange-yellow. Like its' close relative, PY1, it has many industrial applications and is relatively cheap. Although it fared slightly better than PY1 during ASTM testing, with a rating of III, it is still unsuitable for artistic use. Our sample faded rapidly on exposure to light.
When this range of pigments were introduced in 1910 they were known as HANSA Yellows. Although this name is still used the preferred term is ARYLIDE.

Unreliable. Faded quickly on exposure to light, particularly when applied as a thin wash. Worth avoiding.

COMMON NAME

ARYLIDE YELLOW G

COLOUR INDEX NAME
PY1:1

COLOUR INDEX NUMBER
11680

CHEMICAL CLASS
**MONOARYLIDE OR
MONOAZO:ACETOACETYL**

Also called Hansa Yellow Medium

ARYLIDE YELLOW 10G

The 'G' stands for green. Arylide yellow 10G is much greener than other Arylide Yellows on offer. A very practical pigment, it is compatible with all others. Fairly transparent and reliable. ASTM rating II. The optional additional name is HANSA YELLOW LIGHT. If you come across pigments described simply as ARYLIDE or HANSA Yellow treat them with caution, they could be the reliable PY3 or a fugitive member of the family.

PY3 is on the list of ASTM approved pigments for watercolours.

COMMON NAME

ARYLIDE YELLOW 10G

COLOUR INDEX NAME
PY3

COLOUR INDEX NUMBER
11710

CHEMICAL CLASS
ARYLIDE YELLOW

Also called Hansa Yellow Light

ARYLIDE YELLOW 13G

There can be some confusion about the common name. This pigment is sometimes given a trade name followed by 5G. The Colour Index Number PY4 will identify it for the artist. A bright greenish - yellow discovered in 1909. Sensitive to lime. The main use of this pigment is in the manufacture of printing inks.

Not yet tested in any artists' media. Rated WG III on the strength of our own preliminary testing. Treat with caution.

L/FAST W/G III

COMMON NAME

ARYLIDE YELLOW 13G

COLOUR INDEX NAME
11665
COLOUR INDEX NUMBER
PY4
CHEMICAL CLASS
MONOARYLIDE OR MONOAZO : ACETOACETYL

Also called Fast Yellow 13G.

DIARYLIDE YELLOW AAA

Vast amounts of this pigment are used in industry, particularly in the manufacture of printing inks. PY12 represents over 55% of all organic yellow production. Semi-opaque and quite strong. I found only one example of its use in artists' watercolours and that in a Sepia which would be less severely damaged than most other colours. This is fortunate as PY12 has a very poor reputation for lightfastness.

An unreliable pigment which will quickly fade.

L/FAST W/GUIDE IV

COMMON NAME

DIARYLIDE YELLOW AAA

COLOUR INDEX NAME
PY12
COLOUR INDEX NUMBER
21090
CHEMICAL CLASS
DISAZO

Also called Benzidine AAA DI

DIARYLIDE YELLOW AAMX

A brownish orange-yellow. When applied heavily it takes on a rather dull, heavy appearance but washes out to a reasonably clean yellow. Semi-opaque, it has reasonable covering power. This is another fugitive yellow which is best avoided. Rather more orange than PY12 but sharing the same failings. Such yellows are relatively cheap due to their industrial applications, but should not be considered for artistic expression.

After only a brief exposure to light our sample had changed considerably. After the full exposure the tint had faded and the mass tone had become very dull.

L/FAST W/GUIDE IV

COMMON NAME

DIARYLIDE YELLOW AAMX

COLOUR INDEX NAME
PY13
COLOUR INDEX NUMBER
21100
CHEMICAL CLASS
DISAZO

DIARYLIDE YELLOW OT

Pigment Yellow 14 is a rather bright greenish-yellow. Although semi-opaque, it is strong enough to give a reasonably clear wash when applied well diluted. Diarylide yellows as a group are twice as strong as Arylide Yellows but less resistant to light. This pigment is popular in the printing industry where fastness to light is less important. Recognised as having poor resistance to light when applied thinly.

Our sample faded considerably. Deterioration of the wash commenced after only a short exposure to light. Best avoided.

Also Benzidine Yellow AAOT

DIARYLIDE YELLOW AO

A bright slightly greenish-yellow. Transparent to semi-opaque. Quite a strong pigment which will quickly influence many others when mixed. Unfortunately it has a very poor reputation for lightfastness. Its strength makes it popular in the printing industry. There are, unfortunately, many instances of colorants more suited to industrial purposes which have found their way into artists' paints.

When applied as a thin wash our sample disappeared rapidly. The mass tone became duller. A material well worth avoiding.

BENZIDINE YELLOW B

This pigment is used industrially in the colouring of plastics and rubber. It has a good reputation in this area. Seldom used in artists' paints, it has not been subjected to any formal testing that I am aware of. Diarylides are usually considered to be unsuitable for artistic use.

Judging by the speed of deterioration I will rate it as WG IV pending further testing. Unreliable.

GAMBOGE

An example of a traditional organic pigment which has lingered on well past its time. A fairly bright orange - yellow, long valued for its transparency. The mass tone is a rather heavy, dull colour and the true beauty is only revealed when it is applied thinly. Unfortunately, it is a temporary beauty, as the colour disappears rather quickly. If faded examples are kept in the dark some colour might return.

The wash on our sample bleached out within a short while. This substance is most unsuitable for artistic expression.

L/FAST W/GUIDE V

COMMON NAME

GAMBOGE

COLOUR INDEX NAME

NY24

COLOUR INDEX NUMBER

CHEMICAL CLASS

Imported to West from 1615

BARIUM CHROMATE LEMON

This is an example of the sort of pigment which artists should be more aware of. Absolutely light-fast, it was rated I during ASTM testing. A quite definite green yellow, it has a rather dull, flat appearance. The quiet coolness of the hue has many applications for the water-colourist. Tinctorial power is rather low so it will have a limited influence when blended with stronger colours.

Our sample was unaffected by light in any way. An excellent pigment which is on the ASTM list of recommended pigments.

L/FAST ASTM I

COMMON NAME

BARIUM CHROMATE LEMON

COLOUR INDEX NAME

PY31

COLOUR INDEX NUMBER

77103

CHEMICAL CLASS

BARIUM CHROMATE

CHROME YELLOW LEMON

Usually a definite green - yellow, but orange yellows are available. Often used in 'Lemon Yellows'. Fairly strong with good covering power. Darkened by light and the Hydrogen Sulphide of the atmosphere. Rated ASTM I as a watercolour. It is thought however that one of the new encapsulated varieties could have been tested. Alternatively, our exposure to the atmosphere might have caused the damage, as all of our samples darkened.

Poor acid and alkali resistance. Work glazed over in a frame, will be protected from the atmosphere at least.

L/FAST W/GUIDE IV

COMMON NAME

CHROME YELLOW LEMON

COLOUR INDEX NAME

PY34

COLOUR INDEX NUMBER

77600 & 77603

CHEMICAL CLASS

LEAD CHROMATE AND LEAD SULPHATE

CADMIUM YELLOW LIGHT

A clean, strong, bright yellow. Noted for its opacity, it has very good covering power. This of course is a quality more valued in other media. Strong enough to allow for reasonably clear washes when well diluted. Extremely lightfast, it rated I during ASTM testing. A fine yellow with a useful range of values. Justifiably considered by many, including the author, to be the most important light yellow of the palette.

Unaffected by light under normal circumstances, it is however, sensitive to moisture in strong light. An outstanding pigment. On the ASTM recommended list.

L/FAST ASTM I

COMMON NAME

CADMIUM YELLOW LIGHT

COLOUR INDEX NAME
PY35
COLOUR INDEX NUMBER
77205
CHEMICAL CLASS
CONCENTRATED CADMIUM ZINC SULPHIDE (CC) (SM)

Former CI No 77117

CADMIUM - BARIUM YELLOW LIGHT

An excellent alternative to the more expensive chemically pure Cadmium Yellow Light. In the watercolour ranges it is invariably blended with other colours. Although cheaper than Cadmium Yellow Light, it is usually as bright and as permanent. It does however, share that pigments sensitivity to a combination of moisture and strong light. Finished paintings must be kept perfectly dry, as of course should all artwork, (with the possible exception of swimming pool mosaics).

Absolutely lightfast under normal conditions. Our sample remained unaffected. On the list of ASTM approved pigments. Tested I in watercolour.

L/FAST ASTM I

COMMON NAME
CADMIUM - BARIUM YELLOW LIGHT

COLOUR INDEX NAME
PY 35 : 1
COLOUR INDEX NUMBER
77205 : 1
CHEMICAL CLASS

CADMIUM ZINC SULPHIDE COPRECIPITATED WITH BARIUM SULPHATE (SM)

CADMIUM YELLOW MEDIUM OR DEEP

A bright, strong, orange - yellow. Although opaque and possessing excellent covering power, it is strong enough to allow for reasonably clear washes when well diluted. There have been moves to ban the use of the Cadmium colours on environmental grounds. If such a ban should come into effect, artists will lose some of the most valuable pigments ever invented. As with other Cadmium Yellows, it is sensitive to a combination of light and moisture.

Absolutely lightfast, PY37 is on the list of pigments approved by the ASTM. An invaluable colour for the discerning artist.

L/FAST ASTM I

COMMON NAME
CADMIUM YELLOW MEDIUM OR DEEP

COLOUR INDEX NAME
PY37
COLOUR INDEX NUMBER
77199
CHEMICAL CLASS
CONCENTRATED CADMIUM SULPHIDE (CC) (SM)

Also known as Aurora Yellow.

CADMIUM - BARIUM YELLOW, MEDIUM OR DEEP

A rich, deep, orange - yellow.
Being opaque, PY37 : 1 has good
covering power. Although this
is arguably a property more of
interest to users of media such
as acrylics or oils, it is neverthe-
less of value to the water-
colourist. There are many
occasions where
work has to be painted out.
Better to use an opaque colour
which will hide others with a
relatively thin film. As lightfast
and usually as bright as the
chemically pure PY37.

Absolutely lightfast and on the
list of pigments approved by the
ASTM. A reliable colour, well
worth any extra cost over
inferior deep yellows.

L/FAST ASTM I

COMMON NAME
**CADMIUM - BARIUM
MEDIUM OR DEEP**
COLOUR INDEX NAME
PY37:1
COLOUR INDEX NUMBER
77199:1
CHEMICAL CLASS
**CADMIUM SULPHIDE
COPRECIPITATED WITH
BARIUM SULPHATE (SM)**

AUREOLIN

Aureolin, or Cobalt Yellow as it
is sometimes called, is a reliable
and very transparent mid -
yellow. Fast to light under nor-
mal circumstances it can be af-
fected by weak acids and alkalis.
The use of neutral Ph watercol-
our paper and quality framing
will overcome this. If applied
heavily it looks hard and leath-
ery, when well diluted it reveals
its true beauty and transparency.
Fairly high tinting strength, hid-
ing power low.

With an ASTM lightfast rating of
II it can be considered amongst
the more trustworthy yellow
pigments available to the artist.

L/FAST ASTM II

COMMON NAME
AUREOLIN

COLOUR INDEX NAME
PY40
COLOUR INDEX NUMBER
77357
CHEMICAL CLASS
POTASSIUM COBALTINITRITE

Also called Cobalt Yellow.

MARS YELLOW

A neutralised or dulled orange -
yellow. Mars Yellow can be
considered to be a synthetic
version of naturally occurring
Yellow Ochre. High quality
grades have very good tinting
strength and high covering
power. Often slightly brighter
and stronger than natural Yellow
Ochre, it can also be more trans-
parent due to the absence of
clay. Inert and compatible with
all other pigments, it is a reliable
addition to the artists' palette.

Absolutely lightfast, it was rated I
after ASTM testing and is on the
list of approved pigments.

L/FAST ASTM I

COMMON NAME
MARS YELLOW

COLOUR INDEX NAME
PY42
COLOUR INDEX NUMBER
77492
CHEMICAL CLASS
SYNTHETIC HYDRATED IRON OXIDE

YELLOW OCHRE

A soft dull golden yellow which brushes and mixes well. Naturally occurring iron oxide, Yellow Ochre is considered by many to be less brash than its artificial counterpart, Mars Yellow. It is one of the oldest known pigments and has been in constant use by artists since the cave painter. Tinting strength and covering power are usually high. The better grades are reasonably transparent.

Absolutely lightfast, a most reliable pigment. Rated I during ASTM testing and on the list of approved pigments.

L/FAST ASTM I

COMMON NAME
YELLOW OCHRE

COLOUR INDEX NAME
PY43

COLOUR INDEX NUMBER
77492

CHEMICAL CLASS
NATURAL HYDRATED IRON OXIDE

NICKEL TITANATE YELLOW

A recently introduced artificial mineral pigment. Being a greenish - yellow it lends itself to the manufacture of 'Lemon Yellows'. Although not yet tested by the ASTM in watercolours, it rated I in oils and acrylics. It does have a good reputation for lightfastness in both mass tone and tint. Our sample, however, altered slightly under exposure. Moderately transparent to opaque, with reasonable hiding power. Having a rather weak tinting strength limits its value in mixing.

Although our sample did change slightly during exposure to light, Nickel Titanate Yellow can be considered to be reliable under normal circumstances. Excellent reputation.

L/FAST W/GUIDE II

COMMON NAME
NICKEL TITANATE YELLOW

COLOUR INDEX NAME
PY53

COLOUR INDEX NUMBER
77788

CHEMICAL CLASS
OXIDE OF NICKEL, ANTIMONY AND TITANIUM

DIARYLIDE YELLOW PT

Although twice as strong as the Arylides, Diarylide Yellows are significantly less lightfast. Popular in the printing industry where strength of colour is usually more important than permanence, few can be considered suitable for artistic use. PY55 is a bright orange - yellow of reasonable transparency. Not yet tested under ASTM conditions as a watercolour. It has a poor reputation for fastness to light. Our sample faded rapidly under exposure, particularly the tint.

Reputation alone makes this a pigment to be wary of. The deterioration of our sample would seem to back this up.

L/FAST W/GUIDE IV

COMMON NAME
DIARYLIDE YELLOW PT

COLOUR INDEX NAME
PY55

COLOUR INDEX NUMBER
21096

CHEMICAL CLASS
BENZIDINE AAPT

Also called Benzidine AAPT.

ARYLIDE YELLOW RN

This is a bright orange - yellow with superior lightfastness to its cousin, Arylide Yellow G (PY1). Semi-transparent, it has a useful range of values. This pigment has not yet been tested under ASTM conditions as a watercolour. When protected by the binder it stood up very well as an acrylic and oil paint, with a rating of I. Our preliminary trials however, suggest that it is less lightfast as a watercolour.

Our sample started to fade slightly towards the end of the light exposure period. However, under normal conditions it can be considered reliable.

L/FAST W/GUIDE II

COMMON NAME

ARYLIDE YELLOW RN

COLOUR INDEX NAME
PY65

COLOUR INDEX NUMBER
11740

CHEMICAL CLASS
MONOARYLIDE OR MONOAZO : ACETOACETYL

Also called Hansa Yellow RN.

ARYLIDE YELLOW 5GX

A bright yellow, slightly on the green side. Although considered to be semi-transparent, this can vary depending on whether filler has been added. There are two versions of PY74, LF and HS. The LF stands for Light Fast and the HS for High Strength. Manufacturers seldom differentiate between the two. Unless identified you might come across the even less reliable lightfast HS version.

Rated ASTM III this pigment can be considered to be less than reliable.

L/FAST ASTM III

COMMON NAME

ARYLIDE YELLOW 5GX

COLOUR INDEX NAME
PY74LF

COLOUR INDEX NUMBER
11741

CHEMICAL CLASS
MONOARYLIDE OR MONOAZO : ACETOACETYL OR ARYLIDE AAOA

Also called Hansa Yellow 5GX.

DIARYLIDE YELLOW HR70

This is a very orange yellow of reasonable brightness. PY83 HR70 makes up into a transparent watercolour which is easily clouded by the addition of filler. Not yet tested as a watercolour under ASTM conditions, it rated I in both oils and acrylics. What must be remembered however, is that the pigment is given extra protection by the binder in these media. Our samples varied, some faded, others resisted the light. This could well be to do

with a difference in manufacture. There are several versions of this pigment. HR70 will be rated WG II for this book.

L/FAST W/GUIDE II

COMMON NAME

DIARYLIDE YELLOW HR70

COLOUR INDEX NAME
PY83 HR70

COLOUR INDEX NUMBER
21108

CHEMICAL CLASS
DISAZO

Also called Benzide Yellow AAHR.

ARYLIDE YELLOW FGL

Introduced in the 1950's, PY97 has a reputation for being one of the more lightfast of the Arylide Yellows. A bright greenish - yellow, it mixes into clean greens when combined with any of the green - blues. Reasonably strong, it will influence most other colours in a mix. Being both strong in colour and semi-transparent it provides a useful range of hues. When diluted its strength allows for reasonably clear washes.

Rated II as a watercolour under ASTM controlled lightfast testing. A reliable pigment under normal conditions. Our sample was unaffected by light.

Also called Hansa Yellow FGL

TARTRAZINE LAKE

Tartrazine Lake bleached out very early under both ASTM testing and our own. Recognised as having very poor fastness to light and a low tinting strength, one wonders how it ever came to find its way into artists' paints. Amongst other industrial uses it is employed to dye wool, silk, drugs and food. We might inadvertently eat the substance in our breakfast cereal, but we can choose whether or not to paint with it.

Our sample changed dramatically after only a short exposure. An utterly worthless substance as far as the artist is concerned. Parent dye is Acid Yellow 23.

ANTHRAPYRIMIDINE YELLOW

Available in several versions, the colour varies from a neutral orange - yellow (similar to most Naples Yellow), to a more brownish yellow. Rarely used in modern watercolours, I could only find one example and that was in a mix. Not yet tested as a watercolour under ASTM conditions, it was rated I when made up into both oil and acrylic paints. PY108 has a very good reputation for lightfastness. Good tinting strength.

Our sample was unaffected by light. A reliable colour with little application. The base dye is Vat Yellow 20.

Also called Anthra Yellow.

ISOINDOLINONE YELLOW R

A neutralised or dulled orange - yellow. Transparent washes result when well diluted with water. This is a good example of the protection offered by the binder in certain other media, which is not available in water-colours. ASTM testing of this pigment gave a rating of I when made up into an oil or acrylic paint, but only III as a watercolour. A little violet added to a reliable orange - yellow gives a similar colour.

Our sample faded considerably on exposure. This would confirm the ASTM rating of III. Unreliable - there are better orange yellows available.

L/FAST ASTM III

COMMON NAME
ISOINDOLINONE YELLOW R

COLOUR INDEX NAME
PY110

COLOUR INDEX NUMBER
56280

CHEMICAL CLASS
TETRACHLOROINDOLINONE

QUINOPHTHALONE YELLOW

PY138 is a bright greenish yellow of reasonable transparency. Introduced in 1974, it is considered to be a high performance pigment. Not yet tested under ASTM conditions as a watercolour, it was rated I in both oil and acrylics. This of course, is not always an indication that the pigment will do well as a watercolour. However, it has a good reputation and certainly stood up well to our testing.

Our sample faded only very slightly on exposure to light. Pending further testing, can be considered to be reliable under normal circumstances.

L/FAST W/GUIDE II

COMMON NAME
QUINOPHTHALONE YELLOW

COLOUR INDEX NAME
PY138

COLOUR INDEX NUMBER
NA

CHEMICAL CLASS
QUINOLINE

NICKEL DIOXINE YELLOW

A rather bright orange - yellow. Reasonably strong, it washes out to give quite transparent tints. At the time of writing, this pigment has not been tested under ASTM conditions as a watercolour. As an oil and as an acrylic, it did very well with a rating of I. PY153 has a reputation for excellent fastness to light. Sensitive to acids, which is another reason for using a neutral Ph watercolour paper.

Our sample was unaffected by light, supporting the excellent reputation of this pigment. Can be considered to be reliable under normal circumstances.

L/FAST W/GUIDE II

COMMON NAME
NICKEL DIOXINE YELLOW

COLOUR INDEX NAME
PY153

COLOUR INDEX NUMBER
NA

CHEMICAL CLASS
DIOXINE YELLOW NICKEL COMPLEX

BENZIMIDAZOLONE YELLOW H3G

A bright, reasonably strong yellow. Semi-opaque, but strong enough to give a fairly transparent wash when well diluted. Benzimidazalone Yellows are recently introduced Monoazo compounds. Available in a range of colours, from bright to brownish yellow. Free of heavy metal salts, they are not considered to pose a health hazard. Rated I in ASTM testing for both oils and acrylics. Not yet tested in watercolour.

PY154 has an excellent reputation for lightfastness. Our sample was unaffected by light. Pending further testing can be considered reliable.

ZINC IRON YELLOW

A soft brownish - yellow. Zinc Iron Yellow was developed as a heat resistant alternative to the iron oxide yellows. Opaque, with good covering power. Has an excellent reputation for reliability. We found only one example of its use in an artists' watercolour, and then as a minor ingredient.

Based on our own observations and the reputation of the pigment, rated WG II pending further testing.

Also called Zinc Ferrite.

IRGAZIN YELLOW 4GT

PY177 is a comparatively new pigment. So far not registered which is why it does not have a Colour Index Number. A very dull greenish - yellow. Reasonably transparent in thin washes. As far as I can ascertain it has yet to be subjected to controlled testing as an artists' paint. No other information was available.

Judging solely on the performance of our sample, rated WG II pending further testing.

THE FOLLOWING ARE PIGMENTS RECENTLY INTRODUCED BY MANUFACTURERS AND FOR WHICH FURTHER RESEARCH IS REQIRED.

DISAZO YELLOW R -
Colour Index Name PY95
Colour Index Number - not applicable. Chemical Class 'Disazo'.
A transparent orange-yellow, high in tinting strength. No lightfast rating can be offered until further research has been carried out.

DIARYLIDE YELLOW H10G
Colour Index Name PY81
Colour Index Number - 21127. Chemical Class 'Disazo Type II'.
A bright greenish - yellow, similar in hue to PY3. Transparent, giving good clear washes. This pigment has not yet been subjected to ASTM testing in any media. I cannot offer a lightfast rating until further research has been carried out.

AZOMETHINE YELLOW 5GT
Colour Index Name PY129
Colour Index Number - not applicable. Chemical Class 'Methine (Copper).
A greenish - yellow. Reputed to have very good lightfastness. Not tested in watercolours, oils, acrylics or gouache. I cannot offer a rating for lightfastness rating until full testing has been carried out.

ARYLIDE YELLOW FGL
Colour Index Name PY97
Colour Index Number - 11767. Chemical Class 'Monoazo'.
A greenish - yellow (slightly greener than PY1). Semi-transparent. Introduced in the 1950's. Reputed in the paint industry to have very good lightfastness. This was confirmed by ASTM testing .
Lightfast Category ASTM II

BENZIMIDAZOLONE YELLOW H4G
Colour Index Name PY151
Colour Index Number - 13980. Chemical Class 'Monoazo Benzimidazolone'.
A greenish - yellow . Not yet subjected to ASTM testing as a watercolour paint. However, it rated particularly well in other media. Category I in Acrylics and Oils. I will rate it as WG II for this edition.
Lightfast Category WG II

DIARYLIDE YELLOW
Colour Index Name PY155
Colour Index Number - not applicable. Chemical Class 'Disazo, Type I'.
A bright, transparent yellow. Not yet tested in any art material. I cannot offer a rating for lightfastness until full testing has been carried out.

NICKEL AZO YELLOW
Colour Index Name PY150
Colour Index Number - 12764. Chemical Class 'Monoazo: Nickel complex of a pyrimidine derivative'.
A very greenish - yellow . Not yet subjected to ASTM testing as a watercolour paint. However, it rated particularly well in other media. Category I in Acrylics and Oils. I will rate it as WG II for this edition.
Lightfast Category WG II

YELLOW
WATERCOLOURS

YELLOW WATERCOLOURS

COLOUR MIXING

For the benefit of those who follow my approach to colour mixing - outlined in 'Blue and Yellow Don't Make Green' - I have included an outline guide with each colour section. The guide is based on my mixing palette.

This will help you to identify colours according to type. When mixing, 'colour type' is always more important than 'colour - name'.

See appendix at end of book for further information.

1.1 Aureolin

A particularly transparent yellow which takes on a dull leathery appearance when applied heavily. The true beauty is only revealed in thin washes.

Varies in hue between green - yellow and orange - yellow, depending on manufacturer. In either case the bias is only slight.

Highly recommended.

AUREOLIN 313

A reliable watercolour produced with the correct pigment. Particularly transparent. Brushed out very well. Transparent.

BLOCKX

AQUARELLES
ARTISTS'
WATER COLOUR

PY40 AUREOLIN (P. 34)

HEALTH	ASTM	RATING
✕	II	★★
INFO	L'FAST	★★

AUREOLIN 016 (063)

The correct pigment, PY40, ensures particularly transparent, clean tints. Brushed out very smoothly. Transparent.

WINSOR & NEWTON

ARTISTS'
WATER COLOUR

PY40 AUREOLIN (P. 34)

HEALTH	ASTM	RATING
✕	II	★★
INFO	L'FAST	★★

AUREOLIN 630

Imitation Aureolin. Less transparent than genuine. The word 'Hue' would help with identification. Both pigments reliable. Semi-transparent.

HOLBEIN

ARTISTS'
WATER COLOR

PY42 MARS YELLOW (P. 34)
PY3 ARYLIDE YELLOW 10G (P. 29)

HEALTH	ASTM	RATING
✕	II	★★
INFO	L'FAST	★★

AUREOLIN 601

Particularly transparent, vibrant mid - yellow. Correct pigment. Handles well giving good range of values. Transparent.

ROWNEY

ARTISTS'
WATER COLOUR

PY40 AUREOLIN (P. 34)

HEALTH	ASTM	RATING
✕	II	★★
INFO	L'FAST	★★

1.2 Cadmium Yellow Light

A clean, strong, bright yellow with a bias towards green - although it can be rather orange - depending on manufacture. Opaque, with good covering power, its strength does allow for its use in very thin washes. A fine yellow, with a very useful range of application. It is justifiably considered by many artists to be the most important light yellow of the palette. Be wary of imitations, they are not always described correctly.

For mixing purposes it is important to first establish the bias or leaning of the yellow you have. (Information on deciding bias is given on page 64). If the leaning is towards green, the yellow will give bright greens with a green-blue such as Cerulean Blue. Oranges will always be dull with any red. If the bias is towards orange - expect bright oranges with an orange - red and dull greens with any blue.

CADMIUM YELLOW LIGHT 208

TALENS

Bright, strong orange - yellow. The little Cadmium Orange takes it towards orange. Both pigments absolutely lightfast. Opaque.

PY35 CADMIUM YELLOW LIGHT (P. 33)
PO20 CADMIUM ORANGE (P. 68)

REMBRANDT ARTISTS' WATER COLOUR

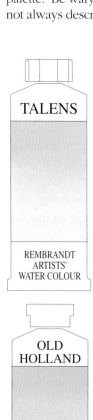

HEALTH	ASTM	RATING
✕ INFO	I L'FAST	★

CADMIUM YELLOW LIGHT 515

MAIMERI

Absolutely lightfast. Well ground and brushes out well. Reasonably transparent when diluted. A superb watercolour, highly recommended.

PY37 CADMIUM YELLOW MEDIUM OR DEEP (P. 33)

ARTISTI EXTRA-FINE WATERCOLOURS

HEALTH	ASTM	RATING
✕ INFO	I L'FAST	★

CADMIUM YELLOW LIGHT 224

SCHMINCKE

Slightly on the orange side. Brushed out very well. Good covering and tinting strength. Opaque. Recommended.

PY35 CADMIUM YELLOW LIGHT (P. 33)
PREVIOUSLY PY35:1 (P. 33)

HORADAM FINEST ARTISTS' WATER COLOURS

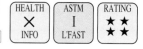

HEALTH	ASTM	RATING
✕ INFO	I L'FAST	★★ ★★

CADMIUM YELLOW LIGHT 407

OLD HOLLAND

A most reliable pigment which will not change on exposure. Brushed well. Rather gummy, dries to a shine when heavy. Opaque.

PY37 CADMIUM YELLOW MEDIUM OR DEEP (P. 33)

CLASSIC WATERCOLOURS

HEALTH	ASTM	RATING
✕ INFO	I L'FAST	★ ★

CADMIUM YELLOW LIGHT 160

BINNEY & SMITH

Very well produced. Handled particularly smoothly, giving a good range of values. Absolutely lightfast. An ideal mid-yellow. Opaque.

PY35 CADMIUM YELLOW LIGHT (P. 33)

PROFESSIONAL ARTISTS' WATER COLOR

HEALTH	ASTM	RATING
✓ INFO	I L'FAST	★ ★

CADMIUM YELLOW LIGHT 529

SENNELIER

Quality ingredients giving an excellent yellow. Strong, bright and brushes out very well giving a good range of values. Opaque.

PY35 CADMIUM YELLOW LIGHT (P. 33)
PREVIOUSLY PY37 (P. 33)

EXTRA-FINE ARTISTS' WATER COLOURS

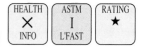

HEALTH	ASTM	RATING
✕ INFO	I L'FAST	★

CADMIUM YELLOW LIGHT 639

HOLBEIN

An excellent watercolour. Brushed out very smoothly. Most reliable pigment, unaffected by light. Opaque.

PY37 CADMIUM YELLOW MEDIUM OR DEEP (P. 33)

ARTISTS' WATER COLOR

HEALTH	ASTM	RATING
✕ INFO	I L'FAST	★ ★

CADMIUM YELLOW PALE 638

HOLBEIN

Closer in hue to Cadmium Yellow Light or Pale than Holbein 639. Ideal ingredient. PY37 will not change on exposure to light. Opaque.

PY37 CADMIUM YELLOW MEDIUM OR DEEP (P. 33)

ARTISTS' WATER COLOR

HEALTH	ASTM	RATING
✕ INFO	I L'FAST	★

CADMIUM YELLOW PALE 118 (087)

WINSOR & NEWTON

An excellent mid - yellow. Absolutely lightfast. Brushed out particularly well giving a good range of values. Bright and strong. Opaque.

PY35 CADMIUM YELLOW LIGHT (P. 33)
PREVIOUSLY PY37 (P. 33)

ARTISTS' WATER COLOUR

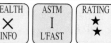

HEALTH	ASTM	RATING
✕ INFO	I L'FAST	★ ★

PĒBĒO

FRAGONARD
ARTISTS'
WATER COLOUR

LIGHT CADMIUM YELLOW 332

Brushed out particularly well giving good gradated washes. Both pigments absolutely lightfast. A highly recommended orange - yellow.

PY35 CADMIUM YELLOW LIGHT (P. 33)
PY37 CADMIUM YELLOW MEDIUM OR DEEP (P. 33)

HEALTH	ASTM	RATING
✕ INFO	I L'FAST	★★ ★★

BLOCKX

AQUARELLES
ARTISTS'
WATER COLOUR

CADMIUM PALE 311

An excellent watercolour. Bright, strong and completely fast to light. Brushed out very well giving good range of values. Opaque.

PY35 CADMIUM YELLOW LIGHT (P. 33)

HEALTH	ASTM	RATING
✕ INFO	I L'FAST	★★ ★★

ROWNEY

ARTISTS'
WATER COLOUR

CADMIUM YELLOW PALE 611

Highly recommended. This paint brushes out into excellent gradated washes. Strong, vibrant and absolutely lightfast. Opaque.

PY37 CADMIUM YELLOW MEDIUM OR DEEP (P. 33)

HEALTH	ASTM	RATING
✓ INFO	I L'FAST	★★ ★★

LEFRANC & BOURGEOIS

LINEL
EXTRA-FINE
ARTISTS'
WATERCOLOUR

CADMIUM YELLOW LIGHT 158

Washes out very well. Strong enough to be reasonably transparent in tints. Ideal pigment used. An excellent watercolour. Opaque.

PY35 CADMIUM YELLOW LIGHT (P. 33)

HEALTH	ASTM	RATING
✕ INFO	I L'FAST	★★ ★★

LUKAS

ARTISTS'
WATER COLOUR

CADMIUM YELLOW LIGHT 1026

A strong, opaque, orange - yellow. Very reliable pigment, unaffected by light. Brushes out very smoothly giving excellent washes.

PY37 CADMIUM YELLOW MEDIUM OR DEEP (P. 33)

HEALTH	ASTM	RATING
✕ INFO	I L'FAST	★★ ★★

GRUMBACHER

FINEST
PROFESSIONAL
WATERCOLORS

CADMIUM YELLOW LIGHT 033

The inclusion of a little PO20 takes the colour towards orange. Both pigments particularly reliable. Handles very well. Opaque.

PY35 CADMIUM YELLOW LIGHT (P. 33)
PO20 CADMIUM ORANGE (P. 68)

HEALTH	ASTM	RATING
✕ INFO	I L'FAST	★★ ★★

HUNTS

SPEEDBALL
PROFESSIONAL
WATERCOLOURS

CADMIUM YELLOW LIGHT

As bright and certainly as lightfast as the chemically pure Cadmium Yellows. Brushed out smoothly. Recommended. Opaque.

CADMIUM SULPHIDE COPRECIPITATED WITH BARIUM SULPHATE

HEALTH	ASTM	RATING
✕ INFO	I L'FAST	★ ★★

DA VINCI PAINTS

PERMANENT
ARTISTS'
WATER COLOR

CADMIUM YELLOW LIGHT 217

Brushes out particularly well, giving smooth gradated washes. Absolutely lightfast. Highly recommended, an excellent, well labelled watercolour. Opaque.

PY35 CADMIUM YELLOW LIGHT (P. 33)

HEALTH	ASTM	RATING
✓ INFO	I L'FAST	★★ ★★

TALENS

WATER COLOUR
2ND RANGE

CADMIUM YELLOW LIGHT (AZO) 213

As the PY74 is not specified LF (Lightfast) or HS (High Strength) I am assuming the latter. Brushed out well. Semi-opaque.
'To be discontinued'.

PY74 ARYLIDE YELLOW (P. 36)
PW4 ZINC WHITE (P. 270)
PY3 ARYLIDE YELLOW 10 (P. 29)

HEALTH	ASTM	RATING
✕ INFO	IV L'FAST	★★

WINSOR & NEWTON

COTMAN
WATER COLOUR
2ND RANGE

CADMIUM YELLOW LIGHT 113 (USA ONLY)

Unusual to see such an excellent pigment used in other than Artists' Quality. Brushed out particularly well. Opaque.

PY35 CADMIUM YELLOW LIGHT (P. 33)
PREVIOUSLY PY37 (P. 33)

HEALTH	ASTM	RATING
✓ INFO	I L'FAST	★★ ★★

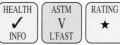

GRUMBACHER

Sample not supplied.

ACADEMY
ARTISTS'
WATERCOLOUR
2ND RANGE

CADMIUM YELLOW PALE HUE 036

The inclusion of PY1, has led to the low lightfast rating. The word hue in the name indicates that this is not genuine Cadmium Yellow. Transparent.

PY1 ARYLIDE YELLOW G (P. 29)
PY3 ARYLIDE YELLOW 10G (P. 29)

HEALTH	ASTM	RATING
✓ INFO	V L'FAST	★

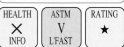

WINSOR & NEWTON

COTMAN
WATER COLOUR
2ND RANGE

CADMIUM YELLOW PALE HUE (AZO) 119 (308)

The pigment failed ASTM testing . Most unreliable, particularly when thin. USA version far superior in this range. Transparent.

PY1 ARYLIDE YELLOW G (P. 29)

HEALTH	ASTM	RATING
✕ INFO	V L'FAST	★

1.3 Cadmium Yellow (Medium)

A clean, strong, bright orange - yellow. As with the other Cadmiums it is valued for its opacity. Its strength of colour does allow for its use in thin washes however. Although permanent, it is susceptible to damp and will fade when exposed to light in a humid atmosphere. Will give bright oranges when mixed with an orange - red such as Cadmium Red Light and dull greens with any blue.

Due to environmental and health concerns, legislation might well remove the Cadmiums from circulation. They will be difficult to replace.

CADMIUM YELLOW MEDIUM 161

Brushes out particularly well into gradated washes. Finely ground. An excellent pigment, unaffected by light. Bright and strong. Opaque.

PY37 CADMIUM YELLOW MEDIUM OR DEEP (P. 33)

PROFESSIONAL ARTISTS' WATER COLOR

HEALTH	ASTM	RATING
✓ INFO	I L'FAST	★★ ★★

CADMIUM YELLOW MEDIUM 5711

Ingredients are as lightfast as the chemically pure Cadmium Yellows. Strong, bright and opaque.

CADMIUM SULPHIDE COPRECIPITATED WITH BARIUM SULPHATE.

SPEEDBALL PROFESSIONAL WATERCOLOURS

HEALTH	ASTM	RATING
✗ INFO	I L'FAST	★★

CADMIUM MEDIUM 315

Produced from a first rate pigment. Gives very good washes, handling particularly well. Most reliable. Opaque.

PY37 CADMIUM YELLOW MEDIUM OR DEEP (P. 33)

AQUARELLES ARTISTS' WATER COLOUR

HEALTH	ASTM	RATING
✗ INFO	I L'FAST	★★ ★★

CADMIUM YELLOW MEDIUM 159

A first rate watercolour. Handles very well giving smooth washes. Excellent pigment, strong, bright and reliable. Opaque.

PY37 CADMIUM YELLOW MEDIUM OR DEEP (P. 33)

LINEL EXTRA-FINE ARTISTS' WATERCOLOUR

HEALTH	ASTM	RATING
✗ INFO	I L'FAST	★★ ★★

CADMIUM YELLOW 209

Strong, bright and produced from a first class pigment. Handles very well giving good washes. Dependable. Opaque.

PY35 CADMIUM YELLOW LIGHT (P. 33)
PO20 CADMIUM ORANGE (P. 68)

REMBRANDT ARTISTS' WATER COLOUR

HEALTH	ASTM	RATING
✗ INFO	I L'FAST	★★ ★★

CADMIUM YELLOW MIDDLE 225

Pigment recently changed from PY37:1 to the chemically pure Cadmium Yellow Light, PY35. Brushed out particularly well. Opaque.

PY35 CADMIUM YELLOW LIGHT (P. 33)
PREVIOUSLY PY37:1 (P. 34)

HORADAM FINEST ARTISTS' WATER COLOURS

HEALTH	ASTM	RATING
✗ INFO	I L'FAST	★★ ★★

CADMIUM YELLOW 612

First rate pigment used. Completely unaffected by light. Brushes well giving good range of values. Opaque.

PY37 CADMIUM YELLOW MEDIUM OR DEEP (P. 33)

ARTISTS' WATER COLOUR

HEALTH	ASTM	RATING
✓ INFO	I L'FAST	★★ ★★

CADMIUM YELLOW MEDIUM 408

Excellent pigment. Strong, bright and washes out smoothly. Sample slightly overbound. Opaque.

PY37 CADMIUM YELLOW MEDIUM OR DEEP (P. 33)

CLASSIC WATERCOLOURS

HEALTH	ASTM	RATING
✗ INFO	I L'FAST	★★

CADMIUM YELLOW MEDIUM 034

The inclusion of Cadmium Orange takes it towards Cadmium Yellow Deep. Washes well. Most dependable orange - yellow. Opaque.

PY35 CADMIUM YELLOW LIGHT (P. 33)
PO20 CADMIUM ORANGE (P. 68)

FINEST PROFESSIONAL WATERCOLORS

HEALTH	ASTM	RATING
✗ INFO	I L'FAST	★★ ★★

CADMIUM YELLOW 108 (085)

WINSOR & NEWTON

Strong, bright, good covering power and completely fast to light. Ideal pigment used. Handles very well. Opaque.

ARTISTS' WATER COLOUR

PY35 CADMIUM YELLOW LIGHT (P. 33)

HEALTH	ASTM	RATING
✗ INFO	I L'FAST	★★ ★★

CADMIUM YELLOW HUE (AZO) 109 (307)

WINSOR & NEWTON

Both pigments failed ASTM testing as watercolours. Reliable, low cost alternatives are available for second range colours. Semi-transparent.

COTMAN WATER COLOUR 2ND RANGE

PY1 ARYLIDE YELLOW G (P. 29)
PO13 PYRAZONLONE ORANGE (P. 68)

HEALTH	ASTM	RATING
✗ INFO	V L'FAST	★

CADMIUM YELL0W 108 (USA ONLY)

WINSOR & NEWTON

In marked contrast to the equivalent colour marketed outside of the USA. Excellent pigment, absolutely lightfast. Well labelled. Opaque.

COTMAN WATER COLOUR 2ND RANGE

PY35 CADMIUM YELLOW LIGHT (P. 33)

HEALTH	ASTM	RATING
✓ INFO	I L'FAST	★★ ★★

CADMIUM YELLOW MEDIUM 034

GRUMBACHER

Both the PO1 and the PY1 are particularly fugitive. Alternative, low cost pigments for students' work are available. Most unreliable. Transparent.

ACADEMY ARTISTS' WATERCOLOUR 2ND RANGE

PO1 HANSA ORANGE (P. 68)
PY1 ARYLIDE YELLOW G (P. 29)
PY3 ARYLIDE YELLOW 10G (P. 29)

HEALTH	ASTM	RATING
✓ INFO	V L'FAST	★

CADMIUM YELLOW (HUE) 620

ROWNEY

I can see no reason why students' colours should be so fugitive. Alternatives are available. Brushed out poorly. Transparent.

GEORGIAN WATER COLOUR 2ND RANGE

PY1 ARYLIDE YELLOW G (P.29)

HEALTH	ASTM	RATING
✓ INFO	V L'FAST	★

All Cadmium Yellows are prone to fade if exposed to light in a humid atmosphere.

1.4 Cadmium Yellow Deep

A very definite orange - yellow. Will give bright oranges when mixed with an orange - red such as Cadmium Red Light, mid greens with a green - blue and dull greens when mixed with Ultramarine, a violet - blue.

Strong, opaque and absolutely lightfast. An invaluable colour. Beware of poorly labelled imitations.

CADMIUM YELLOW DEEP 210

TALENS

Dense pigment, well ground. Handles particularly well across the range of washes. A strong, bright, reliable watercolour. Opaque.

REMBRANDT ARTISTS' WATER COLOUR

PY35 CADMIUM YELLOW LIGHT (P. 33)
PO20 CADMIUM ORANGE (P. 68)

HEALTH	ASTM	RATING
✗ INFO	I L'FAST	★★ ★★

DARK CADMIUM YELLOW 333

PĒBĒO

Handles particularly well, giving a versatile range of values. Particularly lightfast pigment used. Well prepared. Opaque.

FRAGONARD ARTISTS' WATER COLOUR

PY35 CADMIUM YELLOW LIGHT (P. 33)

HEALTH	ASTM	RATING
✗ INFO	I L'FAST	★★ ★★

CADMIUM YELLOW DEEP 516

MAIMERI

Densely packed pigment. The paint brushes out beautifully giving very even washes. A most reliable watercolour. Opaque.

ARTISTI EXTRA-FINE WATERCOLOURS

PY37 CADMIUM YELLOW MEDIUM OR DEEP (P. 33)

HEALTH	ASTM	RATING
✗ INFO	I L'FAST	★★ ★★

CADMIUM YELLOW DEEP 613

ROWNEY

A strong, bright orange - yellow which brushed out very well. Densely packed pigment. Opaque.

ARTISTS' WATER COLOUR

PY37 CADMIUM YELLOW MEDIUM OR DEEP (P. 33)
PO20 CADMIUM ORANGE (P. 68)

HEALTH	ASTM	RATING
✓ INFO	I L'FAST	★★ ★★

CADMIUM YELLOW DEEP 226

SCHMINCKE

Pigment recently changed from PY37:1 to the chemically pure Cadmium Yellow Light. Washes out very well. Absolutely lightfast. Opaque.

PY35 CADMIUM YELLOW LIGHT (P. 34)
PREVIOUSLY PY37:1 (P. 34)

HORADAM
FINEST
ARTISTS'
WATER COLOURS

HEALTH	ASTM	RATING
✕ INFO	I L'FAST	★★ ★★

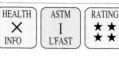

CADMIUM YELLOW DEEP 640

HOLBEIN

Strong, opaque colour. Brushes out very well giving good gradated washes. Strong enough to provide reasonable tints.

PY37 CADMIUM YELLOW MEDIUM OR DEEP (P. 33)

ARTISTS'
WATER COLOR

HEALTH	ASTM	RATING
✕ INFO	I L'FAST	★★

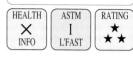

CADMIUM YELLOW DEEP 1028

LUKAS

Brushes out reasonably well. PO20 has been used instead of the more usual Cadmium Yellow. Completely fast to light. Opaque.

PO20 CADMIUM ORANGE (P. 68)

ARTISTS'
WATER COLOUR

HEALTH	ASTM	RATING
✕ INFO	I L'FAST	★

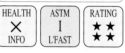

CADMIUM YELLOW DEEP 533

SENNELIER

An excellent watercolour. Handles particularly well. Strong, opaque and bright. Gives reasonable tints when diluted.

PY35 CADMIUM YELLOW LIGHT (P. 33)
PREVIOUSLY PY37 (P. 33)

EXTRA-FINE
ARTISTS'
WATER COLOURS

HEALTH	ASTM	RATING
✕ INFO	I L'FAST	★★ ★★

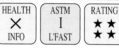

CADMIUM YELLOW DEEP 111 (086)

WINSOR & NEWTON

Both pigments are equally lightfast and opaque. When applied thinly is reasonably transparent due to its strength. Dependable.

PY35 CADMIUM YELLOW LIGHT (P. 33)
PR108 CADMIUM RED LIGHT, MEDIUM OR DEEP (P. 91)

ARTISTS'
WATER COLOUR

HEALTH	ASTM	RATING
✕ INFO	I L'FAST	★★ ★★

CADMIUM YELLOW DEEP 162

BINNEY & SMITH

Well labelled - full ingredient details and health information are given. Perfect ingredients, making for a strong, smooth watercolour. Opaque.

PY37 CADMIUM YELLOW MEDIUM OR DEEP (P. 33)

PROFESSIONAL
ARTISTS'
WATER COLOR

HEALTH	ASTM	RATING
✓ INFO	I L'FAST	★★ ★★

CADMIUM YELLOW DEEP 031

GRUMBACHER

Produced using two absolutely lightfast ingredients, very similar chemically. Brushes out very well. An excellent watercolour. Opaque.

PY35 CADMIUM YELLOW LIGHT (P. 33)
PO20 CADMIUM ORANGE (P. 68)

FINEST
PROFESSIONAL
WATERCOLORS

HEALTH	ASTM	RATING
✕ INFO	I L'FAST	★★ ★★

CADMIUM YELLOW DEEP 160

LEFRANC & BOURGEOIS

Smooth, bright and strong. A well produced watercolour. Absolutely lightfast ingredients used. Brushed out well. Opaque.

PY37 CADMIUM YELLOW MEDIUM OR DEEP (P. 33)

LINEL
EXTRA-FINE
ARTISTS'
WATERCOLOUR

HEALTH	ASTM	RATING
✕ INFO	I L'FAST	★

CADMIUM YELLOW DEEP 409

OLD HOLLAND

A well made watercolour. Dense pigment, well ground. Handles particularly well. Strong, opaque and particularly lightfast.

PY37 CADMIUM YELLOW MEDIUM OR DEEP (P. 33)

CLASSIC
WATERCOLOURS

HEALTH	ASTM	RATING
✕ INFO	I L'FAST	★★ ★★

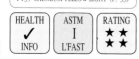

CADMIUM YELLOW DEEP 215

DA VINCI PAINTS

A very well labelled paint. Full information on ingredients, binder and health risks are given. Handles very well. Opaque.

PY35 CADMIUM YELLOW LIGHT (P. 33)

PERMANENT
ARTISTS'
WATER COLOR

HEALTH	ASTM	RATING
✓ INFO	I L'FAST	★★ ★★

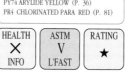

CADMIUM YELLOW DEEP (AZO) 215

TALENS

The red content will fade rapidly followed closely by the yellow. Most unreliable. A rather dull, brownish yellow. *This range of colours is to be discontinued.*

PY74 ARYLIDE YELLOW (P. 36)
PR4 CHLORINATED PARA RED (P. 81)

WATER COLOUR
2ND RANGE

HEALTH	ASTM	RATING
✕ INFO	V L'FAST	★

CADMIUM YELLOW DEEP 031

GRUMBACHER

As with many second range, or student colours, it would be cheaper to buy the artists quality as far as value for money is concerned.

PY1 ARYLIDE YELLOW G (P. 29)
PO1 HANSA ORANGE (P. 68)

ACADEMY
ARTISTS'
WATERCOLOUR
2ND RANGE

HEALTH	ASTM	RATING
✓ INFO	V L'FAST	★

1.5 Chrome Yellow (Light, Medium, Deep)

Fairly strong with good covering power.

A most unreliable colour which can become very dark on exposure to light or the atmosphere. The atmosphere in fact might cause even more damage than the light. Imitations are usually little better.

For mixing purposes, varies between green - yellow and orange - yellow.

It can spoil any colour with which it is combined. Personally I would not even consider it.

CHROME YELLOW LIGHT 549

Can darken quite dramatically on exposure to the atmosphere and to light. An unreliable pigment. Brushes out quite well. Semi-opaque. *Colour now discontinued.*

SENNELIER — EXTRA-FINE ARTISTS' WATER COLOURS

PY34 CHROME YELLOW LEMON (P. 32)

HEALTH INFO ✓	WG IV L'FAST	RATING ★

CHROME YELLOW LIGHT 212

I feel that I need further information on PY155 before offering assessments. Has not been subjected to ASTM testing. The PY153 is lightfast.

PY155 DIARYLIDE YELLOW (P.40)
PY153 NICKEL DIOXINE YELLOW P38
PREVIOUSLY PY83 (P. 36) - PW6 (P. 271)
AND PY 74LF (P. 36)

SCHMINCKE — HORADAM FINEST ARTISTS' WATER COLOURS

HEALTH INFO ✗		

CHROME YELLOW LIGHT 165

The pigment used, PY34 can gradually darken, greying the colour considerably. Reliable alternatives are available. Semi-opaque.

LEFRANC & BOURGEOIS — LINEL EXTRA-FINE ARTISTS' WATERCOLOUR

PY34 CHROME YELLOW LEMON (P. 32)

HEALTH INFO ✓	WG IV L'FAST	RATING ★

CHROME YELLOW 164 (015)

Very densely packed pigment. PY 34 tends to darken when exposed to light and the atmosphere. Semi-opaque. *This colour has been discontinued due to its toxicity.*

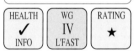

WINSOR & NEWTON — ARTISTS' WATER COLOUR

PY34 CHROME YELLOW LEMON (P. 32)

HEALTH INFO ✓	WG IV L'FAST	RATING ★

CHROME YELLOW 622

So densely packed that the tube was damaged trying to remove the paint. A most unreliable pigment, can darken considerably. Semi-opaque.

ROWNEY — ARTISTS' WATER COLOUR

PY34 CHROME YELLOW LEMON (P. 32)

HEALTH INFO ✓	WG IV L'FAST	RATING ★

CHROME YELLOW DEEP 551

This can darken on exposure to light or the atmosphere. A most unreliable pigment which will usually gradually spoil. Semi-opaque. *This colour has been discontinued.*

SENNELIER — EXTRA-FINE ARTISTS' WATER COLOURS

PY34 CHROME YELLOW LEMON (P. 32)

HEALTH INFO ✓	WG IV L'FAST	RATING ★

CHROME YELLOW DEEP 152 (012)

Similar in hue to a Cadmium Yellow Medium. That is as far as the comparison goes. Most unreliable. *This colour has been discontinued due to its toxicity.*

WINSOR & NEWTON — ARTISTS' WATER COLOUR

PY34 CHROME YELLOW LEMON (P. 32)

HEALTH INFO ✓	WG IV L'FAST	RATING ★

CHROME YELLOW DEEP HUE 213

This is not Chrome Yellow at all, which is an advantage. Pigment recently upgraded from the unreliable PY83 to PY65. The word 'Hue' has now been added. Semi-trans. Excellent.

SCHMINCKE — HORADAM FINEST ARTISTS' WATER COLOURS

PY65 ARYLIDE YELLOW RN (P. 36)

HEALTH INFO ✗	WG II L'FAST	RATING ★★

PY34, Chrome Yellow Lemon, can became very dark on exposure to light or the atmosphere.

1.6 Gamboge

Genuine Gamboge (Natural Yellow 24), is produced from a brown resin taken from the bark of an Asian gum tree. It is a pity that it is not left there.

In use for hundreds of years, it makes a bright, very transparent watercolour. Unfortunately it is particularly fugitive.

Alternatives are employed by most colourmen, they are not always much better.

For mixing purposes, Gamboge usually leans towards orange. This is not always the case as there are many imitations, employing a variety of pigments.

GAMBOGE 124

PÉBÉO

A dull, brownish yellow. Washed out reasonably well into a series of useful values. Reliable under normal conditions. Semi-transparent.

PR101 MARS RED (P. 89)
PY138 QUINOPHTHALONE YELLOW (P. 38)

FRAGONARD ARTISTS' WATER COLOUR

HEALTH	WG	RATING
✗ INFO	II L'FAST	★★

GAMBOGE 440

BINNEY & SMITH

Both pigments will tend to gradually fade, especially when applied as a thin wash. Handles reasonably well. Semi-transparent.

PY83 DIARYLIDE YELLOW HR70 (P. 36)
PY 74LF ARYLIDE YELLOW 5GX (P. 36)

PROFESSIONAL ARTISTS' WATER COLOR

HEALTH	ASTM	RATING
✓ INFO	III L'FAST	★★

GAMBOGE (HUE) 521

MAIMERI

Our sample bleached out and became very blotchy in a short time. PY17 is most unreliable. Semi-opaque.

PY17 DIARYLIDE YELLOW AO (P. 31)

ARTISTI EXTRA-FINE WATERCOLOURS

HEALTH	WG	RATING
✗ INFO	V L'FAST	★

GAMBOGE 216

BLOCKX

Both ingredients are most unsuitable as far as fastness to light is concerned. They make into an unreliable paint. Semi-transparent.

PR3 TOLUIDINE RED (P. 81)
PY1 ARYLIDE YELLOW G (P. 29)

AQUARELLES ARTISTS' WATER COLOUR

HEALTH	WG	RATING
✗ INFO	V L'FAST	★

GAMBOGE (HUE) 077

GRUMBACHER

Washes out adequately. The description on the tube, 'Hansa Yellow Base', is meaningless. At least it is a description. Semi-opaque.

PY42 MARS YELLOW (P. 34)
PY3 ARYLIDE YELLOW 10G (P. 29)

FINEST PROFESSIONAL WATERCOLORS

HEALTH	ASTM	RATING
✗ INFO	II L'FAST	★ ★★

GAMBOGE 238

TALENS

Slightly gummy which made for uneven washes over the full range of values. A reliable pigment has been used. Semi-transparent.

PY97 ARYLIDE YELLOW FGL (P. 37)

REMBRANDT ARTISTS' WATER COLOUR

HEALTH	ASTM	RATING
✗ INFO	II L'FAST	★ ★★

GAMBOGE 265 (069)

WINSOR & NEWTON

This substance will fade rather quickly. Our sample was heavy and unpleasant to use, unless as a thin wash. Most unreliable. Transparent.

NY24 GAMBOGE (P. 32)

ARTISTS' WATER COLOUR

HEALTH	WG	RATING
✗ INFO	V L'FAST	★

GAMBOGE NEW 267 (020)

WINSOR & NEWTON

Neither pigment is reliable. Both have tested out poorly. Our sample did likewise. Brushed out rather well. Semi-transparent.

PR3 TOLUIDINE RED (P. 81)
PY1 ARYLIDE YELLOW G (P. 29)

ARTISTS' WATER COLOUR

HEALTH	ASTM	RATING
✗ INFO	V L'FAST	★

GAMBOGE (SUBSTITUTE) 152

LEFRANC & BOURGEOIS

If this rather outdated name must be retained then at least reliable pigments such as PY97 should be used. Semi-transparent.

PY97 ARYLIDE YELLOW FGL (P. 37)

LINEL EXTRA-FINE ARTISTS' WATERCOLOUR

HEALTH	ASTM	RATING
✓ INFO	II L'FAST	★★ ★★

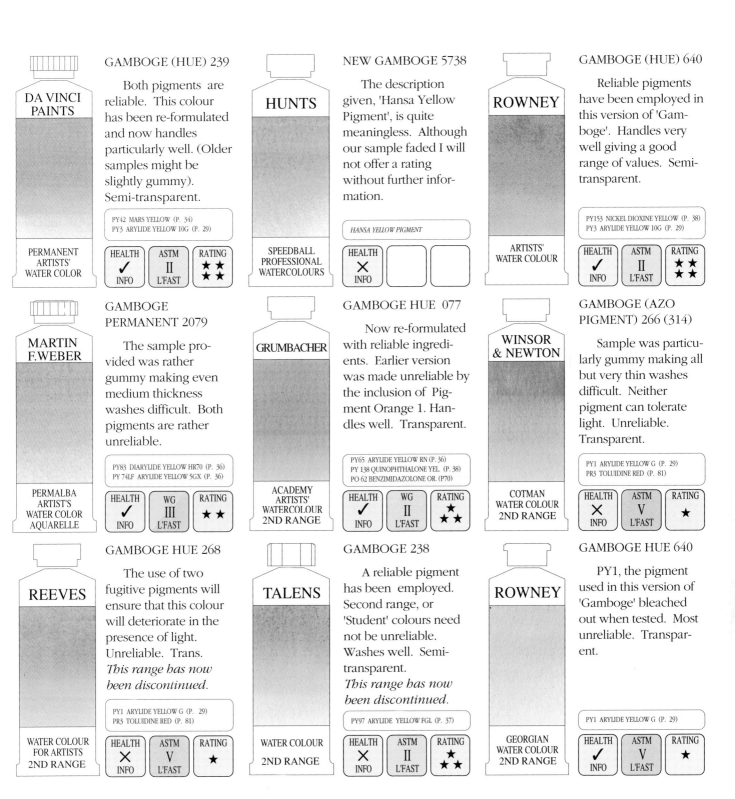

DA VINCI PAINTS

GAMBOGE (HUE) 239

Both pigments are reliable. This colour has been re-formulated and now handles particularly well. (Older samples might be slightly gummy). Semi-transparent.

PY42 MARS YELLOW (P. 34)
PY3 ARYLIDE YELLOW 10G (P. 29)

PERMANENT ARTISTS' WATER COLOR

HEALTH	ASTM	RATING
✓ INFO	II L'FAST	★★ ★★

HUNTS

NEW GAMBOGE 5738

The description given, 'Hansa Yellow Pigment', is quite meaningless. Although our sample faded I will not offer a rating without further information.

HANSA YELLOW PIGMENT

SPEEDBALL PROFESSIONAL WATERCOLOURS

HEALTH		
✗ INFO		

ROWNEY

GAMBOGE (HUE) 640

Reliable pigments have been employed in this version of 'Gamboge'. Handles very well giving a good range of values. Semi-transparent.

PY153 NICKEL DIOXINE YELLOW (P. 38)
PY3 ARYLIDE YELLOW 10G (P. 29)

ARTISTS' WATER COLOUR

HEALTH	ASTM	RATING
✓ INFO	II L'FAST	★★ ★★

MARTIN F. WEBER

GAMBOGE PERMANENT 2079

The sample provided was rather gummy making even medium thickness washes difficult. Both pigments are rather unreliable.

PY83 DIARYLIDE YELLOW HR70 (P. 36)
PY 74LF ARYLIDE YELLOW 5GX (P. 36)

PERMALBA ARTIST'S WATER COLOR AQUARELLE

HEALTH	WG	RATING
✓ INFO	III L'FAST	★★

GRUMBACHER

GAMBOGE HUE 077

Now re-formulated with reliable ingredients. Earlier version was made unreliable by the inclusion of Pigment Orange 1. Handles well. Transparent.

PY65 ARYLIDE YELLOW RN (P. 36)
PY 138 QUINOPHTHALONE YEL. (P. 38)
PO 62 BENZIMIDAZOLONE OR. (P70)

ACADEMY ARTISTS' WATERCOLOUR 2ND RANGE

HEALTH	WG	RATING
✓ INFO	II L'FAST	★★

WINSOR & NEWTON

GAMBOGE (AZO PIGMENT) 266 (314)

Sample was particularly gummy making all but very thin washes difficult. Neither pigment can tolerate light. Unreliable. Transparent.

PY1 ARYLIDE YELLOW G (P. 29)
PR3 TOLUIDINE RED (P. 81)

COTMAN WATER COLOUR 2ND RANGE

HEALTH	ASTM	RATING
✗ INFO	V L'FAST	★

REEVES

GAMBOGE HUE 268

The use of two fugitive pigments will ensure that this colour will deteriorate in the presence of light. Unreliable. Trans. *This range has now been discontinued.*

PY1 ARYLIDE YELLOW G (P. 29)
PR3 TOLUIDINE RED (P. 81)

WATER COLOUR FOR ARTISTS 2ND RANGE

HEALTH	ASTM	RATING
✗ INFO	V L'FAST	★

TALENS

GAMBOGE 238

A reliable pigment has been employed. Second range, or 'Student' colours need not be unreliable. Washes well. Semi-transparent. *This range has now been discontinued.*

PY97 ARYLIDE YELLOW FGL (P. 37)

WATER COLOUR 2ND RANGE

HEALTH	ASTM	RATING
✗ INFO	II L'FAST	★★ ★★

ROWNEY

GAMBOGE HUE 640

PY1, the pigment used in this version of 'Gamboge' bleached out when tested. Most unreliable. Transparent.

PY1 ARYLIDE YELLOW G (P. 29)

GEORGIAN WATER COLOUR 2ND RANGE

HEALTH	ASTM	RATING
✓ INFO	V L'FAST	★

Genuine Gamboge, long employed in Asia, has been used by European artists for several hundred years. First used as a pigment for spirit varnishes, but now almost exclusively as a watercolour.

Originally imported by the East Indian Company around 1615. Unique as an artist's colour in that it is a complete paint in its natural state, being colouring matter in a gum.

A fugitive substance, it should have been replaced many years ago by other, more reliable yellows.

An unimportant relic from the past.

1.7 Indian Yellow

Indian Yellow has a rather bizarre background. As the name suggests, it was originally produced in India. Cows were fed a diet of mango leaves and then denied water. Their concentrated urine was collected and mixed with mud. This was later purified into a very clear yellow.

Generally leans towards orange, although green - yellows are available.

Once the bias, or leaning of the particular colour you have has been decided, it is possible to plan colour mixing in advance. If the yellow leans towards orange the mixing complementary will be a blue - violet, if it is a green - yellow select a red - violet as the mixing partner. Complementary colours will darken each other very successfully.

ROWNEY — INDIAN YELLOW 643

The pigments used in this watercolour are both unreliable, the yellow in particular. As expected, our sample bleached white. Transparent.

PY100 TARTRAZINE (P. 37)
PR83:1 ALIZARIN CRIMSON (P. 88)

ARTISTS' WATER COLOUR

HEALTH	ASTM	RATING
✓ INFO	V L'FAST	★

SCHMINCKE — INDIAN YELLOW 220

Unreliable. The inclusion of PY110 (which has been tested under ASTM conditions), lowered the lightfast rating. Tints in particular are liable to fade. Semi-opaque.

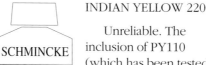

PY110 ISOINDOLINONE YELLOW R (P. 38)
PY154 BENZIMIDAZOLONE YELLOW H3G (P. 39)

HORADAM FINEST ARTISTS' WATER COLOURS

HEALTH	ASTM	RATING
✗ INFO	III L'FAST	★★

MAIMERI — INDIAN YELLOW (HUE) 520

On exposure the colour will fade, It will also become more orange as the PO43 is reliable. Semi-opaque.

PY17 PERMANENT YELLOW GG (P. 31)
PO43 PERINONE ORANGE (P. 69)

ARTISTI EXTRA-FINE WATERCOLOURS

HEALTH	WG	RATING
✗ INFO	V L'FAST	★

GRUMBACHER — INDIAN YELLOW HUE 111

Re-formulated using excellent pigments. (The earlier version was produced using very unreliable ingredients). Check contents if purchasing. Handles very well. Transparent.

PY97 ARYLIDE YELLOW FGL (P. 37)
PO62 BENZIMIDAZOLONE OR. (P. 70)
PREVIOUSLY PY1 (P.29) & PO1 (P.68)

FINEST PROFESSIONAL WATERCOLORS

HEALTH	ASTM	RATING
✗ INFO	II L'FAST	★★

TALENS — INDIAN YELLOW 244

Sample was very gummy, giving poor washes unless very thin. Will gradually fade on exposure. Semi-transparent.

PY110 ISOINDOLINONE YELLOW R (P. 38)

REMBRANDT ARTISTS' WATER COLOUR

HEALTH	ASTM	RATING
✗ INFO	III L'FAST	★★

LEFRANC & BOURGEOIS — INDIAN YELLOW (IMITATION) 182

A reliable pigment has been employed. Brushed out very well, giving even washes over the full range. Semi-transparent.

PY153 NICKEL DIOXINE YELLOW (P. 38)

LINEL EXTRA-FINE ARTISTS' WATERCOLOUR

HEALTH	WG	RATING
✗ INFO	II L'FAST	★★ ★★

LUKAS — INDIAN YELLOW 1024

Handles particularly well, giving smooth, gradated washes. Reliable pigment which will resist light. Transparent.

PY3 ARYLIDE YELLOW 10G (P. 29)

ARTISTS' WATER COLOUR

HEALTH	ASTM	RATING
✗ INFO	II L'FAST	★★ ★★

WINSOR & NEWTON — INDIAN YELLOW 319 (024)

Sample was rather gummy and dried to a shine unless very thin. Will gradually fade on exposure to light. Semi-transparent.

PY1:1 ARYLIDE YELLOW G (P. 29)

ARTISTS' WATER COLOUR

HEALTH	ASTM	RATING
✗ INFO	III L'FAST	★★

HOLBEIN — INDIAN YELLOW 647

Late notification on the use of PY95. Insufficient time to test the pigment, therefore no assessments offered.

PY83 DIARYLIDE YELLOW HR70 (P. 36)
PY95 DISAZO YELLOW R (P. 40)

ARTISTS' WATER COLOR

HEALTH
✗ INFO

INDIAN YELLOW 517

Now re-formulated using excellent ingredients. (The earlier version was unreliable due to the inclusion of PY83). Check ingredients if purchasing. Semi-transparent.

PY153 NICKEL DIOXINE YELLOW (P. 38)
PW 21 BLANC FIXE (P.272)
PREVIOUSLY PY43 (P. 35) & PY83 (P.36)

HEALTH	WG	RATING
✗ INFO	II L'FAST	★★

PAILLARD

INDIAN YELLOW

Information on ingredients withheld. No assessment offered. Our sample faded dramatically however.

LOUVRE AQUARELLE ARTISTS' COLOUR 2ND RANGE

HEALTH		
✗ INFO		

Production of Genuine Indian Yellow ceased in 1921. Today the name is used to sell a variety of yellows. Some are reliable, others will fade as in the example above.

1.8 Lemon Yellow

A general term in use for a pale green yellow, rather than the name for a particular ingredient.

Various yellow pigments are employed, the most common being PY3, which is reliable. Transparency varies, usually semi - transparent.

In mixing, this green - yellow will give semi - opaque bright greens when combined with an opaque green - blue such as Cerulean Blue. Clearer bright greens result when mixed with a transparent green - blue such as Phthalocyanine Blue. Dull oranges will be created when Lemon Yellow is combined with any red.

Mixing complementary is a red - violet. These two colours will darken each other without destroying the character of their partner.

BLOCKX

AQUARELLES ARTISTS' WATER COLOUR

LEMON YELLOW 211

Both pigments are absolutely lightfast making for a most reliable paint. Washed out well but had little body. Semi-transparent.

PY31 BARIUM CHROMATE LEMON (P. 32)
PY35 CADMIUM YELLOW LIGHT (P. 33)

HEALTH	ASTM	RATING
✗ INFO	I L'FAST	★ ★★

ROWNEY

ARTISTS' WATER COLOUR

LEMON YELLOW 651

A reliable pigment has been used. The paint will resist light very well. Brushed out smoothly. Semi-transparent.

PY3 ARYLIDE YELLOW 10G (P. 29)

HEALTH	ASTM	RATING
✓ INFO	II L'FAST	★★

HUNTS

SPEEDBALL PROFESSIONAL WATERCOLOURS

LEMON YELLOW 5710

Information on ingredients withheld. The description offered in the literature, 'Hansa Yellow Pigment' is meaningless. No assessment offered.

HANSA YELLOW PIGMENT

HEALTH		
✗ INFO		

HOLBEIN

ARTISTS' WATER COLOR

LEMON YELLOW 635

Colour is slightly clouded by the use of white in the make up. Reliable pigments. Handles very well. Semi-transparent.

PY3 ARYLIDE YELLOW 10G (P. 29)
PW6 TITANIUM WHITE (P. 271)

HEALTH	ASTM	RATING
✗ INFO	II L'FAST	★ ★★

HOLBEIN

ARTISTS' WATER COLOR

PERMANENT YELLOW LEMON 631

Our first sample contained PY14 (page 31) and faded badly. Now reformulated with lightfast pigments. Select new stock. Semi-transparent.

PY3 ARYLIDE YELLOW 10G (P. 29)
PY53 NICKEL TITANATE YELLOW (P. 35)

HEALTH	ASTM	RATING
✗ INFO	II L'FAST	★ ★★

MARTIN F.WEBER

PERMALBA ARTIST'S WATER COLOR AQUARELLE

LEMON YELLOW 2056

Brushes out very well over a range of values. Reliable pigments used. Previously produced from PY3. A little Phthalo Green has now been added. Will resist fading. Transparent.

PY3 ARYLIDE YELLOW 10G (P. 29)
PG7 PHTHALOCYANINE GREEN (P. 177)

HEALTH	ASTM	RATING
✓ INFO	II L'FAST	★ ★★

LEMON YELLOW (HANSA YELLOW) 118

GRUMBACHER

Well packed with pigment. A strong watercolour which washes out very well at any strength. Dependable. Semi-transparent.

FINEST PROFESSIONAL WATERCOLORS

PY3 ARYLIDE YELLOW 10G (P. 29)

HEALTH	ASTM	RATING
✗ INFO	II L'FAST	★★

LEMON YELLOW HANSA 252

BINNEY & SMITH

Very well labelled. Full details on ingredients and health information. Handles particularly well. A reliable green - yellow. Semi-transparent.

PROFESSIONAL ARTISTS' WATER COLOR

PY3 ARYLIDE YELLOW 10G (P. 29)

HEALTH	ASTM	RATING
✓ INFO	II L'FAST	★★

LEMON YELLOW HUE 347 (070)

WINSOR & NEWTON

A rather dull, weak, Lemon Yellow which will not contribute well when mixing bright greens. Lightfast pigment. Semi-opaque.

ARTISTS' WATER COLOUR

PY53 NICKEL TITANATE YELLOW (P. 35)

HEALTH	WG	RATING
✓ INFO	II L'FAST	★★

HANSA YELLOW LIGHT (LEMON) 242

DA VINCI PAINTS

Well labelled, giving full information on the ingredients. Fairly transparent when thin. Washes out very smoothly. Semi-opaque.

PERMANENT ARTISTS' WATER COLOR

PY3 ARYLIDE YELLOW 10G (P. 29)

HEALTH	ASTM	RATING
✓ INFO	II L'FAST	★★

LEMON YELLOW 501

SENNELIER

PY1, a fugitive pigment, which once led to fading, has now been removed. Check ingredients if purchasing to ensure new stock. Now excellent. Semi-transparent.

EXTRA-FINE ARTISTS' WATER COLOURS

PY3 ARYLIDE YELLOW 10G (P. 29)

HEALTH	ASTM	RATING
✗ INFO	II L'FAST	★★

HELIO GEN. YELLOW LEMON 1044

LUKAS

Will resist exposure to light. Well produced paint which gives smooth, even washes over a range of values. Semi-transparent.

ARTISTS' WATER COLOUR

PY3 ARYLIDE YELLOW 10G (P. 29)

HEALTH	ASTM	RATING
✗ INFO	II L'FAST	★★

TALENS YELLOW LEMON 246

TALENS

Gives good even washes. Reasonably bright despite the use of a white pigment. Dependable ingredients. Semi-opaque.

REMBRANDT ARTISTS' WATER COLOUR

PY3 ARYLIDE YELLOW 10G (P. 29)
PW4 ZINC WHITE (P. 270)

HEALTH	ASTM	RATING
✗ INFO	II L'FAST	★★

PERMANENT LEMON YELLOW 238

PÉBÉO

A reasonably transparent, bright green - yellow. Our sample handled particularly well giving good washes. Dependable ingredients.

FRAGONARD ARTISTS' WATER COLOUR

PY138 QUINOPHTHALONE YELLOW (P. 38)

HEALTH	WG	RATING
✗ INFO	II L'FAST	★★

LEMON YELLOW HUE (NICKEL TITANATE) (USA ONLY) 347

WINSOR & NEWTON

Moderately transparent with reasonable covering power. Our sample resisted fading but did darken slightly in heavy application.

COTMAN WATER COLOUR 2ND RANGE

PY53 NICKEL TITANATE YELLOW (P. 35)

HEALTH	WG	RATING
✓ INFO	II L'FAST	★★

LEMON YELLOW (AZO PIGMENT) 346 (324)

WINSOR & NEWTON

Brushes out well to give good medium to thin layers. Lacks body for heavier application. Reliable ingredients. Semi-transparent.

COTMAN WATER COLOUR 2ND RANGE

PY3 ARYLIDE YELLOW 10G (P. 29)

HEALTH	ASTM	RATING
✗ INFO	II L'FAST	★★

AZO LEMON 066

REEVES

A dependable watercolour which will resist exposure to light. Brushed out quite well. Semi-transparent. *This range has now been discontinued but stock might still be held.*

WATER COLOUR FOR ARTISTS 2ND RANGE

PY3 ARYLIDE YELLOW 10G (P. 29)

HEALTH	ASTM	RATING
✗ INFO	II L'FAST	★★

LEMON YELLOW 608

MAIMERI

Well ground paint giving smooth washes. Practical, lightfast pigment. Good value. Semi-transparent.

STUDIO FINE WATER COLOR 2ND RANGE

PY3 ARYLIDE YELLOW 10G (P. 29)

HEALTH	ASTM	RATING
✗ INFO	II L'FAST	★★

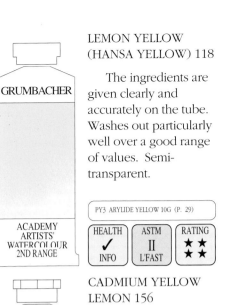

LEMON YELLOW (HANSA YELLOW) 118

GRUMBACHER

The ingredients are given clearly and accurately on the tube. Washes out particularly well over a good range of values. Semi-transparent.

ACADEMY ARTISTS' WATERCOLOUR 2ND RANGE

PY3 ARYLIDE YELLOW 10G (P. 29)

HEALTH	ASTM	RATING
✓ INFO	II L'FAST	★★ ★★

LEMON YELLOW 651

ROWNEY

Earlier examples were rather cloudy and dull due to the inclusion of white pigment. This has now been removed. Reliable ingredients. Semi-transparent. Excellent.

GEORGIAN WATER COLOUR 2ND RANGE

PY3 ARYLIDE YELLOW 10G (P. 29)

HEALTH	ASTM	RATING
✓ INFO	II L'FAST	★★ ★★

1.9 Cadmium Lemon Yellow

PY3, Arylide Yellow, makes a reliable Lemon Yellow but Cadmium Lemon Yellow would be my first choice. Brushes well, is opaque but strong enough to give a clear wash. Absolutely lightfast.

CADMIUM YELLOW LEMON 156

LEFRANC & BOURGEOIS

Absolutely lightfast pigment. Strong, bright and with good covering power. Brushes out well. Opaque.

LINEL EXTRA-FINE ARTISTS' WATERCOLOUR

PY37 CADMIUM YELLOW MEDIUM OR DEEP (P. 33)

HEALTH	ASTM	RATING
✗ INFO	I L'FAST	★★ ★★

CADMIUM YELLOW LEMON 223

SCHMINCKE

Pigment now changed from PY35:1 (see page 33) to the chemically pure Cadmium Yellow Light. A strong colour, handles well. Opaque.

HORADAM FINEST ARTISTS' WATER COLOURS

PY35 CADMIUM YELLOW LIGHT (P. 33)
PREVIOUSLY PY35:1 CAD. BAR. YEL (P.33)

HEALTH	ASTM	RATING
✗ INFO	I L'FAST	★★ ★★

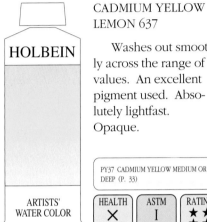

CADMIUM YELLOW LEMON 637

HOLBEIN

Washes out smoothly across the range of values. An excellent pigment used. Absolutely lightfast. Opaque.

ARTISTS' WATER COLOR

PY37 CADMIUM YELLOW MEDIUM OR DEEP (P. 33)

HEALTH	ASTM	RATING
✗ INFO	I L'FAST	★★ ★★

CADMIUM YELLOW LEMON 406

OLD HOLLAND

A well made watercolour which handles very smoothly. Bright, strong, good covering power. Opaque.

CLASSIC WATERCOLOURS

PY37 CADMIUM YELLOW MEDIUM OR DEEP (P. 33)

HEALTH	ASTM	RATING
✗ INFO	I L'FAST	★★ ★★

CADMIUM YELLOW LEMON 514

MAIMERI

PY37 is strong enough to give reasonably transparent washes when well diluted. An excellent watercolour. Opaque.

ARTISTI EXTRA-FINE WATERCOLOURS

PY37 CADMIUM YELLOW MEDIUM OR DEEP (P. 33)

HEALTH	ASTM	RATING
✗ INFO	I L'FAST	★★ ★★

CADMIUM LEMON 086 (080)

WINSOR & NEWTON

Strong, bright, opaque yet giving reasonably clear washes. PY35 is an excellent all round pigment. Recommended.

ARTISTS' WATER COLOUR

PY35 CADMIUM YELLOW LIGHT (P. 33)

HEALTH	ASTM	RATING
✗ INFO	I L'FAST	★★ ★★

CADMIUM YELLOW LEMON 032

GRUMBACHER

A smooth, strong watercolour with good handling properties. The PY35:1 (page 33), once added, has now been removed. Excellent.

FINEST PROFESSIONAL WATERCOLORS

PY35 CADMIUM YELLOW LIGHT (P. 33)

HEALTH	ASTM	RATING
✗ INFO	I L'FAST	★★ ★★

LEMON CADMIUM YELLOW 331

PÉBÉO

Absolutely lightfast. The use of this excellent pigment ensures a quality watercolour which will retain its hue. Opaque.

FRAGONARD ARTISTS' WATER COLOUR

PY35 CADMIUM YELLOW LIGHT (P. 33)

HEALTH	ASTM	RATING
✗ INFO	I L'FAST	★★ ★★

CADMIUM YELLOW LEMON 5708

HUNTS

An excellent paint, strong, bright and covers well. Should be less expensive than the chemically pure Cadmiums. Opaque.

CADMIUM SULPHIDE COPRECIPITATED WITH BARIUM SULPHATE

SPEEDBALL PROFESSIONAL WATERCOLOURS

HEALTH	ASTM	RATING
✗ INFO	I L'FAST	★ ★★

CADMIUM LEMON 207

TALENS

Talens are perhaps more honest than most in declaring the use of PW5. Nevertheless a strong, bright, paint. Opaque.

PW5 LITHOPONE (P. 270)
PY35 CADMIUM YELLOW LIGHT (P. 33)

REMBRANDT ARTISTS' WATER COLOUR

HEALTH	ASTM	RATING
✕ INFO	I L'FAST	★★ ★★

CADMIUM YELLOW LEMON 535

SENNELIER

An excellent all round watercolour. Powerful yet able to give delicate, quite transparent washes. Absolutely lightfast. Opaque.

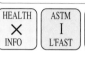
PY35 CADMIUM YELLOW LIGHT (P. 33)
(USED TO BE PY37 SEE PAGE 33)

EXTRA-FINE ARTISTS' WATER COLOURS

HEALTH	ASTM	RATING
✕ INFO	I L'FAST	★★ ★★

CADMIUM LEMON (AZO) 212

TALENS

Lightfast pigments used. Second range or Student colours need not be unreliable. Semi-transparent. *This range has now been discontinued.*

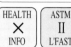
PW4 ZINC WHITE (P. 270)
PY3 ARYLIDE YELLOW 10G (P. 29)

WATER COLOUR · 2ND RANGE

HEALTH	ASTM	RATING
✕ INFO	II L'FAST	★★

1.10 Chrome Yellow Lemon

Genuine Chrome Yellow Lemon, (PY34), can become very dark on exposure to light and the atmosphere.

A definite green - yellow which is easily matched.

CHROME YELLOW LEMON 209

LEFRANC & BOURGEOIS

The use of chalk is quite noticeable, giving a rather clouded, dull, light Lemon Yellow. Reliable pigments. Semi-transparent.

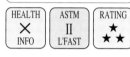
PW18 CHALK (P. 271)
PY3 ARYLIDE YELLOW 10G (P. 29)

LINEL EXTRA-FINE ARTISTS' WATERCOLOUR

HEALTH	ASTM	RATING
✕ INFO	II L'FAST	★★

CHROME LEMON 158 (013)

WINSOR & NEWTON

Paint so densely packed it was difficult to remove. Our sample darkened considerably on exposure to light. *Discontinued due to 'he toxic nature of the*

PY34 CHROME YELLOW LEMON (P. 32)

ARTISTS' WATER COLOUR

HEALTH	WG	RATING
✓ INFO	IV L'FAST	★

CHROME YELLOW LEMON HUE 211

SCHMINCKE

I have insuficient information on PY175 to offer assessments. Not ASTM tested in any art media. Claimed to be lightfast by the company. Brushed out very well.

PY 175 BENZIMIDAZOLONE
USED TO BE PRODUCED USING PY138
(SEE PAGE 38) AND PW6 (P. 271)

HORADAM FINEST ARTISTS' WATER COLOURS

HEALTH		
✕ INFO		

CHROME LEMON 621

ROWNEY

The fact that Chrome Yellow Lemon tends to darken on exposure has been known for a long time. Yet it is still in use. Semi-opaque.

PY34 CHROME YELLOW LEMON (P. 32)
PY3 ARYLIDE YELLOW 10G (P/ 29)

ARTISTS' WATER COLOUR

HEALTH	WG	RATING
✓ INFO	IV L'FAST	★

If using genuine Chrome Yellow, keep work behind glass and in subdued light to minimise potential damage.

1.11 Mars Yellow

Basically a synthetic version of Yellow Ochre, (a natural occurring pigment).

Strangely, many colours described as Yellow Ochre are Mars Yellow and the only watercolour actually called Mars Yellow is Yellow Ochre.

A neutralised orange - yellow for mixing purposes.

MARS YELLOW 505

SENNELIER

It seems odd that Yellow Ochre is marketed under the name of its synthetic cousin. Reliable pigments. Semi-transparent.

PY3 ARYLIDE YELLOW 10G (P. 29)
PY43 YELLOW OCHRE (P. 35)

EXTRA-FINE ARTISTS' WATER COLOURS

HEALTH	ASTM	RATING
✕ INFO	II L'FAST	★★

1.12 Naples Yellow

Originally a lead based pigment suitable only for oil paints.

The name has become more of a colour description than a pigment title.

Commonly a blend of Cadmium Yellow and white, but nowadays the range of pigments used has widened.

When used in mixing, treat as a neutralised orange - yellow. An orange yellow because that is the usual base colour and neutralised, (dulled), by the white. Will give cool, subtle greens and soft neutral oranges. Complementary, a blue - violet.

WINSOR & NEWTON

ARTISTS' WATER COLOUR

NAPLES YELLOW 422 (031)

Sample brushed out smoothly. All ingredients are absolutely lightfast. A useful convenience colour. Semi-opaque.

| PR101 MARS RED (P. 89) |
| PW4 ZINC WHITE (P. 270) |
| PY35 CADMIUM YELLOW LIGHT (P. 33) |

HEALTH	ASTM	RATING
✕ INFO	I L'FAST	★★ ★★

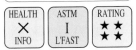

SCHMINCKE

HORADAM FINEST ARTISTS' WATER COLOURS

NAPLES YELLOW 229

The PBr24 content must be at a minimum as our sample was unaffected by light. Brushed out well, if a little overbound. Semi-opaque.

| PBr 24 CHROME ANTIMONY TITANIUM BUFF RUTILE (P. 213) |
| PW6 TITANIUM WHITE (P. 271) |
| PY53 NICKEL TITANATE YELLOW (P. 35) |

HEALTH	WG	RATING
✕ INFO	II L'FAST	★ ★★

LEFRANC & BOURGEOIS

LINEL EXTRA-FINE ARTISTS' WATERCOLOUR

NAPLES YELLOW IMITATION 191

Both pigments absolutely lightfast. The resulting paint brushes out beautifully. Correctly named. 'Hue' would also be correct.

| PY43 YELLOW OCHRE (P. 35) |
| PY35 CADMIUM YELLOW LIGHT (P. 33) |

HEALTH	ASTM	RATING
✕ INFO	I L'FAST	★★ ★★

TALENS

REMBRANDT ARTISTS' WATER COLOUR

NAPLES YELLOW LIGHT 222

As with all colours containing Cadmium Yellow, avoid exposing to light in a humid atmosphere. Brushed out extremely well, a quality product. Opaque.

| PW4 ZINC WHITE (P. 270) |
| PY35 CADMIUM YELLOW LIGHT (P. 33) |

HEALTH	ASTM	RATING
✕ INFO	I L'FAST	★★ ★★

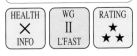

BLOCKX

AQUARELLES ARTISTS' WATER COLOUR

NAPLES YELLOW 112

Quality pigments give a watercolour which brushes out very smoothly. A well produced convenience colour. Opaque.

| PW4 ZINC WHITE (P. 270) |
| PY35 CADMIUM YELLOW LIGHT (P. 33) |
| PY42 MARS YELLOW (P. 34) |

HEALTH	ASTM	RATING
✕ INFO	I L'FAST	★★ ★★

LUKAS

ARTISTS' WATER COLOUR

NAPLES YELLOW 1034

There can be little of the impermanent PBr24 involved, as our sample stood up very well during exposure tests. Brushed out very smoothly.

| PY53 NICKEL TITANATE YELLOW (P. 35) |
| PBr24 CHROME ANTIMONY TITANIUM BUFF RUTILE (P. 213) |

HEALTH	WG	RATING
✕ INFO	II L'FAST	★★

SENNELIER

EXTRA-FINE ARTISTS' WATER COLOURS

NAPLES YELLOW 567

Excellent pigments, particularly fast to light. Sample was slightly over-bound but gave very good washes. Recently re-formulated, PY37 changed to PY35. PW6 added. Opaque.

| PW4 ZINC WHITE (P. 270) |
| PY35 CADMIUM YELLOW LIGHT (P. 33) |
| PW6 TITANIUM WHITE (P. 271) |

HEALTH	ASTM	RATING
✕ INFO	I L'FAST	★

PÉBÉO

FRAGONARD ARTISTS' WATER COLOUR

NAPLES YELLOW 126

The inclusion of PY74LF reduces the overall permanence of this colour. Becomes slightly duller on exposure, especially tints.

| PR101 MARS RED (P. 89) |
| PW6 TITANIUM WHITE (P. 271) |
| PY 74LF ARYLIDE YELLOW 5GX (P. 36) |
| PY42 MARS YELLOW (P. 34) |

HEALTH	ASTM	RATING
✕ INFO	III L'FAST	★★

MAIMERI

ARTISTI EXTRA-FINE WATERCOLOURS

NAPLES YELLOW 519

Sample stood up very well to our light-fast testing. A well made product, washing out very smoothly. Semi-transparent.

| PY83 DIARYLIDE YELLOW HR70 (P. 36) |
| PY37 CADMIUM YELLOW MEDIUM OR DEEP (P. 33) |
| PY53 NICKEL TITANATE YELLOW (P. 35) |

HEALTH	WG	RATING
✕ INFO	II L'FAST	★★ ★★

NAPLES YELLOW 634

Thoroughly reliable ingredients. A useful convenient colour. Good handling characteristics imparted by each pigment. Opaque.

PW6 TITANIUM WHITE (P. 271)
PY37 CADMIUM YELLOW MEDIUM OR DEEP (P. 33)
PO20 CADMIUM ORANGE (P. 68)

ROWNEY
ARTISTS' WATER COLOUR

HEALTH	ASTM	RATING
✓ INFO	I L'FAST	★★ ★★

NAPLES YELLOW 644

Superb ingredients. It is a pity that no mention is given of them on the tube label. Brushed out very well. Opaque.

PY37 CADMIUM YELLOW MEDIUM OR DEEP (P. 33)
PY42 MARS YELLOW (P. 34)
PW6 TITANIUM WHITE (P. 271)

HOLBEIN
ARTISTS' WATER COLOR

HEALTH	ASTM	RATING
✗ INFO	I L'FAST	★★ ★★

NAPLES YELLOW (HUE) 146

As with all paints containing Cadmium Yellow, tends to fade in a humid atmosphere. Excellent pigments used. Opaque.

PBr7 BURNT SIENNA (P. 212)
PR108 CADMIUM RED LIGHT, MEDIUM OR DEEP (P. 91)
PY35:1 CADMIUM -BARIUM YELLOW LIGHT (P. 33)

GRUMBACHER
FINEST PROFESSIONAL WATERCOLORS

HEALTH	ASTM	RATING
✗ INFO	I L'FAST	★★ ★★

NAPLES YELLOW REDDISH 224

A convenience colour easily mixed from the stated ingredients, (as are all Naples Yellows). Quality pigments making an excellent watercolour.

PO20 CADMIUM ORANGE (P. 68)
PY35 CADMIUM YELLOW LIGHT (P. 33)
PW4 ZINC WHITE (P. 270)

TALENS
REMBRANDT ARTISTS' WATER COLOUR

HEALTH	ASTM	RATING
✗ INFO	I L'FAST	★★ ★★

NAPLES YELLOW REDDISH 230

A soft, brownish opaque yellow. I have insufficient information on PR251 to offer assessments. Even washes over the full range.

PY42 MARS YELLOW (P.34)
PR251 COMMON NAME N/K (P.99)
PW4 ZINC WHITE (P. 270)
PW6 TITANIUM WHITE (P. 271)
PREVIOUSLY PO20:1 (P.69) & PY119 (P.39)

SCHMINCKE
HORADAM FINEST ARTISTS' WATER COLOURS

HEALTH
✗ INFO

NAPLES YELLOW REDDISH 1036

The sample provided did not stand up very well to our exposure testing. A pity, as it handled very well in washes.

PBr24 CHROME ANTIMONY TITANIUM BUFF RUTILE (P. 213)

LUKAS
ARTISTS' WATER COLOUR

HEALTH	WG	RATING
✗ INFO	III L'FAST	★★

NAPLES YELLOW HUE 146

The only unreliable pigment is the PR49:1. On exposure the colour gradually becomes lighter and yellower.

PBr7 BURNT SIENNA (P. 212)
PY3 ARYLIDE YELLOW 10G (P. 29)
PR49:1 LITHOL RED (P. 85)
PW6 TITANIUM WHITE (P. 271)

GRUMBACHER
ACADEMY ARTISTS' WATERCOLOUR 2ND RANGE

HEALTH	WG	RATING
✓ INFO	IV L'FAST	★

NAPLES YELLOW

Information on the ingredients was withheld. Our sample faded considerably but no assessments are offered.

PAILLARD
LOUVRE AQUARELLE ARTISTS' COLOUR 2ND RANGE

HEALTH
✗ INFO

Any 'Naples Yellow' containing Cadmium Yellow will tend to fade on exposure to light in a humid atmosphere.

1.13 Miscellaneous Yellows

I am always very wary of colours sold under trade, or fancy names. We now have a range of valuable yellows which could be sold openly under their own titles. Be very careful of purchasing colours which are not fully and accurately labelled.

When mixing with any of the following, it pays to establish the bias or leaning of the colour. Do you have a green or an orange - yellow to work with? see notes on deciding colour type, page 64.

WINSOR & NEWTON

ARTISTS' WATER COLOUR

AURORA YELLOW 017 (079)

Why Cadmium Yellow, an excellent pigment in its own right, is sold under this name is a mystery to me. Opaque.

PY35 CADMIUM YELLOW LIGHT (P. 33)

HEALTH	ASTM	RATING
✗ INFO	I L'FAST	★★

REEVES

WATER COLOUR FOR ARTISTS 2ND RANGE

AZO YELLOW PALE 073

A fugitive colour which will fade rapidly on exposure. Second range colours need not be like this. Transparent.
This range has now been discontinued.

PY1 ARYLIDE YELLOW G (P. 29)

HEALTH	ASTM	RATING
✗ INFO	V L'FAST	★

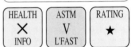

REEVES

WATER COLOUR FOR ARTISTS 2ND RANGE

AZO YELLOW MEDIUM 019

Low grade pigments which will fade rapidly make up this watercolour. Most unreliable. Semi-transparent.
This range has now been discontinued.

PY1 ARYLIDE YELLOW G (P. 29)
PR3 TOLUIDINE RED (P. 81)

HEALTH	ASTM	RATING
✗ INFO	V L'FAST	★

BLOCKX

AQUARELLES ARTISTS' WATER COLOUR

BLOCKX YELLOW 212

It is well known that PY1 is a most unreliable pigment. Yet it finds its way into 'Artist' quality paints. Transparent.

PY1 ARYLIDE YELLOW G (P. 29)

HEALTH	ASTM	RATING
✗ INFO	V L'FAST	★

MAIMERI

ARTISTI EXTRA-FINE WATERCOLOURS

BRILLIANT YELLOW 513

The addition of a white pigment will always dull and cool any colour. This yellow would have been a little brighter without it. Semi-transparent.

PW6 TITANIUM WHITE (P. 271)
PY83 DIARYLIDE YELLOW HR70 (P. 36)

HEALTH	WG	RATING
✗ INFO	II L'FAST	★★

SCHMINCKE

HORADAM FINEST ARTISTS' WATER COLOURS

BRILLIANT YELLOW LIGHT 221

Now re-formulated. This used to be a mix of Cadmium Yellow and White. The unfortunate addition of the PBr24 lowers the lightfastness rating. Opaque.

PW6 TITANIUM WHITE (P. 271)
PY154 BENZIMIDAZOLONE YEL. (P.39)
PBr24 CHROME ANT. TITAN. B/R (P.213)
PREVIOUSLY ALSO PY37:1 (P. 34)

HEALTH	WG	RATING
✗ INFO	III L'FAST	★★

SCHMINCKE

HORADAM FINEST ARTISTS' WATER COLOURS

BRILLIANT YELLOW 1 901

Reliable ingredients. A colour easily reproduced on the palette. Brushed out well. Transparent.
This colour has now been discontinued.

PW5 LITHOPONE (P. 270)
PY3 ARYLIDE YELLOW 10G (P. 29)

HEALTH	ASTM	RATING
✗ INFO	II L'FAST	★★

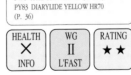

SCHMINCKE

HORADAM FINEST ARTISTS' WATER COLOURS

LASURGELB 902

This colour used to be called Brilliant Yellow 2. It has been re-formulated and now brushes out very well. A green-yellow. Trans.

PY150 NICKEL AZO YELLOW (P.40)
PREVIOUSLY PW5 LITH. (P. 270)
PY37:1 CAD . BARIUM YELLOW, MEDIUM OR DEEP . (P. 34)
PY153 NICKEL DIOXINE YELL. (P. 38)

HEALTH	WG	RATING
✗ INFO	II L'FAST	★★

MAIMERI

STUDIO FINE WATER COLOR 2ND RANGE

DEEP YELLOW 610

Will gradually fade on exposure. It will also become more orange as the PO43 will resist the light. Unreliable. Transparent.

PY1 ARYLIDE YELLOW G (P. 29)
PO43 PERINONE ORANGE (P. 69)

HEALTH	ASTM	RATING
✗ INFO	V L'FAST	★

FLANDERS YELLOW 178

LEFRANC & BOURGEOIS

A reliable watercolour which washes out rather well. The label gives ingredient as 'Azo Pigment'. Which Azo ? Transparent.

LINEL EXTRA-FINE ARTISTS' WATERCOLOUR

PY3 ARYLIDE YELLOW 10G (P. 29)		
HEALTH ✓ INFO	ASTM II L'FAST	RATING ★★

GALLSTONE 208

LEFRANC & BOURGEOIS

The pigment PY153 is normally reliable and proved so in other colours. Our Gallstone sample darkened. No assessments offered. Semi-transparent.

LINEL EXTRA-FINE ARTISTS' WATERCOLOUR

PY153 NICKEL DIOXINE YELLOW (P. 38)		
HEALTH ✗ INFO		

GOLD YELLOW 176

LEFRANC & BOURGEOIS

It is no secret that Chrome Yellow Lemon can darken considerably on exposure. Even marketed under a fancy name. Our sample certainly did. Semi-opaque.

LINEL EXTRA-FINE ARTISTS' WATERCOLOUR

PY34 CHROME YELLOW LEMON (P. 32)		
HEALTH ✓ INFO	WG IV L'FAST	RATING ★

GOLDEN YELLOW 2080

MARTIN F.WEBER

I gave this colour a lightfast rating of WG III in the first edition. Following further testing this has been changed to WGII. Semi-transparent. Excellent.

PERMALBA ARTIST'S WATER COLOR AQUARELLE

PY83 DIARYLIDE YELLOW HR70 (P. 36) PO43 PERINONE ORANGE (P. 69)		
HEALTH ✓ INFO	WG II L'FAST	RATING ★★

GOLDEN YELLOW 081

GRUMBACHER

Neither pigment takes kindly to the light. Second range colours need not be fugitive. Most unreliable. Transparent.

ACADEMY ARTISTS' WATERCOLOUR 2ND RANGE

PY1 ARYLIDE YELLOW G (P. 29) PO1 HANSA ORANGE (P. 68)		
HEALTH ✓ INFO	ASTM V L'FAST	RATING ★

GREEN PINK 665

SCHMINCKE

Late notification on the use of PY129 makes it impossible to offer assessments. Sample overbound and lacking in body.

HORADAM FINEST ARTISTS' WATER COLOURS

PY42 MARS YELLOW (P. 34) PY129 AZOMETHINE YELLOW 5GT (P. 39)		
HEALTH ✗ INFO		

GREENISH - YELLOW 648

HOLBEIN

At full strength is a very dull green - yellow. Washes into a much brighter tint. Settles out when heavy. Transparent.

ARTISTS' WATER COLOR

PY177 IRGAZIN YELLOW 4GT (P. 40)		
HEALTH ✗ INFO	WG II L'FAST	RATING ★★

HANSA YELLOW LIGHT 2074

MARTIN F.WEBER

Gives good, even washes over the full range of values. Reliable pigment used. Transparent.

PERMALBA ARTIST'S WATER COLOR AQUARELLE

PY3 ARYLIDE YELLOW 10G (P. 29)		
HEALTH ✓ INFO	ASTM II L'FAST	RATING ★★

HANSA YELLOW 220

BINNEY & SMITH

As expected, our sample faded readily, especially when applied thinly. Handles very well. Semi-transparent.

PROFESSIONAL ARTISTS' WATER COLOR

PY 74LF ARYLIDE YELLOW 5GX (P. 36)		
HEALTH ✓ INFO	ASTM III L'FAST	RATING ★★

HELIO GENUINE YELLOW LIGHT 1045

LUKAS

Brushes out very well giving very good washes. It is a pity that the colour will depart rapidly. Transparent.

ARTISTS' WATER COLOUR

PY1 ARYLIDE YELLOW G (P. 29)		
HEALTH ✗ INFO	ASTM V L'FAST	RATING ★

HELIO GENUINE YELLOW DEEP 1047

LUKAS

As with its lighter cousin to the left, the use of PY1 will ensure a brief life after exposure. Transparent.

ARTISTS' WATER COLOUR

PY1 ARYLIDE YELLOW G (P. 29)		
HEALTH ✗ INFO	ASTM V L'FAST	RATING ★

HELIOS YELLOW 180

LEFRANC & BOURGEOIS

A strong, semi-transparent green - yellow, giving a useful range of values. Reliable and handles well. Semi-transparent.

LINEL EXTRA-FINE ARTISTS' WATERCOLOUR

PY97 ARYLIDE YELLOW FGL (P. 37)		
HEALTH ✓ INFO	ASTM II L'FAST	RATING ★★

JUANE BRILLIANT No 1 642

HOLBEIN

Very reliable ingredients used. Washed out very smoothly. A convenience colour. Opaque.

PR108 CADMIUM RED LIGHT, MEDIUM OR DEEP (P. 91)
PY37 CADMIUM YELLOW MEDIUM OR DEEP (P. 33)
PW6 TITANIUM WHITE (P. 271)

ARTISTS' WATER COLOR

HEALTH	ASTM	RATING
✗ INFO	I L'FAST	★★

JUANE BRILLIANT No 2 643

HOLBEIN

Both pigments particularly lightfast. A convenience colour, easily mixed. Opaque.

PR108 CADMIUM RED LIGHT, MEDIUM OR DEEP (P. 91)
PW6 TITANIUM WHITE (P. 271)

ARTISTS' WATER COLOR

HEALTH	ASTM	RATING
✗ INFO	I L'FAST	★★

OLD HOLLAND YELLOW LIGHT 403

OLD HOLLAND

Excellent ingredients, but sample difficult to use as over half of the tube was pure gum, rest overbound. No assessment offered.

PW4 ZINC WHITE (P. 270)
PY37 CADMIUM YELLOW MEDIUM OR DEEP (P. 33)

CLASSIC WATERCOLOURS

HEALTH	ASTM
✗ INFO	I L'FAST

OLD HOLLAND YELLOW MEDIUM 404

OLD HOLLAND

Sample excessively gummy. Dried with a beautiful shine. No assessment offered as only weak wash was possible.

PW4 ZINC WHITE (P. 270)
PY37 CADMIUM YELLOW MEDIUM OR DEEP (P. 33)

CLASSIC WATERCOLOURS

HEALTH	ASTM
✗ INFO	I L'FAST

OLD HOLLAND YELLOW DEEP 405

OLD HOLLAND

Sample was overbound. As it was not possible to use unless in a very thin wash, no assessment is offered.

PW4 ZINC WHITE (P. 270)
PY37 CADMIUM YELLOW MEDIUM OR DEEP (P. 33)

CLASSIC WATERCOLOURS

HEALTH	ASTM
✗ INFO	I L'FAST

PERMANENT LIGHT YELLOW 239

PĒBĒO

An unreliable pigment which will fade readily, especially when applied thinly.

PY 74LF ARYLIDE YELLOW 5GX (P. 36)

FRAGONARD ARTISTS' WATER COLOUR

HEALTH	ASTM	RATING
✗ INFO	III L'FAST	★★

PERMANENT YELLOW LIGHT 632

HOLBEIN

Our sample faded dramatically (as was expected). The inclusion of PY55, a fugitive pigment, ensures limited life.

PY55 DIARYLIDE YELLOW PT (P. 35)
PY53 NICKEL TITANATE YELLOW (P. 35)

ARTISTS' WATER COLOR

HEALTH	WG	RATING
✗ INFO	IV L'FAST	★

PERMANENT YELLOW LIGHT 215

SCHMINCKE

Reasonably transparent. Washes out to even gradated washes. Reliable pigments which will resist fading. Transparent.

PY3 ARYLIDE YELLOW 10G (P. 29)
USED TO CONTAIN PW5 (SEE PAGE 270)
THIS HAS NOW BEEN REMOVED.

HORADAM FINEST ARTISTS' WATER COLOURS

HEALTH	ASTM	RATING
✗ INFO	II L'FAST	★★

PERMANENT YELLOW 664

ROWNEY

Permanent Yellow seems a strange name when one considers the fugitive pigment employed. Most unreliable. Transparent.

PY1 ARYLIDE YELLOW G (P. 29)

ARTISTS' WATER COLOUR

HEALTH	ASTM	RATING
✓ INFO	V L'FAST	★

PERMANENT YELLOW MIDDLE 216

SCHMINCKE

The fugitive PY1 has now been replaced by a reliable pigment. Sample washed out very smoothly. A much improved colour. Semi-transparent.

PY 154 BENZIMIDAZOLONE YELL. (P.39)
PW5 LITHOPONE (P. 270)
PREVIOUSLY CONTAINED PY1 (P. 29)

HORADAM FINEST ARTISTS' WATER COLOURS

HEALTH	WG	RATING
✗ INFO	II L'FAST	★·★

PERMANENT DARK YELLOW 240

PĒBĒO

This is a 'permanent' yellow which would appear to be reliable under normal conditions. Washes well. Semi-transparent.

PY65 ARYLIDE YELLOW RN (P. 36)

FRAGONARD ARTISTS' WATER COLOUR

HEALTH	WG	RATING
✗ INFO	II L'FAST	★★

PERMANENT YELLOW DEEP 633

HOLBEIN

A reliable watercolour. Smoothly ground it gives very even washes over the full range. Semi-opaque.

PY53 NICKEL TITANATE YELLOW (P. 35)

ARTISTS' WATER COLOR

HEALTH	WG	RATING
✗ INFO	II L'FAST	★★

PERMANENT YELLOW DEEP 217

The use of PY110 will ensure that this paint will fade gradually on exposure to light. Thin washes particularly vulnerable.

PY154 BENZIMIDAZOLONE YELLOW H3G (P. 39)
PY110 ISOINDOLINONE YELLOW R (P. 38)

SCHMINCKE
HORADAM FINEST ARTISTS' WATER COLOURS

HEALTH	ASTM	RATING
✕ INFO	III L'FAST	★★

PRIMARY YELLOW 517

PY1, an ingredient in this watercolour, is very easily damaged by light. Brushed out well but impermanent. Transparent.

PY1 ARYLIDE YELLOW G (P. 29)
PY3 ARYLIDE YELLOW 10G (P. 29)

MAIMERI
ARTISTI EXTRA-FINE WATERCOLOURS

HEALTH	ASTM	RATING
✕ INFO	V L'FAST	★

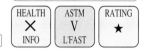

PRIMARY YELLOW 609

As with the Artist quality version of this colour, rapid fading on exposure is assured by the us of PY1. Transparent.

PY1 ARYLIDE YELLOW G (P. 29)

MAIMERI
STUDIO FINE WATER COLOR 2ND RANGE

HEALTH	ASTM	RATING
✕ INFO	V L'FAST	★

SAHARA YELLOW 194

Difficult to access lightfastness accurately. Pending further trials, I would suggest some caution. Washes out very well. Semi-transparent.

PY65 ARYLIDE YELLOW RN (P. 36)

LEFRANC & BOURGEOIS
LINEL EXTRA-FINE ARTISTS' WATERCOLOUR

HEALTH	WG	RATING
✕ INFO	II L'FAST	★★

YELLOW STIL DE GRAIN 537

It is a pity that the fugitive PY1 should have been used as reliable alternatives are available.

PB 29 ULTRAMARINE BLUE (P. 149)
PY1 ARYLIDE YELLOW (P. 29)
PREVIOUSLY PG10 (P. 178) & PO43 (P. 69)

MAIMERI
ARTISTI EXTRA-FINE WATERCOLOURS

HEALTH	ASTM	RATING
✕ INFO	IV L'FAST	★

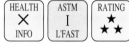

GALLSTONE 565

If it makes them happy to call Yellow Ochre, Gallstone, so be it. (The name has recently been changed from Stone Gall). Brushes out well. Permanent pigment. Semi-opaque.

PY43 YELLOW OCHRE (P. 35)

SENNELIER
EXTRA-FINE ARTISTS' WATER COLOURS

HEALTH	ASTM	RATING
✕ INFO	I L'FAST	★★

SUNNY YELLOW 2068

There can be very little PR108:1 in this as our sample bleached white very quickly. The PY1 is most unreliable.
Semi transparent.

PW6 TITANIUM WHITE (P. 271)
PR108 CADMIUM BARIUM RED LIGHT, MEDIUM OR DEEP (P. 92)
PY1 ARYLIDE YELLOW G (P. 29)

MARTIN F.WEBER
PERMALBA ARTIST'S WATER COLOR AQUARELLE

HEALTH	ASTM	RATING
✓ INFO	V L'FAST	★

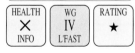

TALENS YELLOW LIGHT 247

The PY74 will either be ASTM III or WG IV depending on type (unspecified). Either way the pigment is unreliable.

PW4 ZINC WHITE (P. 270)
PY3 ARYLIDE YELLOW 10G (P. 29)
PY74 ARYLIDE YELLOW (P. 36)

TALENS
REMBRANDT ARTISTS' WATER COLOUR

HEALTH	WG	RATING
✕ INFO	IV L'FAST	★

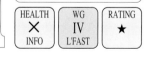

TALENS YELLOW 248

Despite requests we were not informed of the type of PY74. The best it could be would be ASTM III. Unreliable. Semi-transparent.

PY74 ARYLIDE YELLOW (P. 36)

TALENS
REMBRANDT ARTISTS' WATER COLOUR

HEALTH	WG	RATING
✕ INFO	IV L'FAST	★

TALENS YELLOW DEEP 249

Our sample faded badly suggesting the type of PY74 to be H.S. (High Strength). This version is particularly unreliable. Semi-transparent.

PY74 ARYLIDE YELLOW (P. 36)
PR4 CHLORINATED PARA RED (P. 81)

TALENS
REMBRANDT ARTISTS' WATER COLOUR

HEALTH	WG	RATING
✕ INFO	IV L'FAST	★

WINSOR YELLOW 730 (058)

Despite earlier confirmation from the manufacturer, the incorrect pigment was given in the first edition. Reliable PY3 is used, not the unreliable PY1. Transparent.

PY3 ARYLIDE YELLOW 10G (P. 29)

WINSOR & NEWTON
ARTISTS' WATER COLOUR

HEALTH	ASTM	RATING
✕ INFO	II L'FAST	★★

YELLOW GREY 708

Reliable ingredients. Brushed out well. Colour is easily duplicated on the palette. Semi-opaque.

PBk9 IVORY BLACK (P. 257)
PY42 MARS YELLOW (P. 34)
PW6 TITANIUM WHITE (P. 271)

HOLBEIN
ARTISTS' WATER COLOR

HEALTH	ASTM	RATING
✕ INFO	I L'FAST	★★

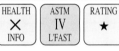

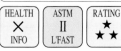
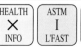

YELLOW LAKE 561

SENNELIER

The less than reliable PY83 has been replaced by lightfast pigments. Sample was slightly overbound but handled very well as a wash. Semi-transparent.

PO49 QUINACRIDONE DEEP GOLD (P.70)
PY153 NICKEL DIOXINE YEL. (P.38)
PREVIOUSLY PY83 DIAR.YELL. HR70
(P. 36) & PY43 YELLOW OCHRE (P. 35)

EXTRA-FINE ARTISTS' WATER COLOURS

HEALTH	WG	RATING
✕ INFO	II L'FAST	★★ ★★

STIL DE GRAIN 618

MAIMERI

Becomes greener and paler as the yellow content gradually fades. Not to be relied on. Transparent.

PG10 GREEN GOLD (P. 178)
PY1 ARYLIDE YELLOW G (P. 29)

STUDIO FINE WATER COLOR 2ND RANGE

HEALTH	ASTM	RATING
✕ INFO	V L'FAST	★

YELLOW LIGHT

PAILLARD

Information on ingredients withheld. No assessments are offered.

LOUVRE AQUARELLE ARTISTS' COLOUR 2ND RANGE

HEALTH		
✕ INFO		

THE FOLLOWING YELLOWS HAVE BEEN INTRODUCED SINCE THE LAST EDITION OF THIS BOOK

AUREOLIN 559

SENNELIER

As with all paints employing this pigment it washes out particularly well but is difficult to use at full strength. Good tinting strength, very transparent and lightfast. Excellent.

PY40 AUREOLIN (P.34)

EXTRA-FINE ARTISTS' WATER COLOURS

HEALTH	ASTM	RATING
✕ INFO	II L'FAST	★★ ★★

AUREOLIN HUE 901

SCHMINCKE

A greenish, semi-transparent yellow which gave very smooth, even washes. Not yet subjected to ASTM testing as a watercolour but rated I in oils and acrylics.

PY151 BENZIMIDAZOLONE YELL. (P.40)

HORADAM FINEST ARTISTS' WATER COLOURS

HEALTH	WG	RATING
✕ INFO	II L'FAST	★★ ★★

ARYLIDE YELLOW FGL 203

DA VINCI PAINTS

A bright yellow leaning towards green. Strong in mixes. Gives very smooth even washes over a useful range of values. Lightfast.

PY97 ARYLIDE YELLOW FGL (P. 37)

PERMANENT ARTISTS' WATER COLOR

HEALTH	ASTM	RATING
✓ INFO	II L'FAST	★★ ★★

CADMIUM YELLOW MEDIUM 216

DA VINCI PAINTS

A well produced colour which handles smoothly over a good range of values. Opaque, bright and fast to light. Excellent.

PY35 CADMIUM YELLOW LIGHT (P. 33)

PERMANENT ARTISTS' WATER COLOR

HEALTH	ASTM	RATING
✓ INFO	I L'FAST	★★ ★★

GAMBOGE HUE 209

SCHMINCKE

The sample provided was a little gummy but handled particularly well in thin washes, giving smooth clear tints. Transparent and lighfast.

PY108 ANTHRAPYRIMIDINE YELL. (P. 37)

HORADAM FINEST ARTISTS' WATER COLOURS

HEALTH	WG	RATING
✕ INFO	II L'FAST	★ ★★

INDIAN YELLOW HUE 111

GRUMBACHER

The pigment used is fast to light. I cannot offer assessments as a sample was not provided.

PY65 ARYLIDE YELLOW RN (P. 36)

ACADEMY ARTISTS' WATERCOLOUR 2ND RANGE

	ASTM	
	II L'FAST	

SENNELIER YELLOW LIGHT 578

SENNELIER

Semi-opaque but strong enough to give fairly transparent washes when well diluted. Very well produced. Brushes out smoothly.

PY154 BENZIMIDAZOLONE YELL. (P.39)

EXTRA-FINE ARTISTS' WATER COLOURS

HEALTH	WG	RATING
✕ INFO	II L'FAST	★★ ★★

SENNELIER YELLOW DEEP 579

SENNELIER

A deep orange-yellow which washes out beautifully. Reliable ingredients used. It is encouraging to see that the majority of newly introduced colours are lightfast.

PY154 BENZIMIDAZOLONE YELL. (P.39)
PY83 DIARYLIDE YELLOW (P.36)

EXTRA-FINE ARTISTS' WATER COLOURS

HEALTH	WG	RATING
✕ INFO	II L'FAST	★★ ★★

TITAN YELLOW LIGHT 210

SCHMINCKE

An opaque, green-yellow which washes out very well. The only drawback to this excellent pigment is that it is weak in tinting strength. A limitation when mixing.

PY53 NICKEL TITANATE YELLOW (P.35)

HORADAM FINEST ARTISTS' WATER COLOURS

HEALTH	WG	RATING
✕ INFO	II L'FAST	★★ ★★

Deciding on Colour Type

Yellows

My approach to colour mixing is based on understanding 'colour type' rather than taking note of the colour name. For accurate and controlled mixing, it is important to be able to decide whether a particular yellow leans towards green or orange.

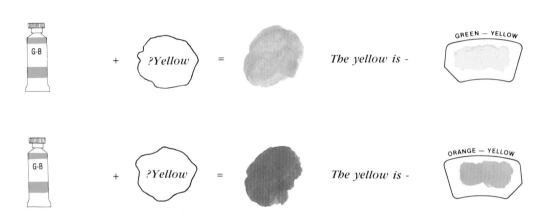

It is usually possible to decide between the various yellows by eye. However, a simple test will quickly confirm the colour-type.

Mix the yellow with a GREEN - blue, such as Cerulean Blue.

If the yellow happens to be a green - yellow, the result of mixing it with the green - blue will be a bright green, as you would expect: green - yellow and green - blue make a bright green.

On the other hand, if the result is a dull, slightly grey green, then the yellow is clearly identified as an orange - yellow. Orange - yellow and green - blue make a mid green.

See appendix at end of book for further information on colour mixing.

ORANGES

Brief History of Orange Pigments

Although artists have traditionally favoured mixed oranges they have turned to orange pigments when a particularly clean, pure hue was required.

The early Egyptians used coloured earths and pre-mixed oranges. Some of their colour work is outstanding.

Realgar, an arsenic based orange, was a real danger to the user and probably helped many to an early grave.

Cadmium Orange, a bright, strong, opaque hue, would have been the envy of earlier artists.

One of the earliest orange pigments was Realgar, an orange - red used by many ancient civilizations and available until the late 19th Century. Realgar was replaced by Cadmium Orange. When well produced, Cadmium Orange has proved itself to be the most reliable of the bright orange pigments available today. It is unsurpassed in clarity of hue by any mix of red and yellow.

Within the range offered by modern colourmen are several unreliable products, and a variety of pre-mixed oranges.

Choose carefully when purchasing a ready produced orange, it might be a simple mix or prove to be unreliable.

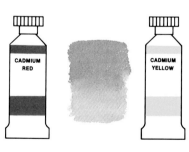

With a strong, reliable orange red and an orange yellow, all but the very brightest oranges can be mixed on the palette.

MODERN ORANGE PIGMENTS

The following are pigments recently introduced and for which further research is required.

QUINACRIDONE GOLD
Colour Index Name PO48
Colour Index Number - 73900 & 73920. Chemical Class - Indigoid: Quinacridone. Not yet subjected to ASTM testing as a watercolour paint. However, it rated particularly well in other media. Category I in Acrylics and Oils. I will rate it as WG II for this edition. Transparent.
Lightfast Category WG II

ISOINDOLIN
Colour Index Name PO69
Colour Index Number - 56292. Chemical Class 'Aminoketone : Isoindoline'.
An opaque, yellowish-orange. Not yet tested in any art material. I cannot offer a rating for lightfastness until full testing has been carried out. Insufficient notice was given concerning the use of this pigment to enable me to carry out independent lightfast testing.
No Lightfast rating is offered.

HANSA ORANGE

PO1 is a bright yellow-orange of reasonable strength and transparency. Unfortunately it fades rather readily and has failed all of the tests for which I have results. Our sample had changed noticeably after only a short exposure. By the end of the test the tint was almost bleached out and the mass tone was duller. This is another example of a colorant better suited to industrial rather than artistic use.

A pigment with a poor reputation for lightfastness. It is surely better to pay the extra for a reliable (and similar) orange such as Cadmium Orange.

L/FAST W/GUIDE V

COMMON NAME
HANSA ORANGE

COLOUR INDEX NAME
PO1

COLOUR INDEX NUMBER
11725

CHEMICAL CLASS
DISAZO

Also called Fanchon Orange.

PYRAZOLONE ORANGE

A strong semi-opaque reddish-orange. Introduced in 1910. PO13 has had plenty of time to establish a reputation as a thoroughly unreliable orange. During ASTM testing the samples quickly bleached and were removed from exposure. The sample shown here had deteriorated to this stage within a short time. A thoroughly worthless substance of no value to the artist. Bear in mind that you will be buying the colour on the right.

If you are looking for an orange which starts to fade as it is applied, this is for you. Quite unsuitable for artistic expression.

L/FAST ASTM V

COMMON NAME
PYRAZOLONE ORANGE

COLOUR INDEX NAME
PO13

COLOUR INDEX NUMBER
21110

CHEMICAL CLASS
AN AZO-BASED PIGMENT, DISAZO DIARYLIDE/ PYRAZOLONE

CADMIUM ORANGE

When well produced, Cadmium Orange is one of the most reliable and versatile of the bright oranges available to today's artist. Mixtures of reds and yellows do not quite compare for clarity of hue. Opaque, with good covering power, it is strong enough to give reasonable washes when well diluted. Given a rating of I following ASTM testing as a watercolour. Similar chemically to PY37 (Cadmium Yellow) and PR108 (Cadmium Red). An excellent pigment.

Unaffected by light, this pigment is on the ASTM recommended list for watercolours. Surely it is worth the extra cost to purchase materials of such excellence.

L/FAST ASTM I

COMMON NAME
CADMIUM ORANGE

COLOUR INDEX NAME
PO20

COLOUR INDEX NUMBER
77202

CHEMICAL CLASS
CONCENTRATED CADMIUM SULPHO-SELENIDE (CC)

CADMIUM-BARIUM ORANGE

Cadmium Barium Orange is usually as bright and certainly as permanent as the chemically pure Cadmium Orange (PO20). When well produced it brushes out very smoothly across the range of values. A fine, strong, bright orange with excellent handling characteristics. Absolutely lightfast, it passed ASTM testing effortlessly.

Rated ASTM I as a watercolour.

BENZIMIDAZOLONE ORANGE HL

PO36 is a moderately bright reddish - orange. In hue it is close to Vermilion. During ASTM lightfast testing, this pigment stood up very well when made up into an oil paint and acrylic. Not yet tested as a watercolour. When it is, it will not have the same protection from the binder, so it should not be presumed that it will also be given a I rating. Semi-opaque.

This would appear to be a trustworthy pigment. It tested well in other media and in our own trial. Consider reliable, pending further testing.

PERINONE ORANGE

A brilliant, reliable orange pigment. In hue it varies from mid-orange to red-orange. PO 43 is found in many artists paints apart from watercolours. As an orange it is second only to Cadmium Orange, PO20. This is understandable as it is very fast to light, transparent and bright. Rated as I in ASTM testing as an oil paint and acrylic. Not yet tested as a watercolour, but has an excellent reputation.

Our sample did not show any sign of change after exposure. This, together with the excellent results of testing in other media, suggests a reliable watercolour.

QUINACRIDONE DEEP GOLD

At the time of writing this pigment has not been tested as a water colour. The results of ASTM testing in both oils and acrylics are encouraging. It was given a rating of I in both media. A reddish - yellow, low in chroma and semi-opaque. I could only find one example of its use in watercolours, as an ingredient in a sap green where its qualities of hue are second-ary.

Mass tone is similar to much cheaper iron oxides. Our tests suggest that is reliable and I will give it the benefits of the doubt when assessing its use.

L/FAST W/GUIDE II

COMMON NAME

QUINACRIDONE DEEP GOLD

COLOUR INDEX NAME

PO49

COLOUR INDEX NUMBER

N.A.

CHEMICAL CLASS

QUINACRIDONE

BENZIMIDAZOLONE ORANGE H5G

PO62 is a reasonably bright yellowish orange. Benzimida-zolone oranges in general have a very good reputation for reliabil-ity. This pigment has been tested under ASTM conditions as a watercolour. It stood up extremely well and was given a rating of I. Semi-opaque, it is strong enough to give a reason-ably clear wash. A wash more-over, which will not start to disappear on you as soon as the brush is laid down.

Our sample exhibited no sign of change. An excellent pigment with an ASTM rating of I. On the list of approved pigments.

L/FAST ASTM I

COMMON NAME

BENZIMIDAZOLONE ORANGE H5G

COLOUR INDEX NAME

PO62

COLOUR INDEX NUMBER

N.A.

CHEMICAL CLASS

BENZIMIDAZOLONE DERIVED PIGMENT MONOAZO:ACETOACTYL

DIARYLIDE ORANGE

Several versions of this pigment are manufactured. In hue it is a very bright orange to reddish - orange. Semi-opaque but allows reasonably clear washes when very dilute. So far only tested under ASTM conditions as a gouache. It failed the testing dismally. Introduced in 1936, it has a poor reputation in Industry.

Most unreliable. Rated WG V

L/F W/GUIDE V

COMMON NAME

DIARYLIDE ORANGE

COLOUR INDEX NAME
PO34

COLOUR INDEX NUMBER

21115

CHEMICAL CLASS

DISAZO: DIARYLIDE/ PYRAZOLONE

Also called Benzidine Orange.

ORANGE
WATERCOLOURS

2.1 Cadmium Orange

A well produced Cadmium Orange is reasonably strong and rather bright. An opaque colour. It is however, strong enough to give reasonably clear washes when applied thinly.

Be wary of paints described as Cadmium Orange but which have cheaper, inferior ingredients. The word 'Hue' following the name is clear identification of an imitation. Pigments described here as Cadmium Orange (PO 20) *from*

information supplied, might well be a blend of Cadmium Yellow and Cadmium Red.

For mixing purposes, varies between yellow - orange (complementary, a violet - blue) to red - orange (complementary a green - blue).

Ultramarine is the only practical violet blue. Cerulean Blue, Prussian Blue and Phthalocyanine Blue are typical green - blues.

BLOCKX
AQUARELLES
ARTISTS'
WATER COLOUR

CADMIUM ORANGE 312

Very well produced, free flowing watercolour paint. A rich velvety orange. Superb ingredients, unaffected by light. Opaque.

PO20 CADMIUM ORANGE (P. 68)

HEALTH	ASTM	RATING
✗ INFO	I L'FAST	★★ ★★

WINSOR & NEWTON
ARTISTS'
WATER COLOUR

CADMIUM ORANGE 089 (081)

A mixed orange easily duplicated on the palette. Very good ingredient however. Paint flows smoothly. Opaque.

PY35 CADMIUM YELLOW LIGHT (P. 33)
PR108 CADMIUM RED LIGHT, MEDIUM OR DEEP (P. 91)

HEALTH	ASTM	RATING
✗ INFO	I L'FAST	★★ ★★

HUNTS
SPEEDBALL
PROFESSIONAL
WATERCOLOURS

CADMIUM ORANGE 5704

Reliable ingredients. Paint flowed well. It is a pity the company would not co-operate with the supply of information. Opaque.

CADMIUM SULPHOSELENIDE COPRECIPITATED WITH BARIUM SULPHATE

HEALTH	ASTM	RATING
✗ INFO	I L'FAST	★★

ROWNEY
ARTISTS'
WATER COLOUR

CADMIUM ORANGE 615

An excellent all - round watercolour. Produced from superb ingredients. Strong, vibrant colour. Handles well. Opaque.

PO20 CADMIUM ORANGE (P. 68)
PY37 CADMIUM YELLOW MEDIUM OR DEEP (P. 33)

HEALTH	ASTM	RATING
✓ INFO	I L'FAST	★★ ★★

DA VINCI PAINTS
PERMANENT
ARTISTS'
WATER COLOR

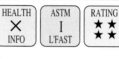

CADMIUM ORANGE 208

Superb. A rich, strong orange. Full information on ingredients on tube, plus comprehensive potential hazard warning. Opaque.

PO20 CADMIUM ORANGE (P. 68)

HEALTH	ASTM	RATING
✓ INFO	I L'FAST	★★ ★★

BINNEY & SMITH
PROFESSIONAL
ARTISTS'
WATER COLOR

CADMIUM ORANGE 150

A superb paint, excellently labelled. One can purchase with confidence when full information is on the tube. Recommended. Opaque.

PO20 CADMIUM ORANGE (P. 68)

HEALTH	ASTM	RATING
✓ INFO	I L'FAST	★★ ★★

OLD HOLLAND
CLASSIC
WATERCOLOURS

CADMIUM ORANGE 410

No assessments offered. There must be more than the PY37 in this red - orange. Company did not confirm ingredients.

PY37 CADMIUM YELLOW MEDIUM OR DEEP (P. 33)

HEALTH
✗ INFO

TALENS
REMBRANDT
ARTISTS'
WATER COLOUR

CADMIUM ORANGE 211

An excellent watercolour. Particularly good ingredients. Flows smoothly over a wide range of values. Opaque.

PO20 CADMIUM ORANGE (P. 68)
PY35 CADMIUM YELLOW LIGHT (P. 33)

HEALTH	ASTM	RATING
✗ INFO	I L'FAST	★★

MAIMERI
ARTISTI
EXTRA-FINE
WATERCOLOURS

CADMIUM ORANGE 503

Bright, strong, well prepared watercolour. Superb ingredients. Will not change in hue on exposure. Opaque.

PO20 CADMIUM ORANGE (P. 68)

HEALTH	ASTM	RATING
✗ INFO	I L'FAST	★★

CADMIUM ORANGE 025

GRUMBACHER

Slightly dull orange - red. Excellent ingredients, particularly fast to light. Flows very well in a wash. Opaque.

PR108:1 CADMIUM- BARIUM RED LIGHT, MEDIUM OR DEEP (P. 92)
PO20 CADMIUM ORANGE (P. 68)

FINEST PROFESSIONAL WATERCOLORS

HEALTH	ASTM	RATING
✕ INFO	I L'FAST	★ ★

CADMIUM ORANGE LIGHT 227

SCHMINCKE

A smooth, strong orange. Handles very well and is completely reliable on exposure. Pigment now changed from PO20:1 (see page 69).Excellent. Opaque.

PO20 CADMIUM ORANGE (P. 68)
PREVIOUSLY PO21:1 (P. 69)

HORADAM FINEST ARTISTS' WATER COLOURS

HEALTH	ASTM	RATING
✕ INFO	I L'FAST	★ ★

CADMIUM ORANGE DEEP 228

SCHMINCKE

Gives good, even washes. Reliable pigment used which will be unaffected by exposure to light. Pigment recently changed. Opaque.

PO20 CADMIUM ORANGE (P. 68)
PIGMENT USED TO BE PO 20:1 (P. 69)

HORADAM FINEST ARTISTS' WATER COLOURS

HEALTH	ASTM	RATING
✕ INFO	I L'FAST	★ ★

CADMIUM ORANGE HUE 2054

MARTIN F.WEBER

Reliable ingredients. Lacking in body somewhat but fine for light application. Difficult to handle when heavy. Pigment not yet tested to ASTM standards. Transparent.

PO43 PERINONE ORANGE (P. 69)

PERMALBA ARTIST'S WATER COLOR AQUARELLE

HEALTH	WG	RATING
✓ INFO	II L'FAST	★ ★ ★

CADMIUM ORANGE HUE 025

GRUMBACHER

Previuosly unreliable, this colour has been re-formulated using lightfast pigments.

PY65 ARYLIDE YELL. RN (P. 36) - PY138 QUINOP.YELL. (P. 38) - PO62 BENZIMID. OR. (P. 70) & PR188 NAPTHOL AS (P. 95)

ACADEMY ARTISTS' WATERCOLOUR 2ND RANGE

HEALTH	WG	RATING
✓ INFO	II L'FAST	★ ★

CADMIUM ORANGE (AZO) 216

TALENS

On exposure the red will fade followed soon after by the yellow. Fine for temporary work. Semi-opaque. *This range is to be discontinued.*

PY74 ARYLIDE YELLOW (P. 36)
PR4 CHLORINATED PARA RED (P. 81)

WATER COLOUR 2ND RANGE

HEALTH	WG	RATING
✕ INFO	V L'FAST	★

CADMIUM ORANGE (HUE) 619

ROWNEY

Fine for temporary sketch work. Will fade rapidly. Semi-opaque.

PR4 CHLORINATED PARA RED (P. 81)
PO13 PYRAZONLONE ORANGE (p. 68)
PW6 TITANIUM WHITE (P. 270)

GEORGIAN WATER COLOUR 2ND RANGE

HEALTH	ASTM	RATING
✓ INFO	V L'FAST	★

CADMIUM ORANGE (AZ0) 090 (304)

WINSOR & NEWTON

Neither pigment is reliable. Will fade rapidly when exposed to light. Semi-opaque.

PY1 ARYLIDE YELLOW G (P. 29)
PO13 PYRAZONLONE ORANGE (P. 68)

COTMAN WATER COLOUR 2ND RANGE

HEALTH	ASTM	RATING
✕ INFO	V L'FAST	★

CADMIUM ORANGE (USA ONLY) 089

WINSOR & NEWTON

Label gives full information. Ingredients are superb, particularly in a 'second range' paint. Opaque.

PY35 CADMIUM YELLOW LIGHT (P. 33)
PR108 CADMIUM RED LIGHT,MEDIUM OR DEEP (P. 91)

COTMAN WATER COLOUR 2ND RANGE

HEALTH	ASTM	RATING
✓ INFO	I L'FAST	★ ★

CADMIUM RED ORANGE 321

BLOCKX

Brushes out reasonably well. A colour that will not be altered by exposure to light. Opaque.

PO20 CADMIUM ORANGE (P. 68)

AQUARELLES ARTISTS' WATER COLOUR

HEALTH	ASTM	RATING
✕ INFO	I L'FAST	★ ★

CADMIUM RED ORANGE 609

SENNELIER

A first rate watercolour. Rich, velvety dark red - orange. Unaffected by light. Smoothly ground. Opaque.

PR108 CADMIUM RED LIGHT,MEDIUM OR DEEP (P. 91)

EXTRA-FINE ARTISTS' WATER COLOURS

HEALTH	ASTM	RATING
✕ INFO	I L'FAST	★ ★

CADMIUM RED ORANGE 608

HOLBEIN

An excellent all round watercolour. Smooth flowing, bright, strong and completely reliable. Opaque.

PR108 CADMIUM RED LIGHT,MEDIUM OR DEEP (P. 91)

ARTISTS' WATER COLOR

HEALTH	ASTM	RATING
✕ INFO	I L'FAST	★ ★

CADMIUM YELLOW ORANGE 641

HOLBEIN

Bright, strong, smooth flowing and absolutely lightfast. A pity that modesty keeps the ingredients off the label. Opaque.

ARTISTS' WATER COLOR

PR108 CADMIUM RED LIGHT, MEDIUM OR DEEP (P. 91)

HEALTH	ASTM	RATING
✕ INFO	I L'FAST	★★ ★★

CADMIUM YELLOW ORANGE 161

LEFRANC & BOURGEOIS

A superb all round watercolour. Excellent ingredients. Strong bright and handles very well. Opaque.

LINEL EXTRA-FINE ARTISTS' WATERCOLOUR

PO20 CADMIUM ORANGE (P. 68)
PY37 CADMIUM YELLOW MEDIUM OR DEEP (P. 33)

HEALTH	ASTM	RATING
✕ INFO	I L'FAST	★★

CADMIUM YELLOW ORANGE 537

SENNELIER

It is a pity that the unreliable PY20 has been added to the excellent PY35. Unreliable. Brushes well. Semi-opaque.

EXTRA-FINE ARTISTS' WATER COLOURS

PY20 BENZIDINE YELLOW B (P. 68)
PY35* CADMIUM YELLOW LIGHT (P. 33)
* PREVIOUSLY PY37 (P. 33)

HEALTH	WG	RATING
✕ INFO	IV L'FAST	★

CADMIUM YELLOW RED 162

LEFRANC & BOURGEOIS

A rich, strong orange which flows well in a wash. Excellent pigments used. Absolutely lightfast. Opaque.

LINEL EXTRA-FINE ARTISTS' WATERCOLOUR

PO20 CADMIUM ORANGE (P. 68)

HEALTH	ASTM	RATING
✕ INFO	I L'FAST	★★ ★★

ORANGE CADMIUM YELLOW 334

PĒBĒO

Bright, strong red - orange with a some-what strange name. Handles well giving even washes. Opaque.

FRAGONARD ARTISTS' WATER COLOUR

PO20 CADMIUM ORANGE (P. 68)

HEALTH	ASTM	RATING
✕ INFO	I L'FAST	★ ★★

PO20, Cadmium Orange, appears to be slightly brighter than a mix of Cadmium Red and Cadmium Yellow. All three are chemically related.

2.2 Chrome Orange

In practise, this is either an unreliable mix of Chrome Yellow Lemon and Chrome Orange, or a concoction of almost anything else.

Varies between yellow and red - orange. Best left alone.

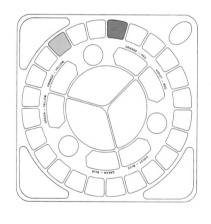

CHROME ORANGE 160 (014)

WINSOR & NEWTON

On exposure our sample changed from a reasonably bright red - orange to a deep brown. Semi-opaque. *Now discontinued due to toxicity of pigment.*

ARTISTS' WATER COLOUR

PY34 CHROME YELLOW LEMON (P. 32)
PR104 CHROME ORANGE (P. 98)

HEALTH	WG	RATING
✓ INFO	IV L'FAST	★

CHROME ORANGE HUE 214

SCHMINCKE

Completely fast to light. Despite the name, fortunately has nothing to do with Chrome Orange. The word 'Hue' recently added. Semi-opaque.

PO62 BENZIMIDAZOLONE ORANGE H5G (P. 70)

HORADAM FINEST ARTISTS' WATER COLOURS

HEALTH	ASTM	RATING
✕ INFO	I L'FAST	★★

CHROME ORANGE 624

ROWNEY

If exposed to light you will soon be left with a pale dull yellow. PY1 and PO13 are both fugitive. Semi-opaque.

PY1 ARYLIDE YELLOW G (P. 29)
PO13 PYRAZONLONE ORANGE (P. 68)
PY42 MARS YELLOW (P. 34)

ARTISTS' WATER COLOUR

HEALTH	ASTM	RATING
✓ INFO	V L'FAST	★

CHROME ORANGE DEEP 625

ROWNEY

Sample became a deep, dull brown during exposure to light and the atmosphere. Semi-opaque.

PY34 CHROME YELLOW LEMON (P. 32)
PR104 CHROME ORANGE (P. 98)

ARTISTS' WATER COLOUR

HEALTH	WG	RATING
✓ INFO	IV L'FAST	★

2.3 Miscellaneous Oranges

Many pre-mixed oranges are of dubious value. If you have control of colour mixing and reliable orange - reds and orange - yellows, you will be able to produce ranges equal to any of the following.

PO43 and PO62 are worth considering, but little else.

When mixing , first decide on the bias or leaning of the colour. Mixing complementary of a red - orange is a green - blue such as Cerulean or Phthalocyanine Blue, that of yellow - orange, a violet - blue. Ultramarine is the only practical violet - blue.

BRILLIANT ORANGE 1
903

Smooth, even flowing in a wash. Both ingredients absolutely lightfast. Not particularly brilliant, rather dull in fact. *Recently discontinued.*

SCHMINCKE
HORADAM FINEST ARTISTS' WATER COLOURS

PO20 CADMIUM ORANGE (P. 68)		
PO62 BENZIMIDAZOLONE ORANGE H5G (P. 70)		

HEALTH	ASTM	RATING
✗ INFO	I L'FAST	★★ ★★

LASUR ORANGE 2
904

This colour used to be named Brilliant Orange 2. Insuficient information about the pigment now used makes it impossible to offer an assesment. Transparent.

SCHMINCKE
HORADAM FINEST ARTISTS' WATER COLOURS

PREVIOUSLY PR6 PARACHLOR (P. 82)

HEALTH
✗ INFO

BRILLIANT ORANGE
504

A reliable pigment used. Reasonably bright. Makes an excellent all round watercolour. Transparent.

MAIMERI
ARTISTI EXTRA-FINE WATERCOLOURS

PO43 PERINONE ORANGE (P. 69)

HEALTH	WG	RATING
✗ INFO	II L'FAST	★★ ★★

CHINESE ORANGE
645

Completely reformulated using lightfast pigments. Check product when purchasing as colour used to be unreliable. Semi-transparent. Excellent.

SENNELIER
EXTRA-FINE ARTISTS' WATER COLOURS

PO 49 QUINACRIDONE DEEP GOLD (P.70)		
PR 209 QUINACRIDONE RED Y (P. 96)		
PW 21 BLANK FIXE (P.272)		

HEALTH	WG	RATING
✗ INFO	II L'FAST	★★ ★★

HELIO GENUINE ORANGE 1048

Completely lightfast. A superb, well prepared watercolour. Bright, reliable oranges are available. First rate. Semi-opaque.

LUKAS
ARTISTS' WATER COLOUR

PO62 BENZIMIDAZOLONE ORANGE H5G (P. 70)	

HEALTH	ASTM	RATING
✗ INFO	I L'FAST	★★ ★★

LEAD RED 621

Particularly unreliable. The colour fades due to the high yellow content. The darkening effect of the Red Lead is minimal suggesting little is present. *Discontinued.*

SENNELIER
EXTRA-FINE ARTISTS' WATER COLOURS

PR105 RED LEAD (P. 91)	
PY1:1 ARYLIDE YELLOW G (P. 29)	

HEALTH	ASTM	RATING
✓ INFO	V L'FAST	★

MARS ORANGE 307

Despite the use of absolutely lightfast pigments our sample darkened slightly in mass tone. An additional ingredient perhaps? Semi-transparent.

LEFRANC & BOURGEOIS
LINEL EXTRA-FINE ARTISTS' WATERCOLOUR

PR101 MARS RED (P. 89)	
PY42 MARS YELLOW (P. 34)	

HEALTH	ASTM	RATING
✗ INFO	I L'FAST	★★ ★★

PERMANENT ORANGE
218

PO69 has not been tested under ASTM conditions in any art media. I cannot find sufficient information to offer a lightfastness rating. Transparent.

SCHMINCKE
HORADAM FINEST ARTISTS' WATER COLOURS

PY153 NICKEL DIOXINE YELLOW (P. 38)	
PO69 NEW PGT ISOINDOLINE (P.67)	
PREVIOUSLY PY110 (P. 38) & PO61 (P. 67)	

HEALTH
✗ INFO

PERMANENT ORANGE
5703

The company description 'Azoic Pigment' is about as specific as calling a cat an animal. I cannot offer more information. No assessments given.

HUNTS
SPEEDBALL PROFESSIONAL WATERCOLOURS

AZOIC PIGMENT

HEALTH
✗ INFO

PĒBĒO
FRAGONARD ARTISTS' WATER COLOUR

PERMANENT ORANGE 242

Both ingredients are reliable. They make into a watercolour that handles well, giving even washes. Semi-transparent.

PY65 ARYLIDE YELLOW RN (P. 36)
PR9 NAPHTHOL AS - OL (P. 83)

HEALTH	WG	RATING
✕ INFO	II L'FAST	★★

HOLBEIN
ARTISTS' WATER COLOR

PERMANENT YELLOW ORANGE 634

A strong, bright colour which handled very well. It is a pity that it will disappear rapidly in light. Semi-transparent.

PY55 DIARYLIDE YELLOW PT (P. 35)
PY53 NICKEL TITANATE YELLOW (P. 35)

HEALTH	WG	RATING
✕ INFO	IV L'FAST	★

TALENS
REMBRANDT ARTISTS' WATER COLOUR

TALENS ORANGE 250

As expected, our sample faded severely in a short time. Most unreliable pigments. Semi-transparent.

PY74 ARYLIDE YELLOW (P. 36)
PR4 CHLORINATED PARA RED (P. 82)

HEALTH	WG	RATING
✕ INFO	V L'FAST	★

REEVES
WATER COLOUR FOR ARTISTS 2ND RANGE

AZO ORANGE 068

A disastrous combination of pigments. Of use in temporary sketch work perhaps. Semi-transparent.

This range has now been discontinued.

PY1 ARYLIDE YELLOW G (P. 29)
PO13 PYRAZONLONE ORANGE (P. 68)

HEALTH	ASTM	RATING
✕ INFO	V L'FAST	★

PAILLARD
LOUVRE AQUARELLE ARTISTS' COLOUR 2ND RANGE

ORANGE

Information on ingredients withheld. Brushed out well when thin. Little body. No assessments offered.

HEALTH
✕ INFO

MAIMERI
STUDIO FINE WATER COLOR 2ND RANGE

ORANGE 601

Gradually becomes lighter and redder as the yellow fades. Brushes out smoothly. Semi-transparent.

PY83 DIARYLIDE YELLOW HR70 (P. 36)
PR9 NAPHTHOL AS - OL (P. 83)

HEALTH	WG	RATING
✕ INFO	III L'FAST	★★

Recently introduced orange watercolour paints.

It is most encouraging to see colours which at one time were unreliable, being re-formulated using lightfast pigments.

It is even more so to see colours which were clearly unsuitable for artistic expression being replaced by paints which, in the main, are lightfast and handle well.

This is due almost entirely to the fact that artists are becoming more knowledgable and therefore more selective.

DA VINCI PAINTS
PERMANENT ARTISTS' WATER COLOR

BENZIMIDA ORANGE 204

A reasonably bright, 'clean', mid-orange. Semi-opaque but strong enough to give good clear washes even when very dilute. Excellent all round.

PO62 BENZIMIDAZOLONE ORANGE H5G (P. 70)

HEALTH	ASTM	RATING
✓ INFO	I L'FAST	★★ ★★

ROWNEY
GEORGIAN WATER COLOUR 2ND RANGE

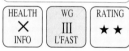

ROWNEY ORANGE 636

A newly introduced colour employing pigments which are known to fade, the PY1 in particular. Surely a backward step!

PR9 NAPTHOL AS-OL (P.83)
PY1 ARYLIDE YELLOW G (P29)

HEALTH	ASTM	RATING
✓ INFO	V L'FAST	★

SENNELIER
EXTRA-FINE ARTISTS' WATER COLOURS

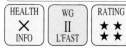

RED ORANGE 640

A well produced mid-orange which brushed out particularly well, giving some very subtle light washes. An excellent all round watercolour paint.

PO69 PERINONE ORANGE (P. 69)
PY83 DIARYLIDE YELLOW (P. 36)

HEALTH	WG	RATING
✕ INFO	II L'FAST	★★ ★★

SENNELIER
EXTRA-FINE ARTISTS' WATER COLOURS

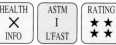

QUINACRIDONE RED ORANGE 655

A fairly bright, transparent red-orange. The sample painted out very well over a good range of values. Absolutely lightfast. Excellent.

PR209 QUINACRIDONE RED Y (P. 96)

HEALTH	ASTM	RATING
✕ INFO	I L'FAST	★★ ★★

GRUMBACHER
ACADEMY ARTISTS' WATERCOLOUR 2ND RANGE

ALIZARIN ORANGE HUE 005

The stated ingredients are all lightfast. I cannot comment further or give an assessment as a sample was not provided.

PY150 NICKEL AZO YELLOW (P.40)
PR209 QUINACRIDONE RED Y (P.96)
PY65 ARYLIDE YELLOW RN (P.36)

HEALTH	WG
✕ INFO	II L'FAST

REDS

History of Red Pigments

The raw materials for the making of red pigments abound in nature. Amongst the substances used have been flowers, woods, resins, roots, seeds, insects, clays and rocks.

In the constant search for durable red pigments, the artist and chemist refined these materials to a high degree, and in very many cases produced them synthetically. The story is really one of the replacement of one red or group of reds by superior products.

One of the earliest red pigments was Cinnabar, produced from a hard red rock, varying from a liver colour to a scarlet, it was the only bright red of the ancient world. Such strongly >

Cinnabar, the first bright red of antiquity.

coloured minerals were highly valued and became articles of commerce. Although many minerals are rich in colour, relatively few make useful pigments, ground ruby for example, becomes a white dust when pow- >

Vermilion, synthetic Cinnabar, was once an important orange - red.

dered, as do many other stones. Vermilion, a synthetically produced version of Cinnabar was an important red for many centuries. Vermilion has always suffered the defect of darkening on exposure to the atmosphere.

Minium was valued by book illustrators for its relative brightness.

Minium, an orange red, similar to today's red lead, was widely used for book illumination and panel painting during the Middle Ages. It owed its popularity to the fact that Cinnabar and Vermilion were difficult to obtain and expensive. It was the closest that many artists could get to a bright red.

Vermilion was of little value when mixing violets.

The inclination of Vermilion towards orange meant that artists could not mix clear violets because with any of the blues Vermilion will give only dull neutral colours. This factor, together with a requirement for rich transparent reds, led to the manufacture of 'Red Lake' pigments from various vegetable and animal dyes.

Brazil, a red produced from a particular bark, was highly prized.

During the Middle Ages a variety of dyes were produced from resins, insects and woods. The most important of them being Lac, Grain and Brazil. These reds were highly esteemed. This is illustrated by the fact that the discovery of a new source of one of them led to the naming of the country Brazil.

Unfortunately, many of these lake colours were very fugitive, certainly by today's standards. Under favourable conditions, where light and moisture have been excluded, such as the illumination on the pages of a book, they have stood up remarkably well. Folium, a vegetable dye which varied in colour depending on its acidity, was also of some importance during Medieval times.

These ancient pigments, together with other red lakes, such as Carmine and Madder have been replaced, almost exclusively by Alizarin. Once extracted from the root of the Madder plant, >

Madder was at one time of vital importance in European trade.

Alizarin, now produced synthetically, has become one of the major reds, this, despite its very poor fastness to light as a tint.

Synthetic Alizarin, an unreliable substance, is overdue for retirement.

We are indeed fortunate to have the Cadmium Reds, excellent pigments worth any additional cost.

Many reliable, modern reds are marketed under ancient and now meaningless names.

Very many of the reds in use today are quite worthless to the artist.

The modern artist is well served by a limited number of very reliable reds. Reds which would have been worth a fortune to earlier painters had they been able to obtain them. A King's ransom would have been paid for the Cadmium Reds and other reliable pigments. We are indeed fortunate.

In recent years a limited range of lightfast, synthetic red pigments have become available. Strangely the names of many of the earlier unreliable reds have been retained to describe these modern and reliable pigments. Therefore, regrettably, making many of the superb modern colour names seem meaningless. This not only adds to the confusion but does not allow the true names of these pigments to emerge and become known.

Today the artist had a greater variety of permanent red pigments available than at any time in history.

Against this background it has to be said that we also have the most extensive range of utterly useless reds that have ever been in use. The vast majority of both orange and violet reds offered as watercolours are unsuitable for artistic use. Most fade when applied thinly, others fade at any strength, still others darken or become discoloured.

Awareness, coupled with clear identification of these poor substances will hopefully drive them from the paint rack

MODERN RED PIGMENTS

NAPHTHOL RED FRR

A reasonably bright violet - red , which to my mind has no place amongst artists' paints. This pigment failed all tests of which I have records, and failed dismally. During our own trials the sample had faded noticeably after only a very short exposure. Testing was discontinued soon after. Why are such thoroughly unreliable pigments offered to the artist?

With time you will end up with the colour on the right. It will also spoil any colours which result from a mix.

COMMON NAME

NAPHTHOL RED FRR

COLOUR INDEX NAME
PR2

COLOUR INDEX NUMBER
12310

CHEMICAL CLASS
MONAZO

Also called Flash Red.

TOLUIDINE RED

Toluidine reds have many industrial applications and are available in light, medium and dark shades. Printers, one of the principal users, regard them as pigments which print out poorly, are dull, weak and fade quickly. So why are they also found in artists' paints when reliable reds, similar in hue, are available? The PR3 that we found was dull, semi-opaque and faded rapidly. It has failed all ASTM testing.

In our sample the tint bleached out quickly and the mass tone became even duller. Not worth considering if you place any value on your work.

COMMON NAME

TOLUIDINE RED

COLOUR INDEX NAME
PR3

COLOUR INDEX NUMBER
12120

CHEMICAL CLASS
**NON-METALISED AZO
RED TOLUIDINE**

Also called Helio Red.

CHLORINATED PARA RED

A bright, rather intense orange red, for a while! Developed in 1907, it is semi-opaque with a high tinting strength. There are many industrial applications for this pigment, where reliability is often a secondary consideration. It has failed all ASTM testing to date. Such substances should not, I feel, be even offered to the artist. Surely even the absolute beginner would not want their work to deteriorate to such an extent.

Our sample bleached rapidly when applied as a tint. The mass tone became darker and considerably duller. It also bled into subsequent paint layers. Not recommended.

COMMON NAME

CHLORINATED PARA RED

COLOUR INDEX NAME
PR4

COLOUR INDEX NUMBER
12085

CHEMICAL CLASS
NON METALISED AZO PIGMENT

Has many other names.

CARMINE

Carmine is produced from the dried bodies of a tiny beetle native to Central America. It is also sold as a food colorant under the name Cochineal. In use for many centuries, it is a transparent violet - red with good tinting strength. Highly fugitive, it will fade rapidly as a tint and move towards brown in mass tone. Although it is entirely unsuitable as an artist's pigment, it is retained because of 'demand'.

Carmine has failed all ASTM lightfast testing. Our sample changed as above within a very short time.

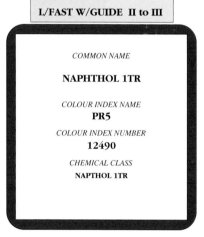
NAPHTHOL 1TR

PR5 is a reasonably bright violet - red. A strong pigment with quite good covering power. It gives reasonably clear washes when very dilute. When offered the protection of the binder it fared well in ASTM testing with a rating of II as an oil paint or acrylic. Without such protection it is more vulnerable. Pending further testing it will be regarded as suspect for the purposes of our evaluations.

As a tint our sample started to show definite fading. The mass tone remained unchanged. It will be better to treat this pigment with caution. Borderline, II to III.

L/FAST W/GUIDE II to III

COMMON NAME

NAPHTHOL 1TR

COLOUR INDEX NAME
PR5
COLOUR INDEX NUMBER
12490
CHEMICAL CLASS
NAPTHOL 1TR

Has many other names.

PARACHLOR RED

Parachlor starts life as a bright orange - red, valued for a brilliance which soon fades. Semi-opaque. Exposure to light quickly fades the tint and dulls the mass tone. This pigment did poorly in every test for which I have results. In our own testing it quickly proved itself to be yet another of the quite unsuitable reds offered to the artist. There are reliable reds available for the discerning.

Pending further testing this pigment will be regarded as unreliable in my assessments.

L/FAST W/GUIDE III

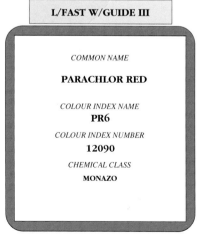

COMMON NAME

PARACHLOR RED

COLOUR INDEX NAME
PR6
COLOUR INDEX NUMBER
12090
CHEMICAL CLASS
MONAZO

Also Parachloronitraniline red.

NAPHTHOL AS -TR

This is another good example of the protection offered by certain binders. When made up into either an oil paint or acrylic this pigment received a rating of I during ASTM testing. As a watercolour it only rated III. A rather bright violet red which gives reasonably transparent washes when well diluted. This pigment should be regarded as unsatisfactory for use in artists' watercolours. Worth avoiding.

Found to be unsuitable as a watercolour during ASTM testing. Our sample faded quickly as a tint and became duller in mass tone.

NAPHTHOL AS - OL

A very bright orange - red, semi-opaque. PR9 has not been tested under ASTM conditions at the time of writing. As an acrylic it rated very well (II) and gouache, also II. It must be borne in mind however, that the pigment is at its most vulnerable when made up into a watercolour paint. A borderline case, especially when applied as a thin wash.

Our sample faded slightly as a tint, but showed no change in mass tone. I would suggest some caution pending further trials.

Also called Naphthol Bright Red.

NATURAL ROSE MADDER

For many centuries a range of dyes have been produced from the root of the madder plant. Such dyes can be utilised in the manufacture of transparent pigments, varying in hue. Rose Madder, a clear violet red, is still with us as a watercolour. It is, unfortunately, particularly fugitive and failed ASTM testing as a watercolour. To retain this pigment for the sake of tradition is rather pointless to my way of thinking.

Rated well as an oil paint (II) but failed ASTM testing as a water-colour. The tint in our sample faded quickly and the mass tone became duller.

ARYLIDE MAROON DARK

This pigment appears to be virtually obsolete. The only colourmen still using it are working through their present stock. A dark brownish - red. I have little information on reliability or characteristics. The colour sample shown is an approximation only.

The only colour in which this is used resisted light very well. No lightfast rating offered.

NAPHTHOL RED

This is a disastrous substance to employ as an artist's pigment. It is no secret that it bleaches out rapidly. All test results that I have seen show that it is most unreliable. It is an unfortunate fact that the majority of red pigments that have found their way into artists' watercolours are either fugitive or less than reliable. There are, however, reliable alternatives available. PR23 is a definite violet - red.

Our sample bleached white as a tint in a very short time and lost its vibrancy in mass tone.

Also called Imperse Red.

PERMANENT RED 2B (BARIUM)

A very bright orange - red. Semi-opaque but gives a reasonable range of values. Strong, with particularly good tinting strength. The common name is very misleading as it is certainly not a permanent pigment. I have no knowledge of any formal testing having been carried out. Discovered in the 1920's. Poor alkaline resistance.

By reputation and the results of our own exposure testing rated WG V.

Also called Barium Red 2B.

PERMANENT RED 2B (CALCIUM)

PR48 : 2 is a brilliant, semi-opaque violet red which has failed all tests of which I have knowledge. With an ASTM rating of IV as a water-colour, it is clearly unsuitable for use as an artist's paint. In our own sample, the tint faded rapidly and the mass tone became noticeably duller. I can think of no reason to use such inferior colorants apart from their relatively low cost as raw pigment.

As in other recorded tests, our sample faded dramatically as a tint and became duller in heavier application. Does not quite live up to its name.

Also called Calcium Red 2B.

PERMANENT RED 2B (MANGANESE)

A bright violet - red, fairly opaque. Not yet tested as a watercolour under ASTM conditions. It contains between 9 - 15% manganese which improves lightfastness. Our own lightfast testing suggested that a certain amount of caution is required when using paints made up with this pigment. Thin washes faded at a steady rate while the colour remained stable in mass tone.

Pending the results of further testing I will give a rating of WG II to III.

Also called Manganese Red 2B.

LITHOL RED

A semi-opaque, medium red. Particularly fugitive, it performed poorly in all tests that I have knowledge of. A low cost pigment with relatively high tinting strength. This might make it suitable for certain industrial applications, but its susceptibility to light should eliminate it from artists' paints. Fortunately, I only found one example of its use as a water-colour, and that in a blend.

A fugitive pigment which has no place amongst artists' water-colours.

Also called Barium Lithol Red.

LITHOL RUBINE (SODIUM)

This pigment has wide industrial application, where, presumably lightfastness cannot be a consideration. PR57 has a poor reputation, this was backed up by our own observations. We have no reports of other independent testing. Amongst its many uses it is employed as a food colorant. As such it probably has a longer life than it does as an artist's paint.

Unsuitable for artistic use. Rated WG V.

LITHOL RUBINE (CALCIUM)

Lithol Rubine is popular in the printing industry, often being employed as the standard process magenta. Valued for its strength, covering power and low cost. It gives a strong, bright print tone where lightfastness does not matter, (in the pro-duction of weekly magazines for example). Fugitive, it is quite unsuitable for use in artists' watercolours. A semi-opaque, violet - red. Failed all testing of which I have knowledge.

Our sample bleached out very quickly. Its strength and covering power might be valued by industry, but they are short lived. Most unsuitable.

Also called Rubine 4G.

SCARLET LAKE (SODIUM)

This is yet another violet red which starts life as a bright transparent hue, but quickly deteriorates after application. PR60 has performed poorly in all tests for which I have results. Our own sample faded badly as a tint and darkened considerably in mass tone. Why are such inferior materials offered to the artist when lightfast reds with desirable qualities are available? Could it be anything to do with the cost of the raw material?

Sample deteriorated badly. The tint faded and moved towards violet and the mass tone darkened and also changed in hue. Unsuitable for artistic use.

RHODAMINE Y

Rhodamine Y is a brilliant, transparent violet red with high tinting strength. Employed also as a printing ink, it is a mobile disaster area as an artist's watercolour. All of the Rhodamines are noted both for their brilliancy and their rate of deterioration. Known as 'daylight' fluorescent colours, they are able not only to fade on exposure but also to discolour. Such bright hues cannot yet be obtained in reliable, quality artists' watercolours.

If you need the colour on the right, this is for you. Sample faded and discoloured as a tint and moved towards a dull brown in mass tone.

Also called PTMA Pink.

RHODAMINE YELLOW SHADE

PR82 is a particularly bright reddish - violet, especially when applied as a medium wash. Like the Rhodamines it sacrifices permanence for temporary brilliance and discolours on exposure. Transparent, it gives very clear washes. This type of bright fluorescent colour would be attractive to, say, an artist who specialised in painting flowers. It is most unfortunate that they would very soon end up with the opposite effect, dull or faded areas in the work.

Our sample discoloured dramatically within a very short time in mass tone. The tint faded equally quickly. Absolutely unsuitable for artistic use.

ROSE MADDER, ALIZARIN

The principal dye of the madder root was known in Asia Minor as 'Uzari' or 'Alizari' which gave the modern name Alizarin. A synthetic version of this dye has been available since 1868. Rose Madder Alizarin is a dilute form of this dye when compared to Alizarin Crimson. Despite its popularity it is unreliable, fading quite quickly as a tint. More reliable when applied heavily but as such is prone to cracking. A transparent violet - red. Failed ASTM testing as a watercolour.

Sample faded quite quickly in both light and medium washes. There are lightfast transparent violet - reds available which are suitable for artistic expression.

ALIZARIN CRIMSON

A reasonably bright violet red, sometimes leaning towards brown. Valued for its transparency. Now synthesised, the basic colorant is some 3,000 years old. Applied as a thick layer it takes on a blackish appearance, has reasonable fastness to light, but cracks. The true beauty of this colour is only revealed when applied as a tint. Mixed with white or well diluted it is disastrous, fading quickly. Rated IV as a watercolour in ASTM tests.

A very popular pigment. Found in most watercolour ranges and paint boxes. It is unsuitable for artistic use. Help to make it obsolete.

THIOINDIGOID VIOLET

PR88 MRS is more a red - violet than a violet red. Thioindigoids (sounds more like a medical condition than a pigment) vary in their fastness to light. The Colour Index Name PR88 MRS identifies this as a version possessing quite good resistance to light. When made into an acrylic and oil paint it did very well in ASTM testing, with a rating of I. Without protection from the binder it might do less well as a watercolour.

Our sample faded slightly so this might be a borderline colour. Pending further testing, I will rate it as II for the purposes of this book.

PHIOXINE RED

A brilliant transparent red, with a soft pink undercolour. Unfortunately the colour is only temporary as it departs rapidly at the first sign of light. The main use of this pigment is in the manufacture of printing inks, coloured pencils and crayons. None of the Xanthene pigments are suitable for artists' paints. How many lovingly produced paintings have been spoiled by this disastrous material? Another reason for artists to become familiar with their pigments.

The colour deteriorates rapidly. As a tint it bleached out completely and the mass tone became very blotchy. Most unsuitable.

Also called Eosine.

MARS VIOLET

Mars Violet is an absolutely lightfast synthetic iron oxides. A very subdued brownish violet. Generally opaque, but with more transparent varieties available. Possesses very good covering power, yet will also give reasonable washes when well diluted. Extremely lightfast, it was given a rating of I following the exacting test methods of the ASTM. Mars Violet offers a useful range of values to the watercolourist, from deep, sullen violets to subtle tints.

A most reliable pigment, compatible with others, inert and absolutely lightfast. Mars Violet is on the ASTM list of approved pigments. Highly recommended.

Also called Violet Iron Oxide.

INDIAN RED

A neutralised red. As is mentioned in the description of Light or English Red Oxide, the term Indian Red is little more than an indication of the basic colour type. One of a range of very reliable synthetic iron oxides. When making a selection from this range, consider the tint or undercolour as well as the mass tone. Indian Red possesses good covering power, but usually washes out to give reasonably clear tints.

Absolutely lightfast. Rated I following ASTM testing as a watercolour. On the list of approved pigments.

MARS RED

A synthetic red iron oxide, Mars Red is similar in hue to its naturally occurring counterpart, Burnt Sienna. The range of Mars colours are really artificial versions of native earth colours. Being manufactured, rather than mined, the quality and hue tends to remain rather more constant. Opaque and reasonably transparent versions are available. A well made Mars Red is a fiery neutralised orange, offering a useful range of values. An excellent pigment all round.

Rated I in ASTM lightfast testing and on the list of approved pigments. Unaffected by light even as a very thin wash.

LIGHT OR ENGLISH RED OXIDE

The distinctions between the various synthetic iron oxides which come under the colour Index Name pigment Red101, are difficult to determine. Of basically the same make up, they are generally separated by the leaning of the hue, yellowish, bluish etc. The various manufacturers might well group them differently. Like Light or English Red Oxide, they are all absolutely lightfast, vary in transparency and have good covering power. They are all excellent pigments.

Rated I following ASTM testing as a watercolour. Compatible with all pigments. A most reliable dull orange.

L/FAST ASTM I

COMMON NAME
LIGHT OR ENGLISH RED OXIDE
COLOUR INDEX NAME
PR101
COLOUR INDEX NUMBER
77491
CHEMICAL CLASS
SYNTHETIC RED IRON OXIDE (YELLOWISH HUE)

VENETIAN RED

An excellent pigment. Venetian Red, one of the synthetic iron oxides, is highly stable, compatible with all other pigments, inexpensive and absolutely lightfast. With a rating of I following ASTM lightfast testing, you can be certain that the colour will remain as you apply it. A dull reddish - orange with a useful range of values. Usually opaque but some grades will give a reasonably transparent wash. A highly recommended pigment.

Absolutely lightfast. This pigment will not be at all affected by light. Rated ASTM I and on the list of approved pigments.

L/FAST ASTM I

COMMON NAME
VENETIAN RED
COLOUR INDEX NAME
PR101
COLOUR INDEX NUMBER
77491
CHEMICAL CLASS
SYNTHETIC IRON OXIDE (YELLOWISH HUE)

LIGHT RED

A neutralised orange. Light Red is produced by heating the naturally occurring Yellow Ochre. When the relevant ASTM standard on artists' pigments was being written, the manufacturers involved agreed that the natural rather than synthetic iron oxide, calcined Yellow Ochre, would be called Light Red. Other companies might well have different ideas. You will know exactly where you are if you choose products with ASTM approved labelling. Covers well, reasonably transparent in washes.

Absolutely lightfast. Rated ASTM I in watercolour and on the list of approved pigments. The colour might well vary from the sample shown.

L/FAST ASTM I

COMMON NAME
LIGHT RED
COLOUR INDEX NAME
PR102
COLOUR INDEX NUMBER
77492
CHEMICAL CLASS
CALCINED YELLOW OCHRE

RED LEAD

A dull orange - red. Opaque, with good covering power. Red Lead is well known as a primer for use on metals. Also well known is the fact that it blackens on exposure to the Hydrogen Sulphide of the atmosphere. It is of little consequence if the undercoat on a bridge gradually darkens, but artists' watercolours are another matter. It is astonishing that the latter use is even considered.

This substance will definitely darken on exposure to the atmosphere, especially in cities and industrial areas. Well worth avoiding.

L/FAST B/GUIDE V

COMMON NAME
RED LEAD

COLOUR INDEX NAME
PR105

COLOUR INDEX NUMBER
77578

CHEMICAL CLASS
INORGANIC. PLUMBIC TETROXIDE

VERMILION

Usually a brilliant orange - red, fairly high in tinting strength. Opaque. A heavy pigment, it tends to settle out in a wash, forming pockets of colour. An artificial inorganic pigment, it contains mercury and should be handled with care. Unfortunately it darkens on exposure to light, particularly when high levels of ultra - violet are present. Once an important pigment, it is now more than adequately replaced by the reliable and less expensive Cadmium Red Light.

As a watercolour it was rated III under ASTM testing. An unreliable colour which can become very dark on exposure. Our experience would suggest a rating of V.

L/FAST ASTM III

COMMON NAME
VERMILION

COLOUR INDEX NAME
PR106

COLOUR INDEX NUMBER
77766

CHEMICAL CLASS
MERCURIC SULPHIDE

CADMIUM RED LIGHT, MEDIUM OR DEEP

A first rate pigment with very desirable qualities. Varying in hue from a bright orange - red to a deeper violet - red. Opaque, with good hiding power, it is nevertheless strong enough to give reasonably transparent washes. Will not bleed into other colours. Resists light, heat, Hydrogen Sulphide and alkalis. There have been moves to ban this excellent pigment. If they are successful we will lose one of the few reliable orange - reds presently available.

Absolutely lightfast. Rated ASTM I as a watercolour. Possesses an excellent range of qualities. An outstanding pigment well worth the cost.

L/FAST ASTM I

COMMON NAME
CADMIUM RED LIGHT, MEDIUM OR DEEP C.P.

COLOUR INDEX NAME
PR108

COLOUR INDEX NUMBER
77202

CHEMICAL CLASS
CONCENTRATED CADMIUM-SELENO SULPHIDE (CC)

CADMIUM-BARIUM RED LIGHT, MEDIUM OR DEEP

An alternative to the chemically pure Cadmium Red Light, Medium or Deep PR108. Usually less expensive, it nevertheless possesses many of the admirable qualities of PR108 although it is somewhat weaker in tinting strength. Opaque, but is strong enough to give a reasonably clear wash when well diluted. Such tints will be quite safe as this is a most reliable pigment. Ranges in hue from an orange - red to a deeper violet - red.

Absolutely lightfast. Rated I as a watercolour following testing under ASTM conditions. A most reliable pigment.

<table>
<tr><td colspan="2">L/FAST ASTM I</td></tr>
</table>

COMMON NAME

CADMIUM-BARIUM RED LIGHT, MEDIUM OR DEEP

COLOUR INDEX NAME

PR108 : 1

COLOUR INDEX NUMBER

77202 : 1

CHEMICAL CLASS

CADMIUM SELENO-SULPHIDE COPRECIPITATED WITH BARIUM SULPHATE

Also called Cadmium Lithopone.

NAPHTHOL AS-D

PR112 is a reasonably bright orange - red. Semi-opaque, it still gives reasonable washes as far as transparency is concerned. An opaque version is available. Not as lightfast as some of the other Naphthol pigments, it rated only III during testing under ASTM conditions. Not really suitable for artistic use where fastness to light is a consideration. Produced under a wide variety of names.

Our sample faded as a tint but remained unchanged in mass tone. Rated only III under ASTM testing conditions. Unsuitable.

L/FAST ASTM III

COMMON NAME

NAPHTHOL AS-D

COLOUR INDEX NAME

PR112

COLOUR INDEX NUMBER

12370

CHEMICAL CLASS

NAPHTHOL AS-D

Also called Permanent Red FGR.

QUINACRIDONE MAGENTA

A bright red, leaning very definitely towards violet. Valued for its transparency. Unaffected by heat, acids or alkalis. Given an ASTM rating of III following testing as a watercolour. It does seem that this pigment resists light very well initially but will eventually fade. In soft light the colour should have a reasonably long life, perhaps many years. Possesses medium tinting strength. Rated ASTM III as a watercolour. Certain companies disagree with this rating following their own experience.

They should, I feel, present their information to the ASTM sub-committee to see if re-testing might be called for.

L/FAST ASTM III

COMMON NAME

QUINACRIDONE MAGENTA

COLOUR INDEX NAME

PR122

COLOUR INDEX NUMBER

73915

CHEMICAL CLASS

QUINACRIDONE Y FORM

NAPHTHOL RED

This is yet another of the many violet - reds employed as an artist's watercolour which can be relied on to deteriorate. Failed ASTM testing with a rating of III in both oils and acrylics. Without the protection of the binder a watercolour will tend to fade much quicker. Not as disastrous as some red pigments, but still unsuitable for use in artistic expression - unless light-fastness is not a consideration.

The tint in our sample faded to a marked extent, but the mass tone was only slightly affected.

COMMON NAME

NAPHTHOL RED

COLOUR INDEX NAME
PR146
COLOUR INDEX NUMBER
12485
CHEMICAL CLASS
NAPHTHOIC ARYLIDE

PERYLENE RED BL

A transparent red, giving reasonably clear washes when well diluted. Reasonably bright pigment with excellent tinting strength. PR149 was the first of the perylene pigments, introduced by Hoechst in 1957. Unfortunately it has not been subjected to any formal testing to my knowledge. Perylene pigments, however, do have an excellent reputation for lightfastness.

Sample stood up particularly well to our testing, darkening slightly in mass tone. Rated WG II pending further testing.

COMMON NAME

PERYLENE RED BL

COLOUR INDEX NAME
PR149
COLOUR INDEX NUMBER
71137
CHEMICAL CLASS
ANTHRAQUINONE. VAT PIGMENT

DISAZO SCARLET

PR166 is a bright orange - red. Semi-opaque, but washes out to give fairly clear tints. A reason-ably strong pigment with good tinting strength, it will quickly influence many other colours in a mix. This pigment stood up quite well in previous testing of which I have knowledge. Not yet trialled under the more exacting conditions of the ASTM. Pending further testing I will rate it as II for the purposes of this book.

Sample fared very well when subjected to light. This will hopefully prove to be a reliable orange - red.

COMMON NAME

DISAZO SCARLET

COLOUR INDEX NAME
PR166
COLOUR INDEX NUMBER
N.A.
CHEMICAL CLASS
DISAZO

NAPHTHOL RED

There are two types of PR170, PR170 F5RK and PR170 F3RK. In addition there is a '70' version of PR170 F3RK. (Apologies for all the numbers). Varieties often exist within a pigment group. The 'family members' are not all equally lightfast. Unless the pigment is fully specified treat it with caution. In this case the pigment is a bright, fairly strong red which tested ASTM II in oil and I in acrylics. A medium performance, moderately priced organic red.

On the basis of previous testing in other media and my own observations I will rate it WG II for this publication. Further testing as a watercolour is required.

BENZIMIDAZOLONE CARMINE HF3C

PR176 is a reasonably bright violet - red. When unadulterated it gives particularly clear, even washes. Being transparent the light tends to sink into heavy layers causing them to look very dark. As far as I am aware this pigment has not been subjected to any formal lightfast testing.

Judging by the performance of the pigment during our own testing rated WG II pending a retest.

Also called Permanent Carmine HF 36.

ANTHRAQUINOID RED

PR177 is a mid - red of high tinting power. Due to its strength it will quickly influence many other colours in a mix. Reasonably transparent in thin washes. Although not yet subject to ASTM testing, it has a reasonable reputation for lightfastness. Mainly used in the automotive industry for the production of clean bright reds.

Rated WG II to III pending further testing. I would suggest that you use with some caution.

PERYLENE RED

PR178 is a slightly violet - red. Introduced in 1966, it is semi-transparent to semi-opaque with reasonable covering power. This is one of the very few reliable violet- reds at our disposal. Following the stringent testing procedures of the ASTM, it was given a rating of II. This pigment has also performed well in other tests that have been carried out. It is one of the few reliable alternatives to impermanent violet - reds such as Alizarin Crimson.

Our sample exhibited only the faintest change to the tint following exposure. An excellent pigment, lightfast and reasonably transparent. Superior to Alizarin Crimson.

THIOINDIGOID MAGENTA

PR181 is a mid - red leaning slightly towards violet. A rather weak pigment with an almost washed out appearance. Poor covering power. Reasonably transparent. At the time of writing it has not been tested under ASTM conditions as a watercolour. It has been tested as an oil paint however, but rated only III despite the protection offered by the binder. Without such protection it will be even more vulnerable as a watercolour.

With a poor rating as an oil paint, it will tend to fade even quicker as a watercolour. Our sample deteriorated quickly. Unreliable.

NAPHTHOL AS

Napthol AS is a rather bright orange - red. Reasonably strong tinctorially. Semi-opaque but gives clear tints when applied as a wash. It rated very well, (I) when tested under ASTM conditions both as an oil and an acrylic. Without the protection of the binder it might not do quite as well, but our sample stood up satisfactorily, darkening slightly at full strength. I will give it a provisional rating of II for this book.

Our sample altered only very slightly during exposure. Pending further testing I will regard it to be one of the few reliable orange - reds.

QUINACRIDONE RED

Quinacridone Red is one of the few violet reds which have stood up well to the rigours of ASTM lightfast testing. As both an oil paint and an acrylic it received a rating of I. This does not of course mean that it will do equally well as a watercolour. Our sample, however, indicated that this will probably prove to be a reliable pigment when further tested. A bright violet - red giving clear washes.

Sample hardly changed during exposure. Pending further testing I will rate it as lightfast II for the purposes of this book. Reliable.

L/FAST W/GUIDE II

COMMON NAME
QUINACRIDONE RED

COLOUR INDEX NAME
PR192
COLOUR INDEX NUMBER

CHEMICAL CLASS
QUINACRIDONE RED

QUINACRIDONE SCARLET

Quinacridone Scarlet is a bright orange - red. Transparent, it brushes out into delicate pinks when well diluted. With an ASTM rating of I when made up into both oil and acrylic paints, it promises to do well when further tested as a watercolour. Without the protection of the binder one cannot be sure how it will stand up. Our own observations, together with the ASTM results in other media, indicate a reliable pigment.

Sample altered imperceptibly during exposure to light. All the evidence indicates a thoroughly reliable pigment. Rated as II for the purposes of this book.

L/FAST W/GUIDE II

COMMON NAME
QUINACRIDONE SCARLET

COLOUR INDEX NAME
PR207
COLOUR INDEX NUMBER
N.A.
CHEMICAL CLASS
QUINACRIDONE RED

QUINACRIDONE RED Y

The vast majority of red pigments employed in watercolours are unsuitable for artistic use. There are materials of excellence available however. PR209 is a reasonably bright, transparent orange - red. With an ASTM rating of I, it has proven reliability. Without an awareness of the meaning and significance of Colour Index Names and Numbers, the artist cannot expect to be able to choose wisely. A most reliable orange - red of great value to the watercolourist.

Our sample was unaffected by light in any way. A first rate pigment with a useful range of qualities. Highly recommended.

L/FAST ASTM I

COMMON NAME
QUINACRIDONE RED Y

COLOUR INDEX NAME
PR209
COLOUR INDEX NUMBER
73905
CHEMICAL CLASS
QUINACRIDONE

SANDORIN SCARLET 4RF

Sandorin Scarlet 4RF is a bright orange - red. This would appear to be one of the few reliable orange- reds yet tested under ASTM conditions. It has a good reputation in industry, where it is used in the production of high performance inks and exterior paints. Our sample certainly stood up extremely well to exposure tests. I will give it a rating of II for the purposes of this book.

On exposure to light our sample showed only the slightest change. Pending further testing this would appear to be an excellent orange - red.

PYRANTHRONE RED

Pigment Red 216 is best described as a neutralised orange - red. A good range of values are available, from a deep, rich, red - brown to soft, dull, orange tints. Semi-opaque, but gives reasonably clear washes when well diluted. Not yet tested under ASTM conditions but has stood up well to other exposure tests. I am surprised that it is so little used in artists' watercolours.

By reputation and our testing rated WG II pending further examination.

Also called Paliogen Red L.

RHODAMINE B

The Rhodamines are brilliant but very short lived colours. Such colours have a certain appeal as they are so bright. That appeal would be diminished if the purchaser realised the rate at which the colour deteriorates. Based on the parent dye Basic Violet 10. This is the dye used in the equally fugitive Pigment Violet 1. A transparent red. The only other use I could find for this colorant was in the manufacture of cosmetics.

Fugitive.

RED LAKE C (BARIUM)

Very bright orange - red. Possesses quite good tinting strength. Known in industry for its low cost, brilliance and tinting strength. The fact that it fades rapidly is often less of a concern. It is a different matter altogether with artists' paints, especially watercolours. We should be able to expect better. Poor alkaline resistance.

Has bleached out in all tests for which I have records, also in our own. Rated WG V.

CHROME ORANGE

A mid orange which can become very dark on exposure to light and the atmosphere. Similar chemically to PY34 Chrome Yellow Lemon. As with PY34 it was given as ASTM rating of I as a watercolour. In our own testing the colour darkened considerably, as did every colour which contained it. During ASTM testing one of the newer encapsulated varieties might have been used. Alternatively, our exposure of the samples to the atmosphere could have caused the damage.

Pending further testing I will not offer an assessment. It is only used in colours darkened by PY34 anyway.

NAPHTHOL RED HF4B

A reasonably bright violet - red. Semi-transparent. There are no independent test results available to us apart from our own. This pigment also has industrial applications where it is used in bicycle coatings.

As our own sample stood up very well to exposure, I will give a rating of WG II pending further testing.

THE FOLLOWING ARE PIGMENTS RECENTLY INTRODUCED BY MANUFACTURERS AND FOR WHICH FURTHER RESEARCH IS REQUIRED.

Insufficient notice was given concerning the use of these pigments to enable me to carry out independent lightfast testing where applicable.

BROMINATED ANTHRANTHRONE - Colour Index Name PR168

Colour Index Number - 59300. Chemical Class - Anthraquinone: Also called Vat Orange.

A bright, transparent, orange-red. Low in tinting strength. Not yet subjected to ASTM testing as a watercolour paint. However, it rated particularly well in other media. Category I in Acrylics and II in Oils. Pending further testing I will rate it as WG II for this edition.

Lightfast Category WG II

PERYLENE MAROONPERYLENE MAROON - Colour Index Name PR 179

Colour Index Number - 71130. Chemical Class 'Anthraquinone: Perylene, a vat pigment.'.

Two types of red are available under this description, a clean orange red and a duller violet reds. Transparent. Not yet subjected to ASTM testing as a watercolour paint. However, it rated particularly well in other media. Category I in Acrylics and Oils. Pending further testing I will rate it as WG II for this edition.

Lightfast Category WG II

QUINACRIDONE MAGENTA B - Colour Index Name PR 202

Colour Index Number - 73907. Chemical Class 'Indigoid: Quinacridone, 2,9 - dichloroquinacridone.'.

A transparent violet red. Similar but duller than PR122. Transparent. Not yet subjected to ASTM testing in any art media. However, it does have a good reputation for lightfastness in other uses, in automobile finishes for example. Pending further testing I will rate it as WG II for this edition.

Lightfast Category WG II

Common Name Unknown - Colour Index Name PR 257

Colour Index Number - not applicable. Chemical Class 'Heterocyclic nickel complex'. Also called Sandorin Red Violet 3RL

A violet-red with good covering power. .Not yet subjected to ASTM testing in any art media. Although reported to have good lightfastness, I feel that I have insufficient information to offer a rating for this edition.

No Lightfast Rating is offered.

Common Name Unknown - Colour Index Name PR 251

Colour Index Number - 12925. Chemical Class 'Monoazo: Pyrazoloaquinazolone. Also called Sico Fast Red 3550 HD

A bright orange - red with good covering power. Not yet subjected to ASTM testing in any art media. Although reported to have good lightfastness, I feel that I have insufficient information to offer a rating for this edition.

No Lightfast Rating is offered.

PYRROLE RED - Colour Index Name PR 254

Colour Index Number - 56110. Chemical Class 'Aminoketone DPP: 'Diketopyrolopyrrole'. Also called Irgazin DPP Red BO.

A bright, transparent red. Not yet subjected to ASTM testing as a watercolour paint. However, it rated particularly well in Acrylics (I). Pending further testing I will rate it as WG II for this edition.

Lightfast Category WG II

Common Name Unknown - Colour Index Name PR 255

Colour Index Number -not applicable. Chemical Class 'Aminoketone DPP: 'Diketopyrolopyrrole. Also called Irgazin DPP Red .

A bright, transparent orange - red with good covering power. Not yet subjected to ASTM testing in any art media. I feel that I have insufficient information to offer a rating for this edition.

No Lightfast Rating is offered.

QUINACRIDONE BURNT ORANGE - Colour Index Name PR 206

Colour Index Number - not applicable. Chemical Class 'Indigoid: Quinacridone.' Also called Quinacridone Maroon.

 Transparent. Not yet subjected to ASTM testing as a watercolour paint. However, it rated I in Acrylics. Pending further testing I will rate it as WG II for this edition.

Lightfast Category WG II

RED
WATERCOLOURS

3.1 Alizarin Crimson

Alizarin is the principle dye of the madder root. It was synthesised in 1868 and was the first of the natural dye stuffs to be made artificially.

When applied heavily it resists light well, it also takes on a very blackish, heavy appearance and tends to crack. When applied lightly it fades at a steady rate.

This substance, very popular with the colourmen, is long past its time. Reliable alternatives are available.

When mixing it is a definite violet - red. Complementary is a yellow - green.

ALIZARIN CRIMSON 004 (002)

WINSOR & NEWTON

Brushes out very well into series of different strength washes. Pigment is unreliable and tends to fade quickly as a wash. Transparent.

ARTISTS' WATER COLOUR

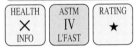

PR83:1 ALIZARIN CRIMSON (P. 88)

HEALTH	ASTM	RATING
✗ INFO	IV L'FAST	★

ALIZARIN CRIMSON 001

GRUMBACHER

Reasonable resistance to light is offered when applied heavily, but thinner washes will fade rather quickly. Transparent.

FINEST PROFESSIONAL WATERCOLORS

PR83 ROSE MADDER ALIZARIN (P. 87)

HEALTH	ASTM	RATING
✓ INFO	IV L'FAST	★

CRIMSON ALIZARIN 515

ROWNEY

As with most watercolours, thinner washes are the norm. When so applied will fade quickly on exposure. Transparent.

ARTISTS' WATER COLOUR

PR83:1 ALIZARIN CRIMSON (P. 88)

HEALTH	ASTM	RATING
✓ INFO	IV L'FAST	★

ALIZARIN CRIMSON HUE 202

DA VINCI PAINTS

A superb, strong, lightfast colour. Recently re-formulated and very much improved. Previously contained the unreliable PR83:1 Crimson Alizarin. Transparent.

PERMANENT ARTISTS' WATER COLOR

PV 19 QUINACRIDONE VIOLET (P. 130)

HEALTH	ASTM	RATING
✓ INFO	II L'FAST	★★ ★★

ALIZARIN CRIMSON 5700

HUNTS

Unreliable ingredients, PR83 will cause rapid fading on exposure. Brushes well. Transparent.

SPEEDBALL PROFESSIONAL WATERCOLOURS

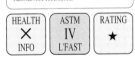
DIHYDROXYANTHRAQUINONE ON ALUMINUM HYDRATE

HEALTH	ASTM	RATING
✗ INFO	IV L'FAST	★

ALIZARIN CRIMSON 2051

MARTIN F. WEBER

The failings of this commonly used pigment are well known. It is unreliable when exposed to light. Transparent.

PERMALBA ARTIST'S WATER COLOR AQUARELLE

PR83 ROSE MADDER, ALIZARIN (P. 87)

HEALTH	ASTM	RATING
✓ INFO	IV L'FAST	★

ALIZARIN CRIMSON 116

BINNEY & SMITH

The use of this very unreliable pigment will have caused damage to countless paintings. Reliable alternatives available. Transparent.

PROFESSIONAL ARTISTS' WATER COLOR

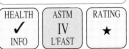
PR83:1 ALIZARIN CRIMSON (P. 88)

HEALTH	ASTM	RATING
✓ INFO	IV L'FAST	★

PERMANENT ALIZARIN CRIMSON HUE 816

BINNEY & SMITH

PR122 seems to vary in performance. This particular paint stood up well to our testing. Sample was unpleasant to use. Semi-transparent.

PROFESSIONAL ARTISTS' WATER COLOR

PR170 F3RK - 70 NAPHTHOL RED (P. 94)
PR122 QUINACRIDONE MAGENTA (P. 92)

HEALTH	ASTM	RATING
✓ INFO	III L'FAST	★★

ALIZARIN CRIMSON GOLDEN 002

GRUMBACHER

Sample not supplied. Assessment made on the stated pigment used.

FINEST PROFESSIONAL WATERCOLORS

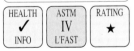
PR83 ROSE MADDER ALIZARIN (P. 87)

HEALTH	ASTM	RATING
INFO	IV L'FAST	★

ALIZARIN CRIMSON
004 (301)

Washes out reasonably well but is as fragile on exposure as its 'Artist' quality cousin. Transparent.

WINSOR & NEWTON

COTMAN WATER COLOUR 2ND RANGE

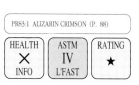

PR83:1 ALIZARIN CRIMSON (P. 88)

HEALTH	ASTM	RATING
✗ INFO	IV L'FAST	★

CRIMSON ALIZARIN
515

Sample was particularly unpleasant to use. Impossible to get an even, gradated wash. Unreliable. Transparent.

ROWNEY

GEORGIAN WATER COLOUR 2ND RANGE

PR83:1 ALIZARIN CRIMSON (P. 88)

HEALTH	ASTM	RATING
✓ INFO	IV L'FAST	★

ALIZARIN CRIMSON
004

Will fade quickly unless applied heavily. Thicker applications take on a very blackish appearance. Transparent.
This range has now been discontinued.

REEVES

WATER COLOUR FOR ARTISTS 2ND RANGE

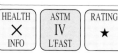

PR83:1 ALIZARIN CRIMSON (P. 88)

HEALTH	ASTM	RATING
✗ INFO	IV L'FAST	★

ALIZARIN CRIMSON
001

Like other Alizarin Crimsons it will fade on exposure, especially when thinly applied. Transparent.

GRUMBACHER

ACADEMY ARTISTS' WATERCOLOUR 2ND RANGE

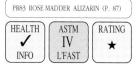

PR83 ROSE MADDER ALIZARIN (P. 87)

HEALTH	ASTM	RATING
✓ INFO	IV L'FAST	★

ALIZARIN CRIMSON

Information on ingredients withheld. No assessments offered.

PAILLARD

LOUVRE AQUARELLE ARTISTS' COLOUR 2ND RANGE

HEALTH		
✗ INFO		

I would suggest that PV19, Quinacridone Red, (page 131), would make the ideal replacement for this inferior pigment. It is bright, similar in hue, transparent and reliable. PR192 (Page 96) is another possibility.

Help to make Alizarin Crimson obsolete, it is well past its time and used in too many other colours.

3.2 Cadmium Red Light

To my mind this is the ideal orange - red. It is bright, washes well and is absolutely lightfast. Being opaque it covers well with a thin layer. Being strong it will give quite transparent washes when diluted.

Cadmium Red Light has, to a large extent, replaced the troublesome Vermilion.

A definite orange - red, it is very versatile in mixes. In order to darken without destroying character, add the complementary green - blue. A superb colour, well worth any extra cost.

CADMIUM RED LIGHT
1072

A fine orange - red. Densely packed pigment gives a watercolour with a wide range of values. Excellent. Opaque.

LUKAS

ARTISTS' WATER COLOUR

PR108 CADMIUM RED LIGHT,MEDIUM OR DEEP (P.91)

HEALTH	ASTM	RATING
✗ INFO	I L'FAST	★★ ★★

CADMIUM RED LIGHT
555

Bright, rich orange - red. A very well made watercolour which handles superbly. An excellent paint. Opaque.

MAIMERI

ARTISTI EXTRA-FINE WATERCOLOURS

PR108 CADMIUM RED LIGHT,MEDIUM OR DEEP (P. 91)

HEALTH	ASTM	RATING
✗ INFO	I L'FAST	★★ ★★

CADMIUM RED LIGHT
027

Despite promises, a sample was not provided. Assessment made purely on the stated ingredients.

GRUMBACHER

FINEST PROFESSIONAL WATERCOLORS

PR108 CADMIUM RED LIGHT,MEDIUM OR DEEP (P.91)

HEALTH	ASTM
✗ INFO	I L'FAST

CADMIUM RED LIGHT 349

SCHMINCKE

A change of ingredient from the norm. Nevertheless a fine, strong paint which works well. Opaque.

HORADAM FINEST ARTISTS' WATER COLOURS

PO20 CADMIUM ORANGE (P. 68)
(USED TO BE PO20:1 SEE PAGE 69)

HEALTH	ASTM	RATING
✕ INFO	I L'FAST	★★ ★★

CADMIUM RED LIGHT 212

DA VINCI PAINTS

Very well labelled product. Carries pigment and extensive health information. Recently re-formulated to improve handling. Opaque.

PERMANENT ARTISTS' WATER COLOR

PR108 CADMIUM RED LIGHT,MEDIUM OR DEEP (P. 91)

HEALTH	ASTM	RATING
✓ INFO	I L'FAST	★★ ★★

CADMIUM RED LIGHT 152

BINNEY & SMITH

Superb labelling on a tube which contains a superb paint. Rich, strong colour, washes particularly well. Opaque.

PROFESSIONAL ARTISTS' WATER COLOR

PR108 CADMIUM RED LIGHT,MEDIUM OR DEEP (P. 91)

HEALTH	ASTM	RATING
✓ INFO	I L'FAST	★★ ★★

CADMIUM RED PALE 303

TALENS

A rich, velvety orange - red. Absolutely lightfast and possesses excellent handling qualities. Opaque.

REMBRANDT ARTISTS' WATER COLOUR

PO20 CADMIUM ORANGE (P. 68)

HEALTH	ASTM	RATING
✕ INFO	I L'FAST	★ ★★

CADMIUM RED LIGHT 411

OLD HOLLAND

More a violet - red than the usual orange - red. This should be noted when mixing. An excellent watercolour. Opaque.

CLASSIC WATERCOLOURS

PR108 CADMIUM RED LIGHT,MEDIUM OR DEEP (P. 91)

HEALTH	ASTM	RATING
✕ INFO	I L'FAST	★ ★★

CADMIUM RED LIGHT 606

HOLBEIN

It is a pity that the ingredients are not given on the tube. They are first class. Brushes out beautifully. Opaque.

ARTISTS' WATER COLOR

PR108 CADMIUM RED LIGHT,MEDIUM OR DEEP (P. 91)

HEALTH	ASTM	RATING
✕ INFO	I L'FAST	★★ ★★

CADMIUM RED PALE 348

SCHMINCKE

A bright, strong colour. Brushes out well into even graduated washes. Absolutely impervious to light. Opaque.

HORADAM FINEST ARTISTS' WATER COLOURS

PO20 CADMIUM ORANGE (P. 68)
(USED TO BE PO20:1 SEE PAGE 69)

HEALTH	ASTM	RATING
✕ INFO	I L'FAST	★★ ★★

CADMIUM RED LIGHT 605

SENNELIER

An excellent watercolour with many admirable qualities. Well worth any extra cost over inferior orange - reds.

EXTRA-FINE ARTISTS' WATER COLOURS

PR108 CADMIUM RED LIGHT,MEDIUM OR DEEP (P. 91)

HEALTH	ASTM	RATING
✕ INFO	I L'FAST	★★ ★★

CADMIUM RED PALE (AZO) 103 (306)

WINSOR & NEWTON

The tint becomes paler and the mass tone darker when exposed to light. Fugitive. Suitable for temporary work. Semi-opaque.

PY1 ARYLIDE YELLOW G (P. 29)
PR4 CHLORINATED PARA RED (P. 81)

COTMAN WATER COLOUR 2ND RANGE

HEALTH	ASTM	RATING
✕ INFO	V L'FAST	★

CADMIUM RED LIGHT 100 (USA ONLY)

WINSOR & NEWTON

Would be judged a superb paint in any range. Pigment and health details on tube. Excellent. Opaque.

COTMAN WATER COLOUR 2ND RANGE

PR108 CADMIUM RED LIGHT,MEDIUM OR DEEP (P. 91)

HEALTH	ASTM	RATING
✓ INFO	I L'FAST	★★

CADMIUM RED LIGHT (AZO) 304

TALENS

Fine for temporary sketch work, particularly if kept away from the light. Handles well, but unreliable. Semi-opaque. *Range now discontinued.*

WATER COLOUR 2ND RANGE

PY74 ARYLIDE YELLOW (P. 36)
PR4 CHLORINATED PARA RED (P. 81)

HEALTH	ASTM	RATING
✕ INFO	IV L'FAST	★

CADMIUM RED LIGHT 027

GRUMBACHER

A fine collection of unreliable pigments. I would suggest for temporary student work only. Semi-opaque.

ACADEMY ARTISTS' WATERCOLOUR 2ND RANGE

PR112 NAPHTHOL AS - D (P. 92)
PY1 ARYLIDE YELLOW G (P. 29)
PO1 HANSA ORANGE (P. 68)

HEALTH	ASTM	RATING
✕ INFO	V L'FAST	★

3.3 Cadmium Red

Deeper in hue than Cadmium Red Light. Possesses the same admirable qualities - brushes well, reasonably bright and absolutely lightfast.

Colour varies between manufacturers so choose carefully.

A superb colour when well made.

For mixing purposes it is nearly always an orange - red. (Violet - red versions are available).

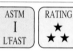

Complementary partner is a blue - green.

CADMIUM RED 335

PÉBÉO

Well produced. A strong, reasonably bright, dark orange - red. Gives good even washes. Opaque.

PR108 CADMIUM RED LIGHT,MEDIUM OR DEEP (P. 91)
PR9 NAPHTHOL AS - OL (P. 83)

FRAGONARD ARTISTS' WATER COLOUR

HEALTH	WG	RATING
✗ INFO	II L'FAST	★★

CADMIUM RED MEDIUM 154

BINNEY & SMITH

A slightly dull red moving towards violet somewhat. Completely lightfast ingredients giving an excellent all round paint. Opaque.

PR108 CADMIUM RED LIGHT,MEDIUM OR DEEP (P. 91)

PROFESSIONAL ARTISTS' WATER COLOR

HEALTH	ASTM	RATING
✓ INFO	I L'FAST	★

CADMIUM RED 323

BLOCKX

Rather dull violet - red. The violet bias should be borne in mind during mixing. An excellent watercolour. Opaque.

PR108 CADMIUM RED LIGHT,MEDIUM OR DEEP (P. 91)

AQUARELLES ARTISTS' WATER COLOUR

HEALTH	ASTM	RATING
✗ INFO	I L'FAST	★

CADMIUM RED 305

TALENS

Superb pigment, densely packed. A well produced watercolour. Washes out very well. Opaque.

PR108 CADMIUM RED LIGHT,MEDIUM OR DEEP (P. 91)

REMBRANDT ARTISTS' WATER COLOUR

HEALTH	ASTM	RATING
✗ INFO	I L'FAST	★★

CADMIUM RED 501

ROWNEY

Such wonderful ingredients should be in big letters on the tube, not missing altogether. Particularly well made. Highly recommended. Opaque.

PR108 CADMIUM RED LIGHT,MEDIUM OR DEEP (P. 91)

ARTISTS' WATER COLOUR

HEALTH	ASTM	RATING
✓ INFO	I L'FAST	★★

CADMIUM RED 094 (082)

WINSOR & NEWTON

A rich, deep colour. The paint washes out very well over the full range of values. Opaque.

PR108 CADMIUM RED LIGHT,MEDIUM OR DEEP (P. 91)

ARTISTS' WATER COLOUR

HEALTH	ASTM	RATING
✗ INFO	I L'FAST	★★

CADMIUM RED MEDIUM 029

GRUMBACHER

A particularly dull, 'heavy' violet - red. The bias should be taken into account when mixing. Lightfast. Opaque.

PR108 CADMIUM RED LIGHT,MEDIUM OR DEEP (P. 910

FINEST PROFESSIONAL WATERCOLORS

HEALTH	ASTM	RATING
✗ INFO	I L'FAST	★★

CADMIUM RED (HUE) 616

MAIMERI

Similar in hue to genuine Cadmium Red Medium. Unfortunately it is affected by light when applied thinly. Suitable for student work. Semi-transparent.

PR112 NAPHTHOL AS - D (P. 92)

STUDIO FINE WATER COLOR 2ND RANGE

HEALTH	ASTM	RATING
✗ INFO	III L'FAST	★★

CADMIUM RED HUE 095

WINSOR & NEWTON

Neither ingredient is reliable. Perhaps for temporary work. The colour will be temporary anyway on exposure to light. Semi- opaque.

PR3 TOLUIDINE RED (P. 81)
PR4 CHLORINATED PARA RED (P. 81)

COTMAN WATER COLOUR 2ND RANGE

HEALTH	WG	RATING
✗ INFO	V L'FAST	★

CADMIUM RED 094
(USA ONLY)

Full information on tube. Dense pigment, washes well but colour is a little dull. Opaque.

PR108 CADMIUM RED LIGHT,MEDIUM OR DEEP (P. 91)

HEALTH	ASTM	RATING
✓ INFO	I L'FAST	★★

WINSOR & NEWTON

COTMAN WATER COLOUR 2ND RANGE

3.4 Cadmium Red Deep

Equally reliable and with similar qualities to the other Cadmium Reds. This is the least versatile and can be duplicated by adding a touch of the mixing complementary to Cadmium Red Medium.

For mixing purposes it varies in hue between a rather heavy violet - red to a deep orange - red.

Mixing complementaries are: For a violet - red , yellow - green and for the orange - red version , blue - green.

CADMIUM RED DEEP 412

Rather 'heavy' dull, red, definitely on the violet side. Gives very even washes over the full range. Opaque.

OLD HOLLAND

PR108 CADMIUM RED LIGHT,MEDIUM OR DEEP (P. 91)

CLASSIC WATERCOLOURS

HEALTH	ASTM	RATING
✗ INFO	I L'FAST	★ ★★

CADMIUM RED DEEP 350

A dull violet - red. The pigment is resistant to just about everything. Washes well at any value. Opaque.

SCHMINCKE

PR108:1 CADMIUM- BARIUM RED LIGHT, MEDIUM OR DEEP (P. 92)

HORADAM FINEST ARTISTS' WATER COLOURS

HEALTH	ASTM	RATING
✗ INFO	I L'FAST	★★

CADMIUM RED DEEP 531

Strong colour which handles very well. Powerful enough to give reasonably thin washes when well diluted. Opaque.

MAIMERI

PR108 CADMIUM RED LIGHT,MEDIUM OR DEEP (P. 91)

ARTISTI EXTRA-FINE WATERCOLOURS

HEALTH	ASTM	RATING
✗ INFO	I L'FAST	★★

CADMIUM RED DEEP 607

A little brighter and closer to orange in mass tone than others. Washes out very well. Reliable. Opaque.

HOLBEIN

PR108 CADMIUM RED LIGHT,MEDIUM OR DEEP (P. 91)

ARTISTS' WATER COLOR

HEALTH	ASTM	RATING
✗ INFO	I L'FAST	★★ ★★

CADMIUM RED DEEP 155

On the dull side. A deep violet - red. Rather difficult to get an even wash when applied heavily. Lightfast. Opaque.

BINNEY & SMITH

PR108 CADMIUM RED LIGHT,MEDIUM OR DEEP (P. 91)

PROFESSIONAL ARTISTS' WATER COLOR

HEALTH	ASTM	RATING
✓ INFO	I L'FAST	★ ★★

CADMIUM RED DEEP 097 (083)

A rich, velvety deep red. Well produced watercolour giving a range of very smooth washes. Opaque.

WINSOR & NEWTON

PR108 CADMIUM RED LIGHT,MEDIUM OR DEEP (P. 91)

ARTISTS' WATER COLOUR

HEALTH	ASTM	RATING
✗ INFO	I L'FAST	★★ ★★

CADMIUM RED DEEP 306

Strong enough to give fairly clear washes when well diluted. A very good watercolour, well produced. Opaque.

PR108 CADMIUM RED LIGHT,MEDIUM OR DEEP (P. 91)

TALENS

REMBRANDT ARTISTS' WATER COLOUR

HEALTH	ASTM	RATING
✗ INFO	I L'FAST	★★ ★★

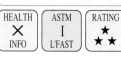

CADMIUM RED DEEP 5709

See page 92 for details of PR108:1 Cadmium - Barium Red. Handles well over the full range. Opaque.

CADMIUM SULFOSELENIDE COPRECIPITATED WITH BARIUM SULPHATE

HUNTS

SPEEDBALL PROFESSIONAL WATERCOLOURS

HEALTH	ASTM	RATING
✗ INFO	I L'FAST	★★

CADMIUM RED DEEP 026

A very densely packed paint. Has good hiding power. Difficult to get a good gradated wash. Reliable. Opaque.

PR108 CADMIUM RED LIGHT,MEDIUM OR DEEP (P. 91)

GRUMBACHER

FINEST PROFESSIONAL WATERCOLORS

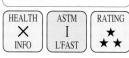

HEALTH	ASTM	RATING
✗ INFO	I L'FAST	★ ★★

CADMIUM RED DEEP 1074

Slightly violet - red. Absolutely lightfast pigment. It really is worth being aware of such ingredients. First class watercolour. Opaque.

PR108 CADMIUM RED LIGHT,MEDIUM OR DEEP (P. 91)

LUKAS

ARTISTS' WATER COLOUR

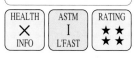

HEALTH	ASTM	RATING
✗ INFO	I L'FAST	★★ ★★

CADMIUM RED DEEP (AZO) 098 (305)

Personally I would rather see colours described under their own name rather than impersonating another. A poor imitation. Semi-opaque.

PR112 NAPHTHOL AS - D (P. 92)

WINSOR & NEWTON

COTMAN WATER COLOUR 2ND RANGE

HEALTH	ASTM	RATING
✗ INFO	III L'FAST	★★

CADMIUM RED DEEP (AZO) 307

The ingredients are not worthy of the title. Not everybody will realise just what they are buying. Semi-opaque. *Range now discontinued.*

PR4 CHLORINATED PARA RED (P. 81)
PR23 NAPHTHOL RED (P. 84)

TALENS

WATER COLOUR 2ND RANGE

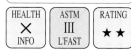

HEALTH	WG	RATING
✗ INFO	V L'FAST	★

3.5 Cadmium Barium Red

Usually as bright and certainly as reliable as the chemically pure Cadmium Reds. Although described as such, the only paints sold under this title employed other pigments.

CADMIUM BARIUM RED MEDIUM 029

The title is very misleading. So is the lightfast rating of I given on the sample tube supplied. Fades and discolours alarmingly. Semi-opaque.

PO1 HANSA ORANGE (P. 68)
PR4 CHLORINATED PARA RED (P. 81)
PR49:1 LITHOL RED (P. 85)
PR3 TOLUIDINE RED (P. 81)

GRUMBACHER

ACADEMY ARTISTS' WATERCOLOUR 2ND RANGE

HEALTH	WG	RATING
✓ INFO	V L'FAST	★

CADMIUM BARIUM RED DEEP 026

The earlier formulation of PR108:1 seems to have been changed to the pigments given here. Rather a pity. Semi-opaque.

PR49:1 LITHOL RED (P. 85)
PY42 MARS YELLOW (P. 34)

GRUMBACHER

ACADEMY ARTISTS' WATERCOLOUR 2ND RANGE

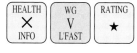

HEALTH	WG	RATING
✓ INFO	IV L'FAST	★

3.6 Carmine

This is another name from the past which is used to sell a variety of violet - reds, often of dubious value.

Genuine Carmine is obtained from the dried bodies of beetles native to South America.

The European use of the pigment dates from the mid 1500's.

A cool transparent violet - red, genuine Carmine is fugitive and unsuitable for most artistic use.

For mixing purposes treat as a violet - red. Complementary is a yellow - green.

CARMINE RED 1061

LUKAS

ARTISTS'
WATER COLOUR

Re-formulated. The PR9 now added can be prone to slight fading as a wash. A well produced colour which handled smoothly. Transparent.

PR 9 NAPTHOL AS - OL (P. 83)
PR 176 BENZIMIDAZOLONE (P. 94)
(PREVIOUSLY PRODUCED FROM PR83
P. 87 - PR176 P. 94 AND PR3 P. 81)

HEALTH	WG	RATING
✗ INFO	III L'FAST	★★

CARMINE 2084

MARTIN F.WEBER

PERMALBA
ARTIST'S
WATER COLOR
AQUARELLE

Our sample stood up very well to exposure testing. Now re-formulated, the PR19 being changed to PV19. Handled well. Transparent.

PV 19 QUINACRIDONE VIOLET (P. 130)
PR108:1 CADMIUM -BARIUM RED (92)
(PREVIOUSLY PRODUCED FROM PR19
P. 84 AND PR108:1 P. 92)

HEALTH	ASTM	RATING
✓ INFO	II L'FAST	★★

CARMINE 602

HOLBEIN

ARTISTS'
WATER COLOR

The almost worthless Crimson Alizarin is sold under a variety of names. Unsuitable for normal artistic use. Transparent.

PR83 ROSE MADDER ALIZARIN (P. 87)

HEALTH	ASTM	RATING
✗ INFO	IV L'FAST	★

CARMINE 353

SCHMINCKE

HORADAM
FINEST
ARTISTS'
WATER COLOURS

Our sample tested very well. Recently re-formulated, the unreliable PR48:4 once added has now been removed.An excellent paint employing a superb pigment.Transp.

PV19 QUINACRIDONE VIOLET (P. 130)
(PREVIOUSLY ALSO CONTAINED PR48:4
PERMANENT RED 2B SEE PAGE 85)

HEALTH	ASTM	RATING
✗ INFO	II L'FAST	★★ ★★

CARMINE RED 355

SCHMINCKE

HORADAM
FINEST
ARTISTS'
WATER COLOURS

Gives very smooth, even washes and stood up particularly well to our lightfast testing. Now re-formulated, the suspect PR48:4 being replaced by the superb PV19. Semi- transparent.

PV19 QUINACRIDONE VIOLET (P. 130)
(WAS PREVIOUSLY PR48:4 SEE PAGE.85)

HEALTH	ASTM	RATING
✗ INFO	II L'FAST	★★ ★★

CARMINE 509

ROWNEY

ARTISTS'
WATER COLOUR

Washes out reasonably well but settles out poorly, giving uneven washes. Lightfastness is borderline, between II and III. Use with caution. Transparent.

PR5 NAPHTHOL ITR (P. 82)

HEALTH	WG	RATING
✓ INFO	II L'FAST	★★

CARMINE 130

BINNEY & SMITH

PROFESSIONAL
ARTISTS'
WATER COLOR

A reasonably bright violet - red. Handled easily, giving very smooth washes. Well labelled. Semi-transparent.

PR187 NAPHTHOL RED HF4B (P. 98)

HEALTH	WG	RATING
✓ INFO	II L'FAST	★★ ★★

CARMINE 127 (094)

WINSOR & NEWTON

ARTISTS'
WATER COLOUR

Pigment used, genuine Carmine, is a fugitive substance long past its time. The colour is easily matched with reliable materials. Transparent.

CARMINE, NATURAL RED 4 (P. 82)

HEALTH	ASTM	RATING
✗ INFO	V L'FAST	★

CARMINE 318

TALENS

REMBRANDT
ARTISTS'
WATER COLOUR

A rosy red. Washes out well. The PR112 content will tend to fade on exposure making the colour paler and rather more violet. Semi-transparent.

PV19 QUINACRIDONE VIOLET (P. 130)
PR112 NAPHTHOL AS - D (P. 92)

HEALTH	ASTM	RATING
✗ INFO	III L'FAST	★★

CARMINE 635

SENNELIER

Whatever name it is sold under, PR83:1, (Alizarin Crimson) is as unreliable as ever. Fades, especially as a tint. Transparent.

PR83:1 ALIZARIN CRIMSON (P. 88)		
HEALTH ✕ INFO	ASTM IV L'FAST	RATING ★

EXTRA-FINE ARTISTS' WATER COLOURS

CARMINE GENUINE 637

SENNELIER

A paint produced using one of the most inferior pigments available - genuine Carmine. Previously called 'Carmine Extra Fine Quality' Trans.

CARMINE, NATURAL RED 4 (P. 82)		
HEALTH ✕ INFO	ASTM V L'FAST	RATING ★

EXTRA-FINE ARTISTS' WATER COLOURS

PERMANENT CARMINE 233

PĒBĒO

Exposure to light will gradually fade the tint and cause the mass tone to become duller. Use with caution. Semi-transparent.

PR5 NAPHTHOL ITR (P. 82)		
HEALTH ✕ INFO	WG III L'FAST	RATING ★★

FRAGONARD ARTISTS' WATER COLOUR

CARMINE PERMANENT 331

LEFRANC & BOURGEOIS

Now we are getting somewhere. Reliable violet - reds are available. This is an excellent all round watercolour. Transparent.

PV19 QUINACRIDONE VIOLET (P. 130)		
HEALTH ✕ INFO	ASTM II L'FAST	RATING ★★ ★★

LINEL EXTRA-FINE ARTISTS' WATERCOLOUR

ALIZARIN CARMINE 510

MAIMERI

This pigment is very popular with the manufacturers for some reason. Not suitable for normal artistic expression. Transparent.

PR83:1 ALIZARIN CRIMSON (P. 88)		
HEALTH ✕ INFO	ASTM IV L'FAST	RATING ★

ARTISTI EXTRA-FINE WATERCOLOURS

ALIZARIN CARMINE 002 (001)

WINSOR & NEWTON

It is well known that this pigment is unreliable unless applied thickly or kept in the dark. Transparent.

PR83:1 ALIZARIN CRIMSON (P. 88)		
HEALTH ✕ INFO	ASTM IV L'FAST	RATING ★

ARTISTS' WATER COLOUR

CADMIUM RED CARMINE 365

LEFRANC & BOURGEOIS

A case of a superb pigment whose name has been linked to a worthless colorant from the past. Excellent. Opaque.

PR108 CADMIUM RED LIGHT, MEDIUM OR DEEP (P. 91)		
HEALTH ✕ INFO	ASTM I L'FAST	RATING ★★ ★★

LINEL EXTRA-FINE ARTISTS' WATERCOLOUR

CARMINE HUE 038

GRUMBACHER

A good imitation of genuine Carmine. Reformulated and very much improved. The fugitive PR48:2 being replaced by the excellent PV19. Lightfast.

PV19 QUINACRIDONE VIOLET (P. 130) WAS PREVIOUSLY PR48:2 (P. 85)		
HEALTH ✓ INFO	ASTM II L'FAST	RATING ★★ ★★

ACADEMY ARTISTS' WATERCOLOUR 2ND RANGE

CARMINE 606

MAIMERI

The PR146 content lets this colour down. It fades at a steady rate on exposure. Brushes out very smoothly. Semi-opaque.

PR146 NAPHTHOL RED (P. 93) PR9 NAPHTHOL AS - OL (P. 83)		
HEALTH ✕ INFO	WG IV L'FAST	RATING ★

STUDIO FINE WATER COLOR 2ND RANGE

CARMINE MADDER 224

BLOCKX

There can be very little of the reliable PV19 in this particular watercolour. Sample faded dramatically to a faint red - brown. Transparent.

PR83:1 ALIZARIN CRIMSON (P. 88) PV19 QUINACRIDONE VIOLET (P. 130)		
HEALTH ✕ INFO	ASTM IV L'FAST	RATING ★

AQUARELLES ARTISTS' WATER COLOUR

MADDER CARMINE 359

SCHMINCKE

First rate watercolour paint. Slightly violet - red. Washes smoothly. Far superior to the usual Crimson Alizarin found in such colours. Semi-transparent.

PR178 PERYLENE RED (P. 95)		
HEALTH ✕ INFO	ASTM II L'FAST	RATING ★★

HORADAM FINEST ARTISTS' WATER COLOURS

MADDER CARMINE 329

LEFRANC & BOURGEOIS

Crimson Alizarin sold under yet another name. As unreliable as ever. Transparent.

PR83 ROSE MADDER, ALIZARIN (P. 87)		
HEALTH ✕ INFO	ASTM IV L'FAST	RATING ★

LINEL EXTRA-FINE ARTISTS' WATERCOLOUR

3.7 Crimson Lake

A term used since ancient times to describe a clear violet - red of either animal or vegetable origin.

Nowadays it is used to market similar hues, often regardless of quality. As you will notice, it is yet another way to sell the almost worthless Alizarin Crimson.

A violet - red, mixing complementary is a yellow - green.

Unless you select with care you could end up with the colour on the right.

CRIMSON LAKE 601

Our sample bleached white in a very short time and lost all vibrancy in mass tone. Unsuitable for most artistic use. Transparent.

PR23 NAPHTHOL RED (P. 84)

HOLBEIN
ARTISTS' WATER COLOR

HEALTH	WG	RATING
✕ INFO	V L'FAST	★

CRIMSON LAKE 514

Washes well when very thin but difficult to apply when heavy. It will unfortunately also fade rapidly when thin. Transparent.

PR83:1 ALIZARIN CRIMSON (P. 88)
PR88 MRS THIOINDIGOID VIOLET (P. 88)

ROWNEY
ARTISTS' WATER COLOUR

HEALTH	ASTM	RATING
✓ INFO	IV L'FAST	★

CRIMSON LAKE 688

As both ingredients are most unreliable, do not expect the colour to remain as applied for long. Washes out poorly. Transparent.

PR83:1 ALIZARIN CRIMSON (P. 88)
PR48:2 PERMANENT RED 2B (P. 85)

SENNELIER
EXTRA-FINE ARTISTS' WATER COLOURS

HEALTH	ASTM	RATING
✕ INFO	IV L'FAST	★

CRIMSON LAKE 205 (017)

PR83:1, Alizarin Crimson is sold under one name after another. Fades rapidly as a thin wash. Not suitable for most artistic uses. Transparent.

PR83:1 ALIZARIN CRIMSON (P. 88)

WINSOR & NEWTON
ARTISTS' WATER COLOUR

HEALTH	ASTM	RATING
✕ INFO	IV L'FAST	★

CRIMSON LAKE 341

It would be better to see an excellent pigment like Quinacridone Violet sold under its own name, instead of an obscure title from the past. Transparent.

PV19 QUINACRIDONE VIOLET (P. 130)

LEFRANC & BOURGEOIS
LINEL EXTRA-FINE ARTISTS' WATERCOLOUR

HEALTH	ASTM	RATING
✓ INFO	II L'FAST	★★ ★★

CRIMSON LAKE 205

Crimson Alizarin under yet another name. Fine for temporary sketch work, nothing more permanent. Transparent. *This range has now been discontinued.*

PR83:1 ALIZARIN CRIMSON (P. 88)

REEVES
WATER COLOUR FOR ARTISTS 2ND RANGE

HEALTH	ASTM	RATING
✕ INFO	IV L'FAST	★

CRIMSON LAKE 514

The pigment used is unreliable. Our sample faded dramatically. Not suitable for normal artistic use.

PR57 LITHOL RUBINE (SODIUM) (P. 86)

ROWNEY
GEORGIAN WATER COLOUR 2ND RANGE

HEALTH	WG	RATING
✓ INFO	V L'FAST	★

Many quite worthless pigments are offered to the artist because of 'demand'. (I have already given my views on why such a demand might exist).

What is disturbing is that excellent, modern pigments such as PV19 are seldom offered, and then not often under their own name. This presumably is because they 'are not in demand'. How can the artist create demand when, for example, PV19 is marketed under a meaningless Medieval name, alongside all manner of substances?

3.8 Madders

A range of clear dyes can be produced from the root of the Madder plant, varying from a rose colour through browns to purple.

The colouring matter is found between the outer skin and the woody core. Together with other colorants, Alizarin has been extracted and used as a dye since the time of the ancient Egyptians.

Alizarin is now produced synthetically and is, unfortunately, in wide use.

For colour mixing purposes Madders are violet reds, usually transparent. Mixing complementary is yellow - green.

Madder Lake

Modern Alizarin Crimson is a synthetic Madder Lake colour. The term 'Lake' refers to any inert, chalk like, pigment which has been coloured with a dye.

Madder Lake is a name under which a variety of violet - reds are marketed.

OLD HOLLAND

CLASSIC WATERCOLOURS

MADDER LAKE LIGHT 413

A particularly overbound sample was sent. Only very thin washes were possible. The colour fades without delay when exposed to light. Semiopaque.

PR48:2 PERMANENT RED 2B (P. 85)

HEALTH	ASTM	RATING
✕ INFO	IV L'FAST	★

SCHMINCKE

HORADAM FINEST ARTISTS' WATER COLOURS

MADDER LAKE LIGHT 356

Sample was particularly gummy and impossible to use unless very thinly applied. Faded without prompting. Semi-opaque.

PR83 :1 ALIZARIN CRIMSON (P. 88)
PR48:4 PERMANENT RED 2B (P. 85)

HEALTH	ASTM	RATING
✕ INFO	IV L'FAST	★

TALENS

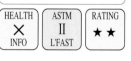

REMBRANDT ARTISTS' WATER COLOUR

MADDER LAKE LIGHT 327

Rather overbound sample, only possible in thin washes. Excellent pigment, better sold under its own name rather than an obscure title. Transparent.

PV19 QUINACRIDONE VIOLET (P. 130)

HEALTH	ASTM	RATING
✕ INFO	II L'FAST	★ ★

LUKAS

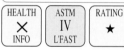

ARTISTS' WATER COLOUR

ALIZARIN MADDER LAKE LIGHT 1064

Each of the various pigments is almost equally unsuitable. For temporary work only. Transparent.

PR83 ROSE MADDER ALIZARIN(P. 87)
PY12 DIARYLIDE YELLOW AAA (P. 30)
PR3 TOLUIDINE RED (P. 81)

HEALTH	WG	RATING
✕ INFO	V L'FAST	★

TALENS

REMBRANDT ARTISTS' WATER COLOUR

MADDER LAKE DEEP 331

Good old Alizarin Crimson again. Apply heavily and it will crack - apply lightly and it will fade. Transparent.

PR83:1 ALIZARIN CRIMSON (P. 88)

HEALTH	ASTM	RATING
✕ INFO	IV L'FAST	★

SENNELIER

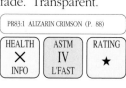

EXTRA-FINE ARTISTS' WATER COLOURS

ALIZARIN CRIMSON 689

The name has recently been changed from 'Madder lake Deep'. This colour will fade as all paints which are produced from Alizarin Crimson will fade. Transparent.

PR83:1 ALIZARIN CRIMSON (P. 88)

HEALTH	ASTM	RATING
✕ INFO	IV L'FAST	★

SCHMINCKE

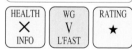

HORADAM FINEST ARTISTS' WATER COLOURS

MADDER LAKE 358

Previously unreliable, this colour has recently been reformulated using light fast pigments. Washed out smoothly. Renamed, was 'Madder Lake Deep'. Transparent.

PV42 QUINACRIDONE MAROON (P.132)
PR254 PYRROLE RED (P.99)
WAS PR83 :1 (P. 88) & PR177 (P. 94)

HEALTH	WG	RATING
✕ INFO	II L'FAST	★ ★ ★ ★

OLD HOLLAND

CLASSIC WATERCOLOURS

MADDER LAKE DEEP 414

The company failed to confirm ingredients. Paint faded at the same rate as Alizarin Crimson. No assessments offered.

HEALTH		
✕ INFO		

ALIZARIN MADDER LAKE DEEP 1066

LUKAS

Sample stood up reasonably well to testing suggesting that little PR83 is involved. Overbound and unpleasant to use.

PR83 ROSE MADDER ALIZARIN (P. 87)
PR176 BENZIMIDAZOLONE CARMINE HF3C (P. 94)
PV23 BS DIOXAZINE PURPLE (P. 131)

ARTISTS' WATER COLOUR

HEALTH	ASTM	RATING
✕ INFO	IV L'FAST	★★

DEEP MADDER 346

LEFRANC & BOURGEOIS

Brushes out well but fades even better. Transparent.

PR83 ROSE MADDER, ALIZARIN (P. 87)

LINEL EXTRA-FINE ARTISTS' WATERCOLOUR

HEALTH	ASTM	RATING
✕ INFO	IV L'FAST	★

MADDER LAKE DEEP 331

TALENS

Sample was difficult to use unless in thin washes (very gummy). Unreliable Alizarin Crimson. Transparent. *This range has now been discontinued.*

PR83:1 ALIZARIN CRIMSON (P. 88)

WATER COLOUR 2ND RANGE

HEALTH	ASTM	RATING
✕ INFO	IV L'FAST	★

Rose Madder

The yellow flowering madder plant was once extensively cultivated in Europe for the dyes which could be extracted from its roots.

Genuine Rose Madder is a weak form of one of the colouring agents from the root.

Preparing genuine Rose Madder requires a great deal of skill and knowledge on the part of the colourman. But is it really worth it? A most unreliable colour, easily matched by modern lightfast alternatives.

To my mind it makes little sense to use a colour which will fade quickly, for the sake of a romantic name and a varied history.

The name is mainly used to sell other red pigments, invariably fugitive.

ROSE MADDER PALE 221

BLOCKX

Sample was very gummy, most unpleasant to use unless applied as a thin wash. The PR83 content will spoil the colour after short exposure. Transparent.

PR83 ROSE MADDER ALIZARIN (P. 87)
QUINACRIDONE

AQUARELLES ARTISTS' WATER COLOUR

HEALTH	ASTM	RATING
✕ INFO	IV L'FAST	★

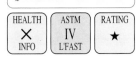

ROSE MADDER 222

BLOCKX

The company state that it is their intention to replace Alizarin with Quinacridone. Depending on the Quinacridone, it will be an excellent move. Transparent.

PR83 ROSE MADDER ALIZARIN (P. 87)

AQUARELLES ARTISTS' WATER COLOUR

HEALTH	ASTM	RATING
✕ INFO	IV L'FAST	★

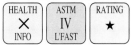

ROSE MADDER 603

HOLBEIN

PR83 is a weaker version of Alizarin Crimson, with all the failings of that pigment. Most unreliable. Washes well. Transparent.

PR83 ROSE MADDER ALIZARIN (P. 87)

ARTISTS' WATER COLOR

HEALTH	ASTM	RATING
✕ INFO	IV L'FAST	★

ROSE MADDER 329

TALENS

An excellent pigment. Sample was rather overbound. Ideal replacement for the usual inferior pigments sold under this name. It can be done. Transparent.

PV19 QUINACRIDONE VIOLET (P. 130)

REMBRANDT ARTISTS' WATER COLOUR

HEALTH	ASTM	RATING
✕ INFO	II L'FAST	★★

ROSE MADDER 344

BINNEY & SMITH

PR83, Rose Madder Alizarin, will only give rather thin washes, heavier use is difficult. Paint handled well but will fade on exposure to light. Transparent.

PR83 ROSE MADDER ALIZARIN (P. 87)

PROFESSIONAL ARTISTS' WATER COLOR

HEALTH	ASTM	RATING
✓ INFO	IV L'FAST	★

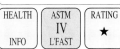

ROSE MADDER 182

GRUMBACHER

Despite promises a sample was not produced. Assessments are based on the stated ingredients.

PR83 ROSE MADDER ALIZARIN (P. 87)

FINEST PROFESSIONAL WATERCOLORS

HEALTH	ASTM	RATING
INFO	IV L'FAST	★

ROSE MADDER GENUINE 587 (090)

Sample was very thin and gummy. Only of use as a light wash. An unreliable pigment prone to rapid fading and discoloration. Transparent.

WINSOR & NEWTON

ARTISTS' WATER COLOUR

NR9 NATURAL ROSE MADDER (P. 83)		
HEALTH ✕ INFO	ASTM IV L'FAST	RATING ★

ROSE MADDER LAKE 690

PR83 makes a rather poor watercolour paint. Gives thin washes only. Poor resistance to light. Transparent.

SENNELIER

EXTRA-FINE ARTISTS' WATER COLOURS

PR83 ROSE MADDER ALIZARIN (P. 87)		
HEALTH ✕ INFO	ASTM IV L'FAST	RATING ★

ROSE MADDER 347

The usual problem when this pigment is employed. Thin, weak paint, rather gummy and tends to deteriorate in colour quickly. Transparent.

LEFRANC & BOURGEOIS

LINEL EXTRA-FINE ARTISTS' WATERCOLOUR

PR83 ROSE MADDER, ALIZARIN (P. 87)		
HEALTH ✕ INFO	ASTM IV L'FAST	RATING ★

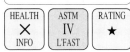

ROSE DORE MADDER LAKE 691

May also be called Rose Madder Dore. Under either name it will change dramatically on exposure to light. Fades and discolours. Transparent.

SENNELIER

EXTRA-FINE ARTISTS' WATER COLOURS

PY83 DIARYLIDE YELLOW HR70 (P. 36)		
PR83 ROSE MADDER ALIZARIN (P. 87)		
HEALTH ✕ INFO	ASTM IV L'FAST	RATING ★

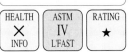

MADDER ALIZARIN LAKE 523

It is a pity that the unreliable PR83, Crimson Alizarin, was added. Name recently changed from 'Rose Madder Alizarin Light'. Transparent.

MAIMERI

ARTISTI EXTRA-FINE WATERCOLOURS

PR83 ALIZARIN CRIMSON (P. 88)		
PV19 QUINACRIDONE VIOLET (P. 130)		
HEALTH ✕ INFO	ASTM IV L'FAST	RATING ★

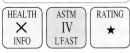

ROSE MADDER ALIZARIN 524

The unreliable Alizarin Crimson previously included has been replaced by the superb PV 19. Now an excellent paint. Transparent.

MAIMERI

ARTISTI EXTRA-FINE WATERCOLOURS

PV19 QUINACRIDONE VIOLET (P. 130)		
PO43 PERINONE ORANGE (P. 69)		
HEALTH ✕ INFO	WG II L'FAST	RATING ★★

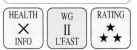

ROSE MADDER (ALIZARIN) DEEP 525

There would seem to be little Ultramarine Blue involved. The paint faded almost back to white paper after short exposure. Transparent.

MAIMERI

ARTISTI EXTRA-FINE WATERCOLOURS

PR83:1 ALIZARIN CRIMSON (P. 88)		
PB29 ULTRAMARINE BLUE (P. 149)		
HEALTH ✕ INFO	ASTM IV L'FAST	RATING ★

ROSE MADDER ALIZARIN 581 (042)

Washes out well but fades at a rapid rate. Transparent.

WINSOR & NEWTON

ARTISTS' WATER COLOUR

PR83:1 ALIZARIN CRIMSON (P. 88)		
HEALTH ✕ INFO	ASTM IV L'FAST	RATING ★

ROSE MADDER DEEP 223

The failings of this pigment are so well known in the industry it is surprising how often it is used. Most unreliable. Transparent.

BLOCKX

AQUARELLES ARTISTS' WATER COLOUR

PR83:1 ALIZARIN CRIMSON (P. 88)		
HEALTH ✕ INFO	ASTM IV L'FAST	RATING ★

ROSE MADDER (ALIZARIN LAKE) 580 (332)

Unpleasant to use unless in very thin washes. Suitable for temporary sketch work perhaps. The colour will be temporary anyway. Transparent.

WINSOR & NEWTON

COTMAN WATER COLOUR 2ND RANGE

PR83:1 ALIZARIN CRIMSON (P. 88)		
HEALTH ✕ INFO	ASTM IV L'FAST	RATING ★

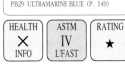
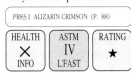

ROSE MADDER (HUE) 563

Unpleasant to handle unless in extremely thin washes. But why worry, the colour will disappear unless you live down a coal mine.

ROWNEY

GEORGIAN WATER COLOUR 2ND RANGE

PR83:1 ALIZARIN CRIMSON (P. 88)		
PR81 RHODAMINE Y (P. 87)		
HEALTH ✓ INFO	WG V L'FAST	RATING ★

ROSE MADDER 182

A weak colour which fades rapidly when applied thinly. Heavier applications tend to crack. Transparent.

GRUMBACHER

ACADEMY ARTISTS' WATERCOLOUR 2ND RANGE

PR83 ROSE MADDER ALIZARIN (P. 87)		
HEALTH ✓ INFO	ASTM IV L'FAST	RATING ★

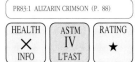

ROSE MADDER (ALIZARIN) DEEP 611

MAIMERI

STUDIO
FINE
WATER COLOR
2ND RANGE

Suitable for temporary sketch work perhaps. Fades on exposure. Transparent.

PR83:1 ALIZARIN CRIMSON (P. 88)
PV23 DIOXAZINE PURPLE (P. 131)

HEALTH	ASTM	RATING
✕ INFO	IV L'FAST	★

Earlier artists were only too pleased to drop unreliable pigments in favour of more lightfast products. Do not be taken in by the marketing of 'tradition'.

Some very poor pigments are sold as 'Madders'. The name and most of the products should pass gracefully into history.

PINK MADDER 235

PĒBĒO

FRAGONARD
ARTISTS'
WATER COLOUR

At last the use of a reliable pigment. A well produced, bright pink watercolour. Washes out very well and is dependable. Transparent.

PR207 QUINACRIDONE SCARLET (P. 96)

HEALTH	WG	RATING
✕ INFO	II L'FAST	★★ ★★

RUBY MADDER 236

PĒBĒO

FRAGONARD
ARTISTS'
WATER COLOUR

PR 122 stands up to light very well for quite some time but will then start to fade. It has failed ASTM testing as a watercolour. Transparent.

PR122 QUINACRIDONE MAGENTA (P. 92)

HEALTH	ASTM	RATING
✕ INFO	III L'FAST	★★

PURPLE MADDER (ALIZARIN) 335

TALENS

REMBRANDT
ARTISTS'
WATER COLOUR

Gives good even washes but the colour will be short lived. Very dark when applied heavily. Transparent.

PR83:1 ALIZARIN CRIMSON (P. 88)
PR122 QUINACRIDONE MAGENTA (P. 92)

HEALTH	ASTM	RATING
✕ INFO	IV L'FAST	★

3.9 Scarlet

The term Scarlet has come to be no more than yet another name under which to sell more red paint. It does not seem to matter whether it is transparent or opaque or whether it is lightfast or fugitive.

Choose carefully and purchase the pigment used rather than the colour name or the brand.

This name (plus certain others), could well be dropped to lessen the confusion of colour descriptions.

When mixing, first decide on the type of red.

SCARLET 2085

MARTIN F.WEBER

PERMALBA
ARTIST'S
WATER COLOR
AQUARELLE

Sample was rather thin and gummy, drying out with a very grainy appearance. Resists light, dependable ingredients. PR9 has not yet been tested to ASTM standards. Transparent.

PR9 NAPHTHOL AS - OL (P. 83)

HEALTH	WG	RATING
✓ INFO	II L'FAST	★★

SCARLET - ALIZARIN 569

ROWNEY

ARTISTS'
WATER COLOUR

Our sample faded dramatically. This was to be expected as such inferior ingredients were used. Transparent.

PR83:1 ALIZARIN CRIMSON (P. 88)
PR4 CHLORINATED PARA RED (P. 81)

HEALTH	ASTM	RATING
✓ INFO	IV L'FAST	★

PERMANENT SCARLET 234

PĒBĒO

FRAGONARD
ARTISTS'
WATER COLOUR

Label claims an ASTM lightfast rating of I. Neither pigment has been given this rating, even as an oil paint. Sample faded as expected. Semi-opaque.

PR9 NAPHTHOL AS - OL (P. 83)
PR5 NAPHTHOL ITR (P. 82)

HEALTH	WG	RATING
✕ INFO	III L'FAST	★★

CADMIUM -SCARLET 106 (084)

A first rate watercolour paint. Very bright, vibrant orange - red. Handled beautifully over full range of values. Excellent. Opaque.

WINSOR & NEWTON

ARTISTS' WATER COLOUR

PR108 CADMIUM RED LIGHT,MEDIUM OR DEEP (P. 91)

HEALTH	ASTM	RATING
✕ INFO	I L'FAST	★★ ★★

CADMIUM - SCARLET 5707

Without the co-operation of the company I did not have a sample to examine. A pity as ingredients are first class.

HUNTS

SPEEDBALL PROFESSIONAL WATERCOLOURS

CADMIUM SULFOSELENIDE COPRECIPITATED WITH BARIUM SULFATE

HEALTH	ASTM
✕ INFO	I L'FAST

SCARLET 601

An intense, vibrant, bright orange - red. Washes out particularly well. A pity that it cannot stand the light for long. Semi-opaque.

This range has been discontinued.

REEVES

WATER COLOUR FOR ARTISTS 2ND RANGE

PR112 NAPHTHOL AS - D (P. 92)

HEALTH	ASTM	RATING
✕ INFO	III L'FAST	★★

SCARLET- LAKE 363

Pr254 has not yet been tested under ASTM conditions as a watercolour. However, it rated very well in oils and acrylics. Sample washed out smoothly. A superb paint.

SCHMINCKE

HORADAM FINEST ARTISTS' WATER COLOURS

PR254 PYRROLE RED (P. 99) WAS PREVIOUSLY PR181 (P. 95)

HEALTH	WG	RATING
✕ INFO	II L'FAST	★★ ★★

SCARLET-LAKE 603 (044)

A fine, vibrant orange - red. Reasonably strong tinctorially. Quite transparent in thin washes. Excellent all round watercolour. Semi-opaque.

WINSOR & NEWTON

ARTISTS' WATER COLOUR

PR188 NAPHTHOL AS (P. 95)

HEALTH	WG	RATING
✕ INFO	II L'FAST	★★ ★★

SCARLET LAKE 612

PR48:1 gives a reasonable range of values but is very prone to fading on exposure. Sample deteriorated quickly. Semi-opaque.

HOLBEIN

ARTISTS' WATER COLOR

PR48:1 PERMANENT RED 2B (BARIUM) (P. 84)

HEALTH	WG	RATING
✕ INFO	V L'FAST	★

SCARLET - LAKE 571

The failings of PR3, Toluidine Red are well known. It is discouraging to see it used by such a respected company. Semi-opaque.

ROWNEY

ARTISTS' WATER COLOUR

PR3 TOLUIDINE RED (P. 81)

HEALTH	WG	RATING
✓ INFO	V L'FAST	★

SCARLET LAKE HUE 189

This colour has recently been re-formulated and much improved. Check ingredients if purchasing. Semi-transparent.

GRUMBACHER

ACADEMY ARTISTS' WATERCOLOUR 2ND RANGE

PO 36 BENZIMIDAZOLONE OR. (P.69)
PR170 NAPTHOL RED (P. 94)
(PGTS. PREVIOUSLY USED WERE P R112 (P. 92), PV19 (P. 131) AND PO1 P. 68)

HEALTH	WG	RATING
✓ INFO	II L'FAST	★ ★★

SCARLET LAKE 571

Once painted out and exposed to light, it will be a race to see which pigment self destructs first. Semi-opaque.

ROWNEY

GEORGIAN WATER COLOUR 2ND RANGE

PR83:1 ALIZARIN CRIMSON (P. 88)
PR3 TOLUIDINE RED (P. 81)

HEALTH	WG	RATING
✓ INFO	V L'FAST	★

3.10 Vermilion

Exactly where and when Vermilion was discovered is uncertain. The first definite reference is contained in an 8th Century Greek manuscript.

A combination of mercury and sulphur, it has played an important part in the history of painting.

Genuine Vermilion is unpredictable and can become very dark, almost black, when exposed to light and the atmosphere. Now more than adequately replaced by the trouble-free Cadmium Red Light.

An orange-red, mixing complementary is a green - blue.

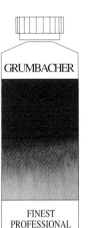

VERMILION LIGHT HUE 228

GRUMBACHER

The ingredients have recently been improved giving a reliable colour. Check pigments when purchasing to ensure new stock. Semi-opaque.

PY3 ARYLIDE YELLOW 10G (P. 29)
PR170 NAPTHOL RED (P. 94)
PR188 NAPTHOL AS (P. 95)

FINEST PROFESSIONAL WATERCOLORS

HEALTH	WG	RATING
✗	II	★★
INFO	L'FAST	

VERMILION LIGHT 548

MAIMERI

If you are looking for a dull, greyed brown, paint out first with this bright orange - red and expose to light and the atmosphere. Opaque.

PR106 VERMILION (P. 91)

ARTISTI EXTRA-FINE WATERCOLOURS

HEALTH	ASTM	RATING
✗	III	★
INFO	L'FAST	

VERMILION (TINT) 651

HOLBEIN

We were informed of the use of certain pigments on going to print. Assessments cannot therefore be offered. Sample faded dramatically.

PR48:1 PERMANENT RED 2B (BARIUM) (P. 84)
PY81 DIARYLIDE YELLOW H10G (P. 40)
PR112 NAPHTHOL AS - D (P. 92)
PW22 BARYTE (P. 272)

ARTISTS' WATER COLOR

HEALTH		
✗		
INFO		

VERMILION 650

HOLBEIN

This is more like it. Bright, vibrant orange - red. Excellent pigment used and it shows in the finished paint. Opaque.

PR108 CADMIUM RED LIGHT,MEDIUM OR DEEP (P. 91)

ARTISTS' WATER COLOR

HEALTH	ASTM	RATING
✗	I	★★
INFO	L'FAST	★★

VERMILION 365

SCHMINCKE

PR255 has not yet been tested under ASTM conditions in any media. I have insufficient information to offer a lightfastness rating.

PR255 COMMON NAME UNKNOWN (P.99)
PREVIOUSLY PO34 (P. 70) AND
PBr24 (P. 213)

HORADAM FINEST ARTISTS' WATER COLOURS

HEALTH		
✗		
INFO		

VERMILION 2064

MARTIN F.WEBER

Sample very thin and gum laden. Settled out on drying, giving a very grainy appearance. Resistant to light. Pigments not yet tested to ASTM standards. Semi-opaque.

PR9 NAPHTHOL AS - OL (P. 83)
PO43 PERINONE ORANGE (P. 69)

PERMALBA ARTIST'S WATER COLOR AQUARELLE

HEALTH	WG	RATING
✓	II	★★
INFO	L'FAST	

VERMILION 320

BLOCKX

The use of genuine Vermilion pigment will guarantee that the colour will quickly move towards a dull greyed - red on exposure. Can deteriorate more than the ASTM rating would suggest. Opaque.

MERCURIC SULPHIDE

AQUARELLES ARTISTS' WATER COLOUR

HEALTH	ASTM	RATING
✗	III	★
INFO	L'FAST	

VERMILION 311

TALENS

Neither pigment is reliable. Our sample faded as a tint and became darker and duller in mass tone. Semi-opaque.

PR4 CHLORINATED PARA RED (P. 81)
PY74 ARYLIDE YELLOW (P. 36)

REMBRANDT ARTISTS' WATER COLOUR

HEALTH	WG	RATING
✗	V	★
INFO	L'FAST	

VERMILION 5706

HUNTS

Without the co-operation of the company I cannot identify the pigment for you. The term 'Perylene Pigment' is meaningless. No assessment offered.

PERYLENE PIGMENT

SPEEDBALL PROFESSIONAL WATERCOLOURS

HEALTH		
✗		
INFO		

VERMILION RED 243

PĒBĒO

FRAGONARD
ARTISTS'
WATER COLOUR

The claimed ASTM lightfast rating of I would appear to be incorrect. As an acrylic would be ASTM I, as an oil ASTM II, but watercolours can be another matter altogether. Nevertheless is reliable. Semi-opaque.

PY65 ARYLIDE YELLOW RN (P. 36)
PR9 NAPHTHOL AS - OL (P. 83)

HEALTH	WG	RATING
✕	II	★★
INFO	L'FAST	

VERMILION RED 1088

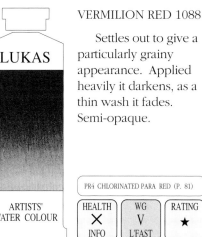

LUKAS

ARTISTS'
WATER COLOUR

Settles out to give a particularly grainy appearance. Applied heavily it darkens, as a thin wash it fades. Semi-opaque.

PR4 CHLORINATED PARA RED (P. 81)

HEALTH	WG	RATING
✕	V	★
INFO	L'FAST	

VERMILION - HUE 326

BINNEY & SMITH

PROFESSIONAL
ARTISTS'
WATER COLOR

ASTM lightfast I claimed. I do not believe PO36 has been tested as a watercolour yet. ASTM I in other media. An excellent watercolour. Semi-opaque.

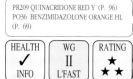

PR209 QUINACRIDONE RED Y (P. 96)
PO36 BENZIMIDAZOLONE ORANGE HL (P. 69)

HEALTH	WG	RATING
✕	II	★★
INFO	L'FAST	

VERMILION RED PERMANENT 394

LEFRANC & BOURGEOIS

LINEL
EXTRA-FINE
ARTISTS'
WATERCOLOUR

Sample performed better than given pigment would suggest. Company failed to confirm ingredients so no assessment offered. Semi-opaque.

PR4 CHLORINATED PARA RED (P. 81)

HEALTH		
✓		
INFO		

CADMIUM RED VERMILION 364

LEFRANC & BOURGEOIS

LINEL
EXTRA-FINE
ARTISTS'
WATERCOLOUR

A fine, strong, vibrant orange - red. Brushes out very well. All that one would expect from the ingredients. Opaque.

PR108 CADMIUM RED LIGHT, MEDIUM OR DEEP (P. 91)

HEALTH	ASTM	RATING
✕	I	★★
INFO	L'FAST	★★

ROWNEY VERMILION HUE 559

ROWNEY

ARTISTS'
WATER COLOUR

Previously produced from the disastrous genuine Vermilion pigment. The word 'Hue' is now added to the name and the pigment changed. Washes out very well.

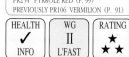

PR254 PYRROLE RED (P. 99)
PREVIOUSLY PR106 VERMILION (P. 91)

HEALTH	WG	RATING
✓	II	★★
INFO	L'FAST	

FRENCH VERMILION RED 675

SENNELIER

EXTRA-FINE
ARTISTS'
WATER COLOURS

Re-formulated and very much improved. Check pgts. if purchasing to ensure new stock. An excellent orange -red, far superior to genuine Vermilion.

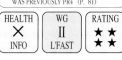

PR242 SANDORIN SCARLET 4RF (P. 97)
WAS PREVIOUSLY PR4 (P. 81)

HEALTH	WG	RATING
✕	II	★★
INFO	L'FAST	

CHINESE VERMILION RED 677

SENNELIER

EXTRA-FINE
ARTISTS'
WATER COLOURS

Used to be produced from the fugitive PR48:2. Now very much improved. A bright, very reliable, transparent red. Handled very well over a range of washes.

PR254 PYRROLE RED (P.99)
PR209 QUINACRIDONE RED Y (P.96)

HEALTH	WG	RATING
✕	II	★★
INFO	L'FAST	

VERMILION DEEP HUE 226

GRUMBACHER

FINEST
PROFESSIONAL
WATERCOLORS

The inferior PR112 once used has been replaced by reliable pigments. Check ingredients if purchasing to ensure new stock. Excellent.

PR188 NAPTHOL AS (P. 95) - PR170 NAPTHOL RED (P. 940 - PR209 QUINACRIDONE RED (P. 96) & PY3 ARYLIDE YELLOW 10G (P. 29)

HEALTH	WG	RATING
✕	II	★
INFO	L'FAST	★★

VERMILION DEEP 549

MAIMERI

ARTISTI
EXTRA-FINE
WATERCOLOURS

It has been known since antiquity that genuine Vermilion pigment darkens on exposure. More so than the ASTM rating would indicate. Opaque. *Discontinued since first edition of this book.*

PR106 VERMILION (P. 91)

HEALTH	ASTM	RATING
✕	III	★
INFO	L'FAST	

VERMILION

PAILLARD

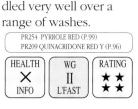

LOUVRE
AQUARELLE
ARTISTS' COLOUR
2ND RANGE

Despite promises to the contrary, information on ingredients was withheld. No assessment possible.

HEALTH		
✕		
INFO		

VERMILION (HUE) 588

ROWNEY

GEORGIAN
WATER COLOUR
2ND RANGE

Sample was difficult to brush out unless very thin. Fades at the first opportunity. Semi-opaque.

PR4 CHLORINATED PARA RED (P. 81)

HEALTH	WG	RATING
✓	V	★
INFO	L'FAST	

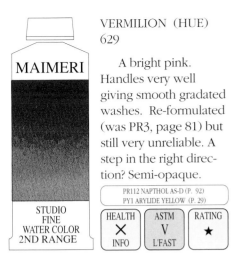

VERMILION (HUE) 629

MAIMERI

A bright pink. Handles very well giving smooth gradated washes. Re-formulated (was PR3, page 81) but still very unreliable. A step in the right direction? Semi-opaque.

PR112 NAPTHOL AS-D (P. 92)
PY1 ARYLIDE YELLOW (P. 29)

STUDIO
FINE
WATER COLOR
2ND RANGE

HEALTH	ASTM	RATING
✕	V	★
INFO	L'FAST	

VERMILION HUE 683

REEVES

Suitable for temporary work only. Very prone to fading as a tint and will darken in heavier application. Semi-opaque.
Range has now been discontinued.

PR4 CHLORINATED PARA RED (P. 81)

WATER COLOUR
FOR ARTISTS
2ND RANGE

HEALTH	WG	RATING
✕	V	★
INFO	L'FAST	

VERMILION 224

GRUMBACHER

Promised sample did not materialise. Rated only on stated ingredients.

PR4 CHLORINATED PARA RED (P. 81)
PO1 HANSA ORANGE (P. 68)

ACADEMY
ARTISTS'
WATERCOLOUR
2ND RANGE

HEALTH	WG	RATING
	V	★
INFO	L'FAST	

There are definite signs that the use of genuine Vermilion is on the decrease. Winsor and Newton have discontinued their Vermilion 680 (097) and Scarlet Vermilion 605 (095). Daler Rowney dropped Scarlet Vermilion 573 some time ago and have now discontinued their Rowney Vermilion. Instead, they now offer a Vermilion Hue.

Maimeri have stopped producing their Vermilion Deep 549 due to the difficulty of obtaining the pigment.

The name might become more of a title to describe an orange - red. Particularly as more companies realise the damage that genuine Vermilion can cause to an artist's work. Better still if the description merged into history and pigments were correctly identified by name.

The knowledgeable artist could then choose with confidence. Perhaps market pressure will bring this about.

Genuine Vermilion can cause immense damage to a painting. Some of the imitations are not a lot better, they usually fade to the same extent that Vermilion can darken.

3.11 Miscellaneous Reds

A glance through pages 81 to 98 will give an indication of the number of red pigments in general use today. As you will see, few of them are suitable for artistic use.

The next few pages will give an indication of the colour names used to market many of these reds.

It is little wonder that most caring artists are confused about what to buy and use.

Select for pigment rather than colour name or make. If the pigment is not clearly identified I would suggest that you do not select at all.

As a basis I would suggest a good quality Cadmium Red Light for the orange - red and a violet - red based on PV19 or PR192 , both Quinacridone Reds.

With colour mixing skill these will give a vast range of results. Additional, selected reds can then be added if required.

ACRA - CRIMSON 110

A possible replacement for the inferior Crimson Alizarin. PR192 makes up into an excellent all round watercolour. Transparent.

BINNEY & SMITH

PROFESSIONAL ARTISTS' WATER COLOR

PR192 QUINACRIDONE RED (P. 96)

HEALTH	WG	RATING
✓ INFO	II L'FAST	★★ ★★

ANGELICO RED

An intense orange - red. Gives reasonably clear washes when well diluted. Reliable pigment used. Semi-opaque.

LEFRANC & BOURGEOIS

LINEL EXTRA-FINE ARTISTS' WATERCOLOUR

PR166 DISAZO SCARLET (P. 93)

HEALTH	WG	RATING
✓ INFO	II L'FAST	★ ★★

BLOCKX RED 225

Dullish, weak and fades readily. Surely a better pigment could be found to carry the company name. Semi-opaque.

BLOCKX

AQUARELLES ARTISTS' WATER COLOUR

PR3 TOLUIDINE RED (P. 81)

HEALTH	WG	RATING
✗ INFO	V L'FAST	★

BREUGHEL RED 359

Sample brushed out poorly making it difficult to get an even wash. Both pigments are particularly fugitive. Semi-opaque.

LEFRANC & BOURGEOIS

LINEL EXTRA-FINE ARTISTS' WATERCOLOUR

PO13 PYRAZONLONE ORANGE (P. 68)
PR4 CHLORINATED PARA RED (P. 81)

HEALTH	ASTM	RATING
✗ INFO	V L'FAST	★

BRIGHT RED 2067

The unreliable PR3 (see page 81) once used has been replaced by the excellent Cadmium Barium Red. The continued use of PR9, however, lowers the lightfast rating.

MARTIN F.WEBER

PERMALBA ARTIST'S WATER COLOR AQUARELLE

PR108:1 CADMIUM-BARIUM RED (P. 92)
PR9 NAPHTHOL AS - OL (P. 83)

HEALTH	WG	RATING
✓ INFO	III L'FAST	★★

BRIGHT RED 396

Clear, vivid red. Strong colour with excellent tinting strength. Handled well. Heavier applications darken slightly on exposure. Transparent.

LEFRANC & BOURGEOIS

LINEL EXTRA-FINE ARTISTS' WATERCOLOUR

PR149 PERYLENE RED BL (P. 93)

HEALTH	WG	RATING
✓ INFO	II L'FAST	★ ★★

BRIGHT RED 042 (006)

Sample paint so stiff was difficult to remove from tube. Tint fades, heavier applications darken dramatically. Semi-opaque.

WINSOR & NEWTON

ARTISTS' WATER COLOUR

PR4 CHLORINATED PARA RED (P. 81)
PY1 ARYLIDE YELLOW G (P. 29)

HEALTH	ASTM	RATING
✗ INFO	V L'FAST	★

RUBY RED 1 905

Previously known as Brilliant Red 1. Recent name and pigment change. Used to be less than reliable, now an excellent violet-red. Lightfast and transparent. Recommended.

SCHMINCKE

HORADAM FINEST ARTISTS' WATER COLOURS

PV19 QUINACRIDONE VIOLET (P. 130)
PREVIOUSLY PR48:4 (P. 85)

HEALTH	ASTM	RATING
✗ INFO	II L'FAST	★★ ★★

MAGENTA 906

Recent name and pigment change. This used to be called 'Brilliant Red 2'. PV42 has not yet been ASTM tested but has a very good reputation for lightfastness. Sample gave very clear washes. Trans.

SCHMINCKE

HORADAM FINEST ARTISTS' WATER COLOURS

PV42 QUINACRIDONE MAROON B (P.132)
PREVIOUSLY PV19 (P.130) & PR122 (P. 92)

HEALTH	WG	RATING
✗ INFO	II L'FAST	★ ★★

CARTHAMUS ROSE 352

LEFRANC & BOURGEOIS

Our sample underwent an amazing transformation on exposure. Light washes disappeared and heavier applications changed to white splashes on a red background. Transparent.

PR90 PHIOXIDE RED (P. 88)

LINEL EXTRA-FINE ARTISTS' WATERCOLOUR

HEALTH	WG	RATING
✕	V	★
INFO	L'FAST	

COBALT ROSE 653

SENNELIER

The inferior PR122 once added has been removed, a great improvement. More a re-violet than a red. The sample provided washed out very well, giving clear, even tints.

PV14 COBALT VIOLET (P. 129)
PW4 ZINC WHITE (P. 270)
PREVIOUSLY PV14 (P.129 & PR122 (P. 92)

EXTRA-FINE ARTISTS' WATER COLOURS

HEALTH	ASTM	RATING
✕	I	★★
INFO	L'FAST	

FLESH TINT 511

MAIMERI

Reliable ingredients. Gives very even, smooth washes.
I suppose that there must be somebody this colour. Opaque.

PW6 TITANIUM WHITE (P. 271)
PY37 CADMIUM YELLOW MEDIUM OR DEEP (P. 33)
PV19 QUINACRIDONE VIOLET (P. 130)
PO43 PERINONE ORANGE (P. 69)

ARTISTI EXTRA-FINE WATERCOLOURS

HEALTH	WG	RATING
✕	II	★★
INFO	L'FAST	

GENUINE ROSE 1092

LUKAS

A rather bright violet pink. Handles well giving very even washes. Fragile on exposure to light. Semi-transparent.

PR5 NAPHTHOL ITR (P. 82)
PR122 QUINACRIDONE MAGENTA (P. 92)

ARTISTS' WATER COLOUR

HEALTH	ASTM	RATING
✕	III	★★
INFO	L'FAST	

GERANIUM LAKE 526

MAIMERI

Sample overbound, making for difficult handling other than thin washes. As expected it faded readily to a marked extent. Transparent.

PR81 RHODAMINE Y (P. 87)

ARTISTI EXTRA-FINE WATERCOLOURS

HEALTH	WG	RATING
✕	V	★
INFO	L'FAST	

GERANIUM LAKE BLUISH 1081

LUKAS

PR 122 resists light very well for a considerable time but will eventually fade. Use with some caution. Transparent.

PR122 QUINACRIDONE MAGENTA (P. 92)

ARTISTS' WATER COLOUR

HEALTH	ASTM	RATING
✕	III	★★
INFO	L'FAST	

GRUMBACHER RED 095

GRUMBACHER

Re-formulated, the unreliable PR112 (see p. 92) has thankfully been removed and replaced by lightfast pigments. A very much improved colour.

PR170 NAPTHOL RED (P. 94)
PR188 NAPTHOL AS (P. 95)

FINEST PROFESSIONAL WATERCOLORS

HEALTH	WG	RATING
✕	II	★★
INFO	L'FAST	

BRIGHT RED 619

SENNELIER

Recent name and pigment change. Was known as 'Helios Red' and produced from the disastrous PR3.(pg. 81). Now very much improved. Both pigments are lightfast.

PO43 PERINONE ORANGE (P.69)
PR 254 PYRROLE RED 81)

EXTRA-FINE ARTISTS' WATER COLOURS

HEALTH	WG	RATING
✕	II	★★
INFO	L'FAST	

MALMAISON ROSE 353

LEFRANC & BOURGEOIS

A particularly bright violet - red, high in tinting strength. Unfortunately is very fugitive. Unsuitable for most artistic use. Transparent.

PV1 RHODAMINE B (P. 128)

LINEL EXTRA-FINE ARTISTS' WATERCOLOUR

HEALTH	WG	RATING
✕	V	★
INFO	L'FAST	

OPERA 604

HOLBEIN

PV1 is a brilliant but temporary violet - red. Such very bright colours invariably fade rapidly. Overall lightfastness improved by the PR122. Washes very well. Transparent.

PR122 QUINACRIDONE MAGENTA (P. 92)
PV1 RHODAMINE B (P. 128)

ARTISTS' WATER COLOR

HEALTH	WG	RATING
✕	V	★
INFO	L'FAST	

PERMANENT RED LIGHT 1099

LUKAS

The inclusion of PV23BS brings the overall lightfast rating right down. By appearance and effect there can be very little involved as sample did reasonably well under test. Semi-opaque.

PR5 NAPHTHOL ITR (P. 82)
PV23 BS DIOXAZINE PURPLE (P. 131)

ARTISTS' WATER COLOUR

HEALTH	ASTM	RATING
✕	V	★★
INFO	L'FAST	

PERMANENT RED 611

HOLBEIN

Gives reasonably transparent washes and handles quite well. Unfortunately prone to fading. Semi-opaque.

PR112 NAPHTHOL AS - D (P. 92)

ARTISTS' WATER COLOR

HEALTH	ASTM	RATING
✕	III	★★
INFO	L'FAST	

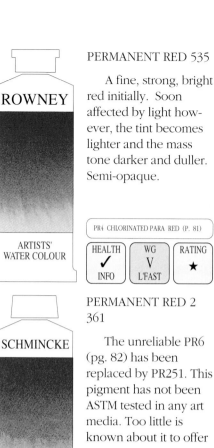

PERMANENT RED 535

ROWNEY

A fine, strong, bright red initially. Soon affected by light however, the tint becomes lighter and the mass tone darker and duller. Semi-opaque.

ARTISTS' WATER COLOUR

PR4 CHLORINATED PARA RED (P. 81)		
HEALTH ✓ INFO	WG V L'FAST	RATING ★

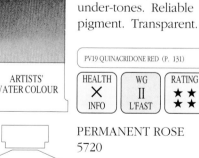

PERMANENT RED 265

DA VINCI PAINTS

A very much improved colour. The inferior PR112 (see page 92) once used has been replaced with a lightfast pigment. Well labelled. Excellent. Semi-opaque.

PERMANENT ARTISTS' WATER COLOR

PR188 NAPTHOL AS (P. 95)		
HEALTH ✗ INFO	WG II L'FAST	RATING ★★

PERMANENT RED 1 360

SCHMINCKE

A bright orange - red which washes out beautifully. Unfortunately, neither pigment has been subjected to ASTM testing and I have insufficient information to offer assessments.

HORADAM FINEST ARTISTS' WATER COLOURS

PR251 COMMON NAME N/K (P.99)
PO69 COMMON NAME N/K (P. 67)
PREVIOUSLY PR242 (P. 97) & PO61(P. 67)

HEALTH ✗ INFO		

PERMANENT RED 2 361

SCHMINCKE

The unreliable PR6 (pg. 82) has been replaced by PR251. This pigment has not been ASTM tested in any art media. Too little is known about it to offer assessments.

HORADAM FINEST ARTISTS' WATER COLOURS

PR251 COMMON NAME N/K (P.99)
PREVIOUSLY PR6 PARACHLOR (P. 82)

HEALTH ✗ INFO		

PERMANENT RED 3 362

SCHMINCKE

The pigment has not been ASTM tested as a watercolour but rated very well in oils and acrylics. A bright, transparent orange-red, low in tinting strength. Brushes very well.

HORADAM FINEST ARTISTS' WATER COLOURS

PR168 BROM. ANTHRANTHRONE (P.99)
WAS PREVIOUSLY PR166 (P. 93)

HEALTH ✗ INFO	WG II L'FAST	RATING ★★ ★★

PERMANENT RED DEEP 345

SCHMINCKE

Reasonably bright, strong violet - red. Gives very even washes over the full range of values.

HORADAM FINEST ARTISTS' WATER COLOURS

PR170 F3RK - 70 NAPHTHOL RED (P. 94)		
HEALTH ✗ INFO	WG II L'FAST	RATING ★★

PERMANENT RED DEEP 1097

LUKAS

PR9 is a borderline case when applied as a very thin wash. In this version it faded considerably. Perhaps a different pigment manufacturer. Semi-opaque.

ARTISTS' WATER COLOUR

PR9 NAPHTHOL AS - OL (P. 83)		
HEALTH ✗ INFO	WG III L'FAST	RATING ★★

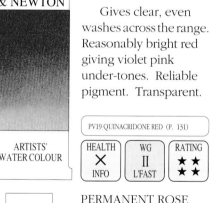

PERMANENT ROSE 502 (QUINACRIDONE) (075)

WINSOR & NEWTON

Gives clear, even washes across the range. Reasonably bright red giving violet pink under-tones. Reliable pigment. Transparent.

ARTISTS' WATER COLOUR

PV19 QUINACRIDONE RED (P. 131)		
HEALTH ✗ INFO	WG II L'FAST	RATING ★★ ★★

PERMANENT ROSE 537

ROWNEY

Smooth, even washes from this well produced watercolour. Quinacridone Red is a reliable pigment under normal conditions. Transparent.

ARTISTS' WATER COLOUR

PV19 QUINACRIDONE RED (P. 131)		
HEALTH ✓ INFO	WG II L'FAST	RATING ★★ ★★

PERMANENT ROSE 610

HOLBEIN

PR60 is an unreliable pigment. Sample faded as a tint and discoloured in mass tone, becoming more violet.

ARTISTS' WATER COLOR

PR60 SCARLET LAKE (SODIUM) (P. 86)		
HEALTH ✗ INFO	WG V L'FAST	RATING ★

PERMANENT ROSE 5720

HUNTS

Referring to the ingredients given I can only say, 'which Quinacridone pigment'? They vary in many ways. Sample not supplied. No assessments offered.

SPEEDBALL PROFESSIONAL WATERCOLOURS

LINEAR QUINACRIDONE PIGMENT

HEALTH ✗ INFO		

ROSE MADDER HUE 346

SCHMINCKE

Previously known as 'Permanent Rose'. Brushes very well giving smooth gradated washes. The pigment used is very reliable Transparent.

HORADAM FINEST ARTISTS' WATER COLOURS

PV19 QUINACRIDONE VIOLET (P. 130)
ALSO USED TO CONTAIN PR177 (P. 94)

HEALTH ✗ INFO	ASTM II L'FAST	RATING ★★

MAIMERI
ARTISTI
EXTRA-FINE
WATERCOLOURS

PRIMARY RED (MAGENTA) 518

There would appear to be little of the unreliable PR122 involved. The colour stood up well to our testing. Transparent.

PR122 QUINACRIDONE MAGENTA (P. 92)
PV19 QUINACRIDONE VIOLET (P. 130)

HEALTH	ASTM	RATING
✗ INFO	III L'FAST	★ ★

MAIMERI
ARTISTI
EXTRA-FINE
WATERCOLOURS

QUINACRIDONE ROSE 554

Washes out particularly well over the full range. A bright, clear violet - red. Dependable. Transparent.

PV19 QUINACRIDONE VIOLET (P. 130)

HEALTH	ASTM	RATING
✗ INFO	II L'FAST	★ ★ ★ ★

DA VINCI PAINTS
PERMANENT
ARTISTS'
WATER COLOR

RED ROSE DEEP 276

PV19 is similar in hue to Alizarin Crimson but brighter and more reliable. This is another excellent example of its qualities. Transparent.

PV19 QUINACRIDONE VIOLET (P. 130)

HEALTH	ASTM	RATING
✓ INFO	II L'FAST	★ ★ ★ ★

TALENS
REMBRANDT
ARTISTS'
WATER COLOUR

REMBRANDT ROSE 368

Faded as suggested by the ASTM rating. A clear violet - red. Only relatively thin washes possible. Transparent.

PR122 QUINACRIDONE MAGENTA (P. 92)

HEALTH	ASTM	RATING
✗ INFO	III L'FAST	★ ★

WINSOR & NEWTON
ARTISTS'
WATER COLOUR

ROSE CARTHAME 574 (076)

Sample darkened slightly in mass tone when applied as a medium wash. Reliable. Semi-opaque.

PR188 NAPHTHOL AS (P. 95)

HEALTH	WG	RATING
✗ INFO	II L'FAST	★ ★

SENNELIER
EXTRA-FINE
ARTISTS'
WATER COLOURS

ROSE PINK 655

Most unreliable. Sample faded dramatically. More suited to industrial use. Semi-opaque.

PR53:1 RED LAKE C (BARIUM) (P. 98)

HEALTH	WG	RATING
✗ INFO	V L'FAST	★

WINSOR & NEWTON
ARTISTS'
WATER COLOUR

ROSE DORE 576 (089)

A rather weak colour, difficult to use unless thin. Then washes out very well. Dependable pigments used. Transparent.

PV19 QUINACRIDONE VIOLET (P. 130)
PY3 ARYLIDE YELLOW 10G (P. 29)

HEALTH	ASTM	RATING
✗ INFO	II L'FAST	★ ★ ★

ROWNEY
ARTISTS'
WATER COLOUR

ROSE DORE (ALIZARIN)

These two pigments give an orange - red with a short life. Semi-transparent.

PR83:1 ALIZARIN CRIMSON (P. 88)
PR4 CHLORINATED PARA RED (P. 81)

HEALTH	ASTM	RATING
✗ INFO	IV L'FAST	★

LEFRANC & BOURGEOIS
LINEL
EXTRA-FINE
ARTISTS'
WATERCOLOUR

RUBY RED 388

A fine, bright violet - red. Washes out particularly well. PV19 is an excellent pigment, dependable and far superior to Alizarin Crimson. Transparent.

PV19 QUINACRIDONE RED (P. 131)

HEALTH	WG	RATING
✗ INFO	II L'FAST	★ ★ ★ ★

HUNTS
SPEEDBALL
PROFESSIONAL
WATERCOLOURS

SPEEDBALL RED 5705

As the company wish to keep pertinent information to themselves, I cannot assess this watercolour. The term ' Naphthol pigment' is meaningless.

NAPHTHOL PIGMENT

HEALTH
✗ INFO

TALENS
REMBRANDT
ARTISTS'
WATER COLOUR

TALENS RED LIGHT 364

Becomes noticeably darker when applied at full strength but stood up reasonably well as a tint. Semi-opaque.

PY74 ARYLIDE YELLOW (P. 36)
PR4 CHLORINATED PARA RED (P. 81)

HEALTH	ASTM	RATING
✗ INFO	IV L'FAST	★ ★

TALENS
REMBRANDT
ARTISTS'
WATER COLOUR

TALENS RED DEEP 365

Darkens on exposure when applied heavily. A strong red which brushes out very smoothly. Semi-opaque.

PR4 CHLORINATED PARA RED (P. 81)
PR23 NAPHTHOL RED (P. 84)

HEALTH	WG	RATING
✗ INFO	V L'FAST	★

THALO CRIMSON 204

Rather overbound which made heavier applications difficult. Excellent pigment used. Transparent.

GRUMBACHER
FINEST PROFESSIONAL WATERCOLORS

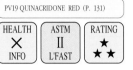

PV19 QUINACRIDONE RED (P. 131)

HEALTH	ASTM	RATING
× INFO	II L'FAST	★★

THALO RED 207

A vibrant strong red with violet - pink under-tone. Washes out very smoothly. Reliable pigment used. Far superior to Alizarin Crimson. Transparent.

GRUMBACHER
FINEST PROFESSIONAL WATERCOLORS

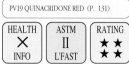

PV19 QUINACRIDONE RED (P. 131)

HEALTH	ASTM	RATING
× INFO	II L'FAST	★★

TYRIAN ROSE 354

A brilliant violet - pink which soon becomes brilliant white paper. Most unsuitable for normal artistic use. Transparent.

LEFRANC & BOURGEOIS
LINEL EXTRA-FINE ARTISTS' WATERCOLOUR

PV1 RHODAMINE B (P. 128)

HEALTH	WG	RATING
× INFO	V L'FAST	★

ROSE TYRIEN 659

Pigment Violet 1 is a disastrous substance to use in an artist's watercolour. A brilliant red - violet. On exposure soon disappears altogether. Transparent.

SENNELIER
EXTRA-FINE ARTISTS' WATER COLOURS

PV1 RHODAMINE B (P. 128)

HEALTH	WG	RATING
× INFO	V L'FAST	★

UCELLO RED 391

The pigment given could not be traced. As the company failed to answer questions on the matter, no assessments can be given.

LEFRANC & BOURGEOIS
LINEL EXTRA-FINE ARTISTS' WATERCOLOUR

HEALTH		
✓ INFO		

WINSOR RED 726 (056)

Pigment Red 2 failed ASTM testing as a watercolour. In mass tone it loses intensity and fades as a tint. Semi-opaque.

WINSOR & NEWTON
ARTISTS' WATER COLOUR

PR2 NAPHTHOL RED FRR (P. 81)

HEALTH	ASTM	RATING
× INFO	IV L'FAST	★

AZO RED 069

The sample confirmed the low lightfast ratings given. Suitable for temporary work only. Semi-opaque. *This range has now been discontinued.*

REEVES
WATER COLOUR FOR ARTISTS 2ND RANGE

PR4 CHLORINATED PARA RED (P. 81)
PR3 TOLUIDINE RED (P. 81)

HEALTH	WG	RATING
× INFO	V L'FAST	★

FLESH TINT 511

Despite promises to the contrary, all information on ingredients was withheld by the company. No assessments are possible.

PAILLARD
LOUVRE AQUARELLE ARTISTS' COLOUR 2ND RANGE

HEALTH		
× INFO		

GERANIUM LAKE 078

Suitable for temporary work only. Handles well in a wash. Fades readily on exposure to light. Semi-opaque.

GRUMBACHER
ACADEMY ARTISTS' WATERCOLOUR 2ND RANGE

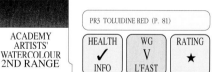

PR3 TOLUIDINE RED (P. 81)

HEALTH	WG	RATING
✓ INFO	V L'FAST	★

GRUMBACHER RED 095

Fine for student work perhaps but unsuitable for more serious work. Washes very smoothly. Semi-opaque.

GRUMBACHER
ACADEMY ARTISTS' WATERCOLOUR 2ND RANGE

PR112 NAPHTHOL AS - D (P. 92)

HEALTH	ASTM	RATING
✓ INFO	III L'FAST	★★

PERMANENT ROSE 502

Sample rather overbound, making full strength washes difficult. Excellent pigments, bright, strong and dependable. Transparent.

WINSOR & NEWTON
COTMAN WATER COLOUR 2ND RANGE

PV19 QUINACRIDONE RED (P. 131)

HEALTH	ASTM	RATING
× INFO	II L'FAST	★★

PRIMARY RED .(MAGENTA) 632

Particularly brilliant 'daylight fluorescent' colours are not yet available in reliable form. This version discolours to a dull brown. Transparent.

MAIMERI
STUDIO FINE WATER COLOR 2ND RANGE

PR81 RHODAMINE Y (P. 87)

HEALTH	WG	RATING
× INFO	V L'FAST	★

THALO CRIMSON 204

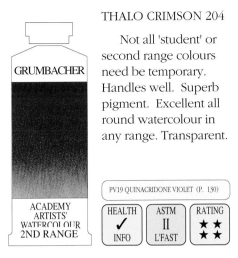

GRUMBACHER

ACADEMY ARTISTS' WATERCOLOUR 2ND RANGE

Not all 'student' or second range colours need be temporary. Handles well. Superb pigment. Excellent all round watercolour in any range. Transparent.

PV19 QUINACRIDONE VIOLET (P. 130)

| HEALTH ✓ INFO | ASTM II L'FAST | RATING ★ ★ ★ ★ |

THALO RED 207

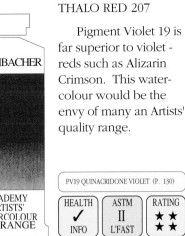

GRUMBACHER

ACADEMY ARTISTS' WATERCOLOUR 2ND RANGE

Pigment Violet 19 is far superior to violet - reds such as Alizarin Crimson. This water-colour would be the envy of many an Artists' quality range.

PV19 QUINACRIDONE VIOLET (P. 130)

| HEALTH ✓ INFO | ASTM II L'FAST | RATING ★ ★ ★ ★ |

TYRIAN ROSE

PAILLARD

LOUVRE AQUARELLE ARTISTS' COLOUR 2ND RANGE

Without company co-operation on ingredients, no assessment can be offered.

| HEALTH ✗ INFO | | |

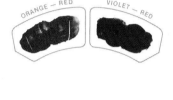

ORANGE — RED VIOLET — RED

Deciding on Colour Type: Reds

As already mentioned, my approach to colour mixing is based firmly on identifying and using colours according to type. Is a red an orange - red or a violet - red etc.

?

It is, of course, essential that you are able to identify colours according to their make-up. The various reds available are, for most people, the most difficult to decide upon.

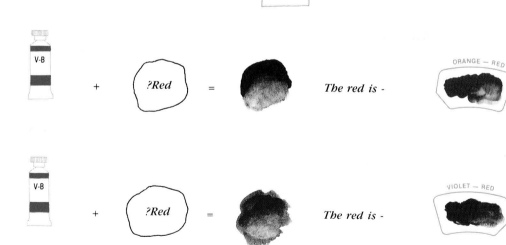

V-B + ?Red = *The red is -* ORANGE — RED

V-B + ?Red = *The red is -* VIOLET — RED

Once you have settled down to a limited palette and have come to associate colour-name with colour-type, (Cadmium Red Light, for example , is an orange - red) it will be smooth sailing until you decide to introduce further colours.

There is a very simple test to decide between the various reds.

Take the red in question and mix it with a known VIOLET - blue, such as Ultramarine Blue.

If the resulting mix is a rather dull, greyed, slightly violet hue, you can be sure that the red in question is an orange - red.

Alternatively, if the result is a bright violet, then, without a doubt, the red has

identified itself as being a violet - red.

The results are always as dramatic as these examples. It is a simple test which is foolproof.

CADMIUM RED (HUE) 503

ROWNEY

The pigment used is prone to fading, especially as a tint. I find this disappointing in a newly introduced colour, whether for students work or not.

GEORGIAN WATER COLOUR 2ND RANGE

PR9 NAPTHOL AS-OL (P. 83)

HEALTH	WG	RATING
✓ INFO	III L'FAST	★★

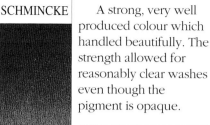

CADMIUM RED MIDDLE 347

SCHMINCKE

A strong, very well produced colour which handled beautifully. The strength allowed for reasonably clear washes even though the pigment is opaque.

HORADAM FINEST ARTISTS' WATER COLOURS

PR108:1 CADMIUM-BARIUM RED (P. 92)

HEALTH	ASTM	RATING
✗ INFO	I L'FAST	★★ ★★

CADMIUM RED MEDIUM 211

DA VINCI PAINTS

A dense, strong, opaque mid red. The sample provided washed out smoothly over a very useful range of values. Excellent.

PERMANENT ARTISTS' WATER COLOR

PR108 CADMIUM RED LIGHT (P. 91)

HEALTH	ASTM	RATING
✓ INFO	I L'FAST	★★ ★★

CADMIUM RED DEEP 210

DA VINCI PAINTS

A dense red, biased towards violet. Although an opaque paint, its strength allows for reasonably clear washes when well diluted. Weaker colours often tend to granulate.

PERMANENT ARTISTS' WATER COLOR

PR108 CADMIUM RED LIGHT (P.91)

HEALTH	ASTM	RATING
✓ INFO	I L'FAST	★★ ★★

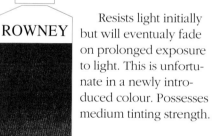

CADMIUM RED DEEP HUE 366

SCHMINCKE

A strong red leaning towards violet. Not yet ASTM tested as a watercolour but rated I in oils and acrylics. Very transparent, washed out smoothly. Semi-opaque

HORADAM FINEST ARTISTS' WATER COLOURS

PR179 PERYLENE MAROON (P.99)

HEALTH	WG	RATING
✗ INFO	II L'FAST	★ ★★

ROSE MADDER QUINACRIDONE 275

DA VINCI PAINTS

A violet-red which gives very clear, 'clean' washes due to the clarity of the pigments. Gives bright violets when mixed with Ultramarine Blue. Lightfast.

PERMANENT ARTISTS' WATER COLOR

PV19 QUINACRIDONE VIOLET (P. 130)

HEALTH	WG	RATING
✓ INFO	II L'FAST	★★ ★★

VERMILION HUE 289

DA VINCI PAINTS

An imitation Vermilion, as indicated by the word 'Hue' in the title. Not as orange-as traditional Vermilion. Semi-opaque but gives reasonably clear tints. Lightfast.

PERMANENT ARTISTS' WATER COLOR

PR188 NAPTHOL AS (P. 95)
PO62 BENZ. ORANGE (P.70Z)

HEALTH	WG	RATING
✓ INFO	II L'FAST	★ ★★

PERMANENT ROSE 537

ROWNEY

Resists light initially but will eventualy fade on prolonged exposure to light. This is unfortunate in a newly introduced colour. Possesses medium tinting strength.

GEORGIAN WATER COLOUR 2ND RANGE

PR122 QUINACRIDONE MAGENTA (P. 92)

HEALTH	ASTM	RATING
✓ INFO	III L'FAST	★★

SENNELIER RED 636

SENNELIER

This is not a new colour as such. Details were not provided for the earlier edition. Bright, transparent and lightfast. The sample gave very even, clear washes.

EXTRA-FINE ARTISTS' WATER COLOURS

PR254 PYRROLE RED (P.99)

HEALTH	WG	RATING
✗ INFO	II L'FAST	★ ★★

QUINACRIDONE ROSE 367

SCHMINCKE

A reasonably bright, transparent, lightfast red. A first rate paint giving a useful range of values. It is encouraging to see so many lightfast colours being introduced.

HORADAM FINEST ARTISTS' WATER COLOURS

PR209 QUINACRIDONE RED Y (P. 96)

HEALTH	ASTM	RATING
✗ INFO	I L'FAST	★★ ★★

PERYLENE MAROON 163

GRUMBACHER

Reliable ingredients. Unfortunatly a sample was not provided for assessment.

ACADEMY ARTISTS' WATERCOLOUR 2ND RANGE

PR179 PERYLENE MAROON (P. 99)

HEALTH	WG	RATING
✗ INFO	II L'FAST	

PERMANENT ROSE 264

DA VINCI PAINTS

PV19,Quinacridone Violet is a superb pigment. Bright, transparent and far more reliable than Crimson Alizarin. This is an excellent paint.

PERMANENT ARTISTS' WATER COLOR

PV19 QUINACRIDONE VIOLET (P. 130)

HEALTH	ASTM	RATING
✓ INFO	II L'FAST	★★ ★★

VIOLETS

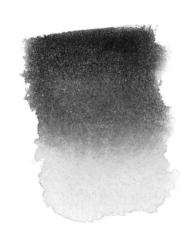

History of Violet Pigments

The first unmixed violet was Tyrian purple, a clear reddish violet in use until about the 10th Century. Produced from a certain species of whelk, it has probably been the most exclusive and expensive colouring matter in history. Mainly used in Mediterranean countries, it also enjoyed some popularity in England, where a local shellfish was used.

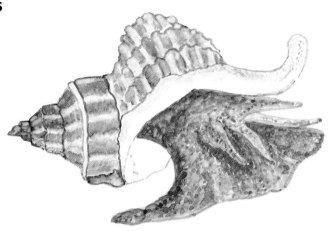

Archil and Folium, vegetable dyes, which were similar in colour to Tyrian Purple, then became the standard pure purples.

The majority of artists in the Middle Ages preferred to mix their violets, either on the palette or as glazes.

A clear substance was extracted from a gland in the whelks body. On exposure to light this became a bright violet.

Vast numbers were required. It takes over 12,000 whelks to produce under 1 1/2 grammes of dye.

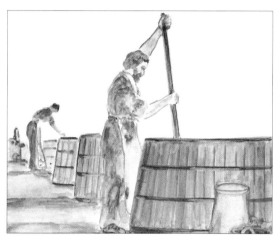

Mauve, discovered by William Perkin in 1856 was the first of the 'coal tar' colours. Many more were introduced.

They were produced from chemicals obtained by distilling coal tar and were usually fugitive.

Despite the quality materials which are readily available we are still offered pigments of dubious quality and permanency.

We now have a range of particularly bright violet pigments, a range which would be the envy of generations of earlier painters.

Many of today's artists also prefer to mix their violets, valuing the more muted effects that are obtainable.

MODERN VIOLET PIGMENTS

RHODAMINE B

As with the Rhodamine Reds, this is a brilliant but short lived colour. A bright, reddish - violet. Being transparent, it washes out into very clear tints. High in tinting strength, it will quickly influence most other colours in a mix. Valued by the printing industry for its strength and brilliance, it is the standard printing ink magenta. With a dismal record as far as permanence is concerned, it is surprising to find it used in artists' paint.

The tint of our sample faded quickly and the mass tone discoloured. Not worth considering unless you wish your work to change similarly.

Parent dye: Basic Violet 10.

VIVID MAGENTA 6B

A dye as such cannot be used to make a watercolour. If it is utilised to dye an inert, colour-less powder, the resulting pigment has the necessary qualities to be made into a workable paint. Such pigments are known as Lake colours. They augment the range of pigments which come naturally in powder form. Basic Violet II, is such a Lake colour. It is a transparent reddish - violet.

All Xanthene pigments fade badly. This version fared no better with a lightfastness rating of ASTM IV in watercolours.

METHYL VIOLET

PV3 is a rather bright bluish - violet. For a while that is. Particularly fugitive, it will deteriorate quickly from the moment it sees the light of day. It also has poor resistance to alkalis, this will probably not be a problem as the colour will usually have departed before-hand. Transparent. For the technical minded the PTMA in the chemical description stands for Phosphotungstomolybic Acid Salt. So now you know.

The poor reputation of this pigment was verified by the rapid deterioration of our sample. The tint virtually disappeared and the mass tone faded and discoloured.

Parent dye : Basic Violet 1.

MAGENTA

PV4, Magenta, is a bright reddish - violet. Transparent, it gives clear washes when well diluted. It would seem to be going out of use. The only colourmen that had been using it, have now switched to another pigment. Mentioned here as you might come across it in other makes.

By reputation and our own testing rated WG V.

Also called Fuchsine.

ALIZARIN MAROON

Alizarin Maroon is a bright reddish violet. Transparent, it gives good clear washes. Although not tested under ASTM conditions at the time of writing, it has a poor reputation as far as lightfastness is concerned. The tint darkened in earlier lightfast testing rather than faded. This pigment is even less resistant to light than PR83, Alizarin Crimson, which only rated IV following ASTM testing. Unreliable.

Faded rapidly during our own lightfast testing. Mass tone discoloured.

COBALT VIOLET

Cobalt Violet first appeared in the early 1800's and was produced from a natural ore. Nowadays it is manufactured chemically. A transparent violet which varies from a red - violet to a bluer version. There are two basic types, both of which are rated ASTM I. A rather weak pigment with little body. In my opinion it makes a very poor watercolour as the result is more of a coloured gum than a paint.

Absolutely lightfast with an ASTM rating of I.

ULTRAMARINE RED
ULTRAMARINE VIOLET

Ultramarine Violet is obtained by heating Ultramarine Blue with certain chemicals until the desired hue is obtained. Ultramarine Red, in turn, is obtained by heating Ultramarine Violet in the presence of gaseous acids. Both versions share the same Colour Index Number as Ultramarine Blue. PV15 varies from a bright violet to a reddish - violet. Brilliant pigments of high colour purity and lightfastness. Both are opaque with low tinting strength.

Both versions of PV15 are absolutely lightfast. They rated ASTM I following lightfast testing as watercolours. Highly recommended.

L/FAST ASTM I

COMMON NAME
**ULTRAMARINE RED
ULTRAMARINE VIOLET**

COLOUR INDEX NAME
PV15

COLOUR INDEX NUMBER
77007

CHEMICAL CLASS
COMPLEX SILICATE OF SODIUM AND ALUMINUM WITH SULPHUR

MANGANESE VIOLET

PV16 is a rather dull, reddish to mid violet. Opaque to semi-opaque with good covering power. Does not give particularly clear tints. Extremely resistant to light, it rated I under ASTM testing as a watercolour. It is a heat sensitive pigment with many industrial uses in temperature indicating paints and crayons. A colour change takes place at a certain temperature. A solid, reliable pigment which will retain its colour in all normal use.

Our sample did not change in the slightest during exposure to light. A most reliable pigment.

L/FAST ASTM I

COMMON NAME
MANGANESE VIOLET

COLOUR INDEX NAME
PV16

COLOUR INDEX NUMBER
77742

CHEMICAL CLASS
MANGANESE AMMONIUM PYPROPHOSPHATE

QUINACRIDONE VIOLET

Quinacridone Violet is a bright, red - violet with many admirable qualities. Made up into both an oil paint and an acrylic, it rated ASTM I, absolutely lightfast. Without the protection of the binder it rated II as a watercolour. This is still an excellent rating. Transparent, it gives very clear washes. (An opaque version is available). As a watercolour it brushes well and has a useful range of values. An excellent red - violet.

PV19 is an ideal replacement for Crimson Alizarin. It is far more reliable, brighter, brushes out better and makes cleaner violets in mixes. Thoroughly recommended.

L/FAST ASTM II

COMMON NAME
QUINACRIDONE VIOLET

COLOUR INDEX NAME
PV19

COLOUR INDEX NUMBER
73900 (46500)

CHEMICAL CLASS
QUINACRIDONE B FORM

QUINACRIDONE RED

Quinacridone Y form is transparent, giving clear washes. (An opaque version is available). The Colour Index number was changed some years ago from 46500 to 73900. You might come across this earlier number as several manufacturers retain it. Not yet ASTM tested as a watercolour, but it rated I in both oils and acrylics. The Quinacridones are a little more expensive than the Naphthol pigments but more reliable. Vastly superior to Alizarin.

There is every indication that this colorant will be very reliable. Pending further testing it will be rated II for this book.

DIOXAZINE PURPLE

Dioxazine Purple is available in two distinct versions. PV23RS (Red Shade) and PV23BS (Blue Shade). The distinction is important as there is a definite lightfastness difference between the two. The Red Shade being more lightfast than the Blue Shade. The results of ASTM lightfast testing give a good indication of the protection offered by certain binders. The Red Shade tested I in oil, II in acrylic and IV in watercolour.

The Red Shade rated ASTM IV which is most unreliable, the Blue Shade is even worse.

CRYSTAL VIOLET

This is a disastrous substance, which to my mind has no place at all amongst artists' watercolours. As a thin wash it will start to fade dramatically. In mass tone it will darken and discolour. The failings of this pigment are not a secret and will (or should) be known by every manufacturer using it. It starts life as a bright blue - violet of good transparency. The parent dye is C.I. Basic Violet 3.

Our sample deteriorated as you see above, in a very short time. Not suitable for artistic expression.

GRAPHTOL VIOLET CI-4RL

A dull, reddish violet. Reasonably transparent, it gives quite clear tints when applied as a thin wash. Takes on a blackish appearance when applied heavily. At the time of writing, this pigment has not been tested under ASTM procedures. However, it does have a good reputation for lightfastness. As our sample only changed by the slightest degree during exposure, I will give it a provisional rating of II for the purpose of this publication.

On reputation and the performance of our sample I would suggest that this pigment be regarded as reliable pending further testing.

L/FAST W/GUIDE II

COMMON NAME

GRAPHTOL VIOLET CI-4RL

COLOUR INDEX NAME
PV46
COLOUR INDEX NUMBER
N.A.
CHEMICAL CLASS
ANTHRAQUINONE. A VAT PIGMENT

COBALT AMMONIUM VIOLET PHOSPHATE

A reddish - violet related to PV14 Cobalt Violet. Some care should be taken when using as the pigment contains soluble cobalt. Semi-opaque. Gives a limited range of values, more useful when applied thinly. Poor resistance to acid and alkali, another reason to use neutral Ph watercolour paper. No test results are available.

Based on our own testing rated WG II pending further trials.

L/FAST W/GUIDE II

COMMON NAME

COBALT AMMONIUM VIOLET PHOSPHATE

COLOUR INDEX NAME
PV49
COLOUR INDEX NUMBER
77362
CHEMICAL CLASS
INORGANIC. METAL SALT

The following pigment was recently introduced. Further research is required.

QUINACRIDONE MAROON B
Colour Index Name PV 42
Colour Index Number - not applicable. Chemical Class 'Indigoid: Quinacridone
A dull, transparent, reddish violet. Not yet subjected to ASTM testing in any art media. However, it does have a good reputation for lightfastness in other areas. Pending further testing I will rate it as WG II for this edition.
Lightfast Category WG II

VIOLET WATERCOLOURS

VIOLET WATERCOLOURS INTRODUCED SINCE THE LAST EDITION OF THIS BOOK.

COBALT VIOLET LIGHT HUE (911)

SENNELIER

A paint which gave very smooth, even washes. Unfortunatly it is let down by the inclusion of the less than reliable PR122.

EXTRA-FINE ARTISTS' WATER COLOURS

PR122 QUINACRIDONE MAGENTA (P. 92)
PV16 MANGANESE VIOLET (P. 130)
PW6 TITANIUM WHITE (P. 271)

HEALTH	ASTM	RATING
✗ INFO	III L'FAST	★★

COBALT VIOLET DEEP HUE 913

SENNELIER

An absolutely lightfast mid-violet. Semi-opaque in heavier applications. The sample washed out very well indeed. An excellent all round watercolour paint.

EXTRA-FINE ARTISTS' WATER COLOURS

PV16 MANGANESE VIOLET (P. 130)

HEALTH	ASTM	RATING
✗ INFO	I L'FAST	★★ ★★

PERMANENT MAGENTA 680

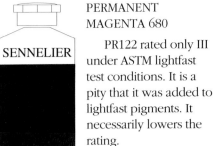

SENNELIER

PR122 rated only III under ASTM lightfast test conditions. It is a pity that it was added to lightfast pigments. It necessarily lowers the rating.

EXTRA-FINE ARTISTS' WATER COLOURS

PV19 QUINACRIDONE VIOLET (P. 130)
PR122 QUINACRIDONE MAGENTA (P. 92)
PW21 BLANK FIXE (P.272)

HEALTH	ASTM	RATING
✗ INFO	III L'FAST	★★

PERMANENT MAGENTA 262

DA VINCI PAINTS

Superb ingredients giving a first rate all-round watercolour paint. Very dark at full strength, it washes out to give a range of very subtle tints.

PERMANENT ARTISTS' WATER COLOR

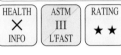
PB29 ULTRAMARINE BLUE (P. 149)
PV19 QUINACRIDONE VIOLET (P. 130)

HEALTH	ASTM	RATING
✓ INFO	II L'FAST	★★ ★★

MAUVE 256

DA VINCI PAINTS

A blue-violet which handles well. Very clear washes are available over a wide range of values. A 'clean' colour produced from excellent pigments.

PERMANENT ARTISTS' WATER COLOR

PV19 QUINACRIDONE VIOLET (P. 130)
PB29 ULTRAMARINE BLUE (P. 149)

HEALTH	ASTM	RATING
✓ INFO	II L'FAST	★★ ★★

BLUE VIOLET 903

SENNELIER

This is not a new colour as such. It is listed here as details were not provided for the earlier edition. A paint which washed out extremely well but will tend to darken on exposure to light.

EXTRA-FINE ARTISTS' WATER COLOURS

PV39 CRYSTAL VIOLET (P. 131)

HEALTH	WG	RATING
✗ INFO	V L'FAST	★

THIOINDIGO VIOLET 280

DA VINCI PAINTS

A reddish-violet which washes out very smoothly. Excellent pigments giving a reliable, well produced colour.

PERMANENT ARTISTS' WATER COLOR

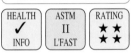
PV19 QUINACRIDONE VIOLET (P. 130)
PR88 THIOINDIGOID VIOLET (P. 88)

HEALTH	WG	RATING
✓ INFO	II L'FAST	★★ ★★

MANGANESE VIOLET 254

DA VINCI PAINTS

A well produced mid-violet. Semi-opaque with good covering power. Handles well over a wide range of values. Absolutely lightfast.

PERMANENT ARTISTS' WATER COLOR

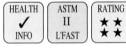
PV16 MANGANESE VIOLET (P. 130)

HEALTH	ASTM	RATING
✓ INFO	I L'FAST	★★ ★★

OLD VIOLET 478

SCHMINCKE

The pigment has not been tested under ASTM conditions in any art media. I have insufficient information from other tests to offer assessments. Claimed to be lightfast.

HORADAM FINEST ARTISTS' WATER COLOURS

PR257 COMMON NAME N/K (P. 99)

HEALTH
✗ INFO

VIOLET 498

SCHMINCKE

Several manufacturers dispute the ASTM rating of IV. Our own tests tended to support the low rating. It might be that the version used here is more reliable. Pending further testing I have to give a low rating.

HORADAM FINEST ARTISTS' WATER COLOURS

PV23 DIOXAZINE PURPLE (P. 131)

HEALTH	ASTM	RATING
✗ INFO	IV L'FAST	★

QUINACRIDONE VIOLET 499

SCHMINCKE

PV19 is a superb, all round pigment. Strong, transparent and bright. It is encouraging to see the use of this pigment becoming more widespread. This is an excellent watercolour.

HORADAM FINEST ARTISTS' WATER COLOURS

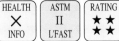
PV19 QUINACRIDONE VIOLET (P. 130)

HEALTH	ASTM	RATING
✗ INFO	II L'FAST	★★ ★★

MANGANESE VIOLET 908

SCHMINCKE

A semi-transparent violet which handles very well over a range of washes. The sample was slightly over bound. Very reliable ingredients.

HORADAM FINEST ARTISTS' WATER COLOURS

PV16 MANGANESE VIOLET (P. 130)

HEALTH	ASTM	RATING
✗ INFO	I L'FAST	★★ ★★

4.1 Cobalt Violet

Every time that I have used Cobalt Violet I have found it difficult to handle.

Having now had the opportunity to examine a wide range, covering all of the major brands, I have come to the conclusion that PV 14, Cobalt Violet, makes a very poor watercolour pigment. It appears to have little body and makes up into a very gummy paint.

The paint is so overbound due to the nature of the pigment that it is a little like trying to work with a thick coloured gum. Very thin washes are fine but heavier applications are very difficult. Absolutley lightfast with an ASTM rating of I as a watercolour. Cobalt Violet has been in use since the early 1800's. In hue is usually a reddish violet. Mixing complementary a green-yellow. Depending on the actual colour that you are working with, a Lemon Yellow is often a close partner.

OLD HOLLAND — CLASSIC WATERCOLOURS

COBALT VIOLET LIGHT 415

Sample was particularly gummy. Impossible to use unless as an extremely thin wash. Lightfast. Transparent.

PV14 COBALT VIOLET (P. 129)

HEALTH	ASTM	RATING
✕ INFO	I L'FAST	★★

HOLBEIN — ARTISTS' WATER COLOR

COBALT VIOLET LIGHT 680

Reliable as far as resistance to light is concerned but difficult to use unless applied very thinly. Transparent.

PV14 COBALT VIOLET (P. 129)

HEALTH	ASTM	RATING
✕ INFO	I L'FAST	★★

SENNELIER — EXTRA-FINE ARTISTS' WATER COLOURS

COBALT VIOLET PALE GENUINE 907

Seems a misleading name to sell Manganese Violet under. Brushes out well over a good range of values. Semiopaque. *This colour has now been discontinued.*

PV16 MANGANESE VIOLET (P. 130)

HEALTH	ASTM	RATING
✕ INFO	I L'FAST	★★

PÉBÉO — FRAGONARD ARTISTS' WATER COLOUR

COBALT VIOLET 338

Suffers the usual problem of Cobalt Violet watercolours, weak, gummy and difficult to use. Transparent.

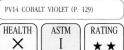
PV14 COBALT VIOLET (P. 129)

HEALTH	ASTM	RATING
✕ INFO	I L'FAST	★★

MAIMERI — ARTISTI EXTRA-FINE WATERCOLOURS

COBALT VIOLET 550

The name is misleading and does not represent the ingredients. Good range of values. Brushes out well. Transparent.

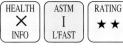
PB28 COBALT BLUE (P. 148)
PV19 QUINACRIDONE RED (P. 131)

HEALTH	WG	RATING
✕ INFO	II L'FAST	★ ★★

WINSOR & NEWTON — ARTISTS' WATER COLOUR

COBALT VIOLET 192 (088)

Sample particularly gummy. A weak paint which was unpleasant to use. Thin washes only. Transparent.

PV14 COBALT VIOLET (P. 129)
PB28 COBALT BLUE (P. 148)

HEALTH	ASTM	RATING
✕ INFO	I L'FAST	★★

TALENS — REMBRANDT ARTISTS' WATER COLOUR

COBALT VIOLET 539

According to the stated ingredients, should be lightfast. Our sample faded and discoloured. No assessment offered. Transparent.

PV14 COBALT VIOLET (P. 129)

HEALTH
✕ INFO

BINNEY & SMITH — PROFESSIONAL ARTISTS' WATER COLOR

COBALT VIOLET 172

Lacks body, gives poor washes unless thin. Unpleasant to use. A typical Cobalt Violet watercolour. Transparent.

PV14 COBALT VIOLET (P. 129)

HEALTH	ASTM	RATING
✓ INFO	I L'FAST	★★

MARTIN F.WEBER — PERMALBA ARTIST'S WATER COLOR AQUARELLE

COBALT VIOLET HUE 2081

The PV23 content will cause the colour to fade, especially as a tint. Rather pasty when applied heavily. Semitransparent.

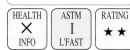
PV23 RS DIOXAZINE PURPLE (P. 131)
PW4 ZINC WHITE (P. 270)
PR122 QUINACRIDONE MAGENTA (P. 92)

HEALTH	ASTM	RATING
✓ INFO	IV L'FAST	★

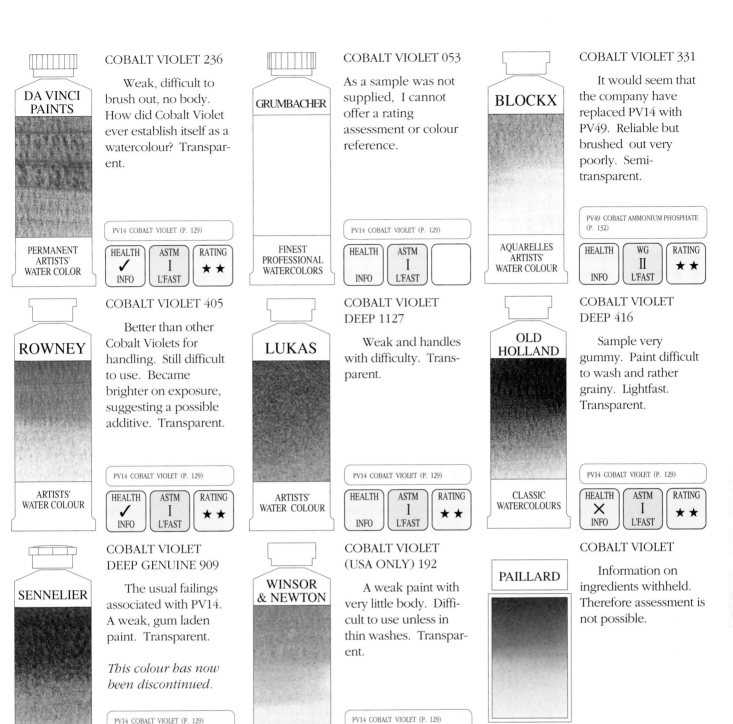

COBALT VIOLET 236

Weak, difficult to brush out, no body. How did Cobalt Violet ever establish itself as a watercolour? Transparent.

DA VINCI PAINTS

PERMANENT ARTISTS' WATER COLOR

PV14 COBALT VIOLET (P. 129)

HEALTH	ASTM	RATING
✓ INFO	I L'FAST	★ ★

COBALT VIOLET 053

As a sample was not supplied, I cannot offer a rating assessment or colour reference.

GRUMBACHER

FINEST PROFESSIONAL WATERCOLORS

PV14 COBALT VIOLET (P. 129)

HEALTH	ASTM	
INFO	I L'FAST	

COBALT VIOLET 331

It would seem that the company have replaced PV14 with PV49. Reliable but brushed out very poorly. Semi-transparent.

BLOCKX

AQUARELLES ARTISTS' WATER COLOUR

PV49 COBALT AMMONIUM PHOSPHATE (P. 132)

HEALTH	WG	RATING
INFO	II L'FAST	★ ★

COBALT VIOLET 405

Better than other Cobalt Violets for handling. Still difficult to use. Became brighter on exposure, suggesting a possible additive. Transparent.

ROWNEY

ARTISTS' WATER COLOUR

PV14 COBALT VIOLET (P. 129)

HEALTH	ASTM	RATING
✓ INFO	I L'FAST	★ ★

COBALT VIOLET DEEP 1127

Weak and handles with difficulty. Transparent.

LUKAS

ARTISTS' WATER COLOUR

PV14 COBALT VIOLET (P. 129)

HEALTH	ASTM	RATING
INFO	I L'FAST	★ ★

COBALT VIOLET DEEP 416

Sample very gummy. Paint difficult to wash and rather grainy. Lightfast. Transparent.

OLD HOLLAND

CLASSIC WATERCOLOURS

PV14 COBALT VIOLET (P. 129)

HEALTH	ASTM	RATING
✗ INFO	I L'FAST	★ ★

COBALT VIOLET DEEP GENUINE 909

The usual failings associated with PV14. A weak, gum laden paint. Transparent.

This colour has now been discontinued.

SENNELIER

EXTRA-FINE ARTISTS' WATER COLOURS

PV14 COBALT VIOLET (P. 129)

HEALTH	ASTM	RATING
✗ INFO	I L'FAST	★ ★

COBALT VIOLET (USA ONLY) 192

A weak paint with very little body. Difficult to use unless in thin washes. Transparent.

WINSOR & NEWTON

COTMAN WATER COLOUR 2ND RANGE

PV14 COBALT VIOLET (P. 129)

HEALTH	ASTM	RATING
✓ INFO	I L'FAST	★ ★

COBALT VIOLET

Information on ingredients withheld. Therefore assessment is not possible.

PAILLARD

LOUVRE AQUARELLE ARTISTS' COLOUR 2ND RANGE

HEALTH		
✗ INFO		

4.2 Miscellaneous Violets

I believe the wide range of violets that are available reflect the difficulty that most painters find in mixing this particular hue. These difficulties have come about because of the widespread belief in the 'Three Primary System'. It is a method of working which will always fail us. When the artist sets about mixing a violet with the belief that blue and red will combine to give the colour, chaos usually results.

My book 'Blue and Yellow Don't Make Green' could equally well be titled 'Blue and Red Don't Make Violet'.

When blue and red are mixed in equal intensity the two colours destroy each other, leaving the amount of violet that they each contain.

With basic colour mixing skills, a vast range of violets can be produced from just four colours. Two reds and two blues.

All but the very brightest can be produced on the palette.

Magenta

The term Magenta is widely used in the printing industry to describe the standard red used in the 'four colour' printing process.

Loosely used in relation to artists materials to describe a violet - red.

MAUVE 499

The use of PV39, will ensure that the tint will fade and the mass tone discolour. Transparent. *The name has recently been changed from 'Magenta' 490.*

PR122 QUINACRIDONE MAGENTA (P. 92)
PV39 CRYSTAL VIOLET (P. 131)
PV19 QUINACRIDONE VIOLET (P. 131)

SCHMINCKE
HORADAM FINEST ARTISTS' WATER COLOURS

HEALTH	WG	RATING
✗ INFO	V L'FAST	★

MAGENTA 232

An excellent pigment has been used to give a reliable watercolour which brushes out smoothly. Transparent.

PV19 QUINACRIDONE VIOLET (P. 131)

BLOCKX
AQUARELLES ARTISTS' WATER COLOUR

HEALTH	ASTM	RATING
✗ INFO	II L'FAST	★★ ★★

MAGENTA 1141

Fades rapidly as a tint and moves towards a dull, greyed, red - violet in mass tone. Semi-transparent.

PR5 NAPHTHOL ITR (P. 82)
PV23 BS DIOXAZINE PURPLE (P. 131)

LUKAS
ARTISTS' WATER COLOUR

HEALTH	WG	RATING
✗ INFO	III L'FAST	★★

PERMANENT MAGENTA (QUINACRIDONE) 489 (073)

PV19 is an excellent pigment worth looking out for. A reliable red - violet which handles very well. Transparent.

PV19 QUINACRIDONE VIOLET (P. 131)

WINSOR & NEWTON
ARTISTS' WATER COLOUR

HEALTH	ASTM	RATING
✗ INFO	II L'FAST	★★ ★★

PERMANENT MAGENTA 684

Brushes out very smoothly. Excellent pigment used. Bright, transparent and gives a wide range of values. Transparent.

PV19 QUINACRIDONE VIOLET (P. 131)

HOLBEIN
ARTISTS' WATER COLOR

HEALTH	ASTM	RATING
✗ INFO	II L'FAST	★★ ★★

PERMANENT MAGENTA 409

The BS (Blue Shade) of PV23 is even more unreliable than the RS (Red Shade). Will gradually deteriorate on exposure. Semi-transparent.

PV23 BS DIOXAZINE PURPLE (P. 131)
PR122 QUINACRIDONE MAGENTA (P. 92)

ROWNEY
ARTISTS' WATER COLOUR

HEALTH	ASTM	RATING
✓ INFO	V L'FAST	★

PERMANENT MAGENTA 2073

PR122 seems to vary in reliability depending on the pigment manufacturer. This example stood up reasonably well to our testing. Unreliable in the long term. Transparent.

PR122 QUINACRIDONE MAGENTA (P. 92)

MARTIN F.WEBER
PERMALBA ARTIST'S WATER COLOR AQUARELLE

HEALTH	ASTM	RATING
✓ INFO	III L'FAST	★★

PERMANENT MAGENTA 241

An excellent watercolour paint. The ingredients give a dependable red - violet which handles very well. Transparent.

PV19 QUINACRIDONE VIOLET (P. 131)

PÉBÉO
FRAGONARD ARTISTS' WATER COLOUR

HEALTH	ASTM	RATING
✗ INFO	II L'FAST	★★ ★★

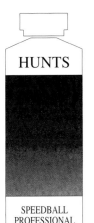

HUNTS

SPEEDBALL
PROFESSIONAL
WATERCOLOURS

**PERMANENT
MAGENTA 5725**

Exact information on ingredients not provided. No assessments offered.

LINEAR QUINACRIDONE PIGMENT

HEALTH		
✕		
INFO		

Magentas are usually a violet-red. When mixing, add Ultramarine (violet-blue) for a range of bright violets. Mixing complementary is a yellow green. Each will darken the other without destroying the character of their partner.

Mauves

The name was originally used for the colour discovered by William Perkin in 1856. Mauve was the first of many thousands of coal tar dyes, most of which proved particularly fugitive. The term is now used somewhat carelessly to describe violets varying from red to blue. Blue violets are the most common.

**WINSOR
& NEWTON**

ARTISTS'
WATER COLOUR

MAUVE 398 (030)

It would appear that the violet component is less than reliable. Sample quickly faded and discoloured. It became a green-blue due to the remaining PB15. Semi-transparent.

ALUMINA LAKE OF BASIC VIOLETS 1,10 AND 14.
PB15 PHTHALOCYANINE BLUE (P. 147)

HEALTH	WG	RATING
✕	V	★
INFO	L'FAST	

TALENS

REMBRANDT
ARTISTS'
WATER COLOUR

MAUVE 532

It is a pity that the unreliable PV23BS was added to the excellent PV19. Brushed out well. Semi-transparent.

PV23 BS DIOXAZINE PURPLE (P. 131)
PV19 QUINACRIDONE VIOLET (P. 131)

HEALTH	ASTM	RATING
✕	V	★
INFO	L'FAST	

**BINNEY
& SMITH**

PROFESSIONAL
ARTISTS'
WATER COLOR

MAUVE 186

Sample resisted light very well for some time but eventually faded. Handles well. Semi-transparent.

PV23 RS DIOXAZINE PURPLE (P. 131)

HEALTH	ASTM	RATING
✓	IV	★
INFO	L'FAST	

LUKAS

ARTISTS'
WATER COLOUR

MAUVE 1142

Our sample faded as a tint and moved towards blue in mass tone. Washed out smoothly. Semi-transparent.

PV23 RS DIOXAZINE PURPLE (P. 131)
PR5 NAPHTHOL ITR (P. 82)

HEALTH	ASTM	RATING
✕	IV	★
INFO	L'FAST	

ROWNEY

ARTISTS'
WATER COLOUR

PERMANENT MAUVE 413

As the ASTM rating suggests, the PV23 content will cause a gradual deterioration of the colour. Semi-transparent.

PV23 RS DIOXAZINE PURPLE (P. 131)
PR122 QUINACRIDONE MAGENTA (P. 92)

HEALTH	ASTM	RATING
✓	IV	★
INFO	L'FAST	

**WINSOR
& NEWTON**

ARTISTS'
WATER COLOUR

PERMANENT MAUVE 491 (074)

Absolutely lightfast. A rather weak colour but handles well. Does not give very clear washes when thin. Semi-opaque.

PV16 MANGANESE VIOLET (P. 130)

HEALTH	ASTM	RATING
✕	I	★★
INFO	L'FAST	

**WINSOR
& NEWTON**

COTMAN
WATER COLOUR
2ND RANGE

MAUVE 398 (326)

On exposure to light the colour moves from a bright red - violet to a very dull mid - violet. Most unreliable. Transparent.

PV2 VIVID MAGENTA (P. 128)
PB15 PHTHALOCYANINE BLUE (P. 147)

HEALTH	ASTM	RATING
✕	IV	★
INFO	L'FAST	

ROWNEY

GEORGIAN
WATER COLOUR
2ND RANGE

MAUVE 413

A sensitive colour which will quickly change from a bright violet, to a very pale grey - violet. Transparent.

PV3 METHYL VIOLET (P. 128)
PR81 RHODAMINE Y (P. 87)
PB15 PHTHALOCYANINE BLUE (P. 147)

HEALTH	WG	RATING
✓	V	★
INFO	L'FAST	

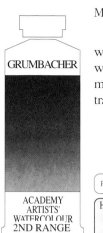

MAUVE 139

Will resist light quite well for some time but will eventually fade to a marked extent. Semi-transparent.

GRUMBACHER
ACADEMY ARTISTS' WATERCOLOUR 2ND RANGE

PV23 BS DIOXAZINE PURPLE (P. 131)

HEALTH	ASTM	RATING
✓ INFO	V L'FAST	★

Mauve is usually considered to be a blue - violet but red - violets are also sold under the title. The mixing complementary of a blue - violet is an orange - yellow such as Cadmium Yellow Light.

If you are working with a Mauve biased towards red, select a green- yellow (Lemon Yellow).

Purples

Whereas Mauves are usually blue - violets, Purples are generally red - violets.

Many are fugitive and all but the brightest can be duplicated on the palette, using reliable ingredients. The brighter manufactured colours tend to fade rapidly.

BRILLIANT PURPLE 1 907

SCHMINCKE
HORADAM FINEST ARTISTS' WATER COLOURS

The fugitive PV1, see page 128, previously added has been removed. The lightfast rating has improved from WGV. Use with caution. Transparent.

PR122 QUINACRIDONE MAGENTA (P. 92)
PREVIOUSLY ALSO PV1 (P. 128)

HEALTH	ASTM	RATING
✗ INFO	III L'FAST	★★

BRILLIANT PURPLE 2 908

SCHMINCKE
HORADAM FINEST ARTISTS' WATER COLOURS

Quickly spoils on exposure due to the use of the fugitive PV1. Most unreliable. Transparent.
This colour has now been discontinued.

PR48:4 PERMANENT RED 2B (P. 85)
PV1 RHODAMINE B (P. 128)

HEALTH	WG	RATING
✗ INFO	V L'FAST	★

CADMIUM RED PURPLE 611

SENNELIER
EXTRA-FINE ARTISTS' WATER COLOURS

The pigment selected gives a very reliable, dense water-colour. Unaffected by light or heat. An excellent product. Opaque.

PR108 CADMIUM RED LIGHT, MEDIUM OR DEEP (P. 91)

HEALTH	ASTM	RATING
✗ INFO	I L'FAST	★★ ★★

CADMIUM RED PURPLE 609

HOLBEIN
ARTISTS' WATER COLOR

An excellent pigment giving a superb watercolour. Strong enough to give reasonably transparent washes. Opaque.

PR108 CADMIUM RED LIGHT, MEDIUM OR DEEP (P. 91)

HEALTH	ASTM	RATING
✗ INFO	I L'FAST	★★ ★★

CADMIUM PURPLE 325

BLOCKX
AQUARELLES ARTISTS' WATER COLOUR

It is always worth seeking out paints produced with such excellent pigments. Brushes out beautifully. Opaque.

PR108 CADMIUM RED LIGHT, MEDIUM OR DEEP (P. 91)

HEALTH	ASTM	RATING
✗ INFO	I L'FAST	★★ ★★

PURPLE LAKE 544 (038)

WINSOR & NEWTON
ARTISTS' WATER COLOUR

Rapidly disintegrates on exposure to light. Thin tints disappear. Becomes discoloured in heavier applications. Most unreliable. Transparent.

PR83:1 ALIZARIN CRIMSON (P. 88)
PV23 BS DIOXAZINE PURPLE (P. 131)

HEALTH	ASTM	RATING
✗ INFO	IV L'FAST	★

PURPLE LAKE 437

ROWNEY
ARTISTS' WATER COLOUR

Why add an inferior substance such as PR83:1 to an excellent pigment like PV19? Fades and discolours. Transparent.

PR83:1 ALIZARIN CRIMSON (P. 88)
PV19 QUINACRIDONE VIOLET (P. 130)

HEALTH	ASTM	RATING
✓ INFO	IV L'FAST	★

QUINACRIDONE PURPLE 671

SENNELIER
EXTRA-FINE ARTISTS' WATER COLOURS

Sample resisted light very well for some time but eventually gave in. Treat with caution. Transparent.
The name has recently been changed from 'Helios Purple'.

PR122 QUINACRIDONE MAGENTA (P. 92)

HEALTH	ASTM	RATING
✗ INFO	III L'FAST	★★

PURPLE MADDER (ALIZARIN) 439

ROWNEY

That this water-colour will move to-wards a dull blackish - red is predictable. The red fades, the black stays. Semi-opaque.

PR83:1 ALIZARIN CRIMSON (P. 88)
PBk6 LAMP BLACK (P. 256)

ARTISTS' WATER COLOUR

HEALTH	ASTM	RATING
✓ INFO	IV L'FAST	★

PURPLE MADDER (ALIZARIN) 546 (039)

WINSOR & NEWTON

PR83:1 Alizarin Crimson is very versa-tile. It is able to fade rapidly whatever it is mixed with. Transpar-ent.

PV23 RS DIOXAZINE PURPLE (P. 131)
PR83:1 ALIZARIN CRIMSON (P. 88)

ARTISTS' WATER COLOUR

HEALTH	ASTM	RATING
✕ INFO	IV L'FAST	★

PURPLE VIOLET 493

SCHMINCKE

PR202 has a particu-larly good reputaion for lightfastness. The sample provided gave very clear, easily managed washes. A first class watercolour paint.

PR202 QUINACRIDONE MAGENTA (P.99)
PREVIOUSLY PR81 (P. 87) & PV1(P. 128)

HORADAM FINEST ARTISTS' WATER COLOURS

HEALTH	WG	RATING
✕ INFO	II L'FAST	★★ ★★

THALO PURPLE 206

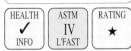

GRUMBACHER

The inclusion of the unreliable PV23BS will cause the colour to spoil on exposure. Semi-transparent.

PV23 BS DIOXAZINE PURPLE (P. 131)
PV15 ULTRAMARINE VIOLET (P. 130)

FINEST PROFESSIONAL WATERCOLORS

HEALTH	ASTM	RATING
✕ INFO	V L'FAST	★

PURPLE 433

ROWNEY

A rather beautiful, bright red - violet which becomes a very pale, discoloured, red - grey on exposure to light. Transparent.

PR81 RHODAMINE Y (P. 87)
PB15 PHTHALOCYANINE BLUE (P. 147)

GEORGIAN WATER COLOUR 2ND RANGE

HEALTH	WG	RATING
✓ INFO	V L'FAST	★

PURPLE 542

REEVES

Suitable for tempo-rary work only. The colour is certainly tem-porary, unless kept in the dark. Fades and discolours. Transpar-ent. *This range has been discontinued.*

PV2 VIVID MAGENTA (P. 128)
PB15 PHTHALOCYANINE BLUE (P. 147)

WATER COLOUR FOR ARTISTS 2ND RANGE

HEALTH	ASTM	RATING
✕ INFO	IV L'FAST	★

PURPLE LAKE 544 (329)

WINSOR & NEWTON

The use of PV2 guarantees fading and severe discoloration on exposure to light. Temporary work only. Transparent.

PV2 VIVID MAGENTA (P. 128)
PB15 PHTHALOCYANINE BLUE (P. 147)

COTMAN WATER COLOUR 2ND RANGE

HEALTH	ASTM	RATING
✕ INFO	IV L'FAST	★

Purple is a red - violet. Its mixing complementary is yellow - green. Violets, in the next section, will vary from red to blue in bias. When selecting for any of them, first decide on the leaning of the colour, place it into the palette and look directly opposite for its mixing partner.

Violets

The term violet is used to describe any pigment or combination of pigments giving either a red, blue or mid - violet colour. All are easily duplicated apart from the very brightest. These invariably fade anyway.

ACRA VIOLET 114

BINNEY & SMITH

A dull red - violet which will fade on prolonged exposure to light. Use with caution. Transparent.

PR122 QUINACRIDONE MAGENTA (P. 92)

PROFESSIONAL ARTISTS' WATER COLOR

HEALTH	ASTM	RATING
✓ INFO	III L'FAST	★★

ALIZARINE VIOLET LAKE 940

SENNELIER

PV5:1 is a most unfortunate substance to use in an artist's watercolour. Fades as a wash and severely dis-colours in mass tone. Transparent.

PV5:1 ALIZARINE MAROON (P. 129)

EXTRA-FINE ARTISTS' WATER COLOURS

HEALTH	WG	RATING
✕ INFO	IV L'FAST	★

BAYEUX VIOLET 603

LEFRANC & BOURGEOIS

Reliable red - violets do exist and the pigments are easily obtainable. This is an excellent all round watercolour. Semi-opaque.

LINEL EXTRA-FINE ARTISTS' WATERCOLOUR

PV46 GRAPHTOL VIOLET CI-4RL (P. 132)

HEALTH	WG	RATING
✓ INFO	II L'FAST	★★

BRILLIANT VIOLET 1 909

SCHMINCKE

Once a disastrous colour due to inferior ingredients. Now re-formulated to give a superb, lightfast paint. Transparent

PV15 ULTRA. RED/VIOLET (P.130)
PV16 MANGANESE VIOLET (P. 130)
WAS PREVIOUSLY PV39 (P. 131) - PR122 (P. 92) AND PV19 (P. 130)

HORADAM FINEST ARTISTS' WATER COLOURS

HEALTH	ASTM	RATING
✗ INFO	I L'FAST	★★

BRILLIANT VIOLET 2 910

SCHMINCKE

Exposure to light will cause the tint to fade and heavier applications to discolour dramatically. A temporary brilliance. Transparent. *Colour now discontinued.*

PV39 CRYSTAL VIOLET (P. 131)

HORADAM FINEST ARTISTS' WATER COLOURS

HEALTH	WG	RATING
✗ INFO	V L'FAST	★

EGYPT VIOLET 610

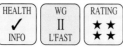

LEFRANC & BOURGEOIS

PV 23 RS takes light very well for some time but then fades rather quickly. A well produced paint which washes out very smoothly. Semi-transparent.

LINEL EXTRA-FINE ARTISTS' WATERCOLOUR

PV23RS DIOXAZINE PURPLE (P. 131)

HEALTH	ASTM	RATING
✗ INFO	IV L'FAST	★

GLOWING VIOLET 497

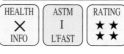

SCHMINCKE

A very much improved colour. Once fugitive, now re-formulated into a superb, lightfast paint. Check pgts. if purchasing. Transparent.

PV15 ULTRA RED/VIOLET (P. 130)
PV16 MANGANESE VIOLET (P.130)
PREVIOUSLY PV23 BS (P. 131) - PV39 (P. 131) AND PB1 (P. 147)

HORADAM FINEST ARTISTS' WATER COLOURS

HEALTH	ASTM	RATING
✗ INFO	I L'FAST	★★

MARS VIOLET 683

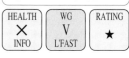

HOLBEIN

The unspecified Pigment Brown 7 and Pigment Red 101 will be reliable. Unfortunately the Pigment Violet 23 will cause a loss of colour.

PBr7
PR101
PV23 DIOXAZINE PURPLE (P. 131)

ARTISTS' WATER COLOR

HEALTH	ASTM	RATING
✗ INFO	V L'FAST	★

MINERAL VIOLET 682

HOLBEIN

Particularly light-fast. Flows very well in a wash. Fairly opaque, with low tinting strength. Semi-opaque.

ARTISTS' WATER COLOR

PV15 ULTRAMARINE VIOLET (P. 130)

HEALTH	ASTM	RATING
✗ INFO	I L'FAST	★★

MANGANESE VIOLET 915

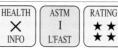

SENNELIER

PV16 is particularly resistant to light. The sample handled well. Thin washes are less than transparent. Semi-opaque. Name recently changed from 'Mineral Violet'.

EXTRA-FINE ARTISTS' WATER COLOURS

PV16 MANGANESE VIOLET (P. 130)

HEALTH	ASTM	RATING
✗ INFO	I L'FAST	★★

PERMANENT VIOLET 248

PÉBÉO

Pigment Violet 23 fades quickly after initially resisting light quite well. A smooth watercolour which handles well. Semi-transparent.

FRAGONARD ARTISTS' WATER COLOUR

PV23 RS DIOXAZINE PURPLE (P. 131)

HEALTH	ASTM	RATING
✗ INFO	IV L'FAST	★

PERMANENT VIOLET 2058

MARTIN F. WEBER

It is a pity that Pigment Violet 23 is so unreliable. It is a strong colour which handles well. On exposure will tend to fade, especially as a tint. Semi-transparent.

PERMALBA ARTIST'S WATER COLOR AQUARELLE

PV23 RS DIOXAZINE PURPLE (P. 131)

HEALTH	ASTM	RATING
✓ INFO	IV L'FAST	★

PERMANENT VIOLET 631

LEFRANC & BOURGEOIS

On exposure, will tend to fade as a tint and discolour slightly in heavier applications. Brushed out well over the full range of values.

PR122 QUINACRIDONE MAGENTA (P. 92)

LINEL EXTRA-FINE ARTISTS' WATERCOLOUR

HEALTH	ASTM	RATING
✓ INFO	III L'FAST	★★

PERMANENT VIOLET 483

SCHMINCKE

Not particularly well named. Fades and discolours readily on exposure. Unsuitable for artistic use. Transparent.

PV23 BS DIOXAZINE PURPLE (P. 131)
PV1 RHODAMINE B (P. 128)

HORADAM FINEST ARTISTS' WATER COLOURS

HEALTH	WG	RATING
✗ INFO	V L'FAST	★

HOLBEIN

ARTISTS' WATER COLOR

PERMANENT VIOLET 685

Will gradually deteriorate on exposure to light, particularly when applied as a thin wash. Handles very well over the full range. Semi-transparent.

PV23 DIOXAZINE PURPLE (P. 131)
PW27 SILICA (P. 272)

HEALTH	ASTM	RATING
✕ INFO	V L'FAST	★

MAIMERI

ARTISTI EXTRA-FINE WATERCOLOURS

QUINACRIDONE VIOLET 559

PR 122 takes the light very well initially but will eventually fade. Use with caution and keep any work in a soft light. Handles very well.

PR122 QUINACRIDONE MAGENTA (P. 92)

HEALTH	ASTM	RATING
✕ INFO	III L'FAST	★★

SENNELIER

EXTRA-FINE ARTISTS' WATER COLOURS

RED VIOLET 905

Very heavy applications turn to a pale dull red, medium and light washes go grey and then vanish altogether. Disastrous. Transparent.

PV1 RHODAMINE B (P. 128)
PV3 METHYL VIOLET (P. 128)

HEALTH	WG	RATING
✕ INFO	V L'FAST	★

HUNTS

SPEEDBALL PROFESSIONAL WATERCOLOURS

SPEEDBALL VIOLET (DIOXAZINE) 5715

Without exact details on the pigment used I cannot offer any advice on lightfastness or a rating.

DIOXAZINE PIGMENT

HEALTH		
✕ INFO		

GRUMBACHER

FINEST PROFESSIONAL WATERCOLORS

THIO VIOLET 211

Transparent, reasonably bright, good range of values and resistant to light. A reliable and well produced watercolour.

PR88 MRS THIOINDIGOID VIOLET (P. 88)

HEALTH	WG	RATING
✕ INFO	II L'FAST	★★ ★★

SCHMINCKE

HORADAM FINEST ARTISTS' WATER COLOURS

ULTRAMARINE VIOLET 495

PV15 has a very strange odour which remains with the paint film. Absolutely lightfast. Difficult in heavier applications. Semi-opaque.

PV 15 ULTRAMARINE RED (P. 130)

HEALTH	ASTM	RATING
✕ INFO	I L'FAST	★ ★★

BLOCKX

AQUARELLES ARTISTS' WATER COLOUR

ULTRAMARINE VIOLET 234

Very close to Ultramarine in hue. Gives smooth washes over a useful range of values. Absolutely lightfast. Semi-opaque.

PV 15 ULTRAMARINE RED (P. 130)

HEALTH	ASTM	RATING
✕ INFO	I L'FAST	★★ ★★

BINNEY & SMITH

PROFESSIONAL ARTISTS' WATER COLOR

ULTRAMARINE VIOLET 388

Slightly 'chalky' in appearance and a little difficult to brush out unless thin. Reliable pigment used. Semi-opaque.

PV15 ULTRAMARINE VIOLET (P. 130)

HEALTH	ASTM	RATING
✓ INFO	I L'FAST	★ ★★

TALENS
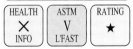

REMBRANDT ARTISTS' WATER COLOUR

VIOLET 536

Will fade after initially resisting the light. This is a pity as the colour is quite strong and the paint handles very well. Treat with caution. Semi-transparent.

PV23 BS DIOXAZINE PURPLE (P. 131)

HEALTH	ASTM	RATING
✕ INFO	V L'FAST	★

ROWNEY

ARTISTS' WATER COLOUR

VIOLET ALIZARIN 453

Washes out very well into a useful range of values. Unfortunately will tend to fade and change colour due to the PV 23 content.

PV23 RS DIOXAZINE PURPLE (P. 131)
PBk6 LAMP BLACK (P. 256)
PV19 QUINACRIDONE VIOLET (P. 130)

HEALTH	ASTM	RATING
✓ INFO	IV L'FAST	★

WINSOR & NEWTON

ARTISTS' WATER COLOUR

VIOLET CARMINE 690 (091)

It would appear that the lake of basic violets is unreliable. Our sample rapidly changed from a reasonably bright violet to a light, dull grey. Disastrous.

ALUMINA LAKE OF BASIC VIOLETS 1,10 AND 14.
PB15 PHTHALOCYANINE BLUE (P. 147)
PBk6 LAMP BLACK (P. 256)

HEALTH	WG	RATING
✕ INFO	V L'FAST	★

LEFRANC & BOURGEOIS

LINEL EXTRA-FINE ARTISTS' WATERCOLOUR

VIOLET EXTRA LIGHT 611

PV3 is a most unsuitable substance for use in the preparation of artists materials. Fades and discolours alarmingly. Transparent.

PV3 METHYL VIOLET (P. 128)

HEALTH	WG	RATING
✓ INFO	V L'FAST	★

VIOLET GREY 711

Reliable pigments. Rather chalky in appearance due to the use of the white. Handled reasonably well. Semi-opaque.

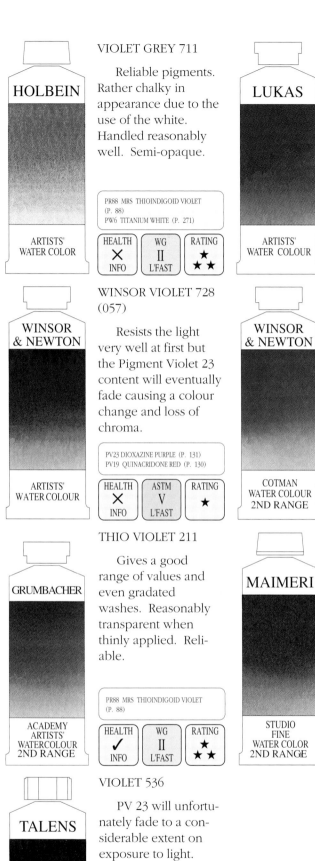

HOLBEIN

ARTISTS' WATER COLOR

PR88 MRS THIOINDIGOID VIOLET (P. 88)
PW6 TITANIUM WHITE (P. 271)

HEALTH	WG	RATING
✕ INFO	II L'FAST	★★

VIOLET LAKE 1128

On exposure will tend to gradually become paler and bluer as the PV 23 content fades. This will be most noticeable in thin washes. Brushed out quite well.

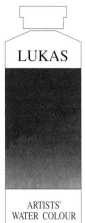

LUKAS

ARTISTS' WATER COLOUR

PV23 RS DIOXAZINE PURPLE (P. 131)
PB15 PHTHALOCYANINE BLUE (P. 147)

HEALTH	ASTM	RATING
✕ INFO	IV L'FAST	★

VIOLET LAKE 527

Washed out very smoothly over the full range. Unreliable due to the Pigment Violet 23 content. As the violet fades the colour will become bluer. Keep any work in soft light.

MAIMERI

ARTISTI EXTRA-FINE WATERCOLOURS

PB29 ULTRAMARINE BLUE (P. 149)
PV23 DIOXAZINE PURPLE (P. 131)

HEALTH	ASTM	RATING
✕ INFO	V L'FAST	★

WINSOR VIOLET 728 (057)

Resists the light very well at first but the Pigment Violet 23 content will eventually fade causing a colour change and loss of chroma.

WINSOR & NEWTON

ARTISTS' WATER COLOUR

PV23 DIOXAZINE PURPLE (P. 131)
PV19 QUINACRIDONE RED (P. 130)

HEALTH	ASTM	RATING
✕ INFO	V L'FAST	★

DIOXAZINE VIOLET 231

Washes out very smoothly. After initially resisting light quite well our sample faded. Use with caution and keep any work away from direct light. Semi-transparent.

WINSOR & NEWTON

COTMAN WATER COLOUR 2ND RANGE

PV23 RS DIOXAZINE PURPLE (P. 131)

HEALTH	ASTM	RATING
✕ INFO	IV L'FAST	★

RED VIOLET 545

It is a pity that the pigment is less than reliable as it would have made a useful violet - red. Thin washes in particular will tend to fade. *Range to be discontinued.*

TALENS

WATER COLOUR 2ND RANGE

PR122 QUINACRIDONE MAGENTA (P. 92)

HEALTH	ASTM	RATING
✕ INFO	III L'FAST	★★

THIO VIOLET 211

Gives a good range of values and even gradated washes. Reasonably transparent when thinly applied. Reliable.

GRUMBACHER

ACADEMY ARTISTS' WATERCOLOUR 2ND RANGE

PR88 MRS THIOINDIGOID VIOLET (P. 88)

HEALTH	WG	RATING
✓ INFO	II L'FAST	★★

VIOLET 630

Re-formulated, but without any real improvement to the lightfastness. The pigment is prone to fading. Semi-trans.

MAIMERI

STUDIO FINE WATER COLOR 2ND RANGE

PV23 DIOXAZINE PURPLE (P. 131)
PREVIOUSLY ALSO CONTAINED PV3 (P. 128) AND PR57:1 LGB -50 (P. 86)

HEALTH	WG	RATING
✕ INFO	IV L'FAST	★

VIOLET 229

Assessments cannot be given as a sample was not supplied.

GRUMBACHER

ACADEMY ARTISTS' WATERCOLOUR 2ND RANGE

PV23 BS DIOXAZINE PURPLE (P. 131)
PB15 PHTHALOCYANINE BLUE (P. 147)

HEALTH		
✕ INFO		

VIOLET 536

PV 23 will unfortunately fade to a considerable extent on exposure to light. Thinner washes are most susceptible to damage. Semi-transparent.

TALENS

WATER COLOUR 2ND RANGE

PV23 DIOXAZINE PURPLE (P. 131)

HEALTH	ASTM	RATING
✕ INFO	V L'FAST	★

ULTRAMARINE RED 1094

The pigment has a strong odour, almost like coal gas. This example lacked body and was rather chalky. Semi-opaque.

LUKAS

ARTISTS' WATER COLOUR

PV15 ULTRAMARINE VIOLET (P. 130)

HEALTH	ASTM	RATING
✕ INFO	I L'FAST	★★

BLUES

History of Blue Pigments

The modern artist is fortunate in having a good selection of bright and reliable blues. Until fairly recent times the painter had to make do with a restrictive range of blue pigments, which were often very costly.

Egyptian Blue Frit was probably the first artificial pigment ever produced. Used by the early Egyptians from about 3,000 BC it was made form a specially manufactured blue glass which was then ground into a powder. Azurite, prepared from a blue mineral was known and used in ancient Egypt, China and Japan, it became important in European art from the 15th to the middle of the 17th Century. The open, coarse particles were said to have sparkled like miniature sapphires.

Egyptian Blue Frit was a sophisticated pigment which required great skill in its production.

A wide variety of blue coloured petals have been used to produce bright but short lived dyes.

Genuine Ultramarine was produced from the semi-precious stone Lapis Lasuli. It was extremely expensive.

Extracting the colour from the stone was a long and laborious process and required considerable skill.

The French invention of an artificial Ultramarine was a major break-through in the history of artists' materials.

The medieval artist preferred to use Ultramarine over Azurite for the more important work, where it could be afforded.

Genuine Ultramarine, made by processing ground Lapis Lazuli, a semi precious stone, was the most expensive and treasured artists pigment from the middle ages to the 1800's. The invention of an artificial Ultramarine, and its production from 1830 was a major breakthrough.

Indigo, a deep violet blue was highly prized by artists and became a valuable article of commerce until it was replaced by a synthetic version around 1897.

The Indigo trade was of vital importance to the East India Company.

Vast amounts of the colorant was imported by Great Britain each year, prior to the introduction of a synthetic version.

The first artificially prepared pigment with a fully recorded history was Prussian Blue. Available after 1724, it became a very important artists' colour.

The introduction of Phthalocyanine Blue in recent times was welcomed by many as an alternative to Prussian Blue. Both are similar in hue and handling but the Phthalocyanine Blue did not tend to take on a bronze sheen as can Prussian Blue.

Bright, clean and very transparent, Cobalt Blue has, since its introduction become the standard blue of many artists.

Cerulean Blue, possessing a greater opacity than the other blues is favoured by many, both for its colour and hiding power. Fairly expensive, it is sometimes substituted by the relatively inferior Manganese Blue.

We now have a good range of reliable blue pigments at our disposal. Despite this we are still offered blues which will fade quickly and otherwise deteriorate. To add to the situation a range of meaningless, fancy names are employed to describe basic blues such as Phthalocyanine.

MODERN BLUE PIGMENTS

The following pigment was recently introduced by a manufacturer covered in this publication.

Insufficient notice was given concerning the use of this pigment to enable me to carry out further research or to provide an accurate colour sample.

PHTHALOCYANINE BLUE
Colour Index Name PB16

Colour Index Number - 74100. Chemical Class - Metal free Phthalocyanine.

Another pigment in the excellent Phthalocyanine range. Bright, strong and transparent. Not yet subjected to ASTM testing as a watercolour paint. However, it rated particularly well in other media. Category I in Acrylics and Oils. Pending further testing I will rate it as WG II for this edition.

Lightfast Category WG II

VICTORIA BLUE

PB1 has many applications in the printing industry. It is valued by printers for its high tinting strength, brightness and transparency. The fact that it has poor lightfastness is a secondary consideration. The blue used in, say, a weekly magazine or an advertising leaflet does not have to be particularly permanent. I feel that is quite a different matter with works of art. This bright violet blue is unsuitable for artistic use.

Our sample deteriorated rapidly, the tint faded and it became darker and duller in mass tone.

Also called Sicilian Blue.

PHTHALOCYANINE BLUE

A bright, powerful green - blue. Valued by artists for its transparency, it gives very clear washes well diluted. PB15 is divided into distinctive commercial types. PB15 : 1, PB15 : 2, PB15 : 3 etc. There is little difference between them in chemical make up and all are equally lighfast.
The colour varies slightly between them, some being greener than others. A powerful pigment, PB15 has to be handled with some care and will quickly influence most other colours in a mix.

Rated II as a watercolour following ASTM testing. An excellent all round pigment.

PHTHALOCYANINE BLUE

74200 is the Colour Index Number of the dye Direct Blue 87. The pigment produced from this dye is PB17. PB17 as such is used in the manufacture of a further pigment PB17:1. Our only reference of its use gives it as PB17 only. I do not have any test results to refer to. Its reputation places it as less lightfast than the other Phthalocyanines. As our sample faded somewhat, I will class it as WG III pending further testing.

Our sample faded on exposure and moved towards green in mass tone. Use with caution.

FUGITIVE PEACOCK BLUE

This pigment, without any doubt, takes my vote as the most unsuitable substance for artistic use that I have ever come across. The colour leaves the tube or pan as a very bright greenish blue. Within a short time it turns a green-grey and then gradually disappears altogether. Has certain industrial applications where its low cost overcomes its inherent weaknesses. Reasonably transparent, but this factor quickly becomes irrelevant. Parent dye is Acid Blue 9.

It would be cheaper to leave the paper white.

L/FAST W/GUIDE V

COMMON NAME
FUGITIVE PEACOCK BLUE

COLOUR INDEX NAME
PB24
COLOUR INDEX NUMBER
42090 : 1
CHEMICAL CLASS
**TRIPHENYLMETHANE.
BARIUM SALT**

Also called Erioglaucine Lake.

PRUSSIAN BLUE

Available since the early 1700's it has been an important pigment. A bright, transparent and very powerful green - blue. Several variations, (PB27 :1 etc) are available, they vary slightly in hue and strength. Rated as ASTM I as a watercolour. This is a pigment with a varied history, being alternatively praised and condemned. It has been reported to darken under certain conditions. Applied heavily, it tends to bronze over, which can be disconcerting.

Bronzing (a metallic sheen) can be a problem. Phthalocyanine Blue is preferred by many artists. Similar in hue, transparency strength and price, but less controversial.

L/FAST ASTM I

COMMON NAME
PRUSSIAN BLUE

COLOUR INDEX NAME
PB27
COLOUR INDEX NUMBER
77510
CHEMICAL CLASS
**FERRI - AMMONIUM
FERROCYANIDE**

Several alternative names.

COBALT BLUE

Absolutely lightfast, with an ASTM rating of I in watercolour. Often erroneously described as a pure 'primary ' blue. It does in fact reflect a certain amount of green and violet as well as blue. The hue usually leans more towards green. Low in tinting strength with moderate covering power. Reasonably transparent. In use since the early 1800's, it has become the standard blue of many a palette. No substitute can rival the true pigment.

A thoroughly reliable pigment with an excellent range of qualities. It might be a little expensive but well worth the money.

L/FAST ASTM I

COMMON NAME
COBALT BLUE

COLOUR INDEX NAME
PB28
COLOUR INDEX NUMBER
77346
CHEMICAL CLASS
**OXIDES OF COBALT AND
ALUMINUM**

ULTRAMARINE BLUE

An excellent all round pigment. Absolutely lightfast, ASTM I as a watercolour. Possesses a high tinting strength with moderate covering power. Valued for its transparency, it gives very clear washes. In hue it leans towards violet. It is in fact the only violet blue really worth considering. Fast to alkali but very easily damaged by even weak acids. (Acid resistant versions are available). Manufactured since 1830, it has more than proven its worth.

A superb pigment, lightfast, transparent and with a useful range of values. An invaluable violet - blue.

MANGANESE BLUE

A moderately transparent greenish blue. Possessing reasonably high tinting strength, it will quickly affect certain other colours in a mix. Manganese Blue is often seen as a cheaper alternative to Cerulean Blue. It is similar in hue, although normally a little greener. However, it does not have the body of Cerulean. Modern Manganese Blue watercolours invariably have a gummy texture, Chemically inert, it is resistant to light, heat, acids and alkalis.

As a watercolour it has been given a rating of I following ASTM controlled lightfast testing. Absolutely lightfast.

Also called Cement Blue.

CERULEAN BLUE

An 'atmospheric' greenish - blue, valued by the landscape painter. It possesses a greater opacity than other blues, which gives it very good covering power. Although dark blues will cover well, they rely on their depth of colour rather than their 'body'. Tends to 'settle' out into pockets of colour in a wash. Low in tinting strength. In use since the early 1800's. The name is derived from the Latin 'Caeruleum' meaning 'sky blue pigment'.

Absolutely lightfast, with an ASTM rating of I as a watercolour. Cheaper imitations are easily duplicated on the palette and are no match for the genuine article.

CERULEAN BLUE, CHROMIUM

A close cousin of Cerulean Blue. The chemical make up varies from oxides of Cobalt and Tin in Cerulean Blue, to Oxides of Cobalt and Chromium in this pigment. Generally rather brighter than PB35, it is similar in hue, being a blue with a definite bias towards green. Being particularly opaque it has very good covering power. This can be very useful when areas of work have to be covered by a relatively thin layer of paint.

Absolutely lightfast, it gained an ASTM rating of I during lightfast testing as a watercolour. A most reliable pigment with many useful qualities.

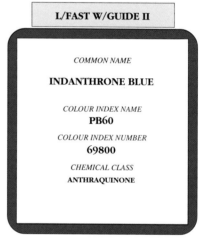

L/FAST ASTM I

COMMON NAME

CERULEAN BLUE, CHROMIUM

COLOUR INDEX NAME

PB36

COLOUR INDEX NUMBER

77343

CHEMICAL CLASS

OXIDES OF COBALT AND CHROMIUM

INDANTHRONE BLUE

Indanthrone Blue is a slightly dull blue, leaning a little towards violet. Semi-opaque, it has poor covering power unless applied rather heavily. When washed out into a tint it is lower in chroma (colour) than other blues in this hue range. PB60 rated as ASTM I as both an oil and an acrylic. Without the protection offered by the binder it might not rate as highly in watercolours. Parent dye is Vat Blue 4.

Excellent results in both oils and acrylics, plus a good reputation for lightfastness. Pending further testing, rated II for the purposes of this book.

L/FAST W/GUIDE II

COMMON NAME

INDANTHRONE BLUE

COLOUR INDEX NAME

PB60

COLOUR INDEX NUMBER

69800

CHEMICAL CLASS

ANTHRAQUINONE

Also called Anthraquinoid Blue.

INDIGO BLUE

Genuine Indigo, now obsolete in artists' paints, has a long and varied history. A valuable article of commerce, it played an important part in the history of the East India Company. The importation into Europe virtually ceased after 1897 on the introduction of a synthetic version. Modern Indigo has a poor reputation for lightfastness. A dull blackish blue, reasonably transparent. Not yet tested under ASTM conditions as a watercolour.

Within a short time our sample had deteriorated badly, fading in all values. An unreliable pigment.

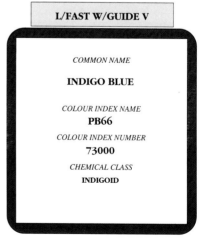

L/FAST W/GUIDE V

COMMON NAME

INDIGO BLUE

COLOUR INDEX NAME

PB66

COLOUR INDEX NUMBER

73000

CHEMICAL CLASS

INDIGOID

Also called CI Vat Blue 1 Dye.

BLUE
WATERCOLOURS

BLUE WATERCOLOURS

5.1 Cerulean Blue

A clean, bright, strong green - blue. As with other pigments produced at high temperature it possesses a high degree of fastness to light.

Cerulean Blue has greater opacity than other blues. Although dark blues will cover well, they rely on their depth of colour rather than their 'body'.

Imitations do not compare in hue, handling or value for money.

For mixing purposes treat as a green - blue. Complementary is a red - orange.

CERULEAN BLUE 164

Genuine ingredients make into an excellent paint. Washes out well into useful range of values. Low in tinting strength. Opaque.

BINNEY & SMITH

PROFESSIONAL ARTISTS' WATER COLOR

PB35 CERULEAN BLUE (P. 149)

HEALTH	ASTM	RATING
✓ INFO	I L'FAST	★ ★ ★ ★

CERULEAN BLUE HUE 481

Recently re-named. the word 'Hue' has been added to indicate that the colour is an imitation 'Cerulean Blue'. Reliable ingredients. Semi-opaque.

SCHMINCKE

HORADAM FINEST ARTISTS' WATER COLOURS

PW4 ZINC WHITE (P. 270)
PB15:3 PHTHALO BLUE (P. 147)

HEALTH	ASTM	RATING
✗ INFO	II L'FAST	★ ★

CERULEAN BLUE 617

First class ingredients give a watercolour which washes out well and is absolutely dependable. Opaque.

HOLBEIN

ARTISTS' WATER COLOR

PB35 CERULEAN BLUE (P. 149)

HEALTH	ASTM	RATING
✗ INFO	I L'FAST	★ ★

CERULEAN BLUE 421

Quality ingredients make into a very reliable green - blue. Gave good, even washes. Opaque.

OLD HOLLAND

CLASSIC WATERCOLOURS

PB36 CERULEAN BLUE,CHROMIUM (P. 150)

HEALTH	ASTM	RATING
✗ INFO	I L'FAST	★ ★ ★ ★

COERULEUM 111

A smooth, well produced watercolour. Genuine ingredients have been used to provide a first class product. Opaque.

ROWNEY

ARTISTS' WATER COLOUR

PB35 CERULEAN BLUE (P. 149)

HEALTH	ASTM	RATING
✓ INFO	I L'FAST	★ ★

CERULEAN BLUE 351

Brighter than most Cerulean Blues. Sample gave particularly smooth, even washes over the full range. Absolutely lightfast. Opaque.

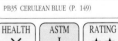

BLOCKX

AQUARELLES ARTISTS' WATER COLOUR

PB35 CERULEAN BLUE (P. 149)

HEALTH	ASTM	RATING
✗ INFO	I L'FAST	★ ★

CERULEAN BLUE 027

Unfortunately, the sample was so overbound that I cannot give an assessment. Genuine ingredients.

LEFRANC & BOURGEOIS

LINEL EXTRA-FINE ARTISTS' WATERCOLOUR

PB35 CERULEAN BLUE (P. 149)

HEALTH	ASTM	
✗ INFO	I L'FAST	

CERULEAN BLUE 1121

Quality ingredients giving a quality paint. Smooth and free flowing, a well produced watercolour paint. Opaque.

LUKAS

ARTISTS' WATER COLOUR

PB36 CERULEAN BLUE,CHROMIUM (P. 150)

HEALTH	ASTM	RATING
✗ INFO	I L'FAST	★ ★

CERULEAN BLUE 5712

This is not Cerulean Blue at all but a simple mix of Phthalocyanine Blue (PB15 page 147) and Titanium White (PW6 page 271). Semi-opaque.

HUNTS

SPEEDBALL PROFESSIONAL WATERCOLOURS

COPPER PHTHALOCYANINE AND TITANIUM DIOXIDE

HEALTH	ASTM	RATING
✗ INFO	II L'FAST	★ ★

SENNELIER

EXTRA-FINE
ARTISTS'
WATER COLOURS

CERULEAN BLUE 305

Was previously an inexpensive mix masquerading under the name. The ingredients have now been changed to the genuine pigment. Semi-opaque.

PB35 CERULEAN BLUE (P. 149)

HEALTH	ASTM	RATING
✓ INFO	I L'FAST	★★

MARTIN F.WEBER

PERMALBA
ARTIST'S
WATER COLOR
AQUARELLE

CERULEAN BLUE HUE 2055

The word 'Hue' in the title indicates that this is not genuine 'Cerulean Blue' but an imitation. Recently re-named. Opaque.

PB29 ULTRAMARINE BLUE (P. 149)
PG7 PHTHALOCYANINE GREEN (P. 177)
PW6 TITANIUM WHITE (P. 271)

HEALTH	ASTM	RATING
✓ INFO	I L'FAST	★★

WINSOR & NEWTON

ARTISTS'
WATER COLOUR

CERULEAN BLUE 137 (065)

A particularly well made Cerulean Blue. It is a pity that the ingredients were not stated on the tube. Opaque.

PB35 CERULEAN BLUE (P. 149)

HEALTH	ASTM	RATING
✗ INFO	I L'FAST	★★

TALENS

REMBRANDT
ARTISTS'
WATER COLOUR

CERULEAN BLUE 534

Excellent pigment used, but no indication given on the tube. Handled very well over full range. Opaque.

PB35 CERULEAN BLUE (P. 149)

HEALTH	ASTM	RATING
✗ INFO	I L'FAST	

TALENS

REMBRANDT
ARTISTS'
WATER COLOUR

CERULEAN BLUE PHTHALO 535

Such imitations never quite match the genuine article for hue and opacity. Reliable. Semi-transparent.

PW6 TITANIUM WHITE (P. 271)
PB15 PHTHALOCYANINE BLUE (P. 147)

HEALTH	ASTM	RATING
✗ INFO	II L'FAST	★

PĒBĒO

FRAGONARD
ARTISTS'
WATER COLOUR

CERULEAN BLUE 329

Brushed out very smoothly, especially in medium to thin washes. Correct ingredients used. Absolutely lightfast. Opaque.

PB35 CERULEAN BLUE (P. 149)

HEALTH	ASTM	RATING
✗ INFO	I L'FAST	★★

GRUMBACHER

FINEST
PROFESSIONAL
WATERCOLORS

CERULEAN 039

Despite promises, a sample was not provided. An assessment cannot therefore be given.

PB35 CERULEAN BLUE (P. 149)

HEALTH	ASTM	
✗ INFO	I L'FAST	

DA VINCI PAINTS

PERMANENT
ARTISTS'
WATER COLOR

CERULEAN BLUE (HUE) 230

Correctly labelled to indicate an imitation Cerulean Blue. Washed out well. Semi-transparent.

PB15 PHTHALOCYANINE BLUE (P. 147)
PW6 TITANIUM WHITE (P. 271)

HEALTH	ASTM	RATING
✗ INFO	II L'FAST	★★

MAIMERI

ARTISTI
EXTRA-FINE
WATERCOLOURS

CERULEAN 512

An excellent water-colour, smoothly ground, dense pigment. Gives a good range of values. Absolutely lightfast. Opaque.

PB36 CERULEAN BLUE CHROMIUM

HEALTH	ASTM	RATING
✗ INFO	I L'FAST	★★

WINSOR & NEWTON

COTMAN
WATER COLOUR
2ND RANGE

CERULEAN BLUE HUE 139 (138)

Correctly labelled to indicate an Imitation Cerulean Blue. Brushes out very well. Reliable. Transparent.

PB15 PHTHALOCYANINE BLUE (P. 147)

HEALTH	ASTM	RATING
✗ INFO	II L'FAST	★★

WINSOR & NEWTON

COTMAN
WATER COLOUR
2ND RANGE

CERULEAN BLUE 137 (USA ONLY)

Genuine Cerulean Blue in a 'second range' colour. A surprising and very encouraging development. Opaque.

PB35 CERULEAN BLUE (P. 149)

HEALTH	ASTM	RATING
✓ INFO	I L'FAST	★★

MAIMERI

STUDIO
FINE
WATER COLOR
2ND RANGE

CERULEAN HUE 607

Closer in hue to a 'turquoise' than Cerulean Blue. Easily duplicated on the palette. Reliable. Transparent.

PG7 PHTHALOCYANINE GREEN (P. 177)
PB15:3 PHTHALOCYANINE BLUE (P. 147)

HEALTH	ASTM	RATING
✗ INFO	II L'FAST	★

COERULEUM (HUE) 112

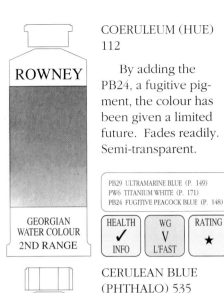

ROWNEY

By adding the PB24, a fugitive pigment, the colour has been given a limited future. Fades readily. Semi-transparent.

PB29 ULTRAMARINE BLUE (P. 149)
PW6 TITANIUM WHITE (P. 171)
PB24 FUGITIVE PEACOCK BLUE (P. 148)

GEORGIAN
WATER COLOUR
2ND RANGE

HEALTH	WG	RATING
✓	V	★
INFO	L'FAST	

CERULEAN BLUE

PAILLARD

Information on ingredients withheld, so purchase at your own risk. Assessments are not possible.

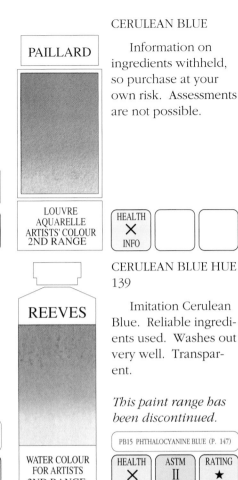

LOUVRE
AQUARELLE
ARTISTS' COLOUR
2ND RANGE

HEALTH		
✕		
INFO		

CERULEAN BLUE 039

Tube well labelled apart from the colour name. The addition of the word 'Hue' would be helpful. Semi-transparent.

GRUMBACHER

PB15 PHTHALOCYANINE BLUE (P. 147)
PW6 TITANIUM WHITE (P. 271)

ACADEMY
ARTISTS'
WATERCOLOUR
2ND RANGE

HEALTH	ASTM	RATING
✓	II	★★
INFO	L'FAST	

CERULEAN BLUE (PHTHALO) 535

TALENS

The use of the work 'Phthalo' indicates an imitation Cerulean Blue. Reliable ingredients. Semi-transparent. *Range discontinued.*

PW6 TITANIUM WHITE (P. 271)
PB15 PHTHALOCYANINE BLUE (P. 147)

WATER COLOUR
2ND RANGE

HEALTH	ASTM	RATING
✓	II	★★
INFO	L'FAST	

CERULEAN BLUE HUE 139

REEVES

Imitation Cerulean Blue. Reliable ingredients used. Washes out very well. Transparent.

This paint range has been discontinued.

PB15 PHTHALOCYANINE BLUE (P. 147)

WATER COLOUR
FOR ARTISTS
2ND RANGE

HEALTH	ASTM	RATING
✕	II	★★
INFO	L'FAST	

5.2 Cobalt Blue

The standard blue for many artists, bright, clean and very transparent. It makes an ideal glazing colour.

Because of its relatively high price it is often subjected to adulteration and imitation. I would suggest that you purchase the best quality, genuine Cobalt Blue, no substitute can match the true pigment.

For mixing purposes Cobalt Blue usually leans towards green. Variations biased towards violet are available, but these invariably contain Ultramarine Blue.

Mixing complementary is a red - orange.

COBALT BLUE LIGHT 487

SCHMINCKE

Thoroughly reliable pigment used. Sample brushed out beautifully giving smooth even washes. Absolutely lightfast. Transparent.

PB28 COBALT BLUE (P. 148)

HORADAM
FINEST
ARTISTS'
WATER COLOURS

HEALTH	ASTM	RATING
✕	I	★★
INFO	L'FAST	★★

COBALT BLUE LIGHT 505

MAIMERI

Genuine Cobalt Blue cannot be matched by substitute mixtures. Washed out very well. Most reliable. Transparent.

PB28 COBALT BLUE (P. 148)

ARTISTI
EXTRA-FINE
WATERCOLOURS

HEALTH	ASTM	RATING
✕	I	★★
INFO	L'FAST	

COBALT BLUE 307

SENNELIER

A definite green - blue. Slightly 'chalky' in appearance. Handled well over a useful range of washes. Semi-transparent.

PB28 COBALT BLUE (P. 148)

EXTRA-FINE
ARTISTS'
WATER COLOURS

HEALTH	ASTM	RATING
✕	I	★★
INFO	L'FAST	

GRUMBACHER

FINEST PROFESSIONAL WATERCOLORS

COBALT BLUE 049

Rather stronger in colour and tinting strength than is usual. Sample gave good series of even washes. Semi-transparent.

PB28 COBALT BLUE (P. 148)

HEALTH	ASTM	RATING
✕ INFO	I L'FAST	★★ ★★

TALENS

REMBRANDT ARTISTS' WATER COLOUR

COBALT BLUE 511

A well produced watercolour paint. Smooth even washes over a good range of values. Lightfast. Transparent.

PB28 COBALT BLUE (P. 148)

HEALTH	ASTM	RATING
✕ INFO	I L'FAST	★★

ROWNEY

ARTISTS' WATER COLOUR

COBALT BLUE 109

Genuine ingredients give a clear blue which brushed out particularly well. Correct ingredients are always worth seeking out. Transparent.

PB28 COBALT BLUE (P. 148)

HEALTH	ASTM	RATING
✓ INFO	I L'FAST	★★

OLD HOLLAND

CLASSIC WATERCOLOURS

COBALT BLUE 420

Unanswered questions on ingredients make it impossible to give assessments.

HEALTH		
✕ INFO		

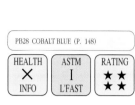

MARTIN F. WEBER

PERMALBA ARTIST'S WATER COLOR AQUARELLE

COBALT BLUE HUE 2075

This was originally produced using the Genuine pigment, PB28. Now an imitation, which is reflected in the name. Handles very well. Lightfast. Semi-transparent.

PB29 ULTRAMARINE BLUE (P. 149)
PB15 PHTHALOCYANINE BLUE (P.147)

HEALTH	ASTM	RATING
✓ INFO	II L'FAST	★★

WINSOR & NEWTON

ARTISTS' WATER COLOUR

COBALT BLUE 178 (066)

Genuine ingredients give an excellent watercolour. Brushes out very well, particularly in thin to medium washes. Absolutely lightfast. Transparent.

PB28 COBALT BLUE (P. 148)

HEALTH	ASTM	RATING
✕ INFO	I L'FAST	★★ ★★

HUNTS

SPEEDBALL PROFESSIONAL WATERCOLOURS

COBALT BLUE 5714

A mix of Phthalocyanine Blue, Ultramarine Blue and Titanium White. Rather harsh in hue compared to genuine article. Semi-transparent.

COPPER PHTHALOCYANINE, ULTRAMARINE PIGMENT AND TITANIUM DIOXIDE

HEALTH	ASTM	RATING
✕ INFO	II L'FAST	★

LEFRANC & BOURGEOIS

LINEL EXTRA-FINE ARTISTS' WATERCOLOUR

COBALT BLUE 030

Brighter in hue than most other examples. A smooth, even colour which brushed out very well. Transparent.

PB28 COBALT BLUE (P. 148)

HEALTH	ASTM	RATING
✕ INFO	I L'FAST	★★ ★★

BLOCKX

AQUARELLES ARTISTS' WATER COLOUR

COBALT BLUE 352

Tubes with a black cap, ('moist' watercolours), are best applied thinly or they resist drying. Select white capped version for 'normal' application. Transparent.

PB28 COBALT BLUE (P. 148)

HEALTH	ASTM	RATING
✕ INFO	I L'FAST	★★

HOLBEIN

ARTISTS' WATER COLOR

COBALT BLUE 615

Smooth, well produced watercolour, employing genuine ingredients. Washed out very well at all strengths. Absolutely lightfast. Transparent.

PB28 COBALT BLUE (P. 148)

HEALTH	ASTM	RATING
✕ INFO	I L'FAST	★★ ★★

PĒBĒO

FRAGONARD ARTISTS' WATER COLOUR

COBALT BLUE 330

An excellent watercolour, clear, bright and washes out very well. Genuine ingredients are absolutely lightfast. Transparent.

PB28 COBALT BLUE (P. 148)

HEALTH	ASTM	RATING
✕ INFO	I L'FAST	★★ ★★

BINNEY & SMITH

PROFESSIONAL ARTISTS' WATER COLOR

COBALT BLUE 170

Genuine Cobalt Blue is always worth the extra cost over imitations, which are always inferior. A first class watercolour. Transparent.

PB28 COBALT BLUE (P. 148)

HEALTH	ASTM	RATING
✓ INFO	I L'FAST	★★ ★★

COBALT BLUE 234

DA VINCI PAINTS

As with most Da Vinci paints this is well labelled, giving full information. A well produced watercolour. Dependable. Transparent.

PERMANENT ARTISTS' WATER COLOR

PB28 COBALT BLUE (P. 148)

HEALTH	ASTM	RATING
✓ INFO	I L'FAST	★ ★ ★ ★

COBALT BLUE IMITATION 1126

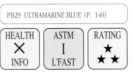

LUKAS

Clearly labelled as an imitation Cobalt Blue. More on the violet side due to the ingredients. Absolutely lightfast. Transparent.

ARTISTS' WATER COLOUR

PB29 ULTRAMARINE BLUE (P. 149)

HEALTH	ASTM	RATING
✗ INFO	I L'FAST	★ ★

COBALT BLUE DARK 506

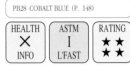

MAIMERI

It is always worth choosing a Cobalt Blue produced with genuine ingredients. Imitations are always a poor second best. Excellent. Transparent.

ARTISTI EXTRA-FINE WATERCOLOURS

PB28 COBALT BLUE (P. 148)

HEALTH	ASTM	RATING
✗ INFO	I L'FAST	★ ★

COBALT BLUE DEEP 488

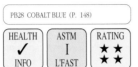

SCHMINCKE

An excellent watercolour giving smooth, even washes over a useful range of values. Correct ingredients, absolutely lightfast. Transparent.

HORADAM FINEST ARTISTS' WATER COLOURS

PB28 COBALT BLUE (P. 148)

HEALTH	ASTM	RATING
✗ INFO	I L'FAST	★ ★ ★ ★

COBALT BLUE DEEP 1125

LUKAS

Brushes out beautifully, a very well produced watercolour paint. A clear, bright blue leaning towards green. Transparent.

ARTISTS' WATER COLOUR

PB28 COBALT BLUE (P. 148)

HEALTH	ASTM	RATING
✗ INFO	I L'FAST	★ ★ ★ ★

COBALT BLUE IMITATION 486

SCHMINCKE

Clearly described as an imitation. As such it will lack the distinctive hue of the genuine article. Semi-transparent.

HORADAM FINEST ARTISTS' WATER COLOURS

PW4 ZINC WHITE (P. 270)
PB29 ULTRAMARINE BLUE (P. 149)

HEALTH	ASTM	RATING
✗ INFO	I L'FAST	★ ★

COBALT BLUE ULTRAMARINE 512

TALENS

A reliable imitation but lacks the subtly of hue of genuine Cobalt Blue. Easily duplicated. Semi-transparent.

REMBRANDT ARTISTS' WATER COLOUR

PW4 ZINC WHITE (P. 270)
PB29 ULTRAMARINE BLUE (P. 149)

HEALTH	ASTM	RATING
✗ INFO	I L'FAST	★ ★

COBALT BLUE TINT 616

HOLBEIN

As the company also produce genuine Cobalt Blue I should by-pass this one. Does not compare. Transparent.

ARTISTS' WATER COLOR

PB29 ULTRAMARINE BLUE (P. 149)
PB15 PHTHALOCYANINE BLUE (P. 147)

HEALTH	ASTM	RATING
✗ INFO	II L'FAST	★ ★

COBALT TURQUOISE 190 (078)

WINSOR & NEWTON

Very definitely on the green side. A reliable paint which handles well at all strengths. Reasonably transparent washes.

ARTISTS' WATER COLOUR

PB36 CERULEAN BLUE,CHROMIUM (P. 150)

HEALTH	ASTM	RATING
✗ INFO	I L'FAST	★ ★

AZURE COBALT 024 (064)

WINSOR & NEWTON

A mix of Cobalt Blue and Viridian, easily duplicated on the palette. Both pigments absolutely lightfast. Transparent.

ARTISTS' WATER COLOUR

PB28 COBALT BLUE (P. 148)
PG18 VIRIDIAN (P. 179)

HEALTH	ASTM	RATING
✗ INFO	I L'FAST	★ ★ ★ ★

COBALT BLUE 049

Be aware that this is a poor imitation, poorly described. Reliable. Transparent.

GRUMBACHER

ACADEMY ARTISTS' WATERCOLOUR 2ND RANGE

PB29 ULTRAMARINE BLUE (P. 149)

HEALTH	ASTM	RATING
✓ INFO	I L'FAST	★ ★

COBALT BLUE

PAILLARD

No assessments are possible as manufacturers declined to supply relevant information.

LOUVRE AQUARELLE ARTISTS' COLOUR 2ND RANGE

HEALTH		
✗ INFO		

COBALT BLUE (HUE) 110

Correctly described, the word 'Hue' identifying it as an imitation. Lightfast ingredients. Semi-transparent.

PW4 ZINC WHITE (P. 270)
PB29 ULTRAMARINE BLUE (P. 149)

ROWNEY
GEORGIAN WATER COLOUR 2ND RANGE

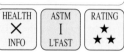

HEALTH	ASTM	RATING
✓ INFO	I L'FAST	★★

COBALT BLUE (VARIETY OF ULTRA-MARINE) 179 (311)

Brushes out well. A reliable 'second range' colour. On the violet side when compared to genuine Cobalt Blue.

PW5 LITHOPONE (P. 270)
PB29 ULTRAMARINE BLUE (P. 149)

WINSOR & NEWTON
COTMAN WATER COLOUR 2ND RANGE

HEALTH	ASTM	RATING
✗ INFO	I L'FAST	★ ★★

COBALT BLUE 178 (USA ONLY)

Excellent ingredients, particularly for a 'second range' colour. The paint brushed out smoothly into gradated washes. Reasonably bright. Transparent.

PB28 COBALT BLUE (P. 148)

WINSOR & NEWTON
COTMAN WATER COLOUR 2ND RANGE

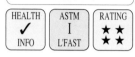

HEALTH	ASTM	RATING
✓ INFO	I L'FAST	★★

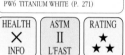

COBALT BLUE (HUE) 603

Phthalocyanine Blue with a little white will give the same colour. A reasonable imitation, closer than Ultramarine and White mixes. Semi-transparent.

PB15:1 PHTHALOCYANINE BLUE (P. 147)
PB15:3 PHTHALOCYANINE BLUE (P. 147)
PW6 TITANIUM WHITE (P. 271)

MAIMERI
STUDIO FINE WATER COLOR 2ND RANGE

HEALTH	ASTM	RATING
✗ INFO	II L'FAST	★★

COBALT BLUE HUE 181

If you have an Ultramarine Blue already you will find little use for this. Virtually the same colour. Semi-transparent.
Range discontinued.

PW5 LITHOPONE (P. 270)
PB29 ULTRAMARINE BLUE (P. 149)

REEVES
WATER COLOUR FOR ARTISTS 2ND RANGE

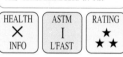

HEALTH	ASTM	RATING
✗ INFO	I L'FAST	★ ★★

COBALT BLUE (ULTRAMARINE) 512

The difference in hue between this paint and Ultramarine Blue is hardly noticeable. Reliable.
This range has now been discontinued.

PB29 ULTRAMARINE BLUE (P. 149)
PW4 ZINC WHITE (P. 270)

TALENS
WATER COLOUR 2ND RANGE

HEALTH	ASTM	RATING
✗ INFO	I L'FAST	★ ★★

5.3 Indigo

Originally imported from India, genuine Indigo has had a varied and eventful history. It was produced from the leaves of the plant Indigofera Tinctoria. Widely used in Asia, Indigo was first imported into Europe in 1516.

A valuable article of commerce, Indigo played an important part in the British take-over of India.

Synthetic Indigo, with a poor reputation for reliability, is usually duplicated by various blue/black mixes.

Easily mixed on the palette, but the use of black might cause dullness. For this type of colour I would always mix Ultramarine Blue with Burnt Sienna. Being complementaries the orange (Burnt Sienna) will darken the blue. As they are both transparent the light will sink in, making the colour very dark. Such a mix is far livelier than any blue/black mixture.

INDIGO 127

ROWNEY

Very little Alizarin Crimson can be involved as our sample did not change when tested. Semi-opaque.

PR83:1 ALIZARIN CRIMSON (P. 88)
PB15 PHTHALOCYANINE BLUE (P. 147)
PBk7 CARBON BLACK (P. 256)
PB29 ULTRAMARINE BLUE (P. 149)

ARTISTS' WATER COLOUR

HEALTH	WG	RATING
✓ INFO	II L'FAST	★ ★★

INDIGO 212

BINNEY & SMITH

Not particularly pleasant to use in heavier application but thin washes are fine. Reliable ingredients. Semi-transparent.

PB27 PRUSSIAN BLUE (P. 148)
PR170 F3RK - 70 NAPHTHOL RED (P. 94)

PROFESSIONAL ARTISTS' WATER COLOR

HEALTH	ASTM	RATING
✓ INFO	II L'FAST	★ ★★

INDIGO 125

PĒBĒO

Almost black at full strength but washes out into a reasonably transparent green - blue. Lightfast. Semi-transparent.

PB15 PHTHALOCYANINE BLUE (P. 147)
PG7 PHTHALOCYANINE GREEN (P. 177)
PR88 MRS THIOINDIGOID VIOLET (P. 88)

FRAGONARD ARTISTS' WATER COLOUR

HEALTH	ASTM	RATING
✗ INFO	II L'FAST	★ ★★

INDIGO 485

SCHMINCKE

PB66 has a poor reputation for reliability. It will cause deterioration in such mixes. Becomes bluer on fading. Semi-transparent.

PB15:1 PHTHALOCYANINE BLUE (P. 147)
PB66 INDIGO BLUE (P. 150)

HORADAM FINEST ARTISTS' WATER COLOURS

HEALTH	WG	RATING
✗ INFO	V L'FAST	★

INDIGO 112

GRUMBACHER

Vat Blue 1 is the dye used in PB66 (page 150) Grumbacher use a special form of this dye in their Indigo. Sample lost its red sheen and became very black in mass tone. Tint faded.

VAT BLUE 1

FINEST PROFESSIONAL WATERCOLORS

HEALTH	WG	RATING
✗ INFO	III L'FAST	★

INDIGO 1122

LUKAS

Reliable, convenience colour easily duplicated on the palette. Washes out very well. Semi-transparent.

PB15 PHTHALOCYANINE BLUE (P. 147)
PR176 BENZIMIDAZOLONE CARMINE HF3C (P. 94)
PBk7 CARBON BLACK (P. 256)

ARTISTS' WATER COLOUR

HEALTH	ASTM	RATING
✗ INFO	II L'FAST	★ ★★

INDIGO 322 (025)

WINSOR & NEWTON

Like most Indigos it is almost black in mass tone and washes out into a dull blue - grey. Reliable.

PBk7 CARBON BLACK (P. 256)
PV19 QUINACRIDONE RED (P. 130)
PB15 PHTHALOCYANINE BLUE (P. 147)

ARTISTS' WATER COLOUR

HEALTH	ASTM	RATING
✗ INFO	II L'FAST	★ ★★

INDIGO 622

HOLBEIN

A reliable convenience colour, simple to mix. Brushes out well over a wide range of values. Semi-transparent.

PB27 PRUSSIAN BLUE (P. 148)
PBk6 LAMP BLACK (P. 256)

ARTISTS' WATER COLOR

HEALTH	ASTM	RATING
✗ INFO	I L'FAST	★ ★★

INDIGO MODERN 533

TALENS

Lightfast pigments giving the usual blue - black. Sample washed out well. Semi-transparent.

PB15 PHTHALOCYANINE BLUE (P. 147)
PBk7 CARBON BLACK (P. 256)
PV19 QUINACRIDONE VIOLET (P. 130)

REMBRANDT ARTISTS' WATER COLOUR

HEALTH	ASTM	RATING
✗ INFO	II L'FAST	★ ★★

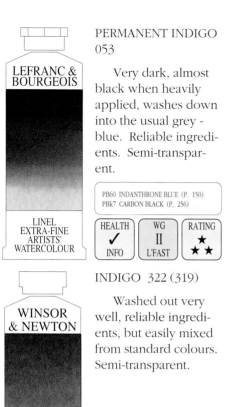

PERMANENT INDIGO 053

LEFRANC & BOURGEOIS

Very dark, almost black when heavily applied, washes down into the usual grey - blue. Reliable ingredients. Semi-transparent.

PB60 INDANTHRONE BLUE (P. 150)
PBk7 CARBON BLACK (P. 256)

LINEL EXTRA-FINE ARTISTS' WATERCOLOUR

HEALTH	WG	RATING
✓ INFO	II L'FAST	★★

INDIGO EXTRA 417

OLD HOLLAND

Comparatively little black can have been added as the hue is a definite green - blue. Lightfast ingredients used. Semi-transparent.

PB15 PHTHALOCYANINE BLUE (P. 147)
PBk9 IVORY BLACK (P. 257)

CLASSIC WATERCOLOURS

HEALTH	ASTM	RATING
✗ INFO	II L'FAST	★★

INDIGO 522

MAIMERI

Will become paler and bluer as the Alizarin Crimson fades. This will be particularly noticeable in the thinner washes. Semi-transparent.

PR83:1 ALIZARIN CRIMSON (P. 88)
PBk7 CARBON BLACK (P. 256)
PB27 PRUSSIAN BLUE (P. 148)

ARTISTI EXTRA-FINE WATERCOLOURS

HEALTH	ASTM	RATING
✗ INFO	IV L'FAST	★★

INDIGO 322 (319)

WINSOR & NEWTON

Washed out very well, reliable ingredients, but easily mixed from standard colours. Semi-transparent.

PBk7 CARBON BLACK (P. 256)
PB29 ULTRAMARINE BLUE (P. 149)
PB15 PHTHALOCYANINE BLUE (P. 147)

COTMAN WATER COLOUR 2ND RANGE

HEALTH	ASTM	RATING
✗ INFO	II L'FAST	★★

INDIGO (MODERN) 533

TALENS

A wide range of values available, from a colour close to black to a light blue - grey. Semi-transparent. *This range has now been discontinued.*

PB15 PHTHALOCYANINE BLUE (P. 147)
PBk7 CARBON BLACK (P. 256)
PV19 QUINACRIDONE VIOLET (P. 130)

WATER COLOUR 2ND RANGE

HEALTH	ASTM	RATING
✗ INFO	II L'FAST	★★

INDIGO 127

ROWNEY

Fortunately little of the Alizarin Crimson seems to have been added, the colour change on exposure was slight. Semi-transparent.

PR83:1 ALIZARIN CRIMSON (P. 88)
PB15 PHTHALOCYANINE BLUE (P. 147)
PBk7 CARBON BLACK (P. 256)
PB29 ULTRAMARINE BLUE (P. 149)

GEORGIAN WATER COLOUR 2ND RANGE

HEALTH	WG	RATING
✓ INFO	III L'FAST	★★

5.4 Manganese Blue

Often thought of as a cheaper alternative to Cerulean Blue. It is however far more transparent and lacks 'body'. It became very noticeable, when the various versions were compared, that Manganese Blue does not make up into a successful watercolour paint. Its lack of body made for paints which were often no more than coloured gum. Personally I would always select genuine Cerulean Blue, even if it were ten times the price.

Mixing complementary is red - orange. Use as a semi-transparent green - blue.

Manufacturers report that the pigment (PB33), is becoming increasingly difficult to obtain.

MANGANESE BLUE 422

OLD HOLLAND

Sample was particularly overbound. A greenish - blue possessing reasonable tinting strength but little body. Semi-opaque.

PB33 MANGANESE BLUE (P. 149)

CLASSIC WATERCOLOURS

HEALTH	ASTM	RATING
✗ INFO	I L'FAST	★★

MANGANESE BLUE 625

HOLBEIN

Pigment possesses little body giving a rather gum laden paint. Brushes out with difficulty. Semi-transparent.

PB33 MANGANESE BLUE (P. 149)

ARTISTS' WATER COLOR

HEALTH	ASTM	RATING
✗ INFO	I L'FAST	★★

MANGANESE BLUE 250

BLOCKX

The nature of the pigment leads to a rather gummy watercolour paint. Difficult to use unless in thin washes. Semi-transparent.

PB33 MANGANESE BLUE (P. 149)

AQUARELLES ARTISTS' WATER COLOUR

HEALTH	ASTM	RATING
✗ INFO	I L'FAST	★★

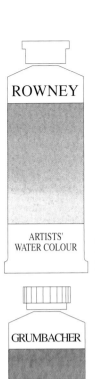

ROWNEY

ARTISTS'
WATER COLOUR

MANGANESE BLUE 108

Gummy and difficult to work with unless washed out very thin. Reasonable tinting strength. Semi-transparent.

PB33 MANGANESE BLUE (P. 149)

HEALTH	ASTM	RATING
✓ INFO	I L'FAST	★ ★

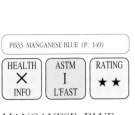

LUKAS

ARTISTS'
WATER COLOUR

MANGANESE BLUE 1119

Weak in body and unpleasant to use. Excessively gummy due to physical nature of pigment. Semi-transparent.

PB33 MANGANESE BLUE (P. 149)

HEALTH	ASTM	RATING
✗ INFO	I L'FAST	★ ★

WINSOR & NEWTON

ARTISTS'
WATER COLOUR

MANGANESE BLUE 382 (071)

Like other examples of Manganese Blue it was unpleasant to use unless in very thin washes. Overbound. Semi-transparent. *This colour has been discontinued.*

PB33 MANGANESE BLUE (P. 149)

HEALTH	ASTM	RATING
✗ INFO	I L'FAST	★ ★

GRUMBACHER

FINEST
PROFESSIONAL
WATERCOLORS

MANGANESE BLUE 131

Sample was rather gummy. Washed out reasonably well as a thin wash, but heavier applications need a trowel. Semi-transparent. *This colour has been discontinued.*

PB33 MANGANESE BLUE (P. 149)

HEALTH	ASTM	RATING
✗ INFO	I L'FAST	★ ★

MAIMERI

ARTISTI
EXTRA-FINE
WATERCOLOURS

MANGANESE BLUE 552

A rather gummy, weak watercolour which washes reasonably well when applied thinly. Lightfast. Semi-transparent. *This colour has been discontinued.*

PB33 MANGANESE BLUE (P. 149)

HEALTH	ASTM	RATING
✗ INFO	I L'FAST	★ ★

LEFRANC & BOURGEOIS

LINEL
EXTRA-FINE
ARTISTS'
WATERCOLOUR

MANGANESE AZURE BLUE 062

PB33 does not make into a particularly useful watercolour. It might be lightfast but is unpleasant to use unless thin. Semi-transparent.

PB33 MANGANESE BLUE (P. 149)

HEALTH	ASTM	RATING
✓ INFO	I L'FAST	★ ★

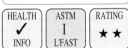

GRUMBACHER

ACADEMY
ARTISTS'
WATERCOLOUR
2ND RANGE

MANGANESE BLUE 131

In whatever quality, the pigment itself causes the paint to be little more than a coloured gum. Semi-transparent.
This colour has been discontinued.

PB33 MANGANESE BLUE (P. 149)

HEALTH	ASTM	RATING
✓ INFO	I L'FAST	★ ★

5.5 Phthalocyanine Blue

Phthalocyanine Blue was discovered by accident when the lining of a dye vat cracked.

A vibrant, deep greenish - blue. Valued for its transparency, it gives very clear washes when diluted. Strong tinctorially, it will quickly influence other colours in a mix and can also dominate a painting quickly.

Sold under its own title as well as fancy or trade names. A very important, inexpensive transparent green - blue.

Mixing complementary is a red - orange.

Makes very transparent blue - greens when mixed with Phthalocyanine Green or Viridian.

MAIMERI

ARTISTI
EXTRA-FINE
WATERCOLOURS

PHTHALOCYANINE BLUE 551

A powerful green - blue. Dense pigment in a well produced watercolour paint. Handles particularly well. Transparent.

PB15 PHTHALOCYANINE BLUE (P. 147)

HEALTH	ASTM	RATING
✕ INFO	II L'FAST	★ ★

SCHMINCKE

HORADAM
FINEST
ARTISTS'
WATER COLOURS

PHTHALO BLUE 484

Bright and powerful, PB15 should be handled with some care due to its strength. Well produced. Transparent.

PB15:1 PHTHALOCYANINE BLUE (P. 147)

HEALTH	ASTM	RATING
✕ INFO	II L'FAST	★ ★

BINNEY & SMITH

PROFESSIONAL
ARTISTS'
WATER COLOR

PHTHALOCYANINE BLUE 316

A quality watercolour in a well labelled tube. Full information given. Very clear washes as pigment is so transparent.

PB15 PHTHALOCYANINE BLUE (P. 147)

HEALTH	ASTM	RATING
✓ INFO	II L'FAST	★ ★

MARTIN F. WEBER

PERMALBA
ARTIST'S
WATER COLOR
AQUARELLE

PHTHALO BLUE 2076

A very well produced paint which washed out particularly well. Smooth washes are available over a useful range of values. Semi - transparent. Excellent.

PB15 PHTHALOCYANINE BLUE (P. 147)

HEALTH	ASTM	RATING
✓ INFO	II L'FAST	★ ★

DA VINCI PAINTS

PERMANENT
ARTISTS'
WATER COLOR

PHTHALO BLUE 267

Like other Phthalocyanine Blues it will quickly stamp its mark on a painting. Powerful, use with care. Transparent.

PB15 PHTHALOCYANINE BLUE (P. 147)

HEALTH	ASTM	RATING
✕ INFO	II L'FAST	★ ★

GRUMBACHER

FINEST
PROFESSIONAL
WATERCOLORS

THALO BLUE 203

A bright, powerful green - blue, valued for its transparency. Washes out into very clear tints. Lightfast.

PB15 PHTHALOCYANINE BLUE (P. 147)

HEALTH	ASTM	RATING
✕ INFO	II L'FAST	★ ★

REEVES

WATER COLOUR
FOR ARTISTS
2ND RANGE

PHTHALO BLUE 514

Washes out very well. Is as strong, intense and lightproof as Artist Quality equivalents. Transparent.

This range has now been discontinued.

PB15 PHTHALOCYANINE BLUE (P. 147)

HEALTH	ASTM	RATING
✕ INFO	II L'FAST	★ ★

TALENS

WATER COLOUR
2ND RANGE

PHTHALO BLUE 570

Gives very clear, bright green - blue washes. Being transparent, it becomes very dark when heavily applied.

This range is being discontinued.

PB15 PHTHALOCYANINE BLUE (P. 147)

HEALTH	ASTM	RATING
✕ INFO	II L'FAST	★ ★

GRUMBACHER

ACADEMY
ARTISTS'
WATERCOLOUR
2ND RANGE

THALO BLUE 203

A densely packed, smoothly ground watercolour, in a well labelled tube. Bright and clear. What more could you ask for?

PB15 PHTHALOCYANINE BLUE (P. 147)

HEALTH	ASTM	RATING
✓ INFO	II L'FAST	★ ★

5.6 Prussian Blue

The discovery of Prussian Blue in the early 1700's is considered to be the beginning of the era of modern pigments.

An intense green - blue of great tinctorial power.

Because of unreliability in the past and a tendency to 'bronze' over, artists welcomed the introduction of Phthalocyanine Blue as an alternative.

Both share similarities of hue, strength and handling characteristics.

Personally I would always choose Phthalocyanine Blue as the bronzing with Prussian Blue can be disconcerting.

Mixing complementary is a red - orange.

WINSOR & NEWTON

ARTISTS' WATER COLOUR

PRUSSIAN BLUE 538 (036)

Gives very clear washes. A vibrant green - blue offering a wide range of values. Absolutely lightfast. Transparent.

PB27 PRUSSIAN BLUE (P. 148)

HEALTH	ASTM	RATING
✕ INFO	I L'FAST	★★

HOLBEIN

ARTISTS' WATER COLOR

PRUSSIAN BLUE 620

A powerful blue which will quickly influence other colours in a mix. Valued for its transparency. Absolutely lightfast.

PB27 PRUSSIAN BLUE (P. 148)

HEALTH	ASTM	RATING
✕ INFO	I L'FAST	★★

ROWNEY

ARTISTS' WATER COLOUR

PRUSSIAN BLUE 135

Being very transparent it takes on a particularly dark appearance when applied heavily. The light sinks in deeply and little escapes. Excellent watercolour.

PB27 PRUSSIAN BLUE (P. 148)

HEALTH	ASTM	RATING
✓ INFO	I L'FAST	★★

BINNEY & SMITH

PROFESSIONAL ARTISTS' WATER COLOR

PRUSSIAN BLUE 318

Like all other Prussian Blues, it should be handled with care due to its great strength. Very well produced watercolour. Transparent.

PB27 PRUSSIAN BLUE (P. 148)

HEALTH	ASTM	RATING
✓ INFO	I L'FAST	★ ★★

LUKAS

ARTISTS' WATER COLOUR

PRUSSIAN BLUE 1134

Bright when applied thinly, also exceedingly transparent. A powerful green - blue, very well made.

PB27 PRUSSIAN BLUE (P. 148)
PG7 PHTHALOCYANINE GREEN (P. 177)

HEALTH	ASTM	RATING
✕ INFO	I L'FAST	★

MAIMERI

ARTISTI EXTRA-FINE WATERCOLOURS

PRUSSIAN BLUE 507

Very well produced watercolour possessing admirable handling qualities. Absolutely lightfast. Transparent.

PB27 PRUSSIAN BLUE (P. 148)

HEALTH	ASTM	RATING
✕ INFO	I L'FAST	★★

SENNELIER

EXTRA-FINE ARTISTS' WATER COLOURS

PRUSSIAN BLUE 318

As with other Prussian Blues, heavier applications can take on a definite bronzed appearance. Well made. Transparent.

PB27 PRUSSIAN BLUE (P. 148)

HEALTH	ASTM	RATING
✕ INFO	I L'FAST	★ ★★

SCHMINCKE

HORADAM FINEST ARTISTS' WATER COLOURS

PRUSSIAN BLUE 492

Exceedingly strong. Brushes out particularly well into a series of smooth gradated washes. Lightfast. Transparent. Re-formulated.

PB27 PRUSSIAN BLUE (P. 148)
PREVIOUSLY ALSO CONTAINED PB15:1 (P. 147) AND PB15:3 (P. 147)

HEALTH	ASTM	RATING
✕ INFO	I L'FAST	★★

DA VINCI PAINTS

PERMANENT ARTISTS' WATER COLOR

PRUSSIAN BLUE 271

Strong, bright and powerful. Use with care in mixing due to its high tinting strength. A well made watercolour. Transparent.

PB27 PRUSSIAN BLUE (P. 148)

HEALTH	ASTM	RATING
✓ INFO	I L'FAST	★★

PRUSSIAN BLUE 168

Several variations of PB27 exist. The pigment used in this watercolour, PB27:1 is very closely related. Excellent product. Transparent.

GRUMBACHER

FINEST PROFESSIONAL WATERCOLORS

| PB27:1 PRUSSIAN BLUE (P. 148) | | |
| HEALTH INFO ✕ | ASTM L'FAST I | RATING ★★ |

PRUSSIAN BLUE 508

Well produced and smoothly ground, giving very clear washes. The strength of Prussian Blue will quickly dominate in a mix. Transparent.

TALENS

REMBRANDT ARTISTS' WATER COLOUR

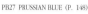

| PB27 PRUSSIAN BLUE (P. 148) | | |
| HEALTH INFO ✕ | ASTM L'FAST I | RATING ★★ |

PRUSSIAN BLUE 2059

Rather pasty in consistency and lacking a certain vibrancy in hue. Pigment is absolutely lightfast. Transparent.

MARTIN F. WEBER

PERMALBA ARTIST'S WATER COLOR AQUARELLE

| PB27 PRUSSIAN BLUE (P. 148) | | |
| HEALTH INFO ✓ | ASTM L'FAST I | RATING ★★ |

PRUSSIAN BLUE 046

Valued for its transparency, this bright green - blue gives a wide range of values. Most reliable.

LEFRANC & BOURGEOIS

LINEL EXTRA-FINE ARTISTS' WATERCOLOUR

| PB27 PRUSSIAN BLUE (P. 148) | | |
| HEALTH INFO ✓ | ASTM L'FAST I | RATING ★★ |

PRUSSIAN BLUE IMITATION 120

The Pigment Violet 23 content could let the colour down. It resists light well for quite some time but will then fade. Other pigments reliable.

PĒBĒO

FRAGONARD ARTISTS' WATER COLOUR

| PB15 PHTHALOCYANINE BLUE (P. 147) |
| PV23 RS DIOXAZINE PURPLE (P. 131) |
| PG7 PHTHALOCYANINE GREEN (P. 177) |

| HEALTH INFO ✕ | ASTM L'FAST V | RATING ★★ |

PRUSSIAN BLUE 538 (328)

Virtually identical to the 'Artists' Quality' Prussian Blue in this make. Bright, strong and transparent.

WINSOR & NEWTON

COTMAN WATER COLOUR 2ND RANGE

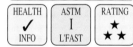

| PB27 PRUSSIAN BLUE (P. 148) | | |
| HEALTH INFO ✓ | ASTM L'FAST I | RATING ★★ |

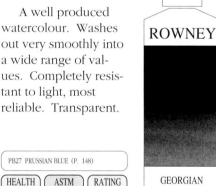

PRUSSIAN BLUE 604

A well produced watercolour. Washes out very smoothly into a wide range of values. Completely resistant to light, most reliable. Transparent.

MAIMERI

STUDIO FINE WATER COLOR 2ND RANGE

| PB27 PRUSSIAN BLUE (P. 148) | | |
| HEALTH INFO ✕ | ASTM L'FAST I | RATING ★★ |

PRUSSIAN BLUE 135

Definitely a green - blue, this should be born in mind when mixing. The strength of this colour must be kept under control. Well produced watercolour. Transparent.

ROWNEY

GEORGIAN WATER COLOUR 2ND RANGE

| PB27 PRUSSIAN BLUE (P. 148) | | |
| HEALTH INFO ✓ | ASTM L'FAST I | RATING ★★ |

PRUSSIAN BLUE 508

This 'Second Range' or Student colour is virtually identical to the 'Artists Quality'. Well produced. Transparent.

This range has now been discontinued.

TALENS

WATER COLOUR 2ND RANGE

| PB27 PRUSSIAN BLUE (P. 148) | | |
| HEALTH INFO ✕ | ASTM L'FAST I | RATING ★★ |

PRUSSIAN BLUE 168

Better labelled than most 'Artist Quality' paints. Also well produced. Smooth and bright. Transparent.

GRUMBACHER

ACADEMY ARTISTS' WATERCOLOUR 2ND RANGE

| PB27 PRUSSIAN BLUE (P. 148) | | |
| HEALTH INFO ✓ | ASTM L'FAST I | RATING ★★ |

5.7 Turquoise

More a colour description than anything else. The name is used to describe a green - blue, usually produced from a mix of Phthalocyanine Blue and Phthalocyanine Green. With the same ingredient you can mix the identical colour on the palette.

The mixing complementary is a red - orange. If the red - orange is also trans- parent the resulting mixes will be very dark when applied heavily, particularly when mixed into greys.

Transparent paints absorb the light. In heavier layers, it sinks in and much is unable to escape, causing the colour to appear blackish.

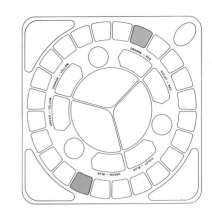

PĒBĒO

FRAGONARD ARTISTS' WATER COLOUR

TURQUOISE BLUE 121

A particularly bright, transparent blue - green. A good range of values are on offer. Transparent.

PB15 PHTHALOCYANINE BLUE (P. 147)
PG7 PHTHALOCYANINE GREEN (P. 177)

HEALTH	ASTM	RATING
✕ INFO	II L'FAST	★★

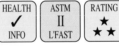

MARTIN F.WEBER

PERMALBA ARTIST'S WATER COLOR AQUARELLE

TURQUOISE 2062

Smooth and pleas- ant to use. The addi- tion of Titanium White causes a loss of trans- parency. A reliable combination of ingre- dients. Semi-opaque.

PW6 TITANIUM WHITE (P. 271)
PB15 PHTHALOCYANINE BLUE (P. 147)
PG7 PHTHALOCYANINE GREEN (P. 177)

HEALTH	ASTM	RATING
✓ INFO	II L'FAST	★★

TALENS

REMBRANDT ARTISTS' WATER COLOUR

TURQUOISE BLUE 522

Handles well and is pleasant to use, partic- ularly in thinner washes. A simple mix of reliable pigments. Transparent.

PB15 PHTHALOCYANINE BLUE (P. 147)
PG7 PHTHALOCYANINE GREEN (P. 177)

HEALTH	ASTM	RATING
✕ INFO	II L'FAST	★★

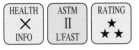

HOLBEIN

ARTISTS' WATER COLOR

TURQUOISE 624

PB17, a less reliable variety of Phthalocya- nine Blue, will cause a certain amount of fading and move heavier applications towards green. Semi- transparent.

PG17 CHROMIUM OXIDE GREEN (P. 147)
PG7 PHTHALOCYANINE GREEN (P. 177)PY3 ARYLIDE YELLOW 10G (P. 29)
PW6 TITANIUM WHITE (P. 271)

HEALTH	ASTM	RATING
✕ INFO	III L'FAST	★★

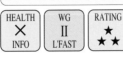

SCHMINCKE

HORADAM FINEST ARTISTS' WATER COLOURS

HELIO TURQUOISE 1 913

This colour has recently been re- formulated. Sample gave very smooth washes. Was called 'Brilliant Turquoise" Transparent.

PR16 PHTHALO BLUE (P.146).
PREVIOUSLY PRODUCED FROM PB15:1 (P. 147) - PY3 (P. 29) AND PG7 (P. 177)

HEALTH	WG	RATING
✕ INFO	II L'FAST	★ ★★

SCHMINCKE

HORADAM FINEST ARTISTS' WATER COLOURS

BRILLIANT TURQUOISE 914

Re-formulated. Handles better in thin washes than in heavier applications. Low in tinting strength. Lightfast pigment. Semi-opaque.

PG 50 LIGHT GREEN OXIDE (P. 180)
PREVIOUSLY PRODUCED FROM PB15:3 (P. 147) AND PG7 (P. 177)

HEALTH	WG	RATING
✕ INFO	II L'FAST	★★

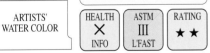

TALENS

WATER COLOUR 2ND RANGE

TURQUOISE BLUE 522

The common 'Turquoise' mix. 'Phthalos' Blue and Green. Bright and strong. Transparent.

This range has recently been discontinued.

PB15 PHTHALOCYANINE BLUE (P. 147)
PG7 PHTHALOCYANINE GREEN (P. 177)

HEALTH	ASTM	RATING
✕ INFO	II L'FAST	★★

GRUMBACHER

ACADEMY ARTISTS' WATERCOLOUR 2ND RANGE

TURQUOISE 213

If you expose this disastrous substance to light, the colour will disappear entirely in a relatively short time. Transparent and then very transparent.

PB24 FUGITIVE PEACOCK BLUE (P. 148)

HEALTH	WG	RATING
✓ INFO	V L'FAST	★

WINSOR & NEWTON

COTMAN WATER COLOUR 2ND RANGE

TURQUOISE 654

Brushes well into very clear washes. A strong combination which will quickly influence other colours in a mix. Transparent.

PB15 PHTHALOCYANINE BLUE (P. 147)
PG7 PHTHALOCYANINE GREEN (P. 177)

HEALTH	ASTM	RATING
✓ INFO	II L'FAST	★★

5.8 Ultramarine

The only definite violet - blue of the palette. Originally produced from the semi-precious stone Lapis Lazuli, it was extremely expensive. Manufactured synthetically from 1830. Much is owed to the inventor, a Frenchman named J.B. Guimet. (Hence the commonly used name, French ultramarine).

A pure, durable colour, high in tinting strength and particularly transparent.

An invaluable hue when mixing, will produce bright violets with a good violet - red, dull greens with an orange - yellow and deep greys with Burnt Sienna.

Mixing complementary is a yellow - orange.

ULTRAMARINE LIGHT 312

Brushed out well. Semi-transparent. This colour has recently been re-formulated to give a very much improved product. Absolutely lightfast.

SENNELIER

EXTRA-FINE ARTISTS' WATER COLOURS

 PB29 ULTRAMARINE BLUE (P. 149)

HEALTH	ASTM	RATING
✕ INFO	I L'FAST	★★

ULTRAMARINE LIGHT 505

Sample was slightly overbound, making heavier applications difficult. Washed out well over rest of range. Transparent.

TALENS

REMBRANDT ARTISTS' WATER COLOUR

PB29 ULTRAMARINE BLUE (P. 149)

HEALTH	ASTM	RATING
✕ INFO	I L'FAST	★★

ULTRAMARINE BLUE LIGHT 251

Bright, vibrant colour. Handled very well over the full range of values. Well produced. Transparent.

BLOCKX

AQUARELLES ARTISTS' WATER COLOUR

PB29 ULTRAMARINE BLUE (P. 149)

HEALTH	ASTM	RATING
✕ INFO	I L'FAST	★★ ★★

ULTRAMARINE LIGHT 056

An intense, vibrant violet - blue. Brushes out beautifully, especially in thin washes where its transparency can be of great value.

LEFRANC & BOURGEOIS

LINEL EXTRA-FINE ARTISTS' WATERCOLOUR

PB29 ULTRAMARINE BLUE (P. 149)

HEALTH	ASTM	RATING
✓ INFO	I L'FAST	★★ ★★

ULTRAMARINE LIGHT 618

A well produced watercolour. High in tinting strength, clear in washes and strong in hue. Absolutely lightfast.

HOLBEIN

 ARTISTS' WATER COLOR

PB29 ULTRAMARINE BLUE (P. 149)

HEALTH	ASTM	RATING
✕ INFO	I L'FAST	★★ ★★

ULTRAMARINE LIGHT

No assessments possible. Despite promises, information on ingredients was not provided.

PAILLARD

LOUVRE AQUARELLE ARTISTS' COLOUR 2ND RANGE

HEALTH
✕ INFO

ULTRAMARINE 508

An intense violet - blue. Well produced, it gives very smooth washes over the full range of values. Transparent.

MAIMERI

ARTISTI EXTRA-FINE WATERCOLOURS

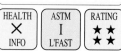 PB29 ULTRAMARINE BLUE (P. 149)

HEALTH	ASTM	RATING
✕ INFO	I L'FAST	★★ ★★

ULTRAMARINE BLUE 219

There is little, if any difference between this and the next colour. If you have one the other will be superfluous. Transparent.

GRUMBACHER

FINEST PROFESSIONAL WATERCOLORS

PB29 ULTRAMARINE BLUE (P. 149)

HEALTH	ASTM	RATING
✕ INFO	I L'FAST	★★ ★★

FRENCH ULTRA- MARINE BLUE 076

Bright, strong, absolutely lightfast and very transparent. All that you would expect from a quality Ultramarine.

GRUMBACHER

FINEST PROFESSIONAL WATERCOLORS

PB29 ULTRAMARINE BLUE (P. 149)

HEALTH	ASTM	RATING
✕ INFO	I L'FAST	★★ ★★

ULTRAMARINE BLUE 496

SCHMINCKE

The addition of Phthalocyanine Blue, a definite green - blue, is not sufficient to move the colour away from being on the violet side. Transparent.

PB15:1 PHTHALOCYANINE BLUE (P. 147)
PB29 ULTRAMARINE BLUE (P. 149)

HORADAM FINEST ARTISTS' WATER COLOURS

HEALTH	ASTM	RATING
✗ INFO	II L'FAST	★ ★ ★

ULTRAMARINE FINEST 494

SCHMINCKE

A bright, strong Ultramarine. Well produced, it washes into a series of very transparent layers. Absolutely lightfast.

PB29 ULTRAMARINE BLUE (P. 149)

HORADAM FINEST ARTISTS' WATER COLOURS

HEALTH	ASTM	RATING
✗ INFO	I L'FAST	★ ★ ★ ★

FRENCH ULTRA-MARINE 123

ROWNEY

Handles well over the full range of values. As with all transparent colours takes on a very dark appearance when applied heavily.

PB29 ULTRAMARINE BLUE (P. 149)

ARTISTS' WATER COLOUR

HEALTH	ASTM	RATING
✓ INFO	I L'FAST	★ ★

ULTRAMARINE BLUE 2063

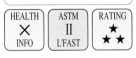

MARTIN F.WEBER

Sample was slightly overbound making gradated washes difficult. A bright, strong colour. Semi-transparent.

PB29 ULTRAMARINE BLUE (P. 149)

PERMALBA ARTISTS' WATER COLOR AQUARELLE

HEALTH	ASTM	RATING
✓ INFO	I L'FAST	★ ★

FRENCH ULTRA-MARINE BLUE 380

BINNEY & SMITH

Sample was slightly overbound. Washed out well, particularly in thinner layers. Transparent and most reliable.

PB29 ULTRAMARINE BLUE (P. 149)

PROFESSIONAL ARTISTS' WATER COLOR

HEALTH	ASTM	RATING
✓ INFO	I L'FAST	★ ★

FRENCH ULTRA-MARINE 263 (068)

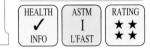

WINSOR & NEWTON

A well produced watercolour. Ultramarine is valued for its transparency, strength and the fact that it is the only worthwhile violet - blue.

PB29 ULTRAMARINE BLUE (P. 149)

ARTISTS' WATER COLOUR

HEALTH	ASTM	RATING
✗ INFO	I L'FAST	★ ★ ★

ULTRAMARINE FINEST 1135

LUKAS

Colour very slightly clouded. Otherwise an excellent watercolour which handled well over the full range. Transparent.

PB29 ULTRAMARINE BLUE (P. 149)

ARTISTS' WATER COLOUR

HEALTH	ASTM	RATING
✗ INFO	I L'FAST	★ ★ ★

ULTRA BLUE 5733

HUNTS

Reliable ingredients. I cannot offer a rating as neither a sample or further information was supplied.

ULTRAMARINE PIGMENT

SPEEDBALL PROFESSIONAL WATERCOLOURS

HEALTH	ASTM	
✗ INFO	I L'FAST	

ULTRAMARINE BLUE 284

DA VINCI PAINTS

This colour has been re-formulated to give a smooth paint which handles very well over a range of values. Particularly transparent washes are available.

PB29 ULTRAMARINE BLUE (P. 149)

PERMANENT ARTISTS' WATER COLOR

HEALTH	ASTM	RATING
✓ INFO	I L'FAST	★ ★ ★

ULTRAMARINE 232

PĒBĒO

Heavier washes were difficult as sample was over - bound. Medium to thin washes very smooth and transparent.

PB29 ULTRAMARINE BLUE (P. 149)

FRAGONARD ARTISTS' WATER COLOUR

HEALTH	ASTM	RATING
✗ INFO	I L'FAST	★ ★ ★

ULTRAMARINE EXTRA 419

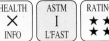

OLD HOLLAND

A very well produced watercolour. Brushed out smoothly into a series of bright, clear washes. Transparent.

PB29 ULTRAMARINE BLUE (P. 149)

CLASSIC WATERCOLOURS

HEALTH	ASTM	RATING
✗ INFO	I L'FAST	★ ★ ★

ULTRAMARINE 660 (337)

WINSOR & NEWTON

Sample was rather overbound making heavier applications difficult. Thinner washes very bright and transparent.

PB29 ULTRAMARINE BLUE (P. 149)

COTMAN WATER COLOUR 2ND RANGE

HEALTH	ASTM	RATING
✓ INFO	I L'FAST	★ ★

REEVES
FRENCH ULTRA-MARINE 263

Difficult to apply, unless as a thin wash, sample overbound. Transparent.

This range has been discontinued.

WATER COLOUR FOR ARTISTS 2ND RANGE

PB29 ULTRAMARINE BLUE (P. 149)

HEALTH	ASTM	RATING
✕ INFO	I L'FAST	★★

ROWNEY
ULTRAMARINE 123

If you need to make savings, this is virtually as bright and transparent as the 'Artists Quality' version.

GEORGIAN WATER COLOUR 2ND RANGE

PB29 ULTRAMARINE BLUE (P. 149)

HEALTH	ASTM	RATING
✓ INFO	I L'FAST	★★

MAIMERI
ULTRAMARINE 615

There is very little difference between this and the 'Artists Quality' of the same make. Absolutely lightfast. Transparent.

STUDIO FINE WATER COLOR 2ND RANGE

PB29 ULTRAMARINE BLUE (P. 149)

HEALTH	ASTM	RATING
✕ INFO	I L'FAST	★★

GRUMBACHER
ULTRAMARINE BLUE 219

Brushed out very well. Almost identical to the 'Artists Quality' version and certainly as lightfast. Transparent.

ACADEMY ARTISTS' WATERCOLOUR 2ND RANGE

PB29 ULTRAMARINE BLUE (P. 149)

HEALTH	ASTM	RATING
✓ INFO	I L'FAST	★★

BLOCKX
ULTRAMARINE BLUE DEEP 253

Slightly deeper than the 'Light' version. I would suggest that you select one or the other as it would not be worth holding both. Washed out well. Transparent.

AQUARELLES ARTISTS' WATER COLOUR

PB29 ULTRAMARINE BLUE (P. 149)

HEALTH	ASTM	RATING
✕ INFO	I L'FAST	★★

LEFRANC & BOURGEOIS
ULTRAMARINE BLUE DEEP 055

Sample rather overbound and difficult to wash out at full strength. Lighter washes were bright and transparent.

LINEL EXTRA-FINE ARTISTS' WATERCOLOUR

PB29 ULTRAMARINE BLUE (P. 149)

HEALTH	ASTM	RATING
✓ INFO	I L'FAST	★ ★★

HOLBEIN
ULTRAMARINE DEEP 619

Bright, clear and strong. Sample washed out well but was slightly overbound. Transparent.

ARTISTS' WATER COLOR

PB29 ULTRAMARINE BLUE (P. 149)

HEALTH	ASTM	RATING
✕ INFO	I L'FAST	★ ★★

SENNELIER
ULTRAMARINE DEEP 315

Very well produced. A much improved colour, earlier version was slightly cloudy. Not dramatically different from their Ultramarine Light. Transparent.

EXTRA-FINE ARTISTS' WATER COLOURS

PB29 ULTRAMARINE BLUE (P. 149)

HEALTH	ASTM	RATING
✕ INFO	I L'FAST	★★

TALENS
ULTRAMARINE DEEP 506

A well produced watercolour paint. Strong, bright and washed out well into a useful range of values. Transparent.

REMBRANDT ARTISTS' WATER COLOUR

PB29 ULTRAMARINE BLUE (P. 149)

HEALTH	ASTM	RATING
✕ INFO	I L'FAST	★★

TALENS
ULTRAMARINE DEEP 506

Smooth, even washes from this well made watercolour. Handled very easily. Transparent.
This range has now been discontinued.

WATER COLOUR 2ND RANGE

PB29 ULTRAMARINE BLUE (P. 149)

HEALTH	ASTM	RATING
✕ INFO	I L'FAST	★★

Ultramarine Blue is very easily damaged by even weak acids. In the example on the right, dilute lemon juice was dropped onto the dried paint film. It bleached white within seconds. Cheap, acid laden watercolour paper can cause deterioration over time, as can poor quality framing. (Acid in the mount and backing).

5.9 Miscellaneous Blues

As you will see, most colours falling into this category are based on the standard blues of the palette. All can be obtained or mixed without the expense of further purchase. When artists come to realise that the paint ranges to take seriously will have a limited number of reliable, well described colours, things will change for the better. Most of the following colour descriptions are more to do with marketing than with real value to the artist.

The mixing complementary of a green - blue is a red - orange, that of a violet - blue, yellow - orange.

ANTWERP BLUE 060

A simple mix of standard colours that are available in most paint boxes. Transparent and reliable.

LEFRANC & BOURGEOIS

LINEL EXTRA-FINE ARTISTS' WATERCOLOUR

PB15 PHTHALOCYANINE BLUE (P. 147)
PG7 PHTHALOCYANINE GREEN (P. 177)

HEALTH	ASTM	RATING
✗ INFO	II L'FAST	★★

ANTWERP BLUE 010 (003)

The name Antwerp Blue was once used to describe Prussian Blue to which a lot of filler had been added. Reliable.

WINSOR & NEWTON

ARTISTS' WATER COLOUR

PB27 PRUSSIAN BLUE (P. 148)

HEALTH	ASTM	RATING
✗ INFO	I L'FAST	★★

ANTWERP BLUE 382

If you have Prussian Blue already you will not need a second version sold under a different name. Reliable.

BINNEY & SMITH

PROFESSIONAL ARTISTS' WATER COLOR

PB27 PRUSSIAN BLUE (P. 148)

HEALTH	ASTM	RATING
✓ INFO	I L'FAST	★★

BLOCKX BLUE 254

To aid overall understanding it would have been better to describe this as Phthalocyanine Blue rather than give it a trade name. Transparent.

BLOCKX

AQUARELLES ARTISTS' WATER COLOUR

PB15 PHTHALOCYANINE BLUE (P. 147)

HEALTH	ASTM	RATING
✗ INFO	II L'FAST	★★

BLUE GREY 707

A Phthalocyanine Blue without the addition of white would have been more useful in the range. Semi-opaque.

HOLBEIN

ARTISTS' WATER COLOR

PB15 PHTHALOCYANINE BLUE (P. 149)
PW6 TITANIUM WHITE (P. 271)

HEALTH	ASTM	RATING
✗ INFO	II L'FAST	★★

BLUE VERDITER (IMITATION) 052

An ancient name for what was an incompatible, poisonous blue. Bears no relation to this unimportant mix. Semi-transparent.

LEFRANC & BOURGEOIS

LINEL EXTRA-FINE ARTISTS' WATERCOLOUR

PB28 COBALT BLUE (P. 148)
PB35 CERULEAN BLUE (P. 149)

HEALTH	ASTM	RATING
✗ INFO	I L'FAST	★★

DELFT BLUE 1 911

PB1, a most unreliable pigment, has been replaced by the far superior PB60. The name has also been changed. It was previously called 'Brilliant Blue'. Well produced. Trans.

SCHMINCKE

HORADAM FINEST ARTISTS' WATER COLOURS

PB60 INDANTHRONE BLUE (P. 150)
WAS PREVIOUSLY PB1 (P. 147)

HEALTH	WG	RATING
✗ INFO	II L'FAST	★★

BRILLIANT BLUE 2 912

If using this brand and you already have their Phthalocyanine Blue, this will be superfluous. Transparent.
This colour has been discontinued.

SCHMINCKE

HORADAM FINEST ARTISTS' WATER COLOURS

PB15:1 PHTHALOCYANINE BLUE (P. 147)

HEALTH	ASTM	RATING
✗ INFO	II L'FAST	★★

CINEREOUS BLUE (BLUE ASH) 344

The name relates to the weak left-overs from the production of genuine Ultramarine. This, on the other hand, is a simple mix. Semi-opaque.

SENNELIER

EXTRA-FINE ARTISTS' WATER COLOURS

PW6 TITANIUM WHITE (P. 271)
PB15:3 PHTHALOCYANINE BLUE (P. 147)

HEALTH	ASTM	RATING
✓ INFO	II L'FAST	★★

COMPOSE BLUE 623

HOLBEIN

A simple mix of Phthalocyanine Blue and white. Easily duplicated on the palette. Semi-opaque.

PW6 TITANIUM WHITE (P. 271)
PB15 PHTHALOCYANINE BLUE (P. 147)

ARTISTS' WATER COLOR

HEALTH	ASTM	RATING
✕ INFO	II L'FAST	★ ★★

CYANIN BLUE 231

PĒBĒO

The name was once used to describe a mix of Prussian and Cobalt Blue. In this case it is another name for Phthalocyanine Blue. Transparent.

PB15 PHTHALOCYANINE BLUE (P. 147)

FRAGONARD ARTISTS' WATER COLOUR

HEALTH	ASTM	RATING
✕ INFO	II L'FAST	★ ★★

CYANINE BLUE 354

BLOCKX

A simple mix of two standard blues. Easily reproduced on the palette. Transparent.

PB28 COBALT BLUE (P. 148)
PB15 PHTHALOCYANINE BLUE (P. 147)

AQUARELLES ARTISTS' WATER COLOUR

HEALTH	ASTM	RATING
✕ INFO	II L'FAST	★ ★★

CYANINE BLUE 209 (018)

WINSOR & NEWTON

Cobalt and Prussian Blue are the traditional mix for this description. Simple to duplicate. Transparent.

PB28 COBALT BLUE (P. 148)
PB27 PRUSSIAN BLUE (P. 148)

ARTISTS' WATER COLOUR

HEALTH	ASTM	RATING
✕ INFO	I L'FAST	★ ★★

HELIO BLUE 1198

LUKAS

Phthalocyanine Blue is sold under a variety of fancy names, this is one of them. Transparent.

PB15 PHTHALOCYANINE BLUE (P. 147)

ARTISTS' WATER COLOUR

HEALTH	ASTM	RATING
✕ INFO	II L'FAST	★ ★★

HOGGAR BLUE 036

LEFRANC & BOURGEOIS

If you already have Phthalocyanine Blue you will not need to buy it again under this fancy title.

PB15 PHTHALOCYANINE BLUE (P. 147)

LINEL EXTRA-FINE ARTISTS' WATERCOLOUR

HEALTH	ASTM	RATING
✓ INFO	II L'FAST	★ ★★

HORTENSIA BLUE 038

LEFRANC & BOURGEOIS

Phthalocyanine Blue yet again. Strong, bright and very transparent. It does have its own name however.

PB15:1 PHTHALOCYANINE BLUE (P. 147)

LINEL EXTRA-FINE ARTISTS' WATERCOLOUR

HEALTH	ASTM	RATING
✓ INFO	II L'FAST	★ ★★

INDIAN BLUE 039

LEFRANC & BOURGEOIS

A dull, slightly violet blue. Rather weak, with poor covering power. Stands up well to light. Semi-opaque.

PB60 INDANTHRONE BLUE (P. 150)

LINEL EXTRA-FINE ARTISTS' WATERCOLOUR

HEALTH	WG	RATING
✓ INFO	II L'FAST	★ ★★

PHTHALO BLUE 326

SENNELIER

This used to be called 'Mineral Blue'. In the last edition I said: "Yet another fancy title used to sell Phthalocyanine Blue". The re-naming is a step in the right direction. Transparent.

PB15:3 PHTHALO BLUE (P. 147)

EXTRA-FINE ARTISTS' WATER COLOURS

HEALTH	ASTM	RATING
✕ INFO	II L'FAST	★ ★★

MONESTIAL BLUE (PHTHALO) 136

ROWNEY

PB15 was first offered in 1935 under the name Monastral Blue. A variation of this name is retained by Rowney. Transparent.

PB15 PHTHALOCYANINE BLUE (P. 147)

ARTISTS' WATER COLOUR

HEALTH	ASTM	RATING
✓ INFO	II L'FAST	★★ ★★

MOUNTAIN BLUE 480

SCHMINCKE

A colour which is easily blended, if really required, from Ultramarine Blue, Phthalo Green and White. Re-formulated recently. Handles well. Semi-transparent.

PW5 LITHOPONE (P. 270) - PB29
ULTRAMARINE BLUE (P. 149) AND PG7 (P.
PHTHALOCYANINE GREEN (P. 177)
WAS PB35 (P. 149) AND PB28 (P. 148)

HORADAM FINEST ARTISTS' WATER COLOURS

HEALTH	ASTM	RATING
✕ INFO	I L'FAST	★ ★★

PARIS BLUE 1133

LUKAS

Paris Blue was once a general term used for Prussian Blue, particularly in Germany. Reliable. Transparent.

PB27 PRUSSIAN BLUE (P. 148)

ARTISTS' WATER COLOUR

HEALTH	ASTM	RATING
✓ INFO	I L'FAST	★★ ★★

PARIS BLUE 491

SCHMINCKE

A seemingly point-less mix of three very similar, transparent green - blues.

PB15:1 PHTHALOCYANINE BLUE (P. 147)
PB27 PRUSSIAN BLUE (P. 148)
PB15:3 PHTHALOCYANINE BLUE (P. 147)

HORADAM FINEST ARTISTS' WATER COLOURS

HEALTH	ASTM	RATING
✕ INFO	II L'FAST	★ ★★

PARIS BLUE EXTRA 418

OLD HOLLAND

Prussian Blue is absolutely lightfast, yet our sample deterior-ated during exposure. No assessments offered.

PB27 PRUSSIAN BLUE (P. 148)

CLASSIC WATERCOLOURS

HEALTH		
✕ INFO		

PEACOCK BLUE 626

HOLBEIN

Although further testing is required, PB17 (a variety of Phthalocyanine Blue), would seem to be less than lightfast. Sample moved towards green. Transparent.

PB17 PHTHALOCYANINE BLUE (P. 147)

ARTISTS' WATER COLOR

HEALTH	WG	RATING
✕ INFO	III L'FAST	★ ★

PERMANENT BLUE 473 (035)

WINSOR & NEWTON

Slightly less violet than the Ultramarine Blue produced by this company and gives a somewhat smoother wash. Transparent.

PB29 ULTRAMARINE BLUE (P. 149)

ARTISTS' WATER COLOUR

HEALTH	ASTM	RATING
✕ INFO	I L'FAST	★ ★★

PERMANENT BLUE 137

ROWNEY

If you use this com-pany's products do not make the mistake of purchasing their Ultramarine twice.

PB29 ULTRAMARINE BLUE (P. 149)

ARTISTS' WATER COLOUR

HEALTH	ASTM	RATING
✓ INFO	I L'FAST	★ ★★

PRIMARY BLUE (CYAN) 501

MAIMERI

The pigment used appears to be a 'Lake colour' produced using 'Direct Blue 86 CI No. 74180. I will examine this dye further and give my assessment in the next edition. Very transparent.

ARTISTI EXTRA-FINE WATERCOLOURS

HEALTH		
✕ INFO		

REMBRANDT BLUE 520

TALENS

Yet another name under which to market Phthalocyanine Blue. Such practices only cause confusion. Transparent.

PB15 PHTHALOCYANINE BLUE (P. 147)

REMBRANDT ARTISTS' WATER COLOUR

HEALTH	ASTM	RATING
✕ INFO	II L'FAST	★ ★★

SPEEDBALL BLUE (PHTHALO) 5726

HUNTS

If the naming of colours was standard-ised and meaningful descriptions used, there would be a lot less confusion. Trans-parent.

PB15 PHTHALOCYANINE BLUE (P. 147)

SPEEDBALL PROFESSIONAL WATERCOLOURS

HEALTH	ASTM	RATING
✕ INFO	II L'FAST	★ ★★

TOUAREG BLUE 049

LEFRANC & BOURGEOIS

A simple mix, fan-cifully described. Not used by the Touaregs as far as I am aware. Transparent.

PG7 PHTHALOCYANINE GREEN (P. 177)
PB15 PHTHALOCYANINE BLUE (P. 147)

LINEL EXTRA-FINE ARTISTS' WATERCOLOUR

HEALTH	ASTM	RATING
✕ INFO	II L'FAST	★ ★★

VERDITER BLUE 621

HOLBEIN

If you use this make and have their Cobalt Blue, just add white and you have instant Verditer Blue, Semi-transparent.

PB28 COBALT BLUE (P. 148)
PW6 TITANIUM WHITE (P. 271)

ARTISTS' WATER COLOR

HEALTH	ASTM	RATING
✕ INFO	I L'FAST	★ ★★

WINSOR BLUE 706 (053)

WINSOR & NEWTON

It would be a major step forward if all fancy and trade names were dropped and the common name used instead.

PB15 PHTHALOCYANINE BLUE (P. 147)

ARTISTS' WATER COLOUR

HEALTH	ASTM	RATING
✕ INFO	II L'FAST	★ ★★

INTENSE BLUE 327 (320)

WINSOR & NEWTON

Yes, Phthalocya-nine Blue is intense. It is also transparent and powerful. Yet another name to market this pigment under.

PB15 PHTHALOCYANINE BLUE (P. 147)

COTMAN WATER COLOUR 2ND RANGE

HEALTH	ASTM	RATING
✕ INFO	II L'FAST	★ ★★

PRIMARY BLUE (CYAN) 633

MAIMERI

I have said enough about using a wide range of fancy names to describe the same pigment.

STUDIO
FINE
WATER COLOR
2ND RANGE

PB15:3 PHTHALOCYANINE BLUE (P. 147)		
HEALTH ✕ INFO	ASTM II L'FAST	RATING ★ ★★

The following blue watercolours have been introduced since the last edition of this book.

One of the main aims of this book has been to offer artists the information required for selective purchasing. Bearing in mind that manufacturers will only produce what artists will buy, we are in a position to insist on reliable colours.

It is claimed by at least one manufacturer that artists demand certain colours even if they fade or are almost impossible to apply. This is, I feel, a cover up as few will knowingly use inferior materials. Market forces are bringing about the changes you see on these pages.

Few unreliable colours are being introduced and many other colours have been improved.

CERULEAN BLUE GENUINE 229

DA VINCI PAINTS

Absolutely lightfast and with good covering power. A well produced colour which brushed out very smoothly.

PERMANENT
ARTISTS'
WATER COLOR

PB36 CERULEUM BLUE, CHROMIUM (P.150)		
HEALTH ✓ INFO	ASTM I L'FAST	RATING ★★ ★★

CERULEAN BLUE 482

SCHMINCKE

The 'Chromium' version of Cerulean Blue is slightly brighter than PB35, page 149. Both are equally lightfast. An invaluable, opaque colour.

HORADAM
FINEST
ARTISTS'
WATER COLOURS

PB36 CERULEUM BLUE, CHROMIUM (P.150)		
HEALTH ✕ INFO	ASTM I L'FAST	RATING ★★ ★★

INDIGO HUE 479

SCHMINCKE

PB60 is a slightly dull blue leaning towards violet. It has a good reputation for lightfastness. The sample washed out very smoothly. Semi-transparent.

HORADAM
FINEST
ARTISTS'
WATER COLOURS

PB60 INDANTHRONE BLUE (P. 150)		
HEALTH ✕ INFO	WG II L'FAST	RATING ★★ ★★

INDIGO 308

SENNELIER

Almost black in mass tone. Washes out to give a very wide range of values. A convenience colour which is easily mixed. Lightfast.

EXTRA-FINE
ARTISTS'
WATER COLOURS

PBk 7 CARBON BLACK (P. 256)		
PB15:1 PHTHALOCYANINE BLUE (P. 147)		
HEALTH ✕ INFO	ASTM II L'FAST	RATING ★ ★★

INDIGO 249

DA VINCI PAINTS

A strong, very transparent blue which leans slightly towards green. Brushes out very smoothly from a very dark hue to a subtle tint.

PERMANENT
ARTISTS'
WATER COLOR

PB27 PRUSSIAN BLUE (P. 148)		
PV19 QUINACRIDONE VIOLET (P.130)		
HEALTH ✓ INFO	ASTM II L'FAST	RATING ★★ ★★

INDIGO 112

GRUMBACHER

Sample not provided.

PB66 Indigo Blue has a very poor reputation for lightfastness. It is unfortunate to see a newly introduced colour which will deteriorate on exposure to light.

ACADEMY
ARTISTS'
WATERCOLOUR
2ND RANGE

PB66 INDIGO BLUE (P. 150)		
HEALTH ✕ INFO	WG V L'FAST	RATING ★

MANGANESE BLUE 253

DA VINCI PAINTS

Sample was slightly gummy at full strength. This is probably due to the PB33 content. Washed out very smoothly however. A lightfast green-blue

PERMANENT
ARTISTS'
WATER COLOR

PB33 MANGANESE BLUE (P. 149)		
PB15 PHTHALOCYANINE BLUE (P. 147)		
HEALTH ✓ INFO	ASTM II L'FAST	RATING ★ ★★

BLUE TURQUOISE 915

SCHMINCKE

A very well made paint which washed out beautifully over a wide range of values. An excellent all round colour. Semi-opaque and fast to light.

HORADAM
FINEST
ARTISTS'
WATER COLOURS

PB36 CERULEUM BLUE, CHROMIUM (P. 150)		
HEALTH ✕ INFO	ASTM II L'FAST	RATING ★★ ★★

MONESTIAL BLUE 136

ROWNEY

A superb transparent green-blue which gives particularly clear washes. The pigment is most reliable. An excellent colour.

ARTISTS'
WATER COLOUR
2ND RANGE

PB15:3 PHTHALOCYANINE BLUE (P. 147)		
HEALTH ✓ INFO	ASTM II L'FAST	RATING ★★ ★★

GREENS

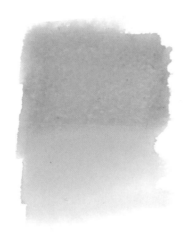

A Short History of Green Pigments

The earliest bright green available was probably the mineral, Malachite. Employed by the early Egyptians, Chinese and Japanese, it remained in use until the end of the 1700's. a coarse pigment with a texture not unlike fine sand.

An ancient pigment still with us is Terre Verte or Green Earth, a dull transparent colour. Found on many early works in India and Italy, it gained great popularity during the Renaissance as an underpainting colour for flesh tones. Many of the better deposits of the green clay from which it is produced have been exhausted.

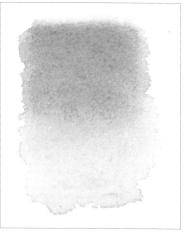

Terre Verte, or Green Earth, is a particularly weak pigment. It lacks 'body' and strength of colour.

When mixing by glazing was widely practised, Terre Verte was often used in the underpainting.

Verdigris, an early bluish green, was a particularly troublesome colorant. Alternatives were not always available.

A type of Verdigris is formed when copper is exposed to the acids of the atmosphere, as on the roof of this Cathedral.

Verdigris, a blue - green acetate of copper, dates back to the early Greeks. It was always a troublesome material to use as it was susceptible to moisture, reacted badly with many other pigments and was blackened by the gases of the atmosphere.

Many of the dull browns that we tend to admire on Renaissance paintings started life as rich blue - greens. The Verdigris with which they were painted darkened and changed colour due to a variety of factors.

During the 13th Century suitable substitute greens were discovered and rapidly developed.

Poisonous Emerald Green, responsible for the death of many artists in the recent past is hopefully now obsolete. The name is still retained by many colourmen for substitute mixes. The genuine article was not only highly poisonous but was also incompatible with many other pigments, and darkened when exposed to metals and air. Not the best of pigments.

A particularly valuable artists' pigment made available in 1862 was Viridian, a bright, cool, very transparent permanent colour. Phthalocyanine Green, very similar in hue has not replaced Viridian as many artists find it a little harsh.

Sap Green, produced from berries, was particularly fugitive. Many modern imitations are little better.

The most important of these were Sap and Iris Green. Sap Green, prepared form Buckthorn berries, gave a fairly versatile but impermanent colour. The name is still retained for various pre-mixed greens.

Cool, bluish, Cobalt Green has been available since the 19th Century. Its cost and poor covering power has led to a gradual decline in its popularity since the 1900's.

Low in tinctorial power, Chromium Green Oxide has remained a favourite with many due to its cool muted colour and permanence.

We are indeed fortunate to have a range of reliable green pigments available to us. Pigments which are far superior to those available to earlier genera-

tions. Considering that we have lightfast greens and equally reliable blues and yellows with which to mix them, it is astounding to discover the number of

green watercolours which are quite unsuitable for artistic use. Hopefully time and awareness will remove them from the paint stands.

MODERN GREEN PIGMENTS

BRILLIANT GREEN

A reasonably bright, mid to bluish green. Primarily used for printing inks where its high tinctorial strength, clean colour and transparency are valued. The fact that it has very poor fastness to light is of secondary importance to the printer. However, this factor might mean a great deal to the artist. The colour can be mixed easily and there are reliable alternatives available. Your work need not suffer. The parent dye is Basic Green 1.

Exposure to light quickly faded the thinner wash and darkened the colour in mass tone. Poor alkali resistance also. Most unreliable.

COMMON NAME

BRILLIANT GREEN

COLOUR INDEX NAME
PG1

COLOUR INDEX NUMBER
42040 : 1

CHEMICAL CLASS
TRIPHENLYMETHANE. PTMA

PERMANENT GREEN

PG2 is a rather bright mid-green. Lightfastness is very poor. Thinly applied layers will fade and discolour, heavier applications darken and also discolour. Poor alkali resistance in addition to poor lightfastness. With such obvious and well known failings, it is surprising that such a substance is used in artists' paints. Easily duplicated on the palette using more reliable pigments. The parent dyes are Basic Green 1 and Basic Yellow 1.

Not yet subjected to ASTM testing. Our sample deteriorated rapidly as shown above. Particularly unreliable.

COMMON NAME

PERMANENT GREEN

COLOUR INDEX NAME
PG2

COLOUR INDEX NUMBER
42040 & 49005 : 1

CHEMICAL CLASS
BLEND OF PG1 AND PY18, BOTH PTMA

PHTHALOCYANINE GREEN

Produced by the further processing of Phthalocyanine Blue. Can be a little more expensive than the latter due to this extra step. This clear blue - green is noted for its high strength and purity of colour. Its resistance properties to practically everything are excellent. In texture it is traditionally rather hard, but softer versions are now available. Particularly transparent, it gives very clear, clean washes on dilution. Very high in tinting strength.

Absolutely lightfast with an ASTM rating of I as a watercolour. A superb pigment all round.

COMMON NAME

PHTHALOCYANINE GREEN

COLOUR INDEX NAME
PG7

COLOUR INDEX NUMBER
74260

CHEMICAL CLASS
CHLORINATED COPPER PHTHALOCYANINE

HOOKER'S GREEN

A dull yellowish green which takes on a blackish appearance when applied heavily. Semi-opaque, it possesses quite good covering power as well as giving reasonable washes. It is a pigment with limited use, being found almost exclusively in watercolours. When tested for lightfastness under ASTM controls, it failed dismally with a rating of IV.

A most unreliable pigment whose poor reputation was re-enforced by controlled testing.

Also Prussian Green.

GREEN GOLD

Green Gold is a very definite yellow - green. Reasonably transparent when well diluted. Lacks 'body' and is rather low in covering power. Although not yet tested as a watercolour, there is every indication that it will do well when it is. When made up into both an acrylic and an oil paint it rated ASTM I, excellent lightfastness. Without the protection of the binder we cannot necessarily expect the same results however.

Considering the findings in other media and the fact that our sample was virtually unaffected by light, I will rate it as II for this book.

GREEN

An all encompassing name, 'Green' is actually a rather dull yellowish to mid - green. There are only two Nitroso pigments available, PG8 and this. Both share the distinction of hope-lessly failing ASTM lightfast testing. As with PG8, PG12 also received a rating of only IV. Such materials are quite unsuit-able for artistic use where light-fastness is a consideration. The parent dye is Acid Green 1.

Exposure to light caused our sample to fade quickly and become even duller in all values.

CHROMIUM OXIDE GREEN

Introduced as an artist's colorant in the mid 1800's, Chromium Oxide Green has a well deserved place on many a palette. A dull, yellow to mid - green that is completely unaffected by light. Reasonably strong in tinctorial power, it will successfully soften and cool other colours. Noted for its opacity, it has very good covering power. Unaffected by acids, alkalis, heat or light, it is a thoroughly reliable pigment.

Received a rating of I as a watercolour following ASTM testing. An excellent all round pigment valued for its great permanence and opacity.

VIRIDIAN

A bright, clear, mid to bluish green. Very transparent, it is highly valued as a glazing colour. Being fairly high in tinting strength it will readily play its part in any mix. When applied in thin washes the true beauty of this pigment is revealed, laid on thickly it takes on a dull almost blackish appearance. An excellent pigment, in use since the mid 1800's.

As a watercolour it gained an ASTM rating of I. Viridian is a first rate pigment that would be difficult to fault.

COBALT GREEN

First introduced as an artist's pigment in 1835. It was once a very popular and fashionable colorant. Cobalt Green has declined in use since the turn of the century. Many of today's artists find that its lack of body, cost and low tinting strength make it easily dispensable. A rather dull, bluish green . Semi-opaque to semi-transparent. Rated I following ASTM testing as a watercolour.

Lightfast but lacks body and tinting strength. Not alkali proof.

GREEN EARTH / TERRE VERTE

A naturally occurring green clay which is mined from open pits. Deposits are found in many parts of the world and vary in colour. After selection, the clay is ground and carefully washed. Nowadays the colour is often hightened by the introduction of a green dye or pigment. Very low in tinting strength and reasonably transparent unless heavy. With very little body it makes into a rather gummy watercolour. A dull greyed green.

When unadulterated this pigment has excellent light-fastness. The blending in of fugitive pigments can cause severe problems.

L/FAST W/GUIDE I

COMMON NAME

GREEN EARTH/ TERRE VERTE

COLOUR INDEX NAME

PG23

COLOUR INDEX NUMBER

77009

CHEMICAL CLASS

FERROUS SILICATE WITH CLAY. INORGANIC

PHTHALOCYANINE GREEN

Pigment Green 36 extends the range of the Phthalocyanine greens. Pigment Green 7, covered on page 177 is a bluish - green whereas PG36 varies from a mid-green to a yellow - green. Available in a variety of types, 2Y, 3Y and 4Y. Each being yellower than the last. The types are not mentioned by paint manufacturers. A particularly transparent pigment giving very clear washes. May bronze if applied heavily.

ASTM I in oils and acrylics but not yet tested in watercolour. Our sample was unaffected by light. Rated WG I pending further testing.

L/FAST W/GUIDE I

COMMON NAME

PHTHALOCYANINE GREEN

COLOUR INDEX NAME

PG36

COLOUR INDEX NUMBER

74265

CHEMICAL CLASS

CHLORINATED & BROMINATED PHTHALOCYANINE

LIGHT GREEN OXIDE

A mid green of low tinting strength. Its weakness can be a drawback in mixing as it is easily swamped by many other colours. I am often asked about proportions of colours to use when mixing. It cannot come down to any sort of formula, as the strength of the different pigments varies enormously. An opaque pigment, PG50 covers well in heavier applications. Thin washes are only moderately transparent.

An ASTM rating of I in oils and acrylics is an encouraging indicator. As our sample was unaffected I will rate it as II for this publication.

L/FAST W/GUIDE II

COMMON NAME

LIGHT GREEN OXIDE

COLOUR INDEX NAME

PG50

COLOUR INDEX NUMBER

77377

CHEMICAL CLASS

OXIDES OF NICKEL, COBALT AND TITANIUM

GREEN
WATERCOLOURS

GREEN WATERCOLOURS

6.1 Cadmium Green

A green mixed by the colourmen from Cadmium Yellow and either Viridian or Phthalocyanine Green.

It is absolutely lightfast and usually handles well.

No more than a convenience colour, it is easily reproduced by the artist. Such mixes on the palette are usually brighter than the machine - blended versions.

Easily mixed from standard colours.

OLD HOLLAND

CADMIUM GREEN LIGHT 424

Sample provided was overbound and difficult to use unless very thin. Reliable ingredients. Semi-transparent.

PY37 CADMIUM YELLOW MEDIUM OR DEEP (P. 33)
PG18 VIRIDIAN (P. 179)

CLASSIC WATERCOLOURS

HEALTH	ASTM	RATING
✕ INFO	I L'FAST	★★

PĒBĒO

LIGHT CADMIUM GREEN 336

Absolutely lightfast ingredients, made up into a watercolour that brushed out very well. Easily mixed. Semi-opaque.

PY35 CADMIUM YELLOW LIGHT (P. 33)
PG7 PHTHALOCYANINE GREEN (P. 177)

FRAGONARD ARTISTS' WATER COLOUR

HEALTH	ASTM	RATING
✕ INFO	I L'FAST	★★

HOLBEIN

CADMIUM GREEN PALE 664

Excellent ingredients give a very smooth, easily duplicated bright green.

PG18 VIRIDIAN (P. 179)
PY37 CADMIUM YELLOW MEDIUM OR DEEP (P. 33)

ARTISTS' WATER COLOR

HEALTH	ASTM	RATING
✕ INFO	I L'FAST	★★

MAIMERI

CADMIUM GREEN 558

Not a unique colour but a simple mix of standard colours. Washed out very well. Semi-opaque.

PY37 CADMIUM YELLOW MEDIUM OR DEEP (P. 33)
PG7 PHTHALOCYANINE GREEN (P. 177)

ARTISTI EXTRA-FINE WATERCOLOURS

HEALTH	ASTM	RATING
✕ INFO	I L'FAST	★★

SENNELIER

CADMIUM GREEN 823

Such greens are easily mixed, either from these ingredients or a Lemon Yellow and Cerulean. Reliable. Semi-opaque.

PY37 CADMIUM YELLOW MEDIUM OR DEEP (P. 33)
PG7 PHTHALOCYANINE GREEN (P. 177)

EXTRA-FINE ARTISTS' WATER COLOURS

HEALTH	ASTM	RATING
✕ INFO	I L'FAST	★★

HOLBEIN

CADMIUM GREEN DEEP 665

Reliable ingredients giving a green which is easy to mix on the palette. Semi-transparent.

PY37 CADMIUM YELLOW MEDIUM OR DEEP (P. 33)
PG18 VIRIDIAN (P. 179)
PG7 PHTHALOCYANINE GREEN (P. 177)

ARTISTS' WATER COLOR

HEALTH	ASTM	RATING
✕ INFO	I L'FAST	★★

OLD HOLLAND

CADMIUM GREEN DEEP 425

If you have the 'Light' version add a little more Viridian and you will have the 'Deep'. Reliable. Semi-transparent.

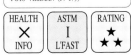

PY37 CADMIUM YELLOW MEDIUM OR DEEP (P. 33)
PG18 VIRIDIAN (P. 179)

CLASSIC WATERCOLOURS

HEALTH	ASTM	RATING
✕ INFO	I L'FAST	★★

Instruments are required for accurate assessment of transparency. However you might wish to decide on a colour for yourself.

A simple and effective method is to paint out an area over a black line. As the information will be for your own use I suggest that you apply the paint as you would work. Usually a light to medium wash. If the line is obliterated the paint is opaque, if it shows clearly you have a transparent watercolour. In these examples the colour to the left is transparent, that to the right appears to be semi - transparent.

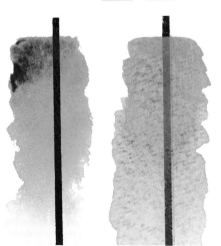

6.2 Chrome Green

Originally produced by blending Chrome Yellow and Prussian Blue. It was available in a wide range of greens. Unreliable as a watercolour, the yellow component usually darkening.

Today the name is used to market simple mixes which are easily produced on the palette.

As I point out in my book 'Blue and Yellow Don't Make Green', control of colour mixing is only possible when the artist knows exactly what is happening *within* the mix. When it is realised that the 'three primary system' is an unworkable invention - and a new approach is taken - greens such as these can be mixed with ease.

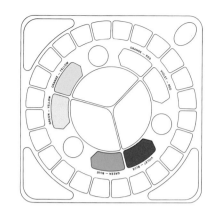

PHTHALO GREEN LIGHT 805

SENNELIER

The name has recently been changed from 'Chrome Green Light'. The fugitive PY1 will ensure fading on exposure. Semi-transparent.

PG7 PHTHALOCYANINE GREEN (P. 177)
PY1 ARYLIDE YELLOW G (P. 29)

EXTRA-FINE ARTISTS' WATER COLOURS

HEALTH	ASTM	RATING
✕ INFO	V L'FAST	★

CHROME GREEN 1 (IMITATION) 520

LEFRANC & BOURGEOIS

A powerful colour which will quickly influence other paints in a mix. Washes out smoothly. Transparent.

PB15 PHTHALOCYANINE BLUE (P. 147)
PY3 ARYLIDE YELLOW 10G (P. 29)

LINEL EXTRA-FINE ARTISTS' WATERCOLOUR

HEALTH	ASTM	RATING
✕ INFO	II L'FAST	★★

PHTHALO GREEN DEEP 807

SENNELIER

Name recently changed from 'Chrome Green Deep'. A powerful colour which can quickly dominate a painting. Transparent.

PB15:3 PHTHALO BLUE (P. 147)
PG7 PHTHALOCYANINE GREEN (P. 177)

EXTRA-FINE ARTISTS' WATER COLOURS

HEALTH	ASTM	RATING
✕ INFO	II L'FAST	★★

6.3 Chromium Oxide Green

A superb pigment. It is absolutely lightfast and is unaffected by acids, alkali, heat or cold. Reasonably strong in tinting power and particularly opaque.

Introduced about 1862 as an artist's pigment, it has become a firm favourite with many painters.

Similar greens can be mixed from an orange - yellow (such as Cadmium Yellow) and a violet - blue (Ultramarine) with perhaps a little red.

Such mixes however, will not have quite the same properties of hue or opacity.

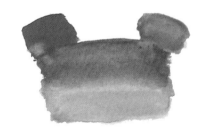

Provides soft, opaque muted greens when mixed with an opaque green - blue such as Cerulean Blue.

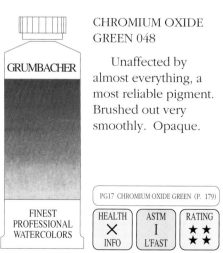

CHROMIUM OXIDE GREEN 048

GRUMBACHER

Unaffected by almost everything, a most reliable pigment. Brushed out very smoothly. Opaque.

PG17 CHROMIUM OXIDE GREEN (P. 179)

FINEST PROFESSIONAL WATERCOLORS

HEALTH	ASTM	RATING
✕ INFO	I L'FAST	★★ ★★

OXIDE OF CHROMIUM 459 (072)

WINSOR & NEWTON

A smooth, well produced watercolour. Very pleasant to use. Reasonably strong tinctorially. Absolutely lightfast. Opaque.

PG17 CHROMIUM OXIDE GREEN (P. 179)

ARTISTS' WATER COLOUR

HEALTH	ASTM	RATING
✕ INFO	I L'FAST	★★

CHROMIUM OXIDE GREEN 166

BINNEY & SMITH

PG17 makes into a very smooth watercolour, which is a pleasure to use. A reliable dull green. Opaque.

PG17 CHROMIUM OXIDE GREEN (P. 179)

PROFESSIONAL ARTISTS' WATER COLOR

HEALTH	ASTM	RATING
✓ INFO	I L'FAST	★★

CHROMIUM OXYDE GREEN 815

SENNELIER

Sample brushed out particularly well. Opaque, with good covering power yet thin washes are reasonably transparent.

PG17 CHROMIUM OXIDE GREEN (P. 179)

EXTRA-FINE ARTISTS' WATER COLOURS

HEALTH	ASTM	RATING
✓ INFO	I L'FAST	★★ ★★

CHROMIUM OXIDE GREEN 668

TALENS

Heavier applications somewhat difficult as sample rather overbound. Brushed out well thinner. Absolutely lightfast. Opaque.

PG17 CHROMIUM OXIDE GREEN (P. 179)

REMBRANDT ARTISTS' WATER COLOUR

HEALTH	ASTM	RATING
✗ INFO	I L'FAST	★★

GREEN OXIDE OF CHROMIUM 542

LEFRANC & BOURGEOIS

Particularly well made. Brushed out beautifully into very smooth washes. Absolutely lightfast. Opaque.

PG17 CHROMIUM OXIDE GREEN (P. 179)

LINEL EXTRA-FINE ARTISTS' WATERCOLOUR

HEALTH	ASTM	RATING
✓ INFO	I L'FAST	★★ ★★

OXIDE OF CHROME OPAQUE 1153

LUKAS

Very pleasant to use. Washed out very smoothy. Possesses good covering power and is reasonably strong. Opaque.

PG17 CHROMIUM OXIDE GREEN (P. 179)

ARTISTS' WATER COLOUR

HEALTH	ASTM	RATING
✗ INFO	I L'FAST	★★ ★★

CHROME OXIDE 2083

MARTIN F.WEBER

Brushed out reasonably well. Pigment resists light, heat, acids and alkalis. Most reliable. Opaque.

PG17 CHROMIUM OXIDE GREEN (P. 179)

PERMALBA ARTIST'S WATER COLOR AQUARELLE

HEALTH	ASTM	RATING
✓ INFO	I L'FAST	★★

CHROMIUM OXIDE GREEN (OPAQUE) 048

GRUMBACHER

Sample was overbound. Fine for lighter washes but difficult at full strength. Absolutely lightfast. Opaque.

PG17 CHROMIUM OXIDE GREEN (P. 179)

ACADEMY ARTISTS' WATERCOLOUR 2ND RANGE

HEALTH	ASTM	RATING
✓ INFO	I L'FAST	★ ★★

6.4 Cobalt Green

Invented by the Swedish chemist Rinmann in 1780. It was not until the 19th Century that the pigment was produced in commercial quantities. Once a much sought after and fashionable colour, it has declined in popularity since the end of World War I.

Many painters find that the cost, poor covering ability and often poor handling qualities, make it dispensable.

An unimportant colour which is still quite widely offered. Easily duplicated through mixing.

A slightly bluish - green, mixing complementary is an orange - red.

COBALT GREEN PUR 522

SCHMINCKE

The formula for this colour has recently been completely overhauled. A reliable dull green. Semi-transparent. Was previously called 'Cobalt Green Light'.

PG19 COBALT GREEN (P. 179)
PREVIOUSLY PW4 ZINC WHITE (P. 270),
PB36 CERULEAN BLUE CHR. (P. 150) AND
PG50 LIGHT GREEN OXIDE (P. 180)

HORADAM FINEST ARTISTS' WATER COLOURS

HEALTH	ASTM	RATING
✗ INFO	I L'FAST	★ ★

COBALT GREEN 324

ROWNEY

Stated ingredients are absolutely lightfast, yet our sample became bluer and paler on exposure. No assessments offered.

PG19 COBALT GREEN (P. 179)

ARTISTS' WATER COLOUR

HEALTH
✓ INFO

COBALT GREEN 663

HOLBEIN

A mix of ingredients which do not include PG19, Cobalt Green. The name is surely misleading. Very reliable combination.

PG18 VIRIDIAN (P. 179)
PW6 TITANIUM WHITE (P. 271)
PB28 COBALT BLUE (P. 148)

ARTISTS' WATER COLOR

HEALTH	ASTM	RATING
✗ INFO	I L'FAST	★ ★★

COBALT GREEN 184 (067)

WINSOR & NEWTON

PG19 is rather weak and lacking in body. It would seem that this factor leads to very gummy watercolours. This example is no exception. Paints out poorly. Semi-transparent.

ARTISTS' WATER COLOUR

PG19 COBALT GREEN (P. 179)

HEALTH	ASTM	RATING
✕ INFO	I L'FAST	★★

COBALT GREEN 610

TALENS

Sample lacked body and was rather gummy. This seems to be normal for genuine Cobalt Green. Semi-transparent.

REMBRANDT ARTISTS' WATER COLOUR

PG19 COBALT GREEN (P. 179)

HEALTH	ASTM	RATING
✕ INFO	I L'FAST	★★

COBALT GREEN 856

SENNELIER

All of the stated ingredients are absolutely lightfast, yet our sample faded to a marked extent on exposure. No assessments can be offered until further testing.

EXTRA-FINE ARTISTS' WATER COLOURS

PG7 PHTHALOCYANINE GREEN (P. 177)
PB28 COBALT BLUE (P. 148)
PW6 TITANIUM WHITE (P. 271)

HEALTH		
✓ INFO		

COBALT GREEN 556

MAIMERI

As with other watercolours employing PG19, our sample lacked body and painted out poorly. Semi-opaque.

ARTISTI EXTRA-FINE WATERCOLOURS

PG19 COBALT GREEN (P. 179)

HEALTH	ASTM	RATING
✕ INFO	I L'FAST	★★

COBALT GREEN DEEP 523

SCHMINCKE

A rather dull, deep green results from this cocktail of pigments. Brushed out well. Reliable ingredients. Semi-transparent.

HORADAM FINEST ARTISTS' WATER COLOURS

PG50 LIGHT GREEN OXIDE (P. 180)
PG19 COBALT GREEN (P. 179)
PB29 ULTRAMARINE BLUE (P. 149)
PG17 CHROMIUM OXIDE GREEN (P. 179)

HEALTH	WG	RATING
✕ INFO	II L'FAST	★ ★★

Rather weak and lacking in 'body'. Cobalt Green tends to be difficult to brush out, unless in very thin washes.

6.5 Emerald Green

The original Emerald Green, in general use after 1814, was darkened when mixed with certain other pigments. It also became blacker on contact with several metals and on exposure to the atmosphere. A further drawback was that it often killed the user, being particularly toxic.

In order to disguise the dangerous nature of the pigment, many manufacturers resorted to using fancy names.

At one time in Germany, up to fifty different titles were used to hide the true nature of the pigment. There are many lurid stories linked to Emerald Green.

Today the name has become respectable and is used to market simple mixes. Such greens are very easy to produce on the palette and will often be brighter than the machine-blended version.

EMERALD GREEN 1167

LUKAS

Rather cloudy, as if a little white had been added. Sample was rather gum laden, but brushed out well in thinner application. Semi-transparent.

ARTISTS' WATER COLOUR

PG7 PHTHALOCYANINE GREEN (P. 177)

HEALTH	ASTM	RATING
✕ INFO	I L'FAST	★★

EMERALD GREEN 615

TALENS

Sample closer to a coloured gum than a watercolour paint. A rating is not offered.

REMBRANDT ARTISTS' WATER COLOUR

PG7 PHTHALOCYANINE GREEN (P. 177)
PY3 ARYLIDE YELLOW 10G (P. 29)

HEALTH	ASTM	RATING
✕ INFO	II L'FAST	

EMERALD GREEN 067

GRUMBACHER

A convenience colour, easily mixed. Both pigments are reliable and made into a smooth, transparent watercolour. Semi-transparent.

FINEST PROFESSIONAL WATERCOLORS

PG7 PHTHALOCYANINE GREEN (P. 177)
PY3 ARYLIDE YELLOW 10G (P. 29)

HEALTH	ASTM	RATING
✕ INFO	II L'FAST	★★

EMERALD GREEN 190

BINNEY & SMITH

Reliable and brushed out well. An unimportant colour which is readily mixed. Transparent.

PG7 PHTHALOCYANINE GREEN (P. 177)
PY3 ARYLIDE YELLOW 10G (P. 29)

PROFESSIONAL ARTISTS' WATER COLOR

HEALTH	ASTM	RATING
✓ INFO	II L'FAST	★ ★★

EMERALD GREEN 261

BLOCKX

Emerald Green is a general colour description. If you already have Viridian you will not need it again. Transparent.

PG18 VIRIDIAN (P. 179)

AQUARELLES ARTISTS' WATER COLOUR

HEALTH	ASTM	RATING
✗ INFO	I L'FAST	★ ★★

EMERALD GREEN 847

SENNELIER

Rather 'chalky' for Phthalocyanine Green, as if filler or white had been added. Lightfast. Semi-transparent.

PG36 PHTHALOCYANINE GREEN (P. 180)

EXTRA-FINE ARTISTS' WATER COLOURS

HEALTH	ASTM	RATING
✗ INFO	I L'FAST	★ ★★

EMERALD GREEN (IMITATION) 550

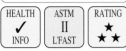

LEFRANC & BOURGEOIS

The name Emerald Green is used to sell any combination which gives a reasonably bright mid-green. Reliable ingredients. Semi-transparent.

PY3 ARYLIDE YELLOW 10G (P. 29)
PW4 ZINC WHITE (P. 270)
PB33 MANGANESE BLUE (P. 149)

LINEL EXTRA-FINE ARTISTS' WATERCOLOUR

HEALTH	ASTM	RATING
✗ INFO	II L'FAST	★ ★★

VERT EMERAUDE (VIRIDIAN) 337

PĒBĒO

A mix of two very similar transparent blue-greens. If you have either, this will be superfluous. Transparent.

PG18 VIRIDIAN (P. 179)
PG7 PHTHALOCYANINE GREEN (P. 177)

FRAGONARD ARTISTS' WATER COLOUR

HEALTH	ASTM	RATING
✗ INFO	I L'FAST	★ ★★

EMERALD GREEN NOVA 670

HOLBEIN

Such colours are easily produced on the palette, either from these or other pigments. Semi-transparent.

PY3 ARYLIDE YELLOW 10G (P. 29)
PG7 PHTHALOCYANINE GREEN (P. 177)
PW6 TITANIUM WHITE (P. 271)

ARTISTS' WATER COLOR

HEALTH	ASTM	RATING
✗ INFO	II L'FAST	★ ★

WINSOR EMERALD 708 (054)

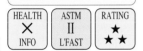

WINSOR & NEWTON

A typical 'Emerald Green'. This, and many similar greens are easily produced with standard colours as you work. Semi-transparent.

PG7 PHTHALOCYANINE GREEN (P. 177)
PY3 ARYLIDE YELLOW 10G (P. 29)
PW4 ZINC WHITE (P. 270)

ARTISTS' WATER COLOUR

HEALTH	ASTM	RATING
✗ INFO	II L'FAST	★ ★★

EMERALD GREEN 545

MAIMERI

An unimportant colour, easily duplicated on the palette. Reliable ingredients. The PW6 (Titanium White) once used has been changed to PW5. Semi-transparent.

PW5 LITHOPONE (P. 270)
PY3 ARYLIDE YELLOW 10G (P. 29)
PG7 PHTHALOCYANINE GREEN (P. 177)

ARTISTI EXTRA-FINE WATERCOLOURS

HEALTH	ASTM	RATING
✗ INFO	II L'FAST	★ ★★

EMERALD GREEN 067

GRUMBACHER

If you desperately need this pre-mixed colour and use this make, the 'Artists Quality' is virtually the same but costs more. Transparent.

PY3 ARYLIDE YELLOW 10G (P. 29)
PG7 PHTHALOCYANINE GREEN (P. 177)

ACADEMY ARTISTS' WATERCOLOUR 2ND RANGE

HEALTH	ASTM	RATING
✓ INFO	II L'FAST	★ ★★

EMERALD GREEN (HUE) 338

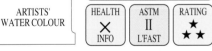

ROWNEY

This colour can be mixed in so many ways that it hardly seems worth having it done for you. Reliable. Semi-transparent.

PW6 TITANIUM WHITE (P. 271)
PY3 ARYLIDE YELLOW 10G (P. 29)
PG7 PHTHALOCYANINE GREEN (P. 177)

GEORGIAN WATER COLOUR 2ND RANGE

HEALTH	ASTM	RATING
✓ INFO	II L'FAST	★ ★

EMERALD GREEN 615

TALENS

Sample was particularly overbound and difficult to work with. Reliable ingredients. Semi-transparent. *This range of colours has recently been discontinued.*

PG7 PHTHALOCYANINE GREEN (P. 177)
PY3 ARYLIDE YELLOW 10G (P. 29)

WATER COLOUR 2ND RANGE

HEALTH	ASTM	RATING
✗ INFO	II L'FAST	★ ★

EMERALD GREEN 627

MAIMERI

A convenience colour. If mixing this yourself do not worry about adding the PW5, it is basically a filler. Washed well. Semi-transparent.

PW5 LITHOPONE (P. 270)
PG7 PHTHALOCYANINE GREEN (P. 177)
PY3 ARYLIDE YELLOW 10G (P. 29)

STUDIO FINE WATER COLOR 2ND RANGE

HEALTH	ASTM	RATING
✗ INFO	II L'FAST	★ ★★

EMERALD 235 (313)

Easily reproduced on the palette. The PW5 is more of a filler than a contributor to the hue. Washes out well. Semi-transparent.

WINSOR & NEWTON

COTMAN WATER COLOUR 2ND RANGE

PW5 LITHOPONE (P. 270)
PY3 ARYLIDE YELLOW 10G (P. 29)
PG7 PHTHALOCYANINE GREEN (P. 177)

HEALTH	ASTM	RATING
✕ INFO	II L'FAST	★ ★★

PHTHALO EMERALD 520

A convenience colour, easily mixed. Brushes out well over the full range. Semi-transparent. *This range of colours has been discontinued.*

REEVES

WATER COLOUR FOR ARTISTS 2ND RANGE

PW5 LITHOPONE (P. 270)
PY3 ARYLIDE YELLOW 10G (P. 29)
PG7 PHTHALOCYANINE GREEN (P. 177)

HEALTH	ASTM	RATING
✕ INFO	II L'FAST	★

The original, genuine Emerald was so poisonous that it was employed as an insecticide and also to remove barnacles from boat hulls. Often used as a colorant for wallpapers. The dust from the paper is thought to have poisoned many people, including, it is speculated, Napoleon.

6.6 Green Earth (Terre Verte)

A green clay dug from open pits at several locations. Varies in colour depending upon the source. Bluish - green from Verona, yellowish from Cyprus and dull, bluish - green from Bohemia. The main deposits of an olive yellow earth are found in Czechoslovakia.

In use since pre-classical times, the best known deposits have long since been dug up and used.

A very weak pigment, it has little influence when mixing. Its lack of body, to my mind makes it unsuitable for use in watercolours, as the paint is invariably overbound. More of a coloured gum, it is only of use in very thin washes. The colour is often strengthened by blending in other pigments.

Amazingly, most of the imitations are also produced with an excess of gum. Perhaps the intention is to duplicate the poor handling qualities of the genuine pigment.

Basic colour mixing skills will enable you to simulate any of the following.

GREEN EARTH 516

A mix of 'Phthalo' Green and Burnt Sienna, easily duplicated on the palette. The consistancy has recently been improved.
Transparent.

SCHMINCKE

HORADAM FINEST ARTISTS' WATER COLOURS

PG7 PHTHALOCYANINE GREEN (P. 177)
PBr7 BURNT SIENNA (P. 212)

HEALTH	ASTM	RATING
✕ INFO	I L'FAST	★ ★★

GREEN EARTH 429

Entire sample was lightly coloured gum. Ingredients were not confirmed. I cannot offer assessments without full information.

OLD HOLLAND

CLASSIC WATERCOLOURS

EARTH COLOURS

HEALTH		
✕ INFO		

GREEN EARTH 137

Quality ingredients, absolutely lightfast. Brushed out very smoothly over the entire range. Should ideally be called 'Green Earth Hue' Semi-transparent.

PĒBĒO

FRAGONARD ARTISTS' WATER COLOUR

PG7 PHTHALOCYANINE GREEN (P. 177)
PR101 MARS RED (P. 89)

HEALTH	ASTM	RATING
✕ INFO	I L'FAST	★★

GREEN EARTH 085

Sample particularly gummy and unpleasant to use. Thin washes only were possible. Ingredients absolutely lightfast. Semi-transparent.

GRUMBACHER

FINEST PROFESSIONAL WATERCOLORS

PBr 7 RAW UMBER (P. 211)
PG18 VIRIDIAN (P. 179)

HEALTH	ASTM	RATING
✕ INFO	I L'FAST	★★

GREEN EARTH 542

Only very weak washes were possible from sample provided. Paint was very gummy. Lightfast. Transparent.

MAIMERI

ARTISTI EXTRA-FINE WATERCOLOURS

PG17 CHROMIUM OXIDE GREEN (P. 179)
PG23 GREEN EARTH /TERRE VERTE (P. 180)

HEALTH	ASTM	RATING
✕ INFO	I L'FAST	★★

VERONA GREEN EARTH 1158

Previous confusion over the pigments used has now been resolved. The sample washed out very smoothly. Reliable ingredients.

LUKAS

ARTISTS' WATER COLOUR

PG7 PHTHALOCYANINE GREEN (P. 177)
PB15 PHTHALOCYANINE BLUE (P. 147)
PY83 DIARYLIDE YELLOW HR70 (P..36)
PBk 7 CARBON BLACK (P. 256)

HEALTH	WG	RATING
✕ INFO	II L'FAST	★ ★★

TERRE VERTE 637 (048)

WINSOR & NEWTON

Ingredients are reliable but the sample was very gummy, weak and unpleasant to use. Transparent.

PG23 GREEN EARTH /TERRE VERTE (P. 180)
PG18 VIRIDIAN (P. 179)

ARTISTS' WATER COLOUR

HEALTH	ASTM	RATING
✕ INFO	I L'FAST	★ ★

TERRE VERTE 483

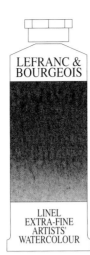

LEFRANC & BOURGEOIS

Sample was most unpleasant to use, a little like painting with wet, raw pastry. Reliable ingredients. Semi-transparent.

PBr7 RAW UMBER (P. 21)
PG36 PHTHALOCYANINE GREEN (P. 180)

LINEL EXTRA-FINE ARTISTS' WATERCOLOUR

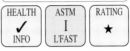

HEALTH	ASTM	RATING
✓ INFO	I L'FAST	★

TERRE VERTE 213

SENNELIER

This pigment simply refuses to make up into a paint which is not gummy and weak. Re-formulated but still difficult to work with. Transparent.

PG23 GREEN EARTH /TERRE VERTE (P. 180)

EXTRA-FINE ARTISTS' WATER COLOURS

HEALTH	WG	RATING
✕ INFO	I L'FAST	★

TERRE VERTE HUE 214

BINNEY & SMITH

I cannot see how the stated ingredients would give other than a dark orange brown. Sample was gummy and weak.

PBr7 BURNT SIENNA (P. 212)
PBk9 IVORY BLACK (P. 257)

PROFESSIONAL ARTISTS' WATER COLOR

HEALTH	ASTM	RATING
✕ INFO	I L'FAST	★ ★

TERRE VERTE 629

TALENS

Fine in very thin washes, impossible to use in heavier applications. Paint lacked body, (and spirit). Semi-transparent.

PG23 GREEN EARTH /TERRE VERTE (P. 180)

REMBRANDT ARTISTS' WATER COLOUR

HEALTH	WG	RATING
✕ INFO	I L'FAST	★

TERRE VERTE 672

HOLBEIN

This would seem to be mainly PG17, a fine dense pigment. Brushed out very well, despite the inclusion of PG23.

PG23 GREEN EARTH /TERRE VERTE (P. 180)
PG17 CHROMIUM OXIDE GREEN (P. 179)

ARTISTS' WATER COLOR

HEALTH	ASTM	RATING
✕ INFO	I L'FAST	★ ★

TERRE VERTE 161

BLOCKX

I presume that the first pigment is PG23. The paint certainly behaved as if it is. Weak and unpleasant to use. Semi-transparent.

GREEN NATURAL PURE EARTH
PY42 MARS YELLOW (P. 34)

AQUARELLES ARTISTS' WATER COLOUR

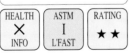

HEALTH	ASTM	RATING
✕ INFO	I L'FAST	★ ★

TERRE VERTE (HUE) 379

ROWNEY

The consistency of this colour has been very much improved over earlier examples. A lightfast, imitation Terre Verte which handles well.

PG18 VIRIDIAN (P. 179)
PY42 MARS YELLOW (P. 42)

ARTISTS' WATER COLOUR

HEALTH	ASTM	RATING
✕ INFO	I L'FAST	★ ★

GREEN EARTH 623

MAIMERI

PG23 strengthened with a little PG17. A most unpleasant paint to handle, weak and overbound. Transparent.

PG23 GREEN EARTH /TERRE VERTE (P. 180)
PG17 CHROMIUM OXIDE GREEN (P. 179)

STUDIO FINE WATER COLOR 2ND RANGE

HEALTH	ASTM	RATING
✕ INFO	I L'FAST	★ ★

GREEN EARTH 085

GRUMBACHER

It seems that whatever ingredients are used, a weak, soap like paint is the desired result.

PBr7 RAW UMBER (P. 211)
PG18 VIRIDIAN (P. 179)

ACADEMY ARTISTS' WATERCOLOUR 2ND RANGE

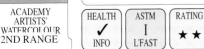

HEALTH	ASTM	RATING
✓ INFO	I L'FAST	★ ★

6.7 Hooker's Green

Originally this was an inferior watercolour paint produced by blending Prussian Blue and Gamboge. The Gamboge faded and the green turned blue as only the Prussian Blue was left.

Nowadays it is still often an inferior, and at best, unnecessary mix of standard colours. There is in fact now a pigment called Hooker's Green, it failed ASTM testing dismally and is not worth considering.

Having examined the contributing pigments used in the modern versions of this colour, I have come to the conclusion that the only limit is the imagination of the blender and the range of pigments which are on hand.

Do not consider any of the Hooker's Greens to be unique in any way, they are easily reproduced using reliable ingredients.

With basic colour mixing skills any of the following can be mixed with ease. Even without such skills you can see the colours that have been used to pre-mix them.

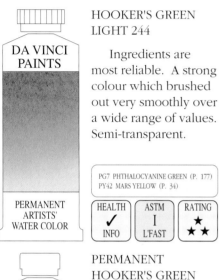

DA VINCI PAINTS

PERMANENT ARTISTS' WATER COLOR

HOOKER'S GREEN LIGHT 244

Ingredients are most reliable. A strong colour which brushed out very smoothly over a wide range of values. Semi-transparent.

PG7 PHTHALOCYANINE GREEN (P. 177)
PY42 MARS YELLOW (P. 34)

HEALTH	ASTM	RATING
✓ INFO	I L'FAST	★★

GRUMBACHER

FINEST PROFESSIONAL WATERCOLORS

HOOKER'S GREEN LIGHT 107

Completely re-formulated from a fugitive to a lightfast colour. Semi-transparent. As a sample was not provided I cannot offer a rating.

PB15:3 PHTHALO. BLUE (P.147) - PG7 PHTHALO GREEN (P.177) - PY153 NICKEL DIOX. YELL. (P. 38) & PY154 BENZ.Y (P. 39) PREVIOUSLY ALSO PY1 (P. 29) & PO1 (P.68)

HEALTH	WG	
✗ INFO	II L'FAST	

PĒBĒO

FRAGONARD ARTISTS' WATER COLOUR

HOOKER'S GREEN LIGHT 244

A yellowish green which moves towards a blue-green as the PY74 content fades. Such colours are easily mixed from reliable ingredients. Semi-transparent.

PG7 PHTHALOCYANINE GREEN (P. 177)
PY 74LF ARYLIDE YELLOW 5GX (P. 36)
PY65 ARYLIDE YELLOW RN (P. 36)

HEALTH	ASTM	RATING
✗ INFO	III L'FAST	★★

BINNEY & SMITH

PROFESSIONAL ARTISTS' WATER COLOR

PERMANENT HOOKER'S GREEN LIGHT HUE 225

The PY74LF is the weak link here. It will tend to fade on exposure, making the colour lighter and less yellow. Semi-transparent.

PG7 PHTHALOCYANINE GREEN (P. 177)
PY 74LF ARYLIDE YELLOW 5GX (P. 36)
PBk9 IVORY BLACK (P. 257)

HEALTH	ASTM	RATING
INFO	III L'FAST	★★

TALENS

REMBRANDT ARTISTS' WATER COLOUR

HOOKER GREEN LIGHT 644

Produced with reliable pigments. A reasonably strong colour which handled very smoothly over the full range. Semi-transparent.

PG7 PHTHALOCYANINE GREEN (P. 177)
PBr7 BURNT SIENNA (P. 211)
PY3 ARYLIDE YELLOW 10G (P. 29)

HEALTH	ASTM	RATING
✗ INFO	II L'FAST	★★

WINSOR & NEWTON

ARTISTS' WATER COLOUR

HOOKER'S GREEN LIGHT 314 (022)

The confirmed ingredients give a paint which will have a very short life on exposure to light. Most unsuitable for artistic expression.

PG12 GREEN (P. 178)
PY100 TARTRAZINE LAKE (P. 37)

HEALTH	ASTM	RATING
✗ INFO	V L'FAST	★

REEVES

WATER COLOUR FOR ARTISTS 2ND RANGE

HOOKERS GREEN PALE 315

Sample faded and discoloured at an alarming rate. Both pigments are known to have a short life. Semi-transparent.
Range discontinued

PY100 TARTRAZINE LAKE (P. 37)
PG12 GREEN (P. 178)

HEALTH	ASTM	RATING
✗ INFO	V L'FAST	★

WINSOR & NEWTON

COTMAN WATER COLOUR 2ND RANGE

HOOKER'S GREEN LIGHT 314 (317)

A disastrous combination of short lived pigments. Easily duplicated using reliable ingredients. Semi-transparent.

PG12 GREEN (P. 178)
PY100 TARTRAZINE LAKE (P. 37)

HEALTH	ASTM	RATING
✗ INFO	V L'FAST	★

GRUMBACHER

ACADEMY ARTISTS' WATERCOLOUR 2ND RANGE

HOOKER'S GREEN LIGHT 107

Despite promises, a sample was not provided. Rated on given ingredients only.

PY1 ARYLIDE YELLOW G (P. 29)
PG8 HOOKER'S GREEN (P. 178)

HEALTH	ASTM	RATING
✓ INFO	V L'FAST	★

HOOKER'S GREEN No 1 353

ROWNEY
ARTISTS' WATER COLOUR

Had the PY100 not been added this would have been a perfectly lightfast colour. Rapidly fades and discolours. Semi-transparent.

PG7 PHTHALOCYANINE GREEN (P. 177)
PY100 TARTRAZINE LAKE (P. 37)
PY42 MARS YELLOW (P. 34)

HEALTH	ASTM	RATING
✓	V	★
INFO	L'FAST	

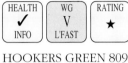

HOOKER'S GREEN No 2 354

ROWNEY
ARTISTS' WATER COLOUR

Sample faded as a tint and became very dark and discoloured in mass tone. Not worth considering for artistic use.

PG2 PERMANENT GREEN (P. 177)

HEALTH	WG	RATING
✓	V	★
INFO	L'FAST	

HOOKER'S GREEN 1 520

SCHMINCKE
HORADAM FINEST ARTISTS' WATER COLOURS

A most unreliable pigment used. It has failed all tests for which I have records.

The company are now in the process of reformulating this colour.

PG8 HOOKER'S GREEN (P. 178)

HEALTH	ASTM	RATING
✗	IV	★
INFO	L'FAST	

HOOKER'S GREEN 2 521

SCHMINCKE
HORADAM FINEST ARTISTS' WATER COLOURS

Strong, deep green easily mixed on the palette. Reliable ingredients gave a paint which brushes out very well. Semi-transparent.

PY42 MARS YELLOW (P. 34)
PB15:3 PHTHALO BLUE (P. 147)
PG7 PHTHALOCYANINE GREEN (P. 177)

HEALTH	ASTM	RATING
✗	II	★★
INFO	L'FAST	

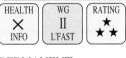

HOOKERS GREEN 809

SENNELIER
EXTRA-FINE ARTISTS' WATER COLOURS

Completely reformulated and transformed from a fugitive colour to a reliable one. The PY13 which once let the colour down has been removed.

PG7 PHTHALOCYANINE GREEN (P.177)
PY83 DIARYLIDE YELLOW HR 70 (P.36)
WAS PREVIOUSLY PY13 (P. 30)
PG7 (P. 177) AND PY43 (P. 35)

HEALTH	WG	RATING
✗	II	★★
INFO	L'FAST	

PERMANENT HOOKER'S GREEN 5717

HUNTS
SPEEDBALL PROFESSIONAL WATERCOLOURS

I cannot offer assessments as the description 'Hansa Yellow Pigment' is quite meaningless. Which Hansa Yellow?

HANSA YELLOW PIGMENT AND COPPER PHTHALOCYANINE

HEALTH		
✗		
INFO		

HOOKER'S GREEN 1170

LUKAS
ARTISTS' WATER COLOUR

PR176 and PO62 have since been added. Handling is very much improved. A reliable, deep green which washes out very well.

PG7 PHTHALO GREEN. (P.177) - PB15 PHTHALO BLUE (P. 147) - PR176 BENZ. CAR.(P.94) AND PO62 BENZ. ORANGE (P.70)

HEALTH	WG	RATING
✗	II	★★
INFO	L'FAST	

PERMANENT HOOKER'S GREEN HUE 224

BINNEY & SMITH
PROFESSIONAL ARTISTS' WATER COLOR

PY74LF, an unreliable pigment, could cause a deterioration of the colour on exposure. Use with caution. Semi-opaque.

PY 74LF ARYLIDE YELLOW 5GX (P. 36)
PBk9 IVORY BLACK (P. 257)
PG7 PHTHALOCYANINE GREEN (P. 177)

HEALTH	ASTM	RATING
✓	III	★★
INFO	L'FAST	

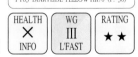

HOOKER'S GREEN 675

HOLBEIN
ARTISTS' WATER COLOR

The yellow content faded in our sample, causing a marked colour change. Moved towards a mid green and became duller. Semi-transparent.

PG36 PHTHALOCYANINE GREEN (P. 180)
PY83 DIARYLIDE YELLOW HR70 (P. 36)

HEALTH	WG	RATING
✗	III	★★
INFO	L'FAST	

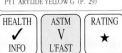

HOOKER'S GREEN 533

LEFRANC & BOURGEOIS
LINEL EXTRA-FINE ARTISTS' WATERCOLOUR

Colour will move towards a mid-green and became paler. PY1 is most unreliable and will cause the damage. Semi-transparent.

PG36 PHTHALOCYANINE GREEN (P. 180)
PY1 ARYLIDE YELLOW G (P. 29)

HEALTH	ASTM	RATING
✓	V	★
INFO	L'FAST	

HOOKERS GREEN 2077

MARTIN F.WEBER
PERMALBA ARTIST'S WATER COLOR AQUARELLE

Previously contained the disastrous PG8, Hooker's Green, and was unsuitable for serious work. Now reformulated and is most reliable. Semi-trans.

PG7 PHTHALOCYANINE GREEN (P.177)
PY3 ARYLIDE. YELL. (P.29) AND *PBr7*
PREVIOUSLY PG8 HOOKERS GREEN (P.178)

HEALTH	ASTM	RATING
✓	II	★★
INFO	L'FAST	

HOOKER'S GREEN 264

BLOCKX
AQUARELLES ARTISTS' WATER COLOUR

Quickly moves from a yellow to a mid-green as the PY1 fades. This particular yellow is well known for its failings. Transparent.

PG18 VIRIDIAN (P. 179)
PY1 ARYLIDE YELLOW G (P. 29)

HEALTH	ASTM	RATING
✗	V	★
INFO	L'FAST	

ROWNEY
GEORGIAN WATER COLOUR 2ND RANGE

HOOKER'S GREEN 352

From stated ingredients I would have expected the colour to become brighter as the red faded. Instead it became far darker and greyer.

PR83:1 ALIZARIN CRIMSON (P. 88)
PG7 PHTHALOCYANINE GREEN (P. 177)
PY3 ARYLIDE YELLOW 10G (P. 29)

HEALTH	ASTM	RATING
✓ INFO	IV L'FAST	★

TALENS
REMBRANDT ARTISTS' WATER COLOUR

HOOKER GREEN DEEP 645

Lightfast ingredients. Paint brushed very smoothly into even washes. Easily mixed convenience colour. Semi-transparent.

PY3 ARYLIDE YELLOW 10G (P. 29)
PBr7 BURNT SIENNA (P. 211)
PG7 PHTHALOCYANINE GREEN (P. 177)

HEALTH	ASTM	RATING
✕ INFO	II L'FAST	★★

WINSOR & NEWTON
ARTISTS' WATER COLOUR

HOOKER'S GREEN DARK 312 (021)

Pigment Green 12 failed ASTM testing dismally. Colour will deteriorate on exposure to light. Not for serious work. Semi-transparent.

PG7 PHTHALOCYANINE GREEN (P. 177)
PG12 GREEN (P. 178)

HEALTH	ASTM	RATING
✕ INFO	IV L'FAST	★

PĒBĒO
FRAGONARD ARTISTS' WATER COLOUR

HOOKER'S GREEN DARK 245

On exposure the colour will move from a yellow to a midgreen, as the PY74 content fades. Use with caution.

PY 74LF ARYLIDE YELLOW 5GX (P. 36)
PY65 ARYLIDE YELLOW RN (P. 36)
PB15 PHTHALOCYANINE BLUE (P. 147)

HEALTH	ASTM	RATING
✕ INFO	III L'FAST	★★

GRUMBACHER
FINEST PROFESSIONAL WATERCOLORS

HOOKER'S GREEN DEEP 106

The use of PY1, a most unsuitable yellow, will ensure damage to the colour when exposed to light. Semi-transparent.

PB15 PHTHALOCYANINE BLUE (P. 147)
PY1 ARYLIDE YELLOW G (P. 29)

HEALTH	ASTM	RATING
✕ INFO	V L'FAST	★

GRUMBACHER
ACADEMY ARTISTS' WATERCOLOUR 2ND RANGE

HOOKER'S GREEN DEEP 106

Previously produced from PG8 Hookers Green & PY1, a disastrous combination. Now very much improved and lightfast.

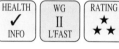

PB15:3 PHTHALO. BLUE (P.147) PY153 NICKEL DIOX. YELL. (P.38) PY97 ARYLIDE YELL (P.37) & PBk6 LAMP BLACK (P.256)

HEALTH	WG	RATING
✓ INFO	II L'FAST	★★

WINSOR & NEWTON
COTMAN WATER COLOUR 2ND RANGE

HOOKER'S GREEN DARK 312 (316)

Pigment Green 12 is an unreliable material. Sample faded and discoloured. Second range paints need not be like this.

PG7 PHTHALOCYANINE GREEN (P. 177)
PG12 GREEN (P. 178)

HEALTH	ASTM	RATING
✕ INFO	IV L'FAST	★

REEVES
WATER COLOUR FOR ARTISTS 2ND RANGE

HOOKERS GREEN DEEP 313

Our sample faded dramatically on exposure. PG12 failed all ASTM testing as well as our own. For temporary work perhaps. *Range discontinued.*

PG7 PHTHALOCYANINE GREEN (P. 177)
PG12 GREEN (P. 178)

HEALTH	ASTM	RATING
✕ INFO	IV L'FAST	★

TALENS
WATER COLOUR 2ND RANGE

HOOKERS GREEN DEEP 645

The same ingredients as are used in Talens 'Artists Quality'. A reliable paint which brushed out well. Semi-transparent. *Range discontinued.*

PG7 PHTHALOCYANINE GREEN (P. 177)
PBr7 BURNT SIENNA (P. 212)
PY3 ARYLIDE YELLOW 10G (P. 29)

HEALTH	ASTM	RATING
✕ INFO	II L'FAST	★ ★★

6.8 Olive Green

A term used almost in an irresponsible manner, to describe any concoction that will give a dull brownish-green.

As reliable ingredients are seldom employed I would suggest that this cannot even be considered a convenience colour.

Such greens can be mixed by applying a touch of either type of red to a standard or mixed yellow - green. A little experimentation will soon show the way.

OLIVE GREEN 1176

The PG7 is the only reliable pigment used in this paint. Expect the colour to become paler and greener unless kept away from light. Semi-transparent.

PR83 ROSE MADDER ALIZARIN (P. 87)
PY1 ARYLIDE YELLOW G (P. 29)
PG7 PHTHALOCYANINE GREEN (P. 177)

LUKAS
ARTISTS' WATER COLOUR

HEALTH	ASTM	RATING
✕ INFO	V L'FAST	★

OLIVE GREEN 669

This colour is most unsuitable for normal artistic use. Changes alarmingly from a yellow-green to a paler grey - green. Semi-opaque.

PG36 PHTHALOCYANINE GREEN (P. 180)
PY17 DIARYLIDE YELLOW AO (P. 31)

HOLBEIN
ARTISTS' WATER COLOR

HEALTH	WG	RATING
✕ INFO	V L'FAST	★

OLIVE GREEN 5724

Once again I have to ask 'which Hansa Yellow Pigment'? Quite a few are in use and vary from reliable to fugitive. Assessments are not possible without further information.

HANSA YELLOW PIGMENT AND COPPER PHTHALOCYANINE

HUNTS
SPEEDBALL PROFESSIONAL WATERCOLOURS

HEALTH		
✕ INFO		

OLIVE GREEN 620

As the type of PY74 is unspecified I will assume it to be the less reliable HS version. Whichever it is the colour deteriorates on exposure.

PG7 PHTHALOCYANINE GREEN (P. 177)
PBr7 BURNT SIENNA (P. 212)
PY74 ARYLIDE YELLOW (P. 36)

TALENS
REMBRANDT ARTISTS' WATER COLOUR

HEALTH	WG	RATING
✕ INFO	IV L'FAST	★

OLIVE GREEN 2072

Previously prone to fading, this colour has been re-formulated using reliable ingredients. Handling is also very much improved. Opaque.

PBk9 IVORY BLACK (P. 257)
PY83 DIARYLIDE YELL.HR70 (P. 36)
PG7 PHTHALOCYANINE GREEN (P. 177)
WAS ALSO PB15 PHTHALO. BLUE (P. 147)
PR122 QUINAC. MAGENTA (P. 92)

MARTIN F.WEBER
PERMALBA ARTIST'S WATER COLOR AQUARELLE

HEALTH	WG	RATING
✓ INFO	II L'FAST	★★

OLIVE GREEN 363

This really is a mobile disaster area. On exposure changes from dull yellow green to pale grey. Semi-transparent.

PG7 PHTHALOCYANINE GREEN (P. 177)
PR83:1 ALIZARIN CRIMSON (P. 88)
PY100 TARTRAZINE LAKE (P. 37)

ROWNEY
ARTISTS' WATER COLOUR

HEALTH	ASTM	RATING
✓ INFO	V L'FAST	★

OLIVE GREEN 447 (033)

If this name must be retained at least quality ingredients such as these should be used. Reliable and washed well. Semi-transparent.

PG7 PHTHALOCYANINE GREEN (P. 177)
PY43 YELLOW OCHRE (P. 35)

WINSOR & NEWTON
ARTISTS' WATER COLOUR

HEALTH	ASTM	RATING
✕ INFO	I L'FAST	★★

OLIVE GREEN 265

It is depressing to have to report yet another unsuitable paint. Depressing because of the careful work which will have been spoilt through its use.

PR83 ROSE MADDER ALIZARIN (P. 87)
PY1 ARYLIDE YELLOW G (P. 29)
PG7 PHTHALOCYANINE GREEN (P. 177)

BLOCKX
AQUARELLES ARTISTS' WATER COLOUR

HEALTH	ASTM	RATING
✕ INFO	V L'FAST	★

OLIVE GREEN 541

The use of PV23RS lowers the overall lightfast rating, but caused limited damage as little could have been used. Becomes a little brighter on exposure.

PV23RS DIOXAZINE PURPLE (P. 131)
PG7 PHTHALOCYANINE GREEN (P. 177)
PY153 NICKEL DIOXINE YELLOW (P. 38)

LEFRANC & BOURGEOIS
LINEL EXTRA-FINE ARTISTS' WATERCOLOUR

HEALTH	ASTM	RATING
✓ INFO	IV L'FAST	★

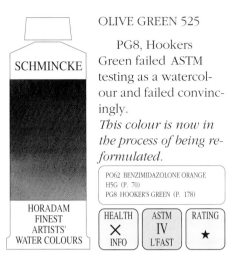

OLIVE GREEN 525

SCHMINCKE

PG8, Hookers Green failed ASTM testing as a watercolour and failed convincingly.
This colour is now in the process of being reformulated.

PO62 BENZIMIDAZOLONE ORANGE H5G (P. 70)
PG8 HOOKER'S GREEN (P. 178)

HORADAM FINEST ARTISTS' WATER COLOURS

HEALTH	ASTM	RATING
✕ INFO	IV L'FAST	★

PERMANENT OLIVE GREEN 515

SCHMINCKE

The most unreliable PG8 Hookers Green now removed. A much improved lightfast green which handles very well. Semi-transparent.

PB15:1 PHTHALOCYANINE BLUE (P. 147)
PY153 NICKEL DIOXINE YELLOW (P.38)
PREVIOUSLY PG8 (P.178) & PB15:3 (P.147)

HORADAM FINEST ARTISTS' WATER COLOURS

HEALTH	WG	RATING
✕ INFO	II L'FAST	★★

OLIVE GREEN 620

TALENS

As the PY74 fades, (as it surely must if exposed to light) the colour will become duller and fainter. Semi-transparent. *This range has now been discontinued.*

PBr7 BURNT SIENNA (P. 212)
PY 74LF ARYLIDE YELLOW 5GX (P. 36)
PG7 PHTHALOCYANINE GREEN (P. 177)

WATER COLOUR 2ND RANGE

HEALTH	ASTM	RATING
✕ INFO	III L'FAST	★★

6.9 Phthalocyanine Green

A particularly clean, vibrant blue - green. High in tinting strength, it should be handled with care when mixing. Phthalo' Green can quickly dominates a painting due to its intensity of hue.

In colour it resembles Viridian and if anything, is even more intense. Although very similar it has not replaced Viridian, as in mixes it will give a slightly different range of effects. Many artists also consider it to be a little harsh or garish. It really is a matter of preference as either green has many admirable qualities.

Phthalocyanine Green is offered under a wide variety of fancy and trade names. Perhaps it is thought that the painter cannot manage words of more than two syllables. Until paints are correctly and uniformly labelled, confusion will continue to exist.

When mixing, the ideal partner is a transparent violet - red such as Pigment Violet 19. Their complementary relationship as far as hue is concerned is reasonably close. As both are transparent it is easy to mix a range of neutrals and greys seething with subdued colour.

Please see palette diagram at end of this section.

PHTHALOCYANINE GREEN 557

MAIMERI

Bright, strong, clear blue - green. Very dark when applied heavily, the true beauty is revealed when well diluted. Transparent.

PG7 PHTHALOCYANINE GREEN (P. 177)

ARTISTI EXTRA-FINE WATERCOLOURS

HEALTH	ASTM	RATING
✕ INFO	I L'FAST	★★ ★★

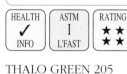

PHTHALO GREEN 268

DA VINCI PAINTS

Phthalocyanine Green makes into an excellent watercolour. It is absolutely lightfast, bright and very transparent.

PG7 PHTHALOCYANINE GREEN (P. 177)

PERMANENT ARTISTS' WATER COLOR

HEALTH	ASTM	RATING
✓ INFO	I L'FAST	★★ ★★

 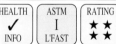

PHTHALOCYANINE GREEN 317

BINNEY & SMITH

Being particularly transparent, heavy applications appear very dark, almost black. Washes out beautifully into a clear blue - green.

PG7 PHTHALOCYANINE GREEN (P. 177)

PROFESSIONAL ARTISTS' WATER COLOR

HEALTH	ASTM	RATING
✓ INFO	I L'FAST	★★ ★★

PHTHALO GREEN 519

SCHMINCKE

A superb all round watercolour. Bright, strong and pure in hue. Washed out beautifully over the full range. Transparent.

PG7 PHTHALOCYANINE GREEN (P. 177)

HORADAM FINEST ARTISTS' WATER COLOURS

HEALTH	ASTM	RATING
✕ INFO	I L'FAST	★★ ★★

THALO GREEN 205

GRUMBACHER

Washed out very smoothly over a useful range of values. Very thin clear washes are possible. An excellent watercolour. Transparent.

PG7 PHTHALOCYANINE GREEN (P. 177)

FINEST PROFESSIONAL WATERCOLORS

HEALTH	ASTM	RATING
✕ INFO	I L'FAST	★★ ★★

THALO YELLOW GREEN 210

GRUMBACHER

A colour easily produced on the palette. Reliable pigments which make up into a paint that handles particularly well. Semi-transparent.

PY3 ARYLIDE YELLOW 10G (P. 29)
PG36 PHTHALO GREEN (P.180)

FINEST PROFESSIONAL WATERCOLORS

HEALTH	ASTM	RATING
✕ INFO	II L'FAST	★ ★★

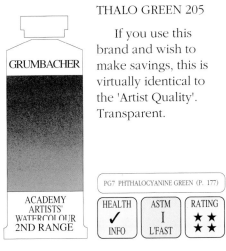

THALO GREEN 205

If you use this brand and wish to make savings, this is virtually identical to the 'Artist Quality'. Transparent.

GRUMBACHER

ACADEMY ARTISTS' WATERCOLOUR 2ND RANGE

PG7 PHTHALOCYANINE GREEN (P. 177)

HEALTH	ASTM	RATING
✓ INFO	I L'FAST	★★ ★★

THALO YELLOW GREEN 210

As with the 'Artist Quality' version, this colour is easily mixed. Reliable ingredients, handles well. Semi-transparent.

GRUMBACHER

ACADEMY ARTISTS' WATERCOLOUR 2ND RANGE

PG7 PHTHALOCYANINE GREEN (P. 177)
PY3 ARYLIDE YELLOW 10G (P. 29)

HEALTH	ASTM	RATING
✓ INFO	II L'FAST	★ ★

6.10 Sap Green

Originally a fugitive 'lake' colour produced from the berries of the Buckthorn bush. During Medieval times it was usually prepared without a binder as the juice was naturally tacky. Allowed to thicken until it became very sticky, it was often kept in animal bladders. Later the colour was imitated by coal tar dyes, these were also usually fugitive.

Today a variety of pigments are mixed to give 'Sap Greens'. These are still often fugitive.

This is not a unique colour in any way at all and it is either unsuitable for artistic use or an unimportant mix.

Such dull greens are easily blended. A violet - blue (Ultramarine), combined with an orange - yellow such as Cad-mium Yellow Light, will come close. Add a touch of either red to darken further.

SAP GREEN 187

Dependable ingredients give a water-colour paint which washes out very smoothly. Dries with a slightly grainy appearance. Semi-transparent.

GRUMBACHER

FINEST PROFESSIONAL WATERCOLORS

PO49 QUINACRIDONE DEEP GOLD (P. 70)
PG7 PHTHALOCYANINE GREEN (P. 177)

HEALTH	WG	RATING
✗ INFO	II L'FAST	★ ★★

SAP GREEN 547

The inclusion of PG8, Hooker's Green, will cause overall fading and a change in colour. Semi-opaque. *The PO43 once added has now been removed.*

MAIMERI

ARTISTI EXTRA-FINE WATERCOLOURS

PY83 DIARYLIDE YELLOW HR70 (P. 36)
PG8 HOOKER'S GREEN (P. 178)
PREVIOUSLY ALSO PO43 PER. OR. (P.69)

HEALTH	ASTM	RATING
✗ INFO	IV L'FAST	★

SAP GREEN 819

Re-formulated from a fugitive colour to a lightfast one. Now very reliable. Handles reasonably well over a wide range of values.

SENNELIER

EXTRA-FINE ARTISTS' WATER COLOURS

PB29 ULTRAMARINE BLUE (149)
PY154 BENZIMIDAZOLONE. YELL. (P. 39)
WAS PG7 (P.177) & PY13 (P. 30)

HEALTH	WG	RATING
✗ INFO	II L'FAST	★★

PERMANENT SAP GREEN 621

Reliable ingredients give a brighter than usual 'Sap Green'. Brushed out very well, particularly as a thin wash. Semi-transparent.

BINNEY & SMITH

PROFESSIONAL ARTISTS' WATER COLOR

PG10 GREEN GOLD (P. 178)
PY42 MARS YELLOW (P. 34)
PG7 PHTHALOCYANINE GREEN (P. 177)

HEALTH	WG	RATING
✓ INFO	II L'FAST	★ ★★

SAP GREEN 676

The PG36 is the only reliable ingredient. Sample deteriorated rapidly from a fairly bright yellow - green to a dull, pale, blue - green. Semi-opaque.

HOLBEIN

ARTISTS' WATER COLOR

PG36 PHTHALOCYANINE GREEN (P. 180)
PG8 HOOKER'S GREEN (P. 178)
PY17 DIARYLIDE YELLOW AO (P. 31)

HEALTH	WG	RATING
INFO	V L'FAST	★

SAP GREEN 375

The colour changes out of all recognition on contact with the light. Becomes a dull blue - green as the red and yellow components disappear. Semi-transparent, becoming very transparent.

ROWNEY

ARTISTS' WATER COLOUR

PR83:1 ALIZARIN CRIMSON (P. 88)
PY100 TARTRAZINE LAKE (P. 37)
PG7 PHTHALOCYANINE GREEN (P. 177)

HEALTH	ASTM	RATING
✓ INFO	V L'FAST	★

SAP GREEN 623

TALENS

Lightfast ingredients give a reliable 'Sap Green'. Brushed out very smoothly giving even washes. Such colours are easily mixed. Semi-transparent.

PG7 PHTHALOCYANINE GREEN (P. 177)
PBr7 BURNT SIENNA (P. 212)
PG10 GREEN GOLD (P. 178)

REMBRANDT ARTISTS' WATER COLOUR

HEALTH	WG	RATING
✕ INFO	II L'FAST	★★

SAP GREEN 361

BLOCKX

A somewhat un-usual combination, Aureolin Yellow plus Viridian. Reliable, brushed out well but of no great impor-tance. Transparent.

PG18 VIRIDIAN (P. 179)
PY40 AUREOLIN (P. 34)

AQUARELLES ARTISTS' WATER COLOUR

HEALTH	ASTM	RATING
✕ INFO	II L'FAST	★★

SAP GREEN 553

LEFRANC & BOURGEOIS

Both given pig-ments are reliable but our sample deterio-rated to a marked extent on exposure. Assessments not offered.

PG7 PHTHALOCYANINE GREEN (P. 177)
PY153 NICKEL DIOXINE YELLOW (P. 38)

LINEL EXTRA-FINE ARTISTS' WATERCOLOUR

HEALTH		
✕ INFO		

SAP GREEN 599 (043)

WINSOR & NEWTON

Unsuitable for artis-tic expression where permanence is a con-sideration. Colour becomes paler and bluer. Both pigments fugitive. Semi-trans-parent.

PG12 GREEN (P. 178)
PY100 TARTRAZINE LAKE (P. 37)

ARTISTS' WATER COLOUR

HEALTH	ASTM	RATING
✕ INFO	V L'FAST	★

SAP GREEN 1 529

SCHMINCKE

Expect a colour change on exposure. Becomes much paler and moves towards a yellow - green. PG8 is most unreliable. *The company are to make changes to the formulation.*

PY83 DIARYLIDE YELLOW HR70 (P. 36)
PO62 BENZIMIDAZOLONE ORANGE H5G (P. 70)
PG8 HOOKER'S GREEN (P. 178)

HORADAM FINEST ARTISTS' WATER COLOURS

HEALTH	ASTM	RATING
✕ INFO	IV L'FAST	★

SAP GREEN 2 530

SCHMINCKE

The Pigment Green 8, Hooker's Green, used in this colour is to be replaced with lightfast ingredients.
Check that this has taken place when considering a purchase.

PY138 QUINOPHTHALONE YELLOW (P. 38)
PG7 PHTHALOCYANINE GREEN (P. 177)
PG8 HOOKER'S GREEN (P. 178)

HORADAM FINEST ARTISTS' WATER COLOURS

HEALTH	ASTM	RATING
✕ INFO	IV L'FAST	★

SAP GREEN 1165

LUKAS

Another case of a mixed colour being let down by one of the ingredients, in this case the PY1. Colour change is serious on exposure. Semi-transparent.

PG7 PHTHALOCYANINE GREEN (P. 177)
PY1 ARYLIDE YELLOW G (P. 29)

ARTISTS' WATER COLOUR

HEALTH	ASTM	RATING
✕ INFO	V L'FAST	★

SAP GREEN 277

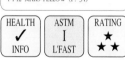

DA VINCI PAINTS

Excellent lightfast-ness, both ingredients are very reliable. Sample brushed out smoothly. An easily mixed convenience colour. Semi-trans-parent.

PG7 PHTHALOCYANINE GREEN (P. 177)
PY42 MARS YELLOW (P. 34)

PERMANENT ARTISTS' WATER COLOR

HEALTH	ASTM	RATING
✓ INFO	I L'FAST	★★

SAP GREEN 247

PĒBĒO

The yellow compo-nent faded more than was expected. No assessments are offered pending further light-fast testing. Semi-transparent.

PG7 PHTHALOCYANINE GREEN (P. 177)
PY65 ARYLIDE YELLOW RN (P. 39)

FRAGONARD ARTISTS' WATER COLOUR

HEALTH		
✕ INFO		

SAP GREEN 623

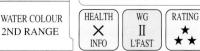

TALENS

All ingredients in this 'Sap Green' are reliable. Sample handled very well over a reasonable range of values. *This range has now been discontinued.*

PG7 PHTHALOCYANINE GREEN (P. 177)
PBr7 BURNT SIENNA (P. 212)
PG10 GREEN GOLD (P. 178)

WATER COLOUR 2ND RANGE

HEALTH	WG	RATING
✕ INFO	II L'FAST	★★

SAP GREEN 375

ROWNEY

One glance at the ingredients will suggest that the yellow in this mix will quickly fade on exposure, altering the colour dramatically. Semi-transparent.

PB29 ULTRAMARINE BLUE (P. 149)
PY1 ARYLIDE YELLOW G (P. 29)

GEORGIAN WATER COLOUR 2ND RANGE

HEALTH	ASTM	RATING
✓ INFO	V L'FAST	★

SAP GREEN 599

REEVES

ASTM testing showed both ingredi-ents to be fugitive. Our own observations confirmed this. Semi-opaque. *This range of colours has now been discontinued.*

PG8 HOOKER'S GREEN (P. 178)
PY1 ARYLIDE YELLOW G (P. 29)

WATER COLOUR FOR ARTISTS 2ND RANGE

HEALTH	ASTM	RATING
✕ INFO	V L'FAST	★

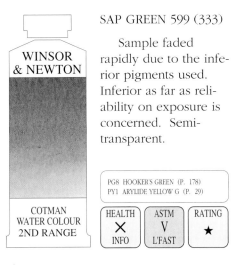

SAP GREEN 599 (333)

WINSOR & NEWTON

Sample faded rapidly due to the inferior pigments used. Inferior as far as reliability on exposure is concerned. Semi-transparent.

PG8 HOOKER'S GREEN (P. 178)
PY1 ARYLIDE YELLOW G (P. 29)

COTMAN WATER COLOUR 2ND RANGE

HEALTH	ASTM	RATING
✗ INFO	V L'FAST	★

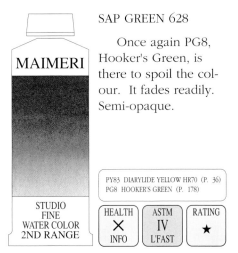

SAP GREEN 628

MAIMERI

Once again PG8, Hooker's Green, is there to spoil the colour. It fades readily. Semi-opaque.

PY83 DIARYLIDE YELLOW HR70 (P. 36)
PG8 HOOKER'S GREEN (P. 178)

STUDIO FINE WATER COLOR 2ND RANGE

HEALTH	ASTM	RATING
✗ INFO	IV L'FAST	★

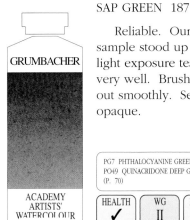

SAP GREEN 187

GRUMBACHER

Reliable. Our sample stood up to light exposure testing very well. Brushed out smoothly. Semi-opaque.

PG7 PHTHALOCYANINE GREEN (P. 177)
PO49 QUINACRIDONE DEEP GOLD (P. 70)

ACADEMY ARTISTS' WATERCOLOUR 2ND RANGE

HEALTH	WG	RATING
✓ INFO	II L'FAST	★★

6.11 Viridian

First class, quality Viridian takes considerable skill to manufacture. If it is not well ground it can be rather gritty and difficult to paint out unless very thin.

A bright, exceedingly clear blue - green. Being very transparent it is highly valued as a glazing colour.

Compatible with all other pigments, unaffected by dilute acids and alkalis and completely lightfast, an excellent all round pigment.

Very similar in hue to Phthalo cyanine Green but a little less intense. For mixing purposes an ideal partner would be a transparent violet - red such as Pigment Violet 19. Close as colour complementaries and both transparent.

Makes very clear blue - greens with Phthalocyanine Blue and transparent yellow-greens with a quality Lemon Yellow.

VIRIDIAN PALE 426

OLD HOLLAND

Sample was nearly all gum, most unpleasant to use. Lightfast.

PY37 CADMIUM YELLOW MEDIUM OR DEEP (P. 33)
PG18 VIRIDIAN (P. 179)

CLASSIC WATERCOLOURS

HEALTH	ASTM	RATING
✗ INFO	I L'FAST	★★

VIRIDIAN GREEN 290

DA VINCI PAINTS

An excellent watercolour. Strong, particularly transparent and washes out smoothly. Tube well labelled. What more could be asked?

PG18 VIRIDIAN (P. 179)

PERMANENT ARTISTS' WATER COLOR

HEALTH	ASTM	RATING
✓ INFO	I L'FAST	★★ ★★

VIRIDIAN 1154

LUKAS

A bright, strong blue - green. Sample washed out beautifully. Pigment is absolutely lightfast. Transparent.

PG18 VIRIDIAN (P. 179)

ARTISTS' WATER COLOUR

HEALTH	ASTM	RATING
✗ INFO	I L'FAST	★★ ★★

VIRIDIAN 381

ROWNEY

Like all transparent colours it takes on a very dark appearance at full strength. An excellent all round watercolour. Transparent.

PG18 VIRIDIAN (P. 179)

ARTISTS' WATER COLOUR

HEALTH	ASTM	RATING
✗ INFO	I L'FAST	★★ ★★

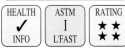

VIRIDIAN 398

BINNEY & SMITH

Sample was somewhat overbound and only suitable for light washes. Reliable ingredients. Transparent.

PG18 VIRIDIAN (P. 179)

PROFESSIONAL ARTISTS' WATER COLOR

HEALTH	ASTM	RATING
✓ INFO	I L'FAST	★★

VIRIDIAN 692 (077)

WINSOR & NEWTON

Sample was very pasty. Only washed well when applied very thinly. Transparent.

PG18 VIRIDIAN (P. 179)

ARTISTS' WATER COLOUR

HEALTH	ASTM	RATING
✗ INFO	I L'FAST	★★

VIRIDIAN 232

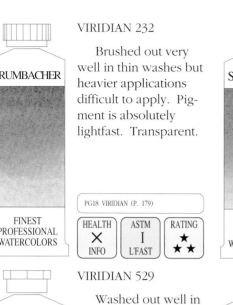

GRUMBACHER

Brushed out very well in thin washes but heavier applications difficult to apply. Pigment is absolutely lightfast. Transparent.

FINEST PROFESSIONAL WATERCOLORS

PG18 VIRIDIAN (P. 179)

HEALTH	ASTM	RATING
✕ INFO	I L'FAST	★★

VIRIDIAN 837

SENNELIER

A mix of two pigments which are very similar in hue and characteristics. Perhaps the 'Phthalo' Green gives a little extra brightness. Transparent.

EXTRA-FINE ARTISTS' WATER COLOURS

PG7 PHTHALOCYANINE GREEN (P. 177)
PG18 VIRIDIAN (P. 179)

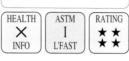

HEALTH	ASTM	RATING
✕ INFO	I L'FAST	★★

VIRIDIAN 2065

MARTIN F. WEBER

Sample was rather overbound and unpleasant to use. Brushed out streaky. Transparent.

PERMALBA ARTIST'S WATER COLOR AQUARELLE

PG7 PHTHALOCYANINE GREEN (P. 177)
PG18 VIRIDIAN (P. 179)

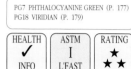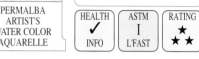

HEALTH	ASTM	RATING
✓ INFO	I L'FAST	★

VIRIDIAN 529

LEFRANC & BOURGEOIS

Washed out well in thinner applications but difficult when heavier as sample rather overbound. Reliable. Transparent.

LINEL EXTRA-FINE ARTISTS' WATERCOLOUR

PG18 VIRIDIAN (P. 179)

HEALTH	ASTM	RATING
✓ INFO	I L'FAST	★

VIRIDIAN 546

MAIMERI

A mixture of two very similar pigments. An excellent all round watercolour with many admirable qualities. Transparent.

ARTISTI EXTRA-FINE WATERCOLOURS

PG7 PHTHALOCYANINE GREEN (P. 177)
PG18 VIRIDIAN (P. 179)

HEALTH	ASTM	RATING
✕ INFO	I L'FAST	★★

VIRIDIAN 616

TALENS

Viridian is extremely transparent and washes out to give very clear, pure tints. Bright and lightfast.

REMBRANDT ARTISTS' WATER COLOUR

PG18 VIRIDIAN (P. 179)

HEALTH	ASTM	RATING
✕ INFO	I L'FAST	★★

VIRIDIAN 673

HOLBEIN

Sample was overbound. Brushed out well in thin washes but heavier applications difficult to apply. Lightfast. Transparent.

ARTISTS' WATER COLOR

PG18 VIRIDIAN (P. 179)

HEALTH	ASTM	RATING
✕ INFO	I L'FAST	★

VIRIDIAN TINT 674

HOLBEIN

This is not Viridian at all but Phthalocyanine Green. It should ideally be sold under its correct title to reduce confusion. Transparent.

ARTISTS' WATER COLOR

PG7 PHTHALOCYANINE GREEN (P. 177)

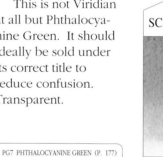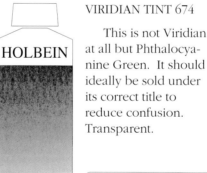

HEALTH	ASTM	RATING
✕ INFO	I L'FAST	★

VIRIDIAN GLOWING 511

SCHMINCKE

Sample rather overbound but brushed out smoothly in thinner washes. Reliable ingredients. Transparent.

HORADAM FINEST ARTISTS' WATER COLOURS

PG7 PHTHALOCYANINE GREEN (P. 177)
PG18 VIRIDIAN (P. 179)

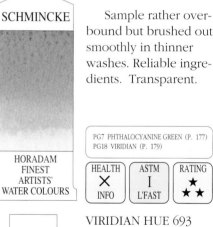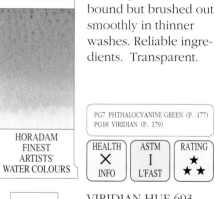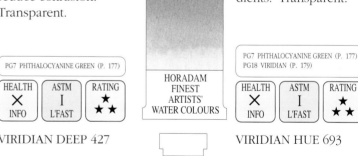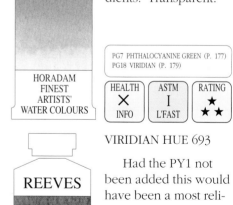

HEALTH	ASTM	RATING
✕ INFO	I L'FAST	★

VIRIDIAN MATT 512

SCHMINCKE

I feel that Chromium Oxide Green should be offered as Chromium Oxide Green. Opaque.

HORADAM FINEST ARTISTS' WATER COLOURS

PG17 CHROMIUM OXIDE GREEN (P. 179)

HEALTH	ASTM	RATING
✕ INFO	I L'FAST	★★

VIRIDIAN DEEP 427

OLD HOLLAND

Sample was particularly gummy and unpleasant to use. Transparent.

CLASSIC WATERCOLOURS

PG18 VIRIDIAN (P. 179)

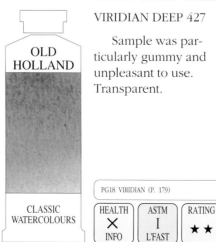

HEALTH	ASTM	RATING
✕ INFO	I L'FAST	★★

VIRIDIAN HUE 693

REEVES

Had the PY1 not been added this would have been a most reliable colour. Transparent.

This range of colours has recently been discontinued.

WATER COLOUR FOR ARTISTS 2ND RANGE

PG7 PHTHALOCYANINE GREEN (P. 177)
PY1 ARYLIDE YELLOW G (P. 29)

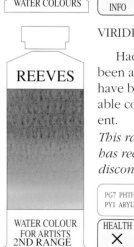

HEALTH	ASTM	RATING
✕ INFO	V L'FAST	★

VIRIDIAN

PAILLARD

LOUVRE
AQUARELLE
ARTISTS' COLOUR
2ND RANGE

Promised information on ingredients was not supplied, for whatever reason. Assessments are not possible.

HEALTH		
✕		
INFO		

VIRIDIAN 616

TALENS

WATER COLOUR
2ND RANGE

A reliable watercolour which brushed out very smoothly at all strengths. As lightfast as the 'Artist Quality' version. Transparent. *This range of colours has recently been discontinued*

PG18 VIRIDIAN (P. 179)

HEALTH	ASTM	RATING
✕	I	★ ★
INFO	L'FAST	★ ★

VIRIDIAN (HUE) 382

ROWNEY

GEORGIAN
WATER COLOUR
2ND RANGE

Why this is not offered as Phthalocyanine Green is somewhat of a mystery. Transparent.

PG7 PHTHALOCYANINE GREEN (P. 177)

HEALTH	ASTM	RATING
✓	I	★
INFO	L'FAST	★

VIRIDIAN HUE 626

MAIMERI

STUDIO
FINE
WATER COLOR
2ND RANGE

Phthalocyanine Green is a little harsher in colour than Viridian and can always be sold under its own name. The word 'Hue' has now been added to indicate an imitation colour. Transparent.

PG7 PHTHALOCYANINE GREEN (P. 177)

HEALTH	ASTM	RATING
✕	I	★
INFO	L'FAST	★

VIRIDIAN 232

GRUMBACHER

ACADEMY
ARTISTS'
WATERCOLOUR
2ND RANGE

A transparent colour which is absolutely lightfast. Washes out well, particularly in thin applications.

PG7 PHTHALOCYANINE GREEN (P. 177)
PG18 VIRIDIAN (P. 179)

HEALTH	ASTM	RATING
✓	I	★
INFO	L'FAST	★

VIRIDIAN 698 (340)

WINSOR & NEWTON

COTMAN
WATER COLOUR
2ND RANGE

The use of PY1, a fugitive substance, will lead to a colour change on exposure to light. Transparent.

PG7 PHTHALOCYANINE GREEN (P. 177)
PY1 ARYLIDE YELLOW G (P. 29)

HEALTH	ASTM	RATING
✕	V	★
INFO	L'FAST	

VIRIDIAN 692 (USA ONLY)

WINSOR & NEWTON

COTMAN
WATER COLOUR
2ND RANGE

Sample was rather gum laden and did not brush out well. Transparent.

PG18 VIRIDIAN (P. 179)

HEALTH	ASTM	RATING
✓	I	★
INFO	L'FAST	★ ★

Viridian is particularly transparent. When applied heavily the light tends to sink into the paint film and much of it stays there.

This causes the paint to appear very dark. In effect it is similar to light sinking into thick green glass.

The true beauty of the colour is only revealed when the paint is applied well diluted. Unfortunately, too few artists seem to appreciate the particular characteristics of their paints, treating both transparent and opaque in much the same way

6.12 Miscellaneous Greens

Many painters rely on the large range of greens available and set about collecting most, if not all, that are on offer. The belief seems to be that each is somehow unique and necessary for a full repertoire.

We have available a limited number of truly unique greens and a wide range of simple mixes. In previous pages I have pointed out that colours such as Olive Green and Hooker's Green are no more than blends of readily available pigments, many being of dubious value. In this section you will find further examples of simple mixes marketed under names which suggest a respectability not always deserved.

You will also find many basic pigments (such as Phthalocyanine Green), which have been given fanciful or trade names. It is little wonder that many painters are confused. How can the artist be selective whilst such practices continue?

ALIZARIN GREEN 301

On exposure to light will change dramatically. Moves from a yellow - green to a light blue - green as the yellow departs.

| PG7 PHTHALOCYANINE GREEN (P. 177) |
| PY100 TARTRAZINE LAKE (P. 37) |

ROWNEY
ARTISTS' WATER COLOUR

HEALTH	ASTM	RATING
✓ INFO	V L'FAST	★

ANTIOCHE GREEN LIGHT 510

A fancy name used to sell a simple mix. Easily reproduced. Reliable ingredients. Semi-transparent.

| PG7 PHTHALOCYANINE GREEN (P. 177) |
| PY3 ARYLIDE YELLOW 10G (P. 29) |

LEFRANC & BOURGEOIS
LINEL EXTRA-FINE ARTISTS' WATERCOLOUR

HEALTH	ASTM	RATING
✗ INFO	II L'FAST	★★

ARMOR GREEN 512

This company does not offer a Phthalocyanine Green as such but markets it under this fancy and confusing title. Transparent.

| PG7 PHTHALOCYANINE GREEN (P. 177) |

LEFRANC & BOURGEOIS
LINEL EXTRA-FINE ARTISTS' WATERCOLOUR

HEALTH	ASTM	RATING
✗ INFO	I L'FAST	★★

BLOCKX GREEN 263

Phthalocyanine Green sold under yet another name. Has all the qualities of that pigment. Transparent.

| PG7 PHTHALOCYANINE GREEN (P. 177) |

BLOCKX
AQUARELLES ARTISTS' WATER COLOUR

HEALTH	ASTM	RATING
✗ INFO	I L'FAST	★★

BRILLIANT GREEN 1 915

A disastrous substance which becomes a dark grey - green when subjected to light. Short lived brilliance. The PG1 causes the damage. *Discontinued.*

| PG1 BRILLIANT GREEN TONER (P. 177) |
| PY3 ARYLIDE YELLOW 10G (P. 29) |

SCHMINCKE
HORADAM FINEST ARTISTS' WATER COLOURS

HEALTH	WG	RATING
✗ INFO	V L'FAST	★

BRILLIANT GREEN 2 916

Reliable ingredients give a bright green which will retain its colour. Brushed out very smoothly over the range. Semi-transparent.

| PG7 PHTHALOCYANINE GREEN (P. 177) |
| PY3 ARYLIDE YELLOW 10G (P. 29) |

SCHMINCKE
HORADAM FINEST ARTISTS' WATER COLOURS

HEALTH	ASTM	RATING
✗ INFO	II L'FAST	★★

BRILLIANT YELLOW GREEN 1 917

I will not offer assessments as our sample darkened in mass tone. The stated ingredients would not normally do this. *To be re-formulated.*

| PG7 PHTHALOCYANINE GREEN (P. 177) |
| PY3 ARYLIDE YELLOW 10G (P. 29) |

SCHMINCKE
HORADAM FINEST ARTISTS' WATER COLOURS

HEALTH
✗ INFO

BRILLIANT YELLOW GREEN 2 918

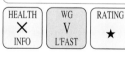

The PY1 which once ruined this colour has been replaced by the reliable PY154. Now a superb, lightfast colour. Semi-transparent. Recommeneded.

| PG7 PHTHALOCYANINE GREEN (P. 177) |
| PY3 ARYLIDE YELLOW 10G (P. 29) |
| PY154 BENZIMIDAZOLONE YELL. (P.39) |
| ONCE CONTAINED PY1 (P. 29) |

SCHMINCKE
HORADAM FINEST ARTISTS' WATER COLOURS

HEALTH	WG	RATING
✗ INFO	II L'FAST	★★

CINNABAR GREEN PALE EXTRA 423

Cinnabar Green is the name once used for Chrome Green. Excellent ingredients. Paint brushed out very smoothly over good range of values. Semi-opaque.

| PY37 CADMIUM YELLOW MEDIUM OR DEEP (P. 33) |
| PG18 VIRIDIAN (P. 179) |

OLD HOLLAND
CLASSIC WATERCOLOURS

HEALTH	ASTM	RATING
✗ INFO	I L'FAST	★★

CINNABAR GREEN LIGHT 1171

LUKAS

Without the addition of PY1, this would have been a lightfast colour. Similar, reliable yellows are available for such mixing. Semi-transparent.

PG7 PHTHALOCYANINE GREEN (P. 177)
PY1 ARYLIDE YELLOW G (P. 29)
PY42 MARS YELLOW (P. 34)

ARTISTS' WATER COLOUR

HEALTH	ASTM	RATING
✕ INFO	V L'FAST	★

CINNABAR GREEN DEEP 1173

LUKAS

Built-in potential to self destruct on two fronts. PY1 and PB1 are both fugitive and unsuitable for lasting artistic work. Semi-transparent.

PG7 PHTHALOCYANINE GREEN (P. 177)
PBk11 MARS BLACK (P. 257)
PY1 ARYLIDE YELLOW G (P. 29)
PB1 VICTORIA BLUE (P. 147)

ARTISTS' WATER COLOUR

HEALTH	ASTM	RATING
✕ INFO	V L'FAST	★

CINNABAR GREEN DEEP 428

OLD HOLLAND

The ingredients are all absolutely lightfast and make into a paint which brushes out very smoothly. Separates slightly on drying. Semi-opaque.

PG18 VIRIDIAN (P. 179)
PY37 CADMIUM YELLOW MEDIUM OR DEEP (P. 33)
PBr 7 RAW UMBER (P. 211)

CLASSIC WATERCOLOURS

HEALTH	ASTM	RATING
✕ INFO	I L'FAST	★★

COMPOSE GREEN 1 666

HOLBEIN

The addition of white takes the paint closer to a gouache than a traditional watercolour. Reliable. Semi-opaque.

PY3 ARYLIDE YELLOW 10G (P. 29)
PW6 TITANIUM WHITE (P. 271)
PG7 PHTHALOCYANINE GREEN (P. 177)

ARTISTS' WATER COLOR

HEALTH	ASTM	RATING
✕ INFO	II L'FAST	★ ★★

COMPOSE GREEN 2 667

HOLBEIN

Despite the reliability of the stated ingredients, our sample showed a marked colour change, becoming bluer. Not assessed pending retesting. Semi-opaque.

PG7 PHTHALOCYANINE GREEN (P. 177)
PW6 TITANIUM WHITE (P. 271)
PY3 ARYLIDE YELLOW 10G (P. 29)

ARTISTS' WATER COLOR

HEALTH
✕ INFO

COMPOSE GREEN 3 668

HOLBEIN

Unreliable when exposed to light, (but how else will you be able to see it). Sample altered considerably, becoming paler and bluer. Semi-transparent.

PG8 HOOKER'S GREEN (P. 178)
PY3 ARYLIDE YELLOW 10G (P. 29)
PY14 DIARYLIDE YELLOW OT (P. 31)

ARTISTS' WATER COLOR

HEALTH	ASTM	RATING
✕ INFO	IV L'FAST	★

CYANIN GREEN 246

PĒBĒO

If Phthalocyanine Green was offered as such, there would be a little less confusion. Transparent.

PG7 PHTHALOCYANINE GREEN (P. 177)

FRAGONARD ARTISTS' WATER COLOUR

HEALTH	ASTM	RATING
✕ INFO	I L'FAST	★ ★★

CYPRUS GREEN 1 PERMANENT 525

LEFRANC & BOURGEOIS

All questions concerning this colour went unanswered. Therefore assessments are not possible.

LINEL EXTRA-FINE ARTISTS' WATERCOLOUR

HEALTH
✕ INFO

CYPRUS GREEN 2 PERMANENT 526

LEFRANC & BOURGEOIS

Lighfast ingredients give a dependable green which is easily duplicated. Transparent.

PG7 PHTHALOCYANINE GREEN (P. 177)
PY3 ARYLIDE YELLOW 10G (P. 29)

LINEL EXTRA-FINE ARTISTS' WATERCOLOUR

HEALTH	ASTM	RATING
✕ INFO	II L'FAST	★ ★★

GREENGOLD 237

PĒBĒO

A reliable bright yellow - green. Such colours are easily mixed from a green - yellow and a green - blue. Semi-transparent.

PG10 GREEN GOLD (P. 178)

FRAGONARD ARTISTS' WATER COLOUR

HEALTH	WG	RATING
✕ INFO	II L'FAST	★★

GREEN GREY 706

HOLBEIN

Well produced watercolour employing lightfast pigments. Such dark greens are easily mixed by adding a touch of red to a green. Semi-opaque.

PBk6 LAMP BLACK (P. 256)
PG23 GREEN EARTH /TERRE VERTE (P. 180)
PG17 CHROMIUM OXIDE GREEN (P. 179)

ARTISTS' WATER COLOR

HEALTH	ASTM	RATING
✕ INFO	I L'FAST	★ ★★

LINDEN GREEN 517

SCHMINCKE

Pigment Green 8, Hooker's Green, has fortunatly been removed. All pigments are now lightfast. Semi-trans. *Recent name change from 'Green Lake Light'.*

PY3 ARYLIDE YELLOW 10G (P. 29)
PG7 PHTHALOCYANINE GREEN (P. 177)
PBr7 BURNT SIENNA (P. 212)

HORADAM FINEST ARTISTS' WATER COLOURS

HEALTH	ASTM	RATING
✕ INFO	II L'FAST	★★

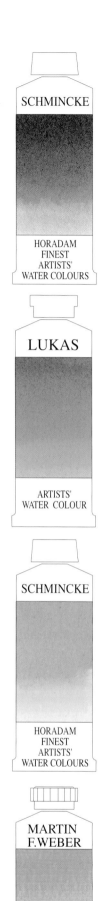

GREEN LAKE DEEP 518

SCHMINCKE

PG8 is very popular with the colourmen. It is unreliable and will fade on exposure to light. Semi-transparent. *Colour now discontinued.*

PB15:1 PHTHALOCYANINE BLUE (P. 147)
PG8 HOOKER'S GREEN (P. 178)
PG7 PHTHALOCYANINE GREEN (P. 177)

HORADAM FINEST ARTISTS' WATER COLOURS

HEALTH	ASTM	RATING
✕ INFO	IV L'FAST	★

GREEN LAKE PERMANENT 548

LEFRANC & BOURGEOIS

The stated ingredients are normally reliable. Our sample however, faded dramatically. Assessments not offered pending further enquiry. Semi-transparent.

PG7 PHTHALOCYANINE GREEN (P. 177)
PY153 NICKEL DIOXINE YELLOW (P. 38)

LINEL EXTRA-FINE ARTISTS' WATERCOLOUR

HEALTH		
✓ INFO		

HELIO GENUINE GREEN LIGHT 1193

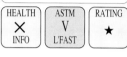

LUKAS

Pigment Yellow 1 is an unreliable colorant which is known to fade on exposure. It will cause damage to any mix. Semi-transparent.

PG7 PHTHALOCYANINE GREEN (P. 177)
PY1 ARYLIDE YELLOW G (P. 29)
PY3 ARYLIDE YELLOW 10G (P. 29)

ARTISTS' WATER COLOUR

HEALTH	ASTM	RATING
✕ INFO	V L'FAST	★

HELIO GENUINE GREEN DEEP 1195

LUKAS

If Phthalocyanine Green, (an excellent pigment), was marketed under its own name, it would be in greater demand. Transparent.

PG7 PHTHALOCYANINE GREEN (P. 177)

ARTISTS' WATER COLOUR

HEALTH	ASTM	RATING
✕ INFO	I L'FAST	★★

LAMORINIERE GREEN 262

BLOCKX

The prevalent use of fancy names to describe standard pigments can only add to the incredible confusion that still exists. Excellent product.

PG17 CHROMIUM OXIDE GREEN (P. 179)

AQUARELLES ARTISTS' WATER COLOUR

HEALTH	ASTM	RATING
✕ INFO	I L'FAST	★★

PERMANENT GREEN LIGHT 811

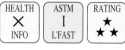

SENNELIER

The inferior Pigment Yellow 13 has been removed and replaced with the superb PY40. *Name recently changed from 'Light Green'.*

PG7 PHTHALOCYANINE GREEN (P. 177)
PY40 AUREOLIN (P.40)
PREVIOUSLY CONTAINED PY13 (P. 30)

EXTRA-FINE ARTISTS' WATER COLOURS

HEALTH	ASTM	RATING
✕ INFO	I L'FAST	★★

MAYGREEN 524

SCHMINCKE

Re-formulated for the better. The fugitive PY1 has been removed and replaced with the lightfast PY154. A superb, lightfast yellow-green. Recommended.

PY3 ARYLIDE YELLOW 10G (P. 29)
PG7 PHTHALOCYANINE GREEN (P. 177)
PY154 BENZIMIDAZOLONE YELLOW (P.39)
PREVIOUSLY CONTAINED PY1 (P. 29)

HORADAM FINEST ARTISTS' WATER COLOURS

HEALTH	WG	RATING
✕ INFO	II L'FAST	★★

MONESTIAL GREEN 362

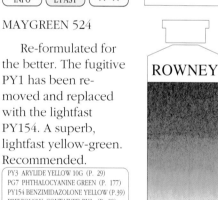

ROWNEY

Rowney have always used this name, based on the original title 'Monastral', to market Phthalocyanine Green. Dependable and well produced.

PG7 PHTHALOCYANINE GREEN (P. 177)

ARTISTS' WATER COLOUR

HEALTH	ASTM	RATING
✓ INFO	I L'FAST	★★

OPAQUE GREEN LIGHT IMITATION 513

SCHMINCKE

Despite the stated ingredients, which are reliable, our sample darkened to a considerable extent. Assessments not offered. *To be re-formulated.*

PW5 LITHOPONE (P. 270)
PY3 ARYLIDE YELLOW 10G (P. 29)
PG7 PHTHALOCYANINE GREEN (P. 177)

HORADAM FINEST ARTISTS' WATER COLOURS

HEALTH		
✕ INFO		

PERMANENT GREEN LIGHT 2069

MARTIN F.WEBER

Excellent ingredients giving a convenience colour which handles very well. Brushed out beautifully. Easily mixed. Semi-transparent.

PY3 ARY. YELL. (P. 29) - PG18 VIRIDIAN (P.179) & PW6 TITANIUM WHITE (P. 271)
PREVIOUSLY PG7 (P. 177) & PY35 (P. 33)

PERMALBA ARTIST'S WATER COLOR AQUARELLE

HEALTH	ASTM	RATING
✓ INFO	II L'FAST	★★

PERMANENT GREEN LIGHT 312

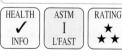

BINNEY & SMITH

A well produced convenience colour. Both ingredients are absolutely lightfast. Washed out very smoothly. Semi-opaque.

PG7 PHTHALOCYANINE GREEN (P. 177)
PY35 CADMIUM YELLOW LIGHT (P. 33)

PROFESSIONAL ARTISTS' WATER COLOR

HEALTH	ASTM	RATING
✓ INFO	I L'FAST	★★

PERMANENT GREEN LIGHT 526

SCHMINCKE

Despite the reliability of the stated ingredients, our sample darkened considerably. Assessments are not offered. *Colour to be re-formulated.*

PY3 ARYLIDE YELLOW 10G (P. 29)
PG7 PHTHALOCYANINE GREEN (P. 177)

HORADAM FINEST ARTISTS' WATER COLOURS

HEALTH		
✕ INFO		

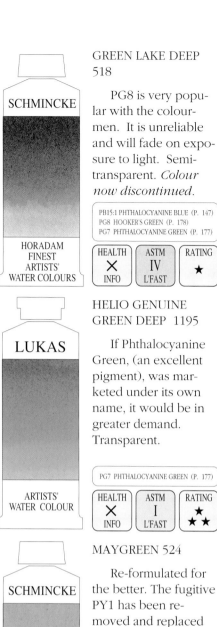
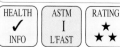

LUKAS
ARTISTS' WATER COLOUR

PERMANENT GREEN LIGHT 1163

Dependable ingredients giving a watercolour which handles very well. Absolutely lightfast. Such colours are easily mixed. Semi-transparent.

PG7 PHTHALOCYANINE GREEN (P. 177)
PY42 MARS YELLOW (P. 34)

HEALTH	ASTM	RATING
✕ INFO	I L'FAST	★ ★★

TALENS
REMBRANDT ARTISTS' WATER COLOUR

PERMANENT GREEN LIGHT 618

Reliable ingredients. A convenience colour which is easy to work. Simple to mix on the palette. Semi-transparent.

PG7 PHTHALOCYANINE GREEN (P. 177)
PY3 ARYLIDE YELLOW 10G (P. 29)

HEALTH	ASTM	RATING
✕ INFO	II L'FAST	★ ★★

MAIMERI
ARTISTI EXTRA-FINE WATERCOLOURS

PERMANENT GREEN 544

An easily mixed convenience colour. Both ingredients are absolutely lightfast. Paint brushed out well. Semi-transparent.

PY37 CADMIUM YELLOW MEDIUM OR DEEP (P. 33)
PG18 VIRIDIAN (P. 179)

HEALTH	ASTM	RATING
✕ INFO	I L'FAST	★ ★★

HOLBEIN
ARTISTS' WATER COLOR

PERMANENT GREEN No 1 660

Had the PY1 not been added, this would have been a reliable paint. Exposure will alter the colour to a marked extent. Semi-transparent.

PY1 ARYLIDE YELLOW G (P. 29)
PY53 NICKEL TITANATE YELLOW (P. 35)
PG7 PHTHALOCYANINE GREEN (P. 177)

HEALTH	ASTM	RATING
✕ INFO	V L'FAST	★

HOLBEIN
ARTISTS' WATER COLOR

PERMANENT GREEN No 2 661

Being fugitive, the PY14 will change the nature of the colour as it fades. Sample altered dramatically. Semi-opaque.

PY14 DIARYLIDE YELLOW OT (P. 31)
PG7 PHTHALOCYANINE GREEN (P. 177)
PY53 NICKEL TITANATE YELLOW (P. 35)

HEALTH	WG	RATING
✕ INFO	IV L'FAST	★

HOLBEIN
ARTISTS' WATER COLOR

PERMANENT GREEN No 3 662

A 'Permanent Green' which is reasonably permanent. Reliable ingredients. Washes out well. Semi-transparent.

PY53 NICKEL TITANATE YELLOW (P. 35)
PY3 ARYLIDE YELLOW 10G (P. 29)
PB15 PHTHALOCYANINE BLUE (P. 147)

HEALTH	ASTM	RATING
✕ INFO	II L'FAST	★ ★★

SCHMINCKE
HORADAM FINEST ARTISTS' WATER COLOURS

HELIO GREEN 527

The pigments previously used were absolutely lightfast, as is the PG36 now employed. Transparent. *This colour was previously called 'Permanent Green Deep'.*

PG36 PHTHALOCYANINE GREEN (P.180)
PREVIOUSLY PG18 VIRIDIAN (P. 179)
& PG7 PHTHALO GREEN (P. 177)

HEALTH	WG	RATING
✕ INFO	I L'FAST	★ ★★

LUKAS
ARTISTS' WATER COLOUR

PERMANENT GREEN DEEP 1164

Reliable ingredients giving an easily mixed convenience colour. Semi-transparent.

PG7 PHTHALOCYANINE GREEN (P. 177)
PY3 ARYLIDE YELLOW 10G (P. 29)
PG18 VIRIDIAN (P. 179)

HEALTH	ASTM	RATING
✕ INFO	II L'FAST	★ ★★

WINSOR & NEWTON
ARTISTS' WATER COLOUR

PRUSSIAN GREEN 540 (037)

This could have been a reliable watercolour had an alternative yellow been used. PY1 failed ASTM testing. Semi-transparent.

PB27 PRUSSIAN BLUE (P. 148)
PY1 ARYLIDE YELLOW G (P. 29)

HEALTH	ASTM	RATING
✕ INFO	V L'FAST	★

SCHMINCKE
HORADAM FINEST ARTISTS' WATER COLOURS

PRUSSIAN GREEN 528

Pigment Green 8, Hooker's Green, failed ASTM testing as a watercolour. *This colour is to be reformulated using reliable ingredients.*

PB15:1 PHTHALOCYANINE BLUE (P. 147)
PV19 QUINACRIDONE VIOLET (P. 139)
PG8 HOOKER'S GREEN (P. 178)

HEALTH	ASTM	RATING
✕ INFO	IV L'FAST	★

BINNEY & SMITH
PROFESSIONAL ARTISTS' WATER COLOR

PRUSSIAN GREEN HUE 313

A particularly lightfast convenience colour. Handled very well over the full range of values. Semi-transparent.

PY35 CADMIUM YELLOW LIGHT (P. 33)
PB27 PRUSSIAN BLUE (P. 148)

HEALTH	ASTM	RATING
✓ INFO	I L'FAST	★ ★★

TALENS
REMBRANDT ARTISTS' WATER COLOUR

REMBRANDT BLUISH-GREEN 647

Mix Phthalocyanine Blue and Green and you have the same colour. Washes out well. Lightfast and very transparent.

PG7 PHTHALOCYANINE GREEN (P. 177)
PB15 PHTHALOCYANINE BLUE (P. 147)

HEALTH	ASTM	RATING
✕ INFO	IV L'FAST	★ ★★

REMBRANDT GREEN 634

TALENS

REMBRANDT
ARTISTS'
WATER COLOUR

The same simple mix as the previous colour, this time with more of the green added. Simple to reproduce. Transparent.

PG7 PHTHALOCYANINE GREEN (P. 177)
PB15 PHTHALOCYANINE BLUE (P. 147)

HEALTH	ASTM	RATING
✕ INFO	II L'FAST	★ ★

SPEEDBALL GREEN (PHTHALO) 5727

HUNTS

SPEEDBALL
PROFESSIONAL
WATERCOLOURS

Phthalocyanine Green sold under yet another name. A little more is added to the confusion. Lightfast. Transparent.

CHLORINATED COPPER PHTHALO-CYANINE

HEALTH	ASTM	RATING
✕ INFO	I L'FAST	★ ★

SPRING GREEN 2082

MARTIN F.WEBER

PERMALBA
ARTIST'S
WATER COLOR
AQUARELLE

A fancy name used to market a simple mix. Easily duplicated on the palette. A reliable convenience colour. Transparent

PY35:1 CADMIUM -BARIUM YELLOW LIGHT (P. 33)
PG7 PHTHALOCYANINE GREEN (P. 177)

HEALTH	ASTM	RATING
✓ INFO	I L'FAST	★ ★

VERMILION GREEN LIGHT 531

SCHMINCKE

HORADAM
FINEST
ARTISTS'
WATER COLOURS

A veritable cocktail of pigments, giving a non-descript mid-green. The PY1 will let it down. *To be re-formulated.*

PY119 ZINC IRON YELLOW (P. 39)
PG7 PHTHALOCYANINE GREEN (P. 177)
PW7 ZINC SULPHIDE (P. 271)
PY1 ARYLIDE YELLOW G (P. 29)
PY3 ARYLIDE YELLOW 10G (P. 29)
PB15:3 PHTHALO BLUE (P. 147)

HEALTH	ASTM	RATING
✕ INFO	V L'FAST	★

VERMILION GREEN DEEP 532

SCHMINCKE

HORADAM
FINEST
ARTISTS'
WATER COLOURS

The inclusion of PG8, Hooker's Green, will lead to eventual deterioration of the colour. *This colour is to be re-formulated.*

PY119 ZINC IRON YELLOW (P. 39)
PB15:1 PHTHALOCYANINE BLUE (P. 147)
PG8 HOOKER'S GREEN (P. 178)

HEALTH	ASTM	RATING
✕ INFO	IV L'FAST	★

VERONESE GREEN 138

PĒBĒO

FRAGONARD
ARTISTS'
WATER COLOUR

This name has long been used rather loosely to describe a variety of combinations. Reliable ingredients. Semi-transparent.

PW6 TITANIUM WHITE (P. 271)
PG7 PHTHALOCYANINE GREEN (P. 177)
PG10 GREEN GOLD (P. 178)

HEALTH	WG	RATING
✕ INFO	II L'FAST	★ ★

WARM GREEN IMITATION 534

LEFRANC & BOURGEOIS

LINEL
EXTRA-FINE
ARTISTS'
WATERCOLOUR

A fancy title used to describe a variety of Phthalocyanine Green. Reliable and transparent.

PG36 PHTHALOCYANINE GREEN (P. 180)

HEALTH	ASTM	RATING
✓ INFO	I L'FAST	★ ★

WINSOR GREEN 720 (055)

WINSOR & NEWTON

ARTISTS'
WATER COLOUR

If Phthalocyanine Green was always offered as such, a greater demand for it would be created and we would all be less confused.

PG7 PHTHALOCYANINE GREEN (P. 177)

HEALTH	ASTM	RATING
✕ INFO	I L'FAST	★ ★

YELLOWISH GREEN 617

TALENS

REMBRANDT
ARTISTS'
WATER COLOUR

A simple mix, easily reproduced on the palette from a Lemon Yellow and Phthalocyanine Green. Reliable. Transparent.

PG7 PHTHALOCYANINE GREEN (P. 177)
PY3 ARYLIDE YELLOW 10G (P. 29)

HEALTH	ASTM	RATING
✕ INFO	II L'FAST	★ ★

INTENSE GREEN 329 (321)

WINSOR & NEWTON

COTMAN
WATER COLOUR
2ND RANGE

Yet another name under which to market Phthalocyanine Green. Lightfast and very transparent.

PG7 PHTHALOCYANINE GREEN (P. 177)

HEALTH	ASTM	RATING
✕ INFO	I L'FAST	★ ★

LEAF GREEN 355

ROWNEY

GEORGIAN
WATER COLOUR
2ND RANGE

Another fancy title used to describe a simple mix of standard pigments. Reliable ingredients, handles very well. Semi-transparent.

PY3 ARYLIDE YELLOW 10G (P. 29)
PG36 PHTHALOCYANINE GREEN (P. 180)
PW6 TITANIUM WHITE (P. 271)

HEALTH	ASTM	RATING
✓ INFO	II L'FAST	★ ★

OCEAN GREEN

PAILLARD

LOUVRE
AQUARELLE
ARTISTS' COLOUR
2ND RANGE

As the company failed to provide details of ingredients, I cannot offer assessments. Our sample faded readily. Semi-transparent.

HEALTH
✕ INFO

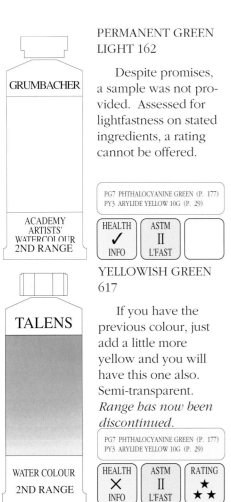

PERMANENT GREEN LIGHT 162

GRUMBACHER

Despite promises, a sample was not provided. Assessed for lightfastness on stated ingredients, a rating cannot be offered.

PG7 PHTHALOCYANINE GREEN (P. 177)
PY3 ARYLIDE YELLOW 10G (P. 29)

ACADEMY ARTISTS' WATERCOLOUR 2ND RANGE

HEALTH	ASTM	
✓ INFO	II L'FAST	

PERMANENT GREEN 625

MAIMERI

A reliable mid-green, easily duplicated on the palette from standard paints. Sample washed out very well, giving a useful range of values.

PY3 ARYLIDE YELLOW 10G (P. 29)
PB15:3 PHTHALO BLUE (P. 147)

STUDIO FINE WATER COLOR 2ND RANGE

HEALTH	ASTM	RATING
✗ INFO	II L'FAST	★ ★★

PERMANENT GREEN LIGHT 618

TALENS

Convenience watercolour produced from reliable pigments. 'Second Range' paints need not be unreliable. Semi-transparent. *Range discontinued.*

PG7 PHTHALOCYANINE GREEN (P. 177)
PY3 ARYLIDE YELLOW 10G (P. 29)

WATER COLOUR 2ND RANGE

HEALTH	ASTM	RATING
✗ INFO	II L'FAST	★ ★★

YELLOWISH GREEN 617

TALENS

If you have the previous colour, just add a little more yellow and you will have this one also. Semi-transparent. *Range has now been discontinued.*

PG7 PHTHALOCYANINE GREEN (P. 177)
PY3 ARYLIDE YELLOW 10G (P. 29)

WATER COLOUR 2ND RANGE

HEALTH	ASTM	RATING
✗ INFO	II L'FAST	★ ★★

The two blues, (violet-blue and green-blue), together with the two types of yellow, (green-yellow and orange-yellow), will give thousands of different greens.

By varying these base colours, many more can be added. For example, an opaque green-blue such as Cerulean Blue can be supplemented by the transparent green-blue Phthalocyanine Blue.

If one now introduces the two reds, (orange-red and violet-red) to darken the greens, the potential range becomes vast.

To this huge selection we can introduce the unique greens such as Viridian and Chromium Oxide Green.

As each colour will also have a tint, or undercolour, the selection obtainable from a few carefully chosen, reliable paints, runs into the millions.

Surely it is better to get to know your paints and to master colour mixing than it is to rely on the choice of premixed greens that are on offer. There are of course dependable blended greens, but I would suggest carefull selection.

The following green watercolours have been introduced since the last edition.

All manufacturers are invited to supply samples of their paints for evaluation. In the main, new colours and technical information was supplied.

OLIVE GREEN HUE 150

GRUMBACHER

The pigments as stated by the company are lightfast. Unfortunately, a sample was not supplied. Assessments are not possible.

PG10 GREEN GOLD (P.178)
PG7 PHTHALOCYANINE GREEN (P.177)
PBr7

ACADEMY ARTISTS' WATERCOLOUR 2ND RANGE

	ASTM	
	II L'FAST	

OLIVE GREEN 813

SENNELIER

A reliable convenience colour, The sample supplied was slightly over bound but washed out very well over a good range of tints. Lightfast ingredients.

PO49 QUINACRIDONE DEEP GOLD (P.70)
PG36 PHTHALOCYANINE GREEN (P.180)
PW21 BLANC FIXE (P.272)

EXTRA-FINE ARTISTS' WATER COLOURS

HEALTH	WG	RATING
✗ INFO	II L'FAST	★ ★★

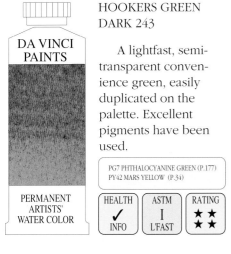

HOOKERS GREEN DARK 243

DA VINCI PAINTS

A lightfast, semi-transparent convenience green, easily duplicated on the palette. Excellent pigments have been used.

PG7 PHTHALOCYANINE GREEN (P.177)
PY42 MARS YELLOW (P.34)

PERMANENT ARTISTS' WATER COLOR

HEALTH	ASTM	RATING
✓ INFO	I L'FAST	★★ ★★

PHALO GREEN LIGHT 805

SENNELIER

A bright mid-green. The sample provided brushed out very well indeed, giving clear tints. Lightfast ingredients. An excellent all round colour.

PG7 PHTHALOCYANINE GREEN (P.177)
PY154 BENZIMIDAZOLONE YELL (P.39)
PW21 BLANC FIXE (P.272)

EXTRA-FINE ARTISTS' WATER COLOURS

HEALTH	WG	RATING
✗ INFO	II L'FAST	★ ★★

MAGNESIUM GREEN

GRUMBACHER

PB36 Cerulean Blue was the only ingredient given. Without follow up, or a sample, I cannot advise further. There must surely be more than just blue involved.

PB36 CERULEUM BLUE,CHROMIUM (P.150)

ACADEMY ARTISTS' WATERCOLOUR 2ND RANGE

BROWNS

History of Brown Pigments

The majority of brown pigments have been and still are obtained from the earth. Unaffected by humidity, light, temperature, alkalis and dilute acids, the earth pigments are almost the ideal. They are non toxic, cheap and possess fairly good tinting strength and covering power. Earth pigments consist of three principle components: the main colouring matter - modifying or secondary colouring agent - and the base carrier.

Main colouring matter:

The principle colour producing agent of nearly all earth pigments is iron oxide, a material found in most rocks and earths. Content varies from the tiny amount found in white clays and chalks, to the very high concentrations in iron ore.

Modifying Colouring Agent:

Other matter present will affect the final colour. Carbon, Manganese Oxides, Calcium, Silica and organic matter will lighten, darken, redden or otherwise influence the main colouring agent.

Base carrier:

Virtually all earth pigments have a clay base. The type of clay has a significant effect on the final colouring and the physical properties of the pigment.

 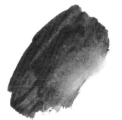

Several of the brown earth pigments in use today are little removed from the colours used by the cave painter. The materials used in Raw Sienna and Raw Umber are essentially the same coloured earths that were once smeared onto cave walls.

Raw Sienna, an excellent glazing colour, has been used in all painting techniques ever since records were started. Although it has its modern, synthetic rivals, it remains unsurpassed for clarity of colour and permanence.

One type of iron ore,

Dimonite, provides the colouring for the Ochres. As the iron oxide content increases, so the Ochres move into the Siennas. An increase in the manganese oxide content of the Siennas leads to the Umbers.

Attempts have been made to replace many of the traditional earth colours with artificially prepared alternatives. These are usually known as Mars colours. Although colour consistency between batches is more reliable and they are just as lightfast, many of the artificially made browns lack the subtlety of the more muted natural earth colours.

The natural red earth colours, in use from the time of the cave artist, have provided a range varying from a warm, light orange - red, to dark cold purples.

Many of these natural red earth colours have been replaced or duplicated by synthetic red oxides such as Mars Red, Venetian Red and Indian Red.

Originally made from the dried ink sacs of cuttlefish or squid, Sepia is now usually a simple mix of a brown and black.

The most macabre of all brown pigments must surely be Mummy, produced from ground Egyptian mummies. Even more bizarre is the fact that it was used as a medicine before it was discovered that a paint could be produced from it. Mummy was considered to be an ideal shading colour.

Bistre, a brown produced by boiling wood soot was replaced during the 18th century by Sepia.

Spanish Liquorice, a fugitive brown manufactured from the root of the liquorice plant, was so sticky that it did not require the addition of gum for watercolour painting.

Van Dyke Brown, produced from earth that is rich in organic matter, came into general use some time before the seventeenth century. Valued for its rich, deep colour, it was and still is used extensively. Countless paintings have been ruined by the use of this unreliable pigment yet it is still with us.

Until comparatively recent times few brown pigments found their way onto the artists' palette. In Europe, during the Middle ages in particular, brighter colours were favoured and browns and other nondescript browns were less frequently used. When a brown was required it was often mixed.

MODERN BROWN PIGMENTS

MARS BROWN

An artificially prepared iron oxide, with a similar chemical make-up to PBr7, PR101, PR102 and PBk11. Available in a variety of colours from a light reddish brown to a deep chocolate. The undercolour that is brought out when certain varieties are mixed with white can be quite purplish. A thoroughly reliable pigment with a good range of values. Possesses very good hiding and tinting strength.

Rated ASTM I in oils and acrylics. Not yet tested as a watercolour. Sample unaffected by light and therefore rated I for this book.

Also called Brown Iron Oxide.

RAW SIENNA

Used by artists from the early cave painter to the present day. A native earth mined at many locations. Named after a particularly fine variety once produced at Sienna, Tuscany. An excellent glazing colour, the better qualities being very transparent. Gives a golden tan when well diluted. Takes on a very laboured appearance in heavy applications. Fairly good tinting strength.

Absolutely lightfast with an ASTM rating of I in watercolour. The crude 'Raw Sienna' used by the cave painter will not have changed in colour to this very day.

RAW UMBER

Raw Umber is a native earth mined at various locations, a particularly fine variety coming from Cyprus. The name is thought to have originated from a production site at Umbria in Italy. An alternative explanation is that it is derived from the Latin 'Ombra', meaning shadow or shade. Varies in colour, tending towards yellow, green or violet. Better grades are greenish. Possesses high tinting strength and good hiding power.

Absolutely lightfast. ASTM rating of I as a watercolour. An excellent pigment.

BURNT UMBER

Prepared by roasting Raw Umber at a dull red heat until it has changed to the required hue. The pigment goes through many colour changes and the final result is very much dependant on the furnace operator. Used in antiquity, it came into general use from the early 1600's. A warm, rich, fairly heavy colour varying from an orange to a reddish brown. High in tinting strength with good hiding power. Not particularly transparent but can be when very dilute.

A thoroughly reliable pigment. ASTM I as a watercolour and on the list of approved pigments. Makes an excellent watercolour. Highly recommended.

L/FAST ASTM I

COMMON NAME
BURNT UMBER

COLOUR INDEX NAME
PBr7

COLOUR INDEX NUMBER
77492

CHEMICAL CLASS
CALCINED NATURAL IRON OXIDE CONTAINING MANGANESE

BURNT SIENNA

It was discovered in antiquity that Raw Sienna could be roasted to produce a warm, rich orange to reddish brown. Particularly valued for its transparency, it is one of the small group of ancient pigments whose beauty and permanence have not been equalled by any modern industrial substitute. Tinting strength varies with different grades, as does clarity of hue and transparency. Choose carefully, a clear, fiery Burnt Sienna can be invaluable.

As a watercolour it rated ASTM I and is on the list of approved pigments. Good grades, unclouded by filler or other pigments, are worth seeking. Highly recommended.

L/FAST ASTM I

COMMON NAME
BURNT SIENNA

COLOUR INDEX NAME
PBr7

COLOUR INDEX NUMBER
77492

CHEMICAL CLASS
CALCINED NATURAL IRON OXIDE

VAN DYKE BROWN

Dug from the ground as a soft brown coal or as a peat like substance. Consists in the main of humus and humic acid from decayed wood. Referred to under a variety of names. Cassel Earth, Cologne Earth, Bituminous Earth, Cappagh Brown etc. Transparent to semi-transparent. Moderately strong. Especially fugitive if applied as a thin wash. From an ancient 'compost heap', where it should perhaps have remained. An unreliable mid-brown.

As a wash it will quickly move towards a cold dull grey and fade in mass tone. There are some absolutely lightfast browns in the same colour range.

L/FAST W/GUIDE IV

COMMON NAME
VAN DYKE BROWN

COLOUR INDEX NAME
NATURAL BROWN 8

COLOUR INDEX NUMBER
N.A.

CHEMICAL CLASS
ORGANIC MATTER. VARIOUS MAKE UP.

MANGANESE BROWN

Manganese Brown is seldom found in artists' materials. Being fast to lime it has many industrial applications. Commonly used to colour lime, cement and artificial stone. A mid brown, easily duplicated on the palette. It is semi-transparent with a useful range of values. I have not come across any test results. Reported to be reliable, I will not regard it as such for the purposes of this publication as our sample faded quickly. Rated IV.

Sample deteriorated rapidly, the tint moved towards grey and the mass tone faded also. Pending further testing I would suggest caution.

CHROME ANTIMONY TITANIUM BUFF RUTILE

PBr24 is a rather dull, light yellowish - brown. Reasonably opaque, it washes out to give fairly clear tints. Rather low in tinting strength it will have a limited influence on many other colours in a mix unless used liberally. This pigment had not been tested under ASTM conditions at the time of writing. Results from other, less exacting tests were very encouraging. Our sample however did not stand up so well to light.

Despite an excellent reputation, which is more to do with its performance in printing inks, I would advise caution as our sample faded quickly. Rated III for this publication.

The following pigments have recently been introduced by manufacturers covered in this publication. Insufficient notice was given for full research to be carried out.

DISAZO BROWN
Colour Index Name PBr 23
Colour Index Number - 20060. Chemical Class 'Disazo Type 1: Condensation.'.
A dull reddish brown. Transparent and strong in tinting strength. Not yet subjected to ASTM testing as a watercolour paint. However, it has a good reputation for lightfastness in other areas. Pending further testing I will rate it as WG II for this edition.
Lightfast Category WG II

Common Name not known.
Colour Index Name PBr41
Colour Index Number - not applicable. Chemical Class 'Disazo Type 1: Condensation
A yellowish, opaque brown with fairly low tinting strength. Not yet subjected to ASTM testing in any art media. A new pigment. I cannot find any reports at all on its lightfastness .
No Lightfast Rating offered.

BROWN WATERCOLOURS

Recently introduced brown watercolours.

This section is not as complete as I would wish it to be. Ideally I prefer to use the results of controlled ASTM examination backed up by my own testing when offering guidance concerning a particular pigment.

Where a colorant has not been subjected to ASTM testing in any art media, I need substantial information regarding other tests that have taken place (and at least 12 months notice), before offering even limited assessments.

Manufacturers are requested to give as much advance information as possible when new pigments are introduced.

BROWN MADDER ALIZARIN HUE 368

Although the pigment used has not been ASTM tested as a watercolour, it rated I in acrylics. A reliable colour which handles better in thinner washes than mass tone.

HEALTH	WG	RATING
✕ INFO	II L'FAST	★★

PR206 QUINAC. BURNT ORANGE (P.99)

RAW UMBER 274

DA VINCI PAINTS

A semi-opaque paint which gives a good range of values. The sample was slightly over bound. This was not noticeable in thinner washes. Lightfast.

PERMANENT ARTISTS' WATER COLOR

PBr7 RAW UMBER (P. 211)

HEALTH	ASTM	RATING
✓ INFO	I L'FAST	★★

WARM SEPIA 440

SENNELIER

This is not a new colour as such. The company did not supply details of it for the earlier edition. The pigments are absolutely lightfast. The sample handled well.

EXTRA-FINE ARTISTS' WATER COLOURS

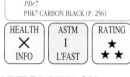

PBr7
PBk7 CARBON BLACK (P. 256)

HEALTH	ASTM	RATING
✕ INFO	I L'FAST	★★

TITANIUM GOLD OCHRE 646

SCHMINCKE

The pigment has not been subjected to ASTM tests. Our own testing suggested that caution was advisable as the colour tends to fade. The company describe it as lightfast.

HORADAM FINEST ARTISTS' WATER COLOURS

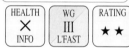

PBr24 CHROME ANT. TITAN. B/R (P.213)

HEALTH	WG	RATING
✕ INFO	III L'FAST	★★

LIGHT BROWN 648

SCHMINCKE

The company claim that this colour is lightfast. I have insufficient information in this regard to offer assessments.

HORADAM FINEST ARTISTS' WATER COLOURS

PBr41 COMMON NAME N/K (P.213)

HEALTH		
✕ INFO		

NUT BROWN 652

SCHMINCKE

Sample not provided.

PBr33 has not been subjected to ASTM lightfast testing in any art media. I cannot find sufficient information on this pigment to offer any guidance. Claimed by the company to be lightfast.

HORADAM FINEST ARTISTS' WATER COLOURS

PBr33 ZINC IRON CHROMATE SPINEL

HEALTH		
✕ INFO		

STIL DE GRAIN VERTE 665

SCHMINCKE

PY129 has not been subjected to ASTM testing in any art media. It is reputed to be lightfast and this is claimed by the company. However, I do not feel that I have sufficient information to offer an assessment.

HORADAM FINEST ARTISTS' WATER COLOURS

PY42 MARS YELLOW (P.34)
PY129 AZOMETHANE YELLOW 5GT (P.40)

HEALTH		
✕ INFO		

7.1 Brown Madder

Brown Madder, or Alizarin Brown as it was also known, was at one time produced by gently heating natural Alizarin or Madder Lake. Paints sold under the name nowadays are usually synthetic Alizarin supported by other pigments.

The name has remained well past its time and is retained to market simple mixes or standard colours.

Alizarin Crimson is used in a wide variety of colours, despite the well known fact that it is unreliable. Thin washes will fade, heavier applications are very dark and prone to cracking. These characteristics are carried with it to any mix, including 'Brown Madder'.

It is difficult to suggest a way of mixing 'Brown Madder' using reliable ingredients, as the colour varies according to the whim of the manufacturer. A violet - red, neutralised with a little of its complementary, yellow - green, will give a colour close to the original Brown Madder. Alternatively, add a little reliable violet - red to Burnt Sienna or Light Red.

SENNELIER

EXTRA-FINE ARTISTS' WATER COLOURS

BROWN MADDER 471

This colour used to contain PR83:1 Alizarin Crimson and was very prone to fading. Now re-formulated using more reliable ingredients. Washed out smoothly.

PY3 ARYLIDE YELLOW (P.29)
PBr23 DISAZO BROWN (P.213)
PREVIOUSLY PR83:1 (P. 88) & PY83 (P. 36)

HEALTH	WG	RATING
✕	II	★★
INFO	L'FAST	

ROWNEY

ARTISTS' WATER COLOUR

BROWN MADDER (ALIZARIN) 207

The use of Alizarin Crimson, a pigment known to be unreliable, will cause the colour to change considerably. Semi-transparent.

PR83:1 ALIZARIN CRIMSON (P. 88)
PY42 MARS YELLOW (P. 34)

HEALTH	ASTM	RATING
✓	IV	★
INFO	L'FAST	

GRUMBACHER

FINEST PROFESSIONAL WATERCOLORS

BROWN MADDER 021

This colour is included as a sample was promised. It did not materialise so a rating is not possible. Burnt Sienna under another name.

PBr7 BURNT SIENNA (P. 212)

	ASTM	
	I	
	L'FAST	

WINSOR & NEWTON

ARTISTS' WATER COLOUR

BROWN MADDER (ALIZARIN) 063 (007)

We are told that the PR101 does not fit traditional classification but is a synthetic equivalent of Burnt Sienna. The colour will eventually spoil due to the use of PR83:1.

PR101
PR83:1 ALIZARIN CRIMSON (P. 88)

HEALTH	ASTM	RATING
✕	IV	★
INFO	L'FAST	

SCHMINCKE

HORADAM FINEST ARTISTS' WATER COLOURS

MADDER BROWN REDDISH 658

A one time fugitive colour has been re-formulated using excellent pigments. Previously called 'Brown Madder'

PV19 QUINACRIDONE VIOLET (P.130)
PBr7 RAW UMBER
PREVIOUSLY PY83 DIAR. YELL.(P. 36)
PR83:1 ALIZARIN CRIMSON & (P. 88) PR177
ANTHRAQUINONE RED (P. 94)

HEALTH	ASTM	RATING
✕	II	★★
INFO	L'FAST	

HOLBEIN

ARTISTS' WATER COLOR

BROWN MADDER 613

A rich red - brown which will retain its colour when under light. Well produced, our sample brushed out very smoothly over a wide range.

PR216 PYRANTHRONE RED (P. 97)

HEALTH	WG	RATING
✕	II	★★
INFO	L'FAST	

TALENS

REMBRANDT ARTISTS' WATER COLOUR

BROWNISH MADDER ALIZARIN 333

Becomes a pale, relatively dull reddish - brown. The day that Alizarin Crimson finally becomes obsolete will be welcomed by all knowledgeable artists. Semi-transparent.

PR101
PR83:1 ALIZARIN CRIMSON (P. 88)

HEALTH	ASTM	RATING
✕	IV	★
INFO	L'FAST	

As you will see in this typical example on the right, exposure to light can cause considerable damage to the colour if it is produced from pigments which include Alizarin Crimson. Fine if you wish your work to alter to the same degree, otherwise worth avoiding.

7.2 Burnt Sienna

It was discovered long ago that Raw Sienna could be roasted to produce a fiery, transparent neutral orange - red.

When applied as a thin layer the true beauty is revealed. Well produced 'Burnt Siennas' are particularly clear and vibrant when so applied. Unfortunately it is often painted out thickly where it is comparatively dull.

Such transparent colours were at one time highly valued for the clear washes that were available. As we have moved away from a real respect for the craft of painting, so we have lost much of our appreciation for such pigments. Like a good wine, a quality Burnt Sienna is worth seeking out. I suggest that you try every example that comes your way.

In mixing it should be treated as a neutral, transparent orange. The ideal mixing complementary is Ultramarine Blue. Both colours are transparent and close to colour complementaries. They darken each other successfully and will give a superb range of neutrals and greys. Being transparent and efficient at destroying each other, they provide an excellent black in a mix of equal intensities.

BLOCKX

AQUARELLES ARTISTS' WATER COLOUR

BURNT SIENNA LIGHT 141

A particularly transparent, finely ground watercolour paint. Handles well over a reasonable range of values. Absolutely lightfast.

PBr7 BURNT SIENNA (P. 212)

HEALTH	ASTM	RATING
✕	I	★★
INFO	L'FAST	★★

PÉBÉO

FRAGONARD ARTISTS' WATER COLOUR

BURNT SIENNA 134

Mars Red, a synthetic iron oxide, should ideally be marketed as such. An excellent watercolour nevertheless. Particularly transparent in thin washes.

PR101 MARS RED (P. 89)

HEALTH	ASTM	RATING
✕	I	★
INFO	L'FAST	★★

SENNELIER

EXTRA-FINE ARTISTS' WATER COLOURS

BURNT SIENNA 211

A thoroughly ground, well produced watercolour. Sample washed out very smoothly at all strengths. A rich neutralised orange of great value to the artist. Transparent.

PBr7 BURNT SIENNA (P. 212)

HEALTH	ASTM	RATING
✕	I	★★
INFO	L'FAST	★★

HOLBEIN

ARTISTS' WATER COLOR

BURNT SIENNA 692

Gives very delicate, soft neutral oranges when well diluted. A wide range of strengths are available. Superb. Transparent.

PBr7 BURNT SIENNA (P. 212)

HEALTH	ASTM	RATING
✕	I	★★
INFO	L'FAST	★★

LEFRANC & BOURGEOIS

LINEL EXTRA-FINE ARTISTS' WATERCOLOUR

BURNT SIENNA 481

Light red should be marketed as such. A finely ground paint which blends smoothly from one value to another. Transparent.

PR102 LIGHT RED (P. 90)

HEALTH	ASTM	RATING
✓	I	★
INFO	L'FAST	★★

MARTIN F.WEBER

PERMALBA ARTIST'S WATER COLOR AQUARELLE

BURNT SIENNA 2052

Sample was rather pasty and overbound. Brushed out poorly unless applied well diluted. Semi-transparent.

PBr7 BURNT SIENNA (P. 212)

HEALTH	ASTM	RATING
✓	I	★
INFO	L'FAST	★★

OLD HOLLAND

CLASSIC WATERCOLOURS

BURNT SIENNA 438

Assessments are not offered, despite a lengthy correspondence we were unable to establish the exact nature of the ingredients. Settled out somewhat on drying, giving a mottled appearance.

EARTH COLOURS

HEALTH		
✕		
INFO		

TALENS

REMBRANDT ARTISTS' WATER COLOUR

BURNT SIENNA 411

Sample rather overbound making handling somewhat difficult. A rich, fiery colour. Transparent.

PBr7 BURNT SIENNA (P. 212)

HEALTH	ASTM	RATING
✕	I	★★
INFO	L'FAST	

DA VINCI PAINTS

PERMANENT ARTISTS' WATER COLOR

BURNT SIENNA 205

Previously difficult to handle, this colour has been re-formulated to give an excellent paint which brushes out extremely well. Lightfast. Recommended.

PBr7 BURNT SIENNA (P. 212)

HEALTH	ASTM	RATING
✓	I	★★
INFO	L'FAST	★★

BURNT SIENNA 221

ROWNEY

Superb. Washes out smoothly from one value to another. A well produced, fiery neutral orange. Particularly transparent.

ARTISTS' WATER COLOUR

PBr7 BURNT SIENNA (P. 212)

HEALTH	ASTM	RATING
✓ INFO	I L'FAST	★★ ★★

BURNT SIENNA 661

SCHMINCKE

The consistancy of this paint has been improved lately. However, the new sample was still a little over bound. Handled well as a wash. Transparent.

HORADAM FINEST ARTISTS' WATER COLOURS

PBr7 BURNT SIENNA (P. 212)
PREVIOUSLY ALSO CONTAINED PR101
LIGHT OR ENGLISH RED OXIDE (P. 90)

HEALTH	ASTM	RATING
✗ INFO	I L'FAST	★ ★★

BURNT SIENNA 127

BINNEY & SMITH

The sample provided had the appearance of a Burnt Sienna to which a little white had been added, clouding the colour. Semi-transparent.

PROFESSIONAL ARTISTS' WATER COLOR

PBr7 BURNT SIENNA (P. 212)

HEALTH	ASTM	RATING
✓ INFO	I L'FAST	★ ★★

BURNT SIENNA 074 (008)

WINSOR & NEWTON

A well produced Burnt Sienna. Extremely transparent in thin washes, rich in colour and handles well. Absolutely lightfast.

ARTISTS' WATER COLOUR

PBr7 BURNT SIENNA (P. 212)

HEALTH	ASTM	RATING
✗ INFO	I L'FAST	★★ ★★

BURNT SIENNA 023

GRUMBACHER

A rich, fiery orange brown, the colour is particularly intense. Washes out beautifully, particularly when well diluted. Transparent.

FINEST PROFESSIONAL WATERCOLORS

PBr7 BURNT SIENNA (P. 212)

HEALTH	ASTM	RATING
✗ INFO	I L'FAST	★★ ★★

BURNT SIENNA 5701

HUNTS

Despite the non cooperation of the company, a sample was obtained. Washed out well, if a little gritty. Transparent.

SPEEDBALL PROFESSIONAL WATERCOLOURS

CALCINED NATURAL IRON OXIDE

HEALTH	ASTM	RATING
✗ INFO	I L'FAST	★ ★★

BURNT SIENNA 1109

LUKAS

Not genuine Burnt Sienna but an unspecified synthetic iron oxide sold under the name. Transparent.

ARTISTS' WATER COLOUR

PR101

HEALTH	ASTM	RATING
✗ INFO	I L'FAST	★ ★★

BURNT SIENNA 541

MAIMERI

A rich, warm, neutral orange. Very well produced. Washed out smoothly and gave extremely clear washes. One of the better examples.

ARTISTI EXTRA-FINE WATERCOLOURS

PBr7 BURNT SIENNA (P. 212)

HEALTH	ASTM	RATING
✗ INFO	I L'FAST	★★ ★★

BURNT SIENNA DEEP 143

BLOCKX

Cassel Earth, one of the ingredients, is another name for Natural Brown 8, Van Dyke Brown. It tends to fade on exposure and will alter any mixture. A pity it was added.

AQUARELLES ARTISTS' WATER COLOUR

CASSEL EARTH
PBr7 BURNT SIENNA (P. 212)

HEALTH	WG	RATING
✗ INFO	IV L'FAST	★

BURNT SIENNA 074 (302)

WINSOR & NEWTON

An excellent all round product. Rich in colour, very smoothly ground and transparent. Superior to many 'Artist Quality' Burnt Siennas.

COTMAN WATER COLOUR 2ND RANGE

PBr7 BURNT SIENNA (P. 212)

HEALTH	ASTM	RATING
✗ INFO	I L'FAST	★★ ★★

BURNT SIENNA 411

TALENS

A quality product. Brushed out well, giving smooth washes. Traditional Burnt Sienna colour, a rich warm orange - brown. Transparent.
This range has been discontinued.

WATER COLOUR 2ND RANGE

PBr7 BURNT SIENNA (P. 212)

HEALTH	ASTM	RATING
✗ INFO	I L'FAST	★★ ★★

BURNT SIENNA

PAILLARD

Without knowledge of the ingredients I cannot comment further. Had I known that the company would later change its mind on the supply of information, I would not have included this range.

LOUVRE AQUARELLE ARTISTS' COLOUR 2ND RANGE

HEALTH		
✗ INFO		

REEVES

WATER COLOUR
FOR ARTISTS
2ND RANGE

BURNT SIENNA 074

An excellent water-colour. Handled very well giving a good range of washes. Particularly transparent.
This range of colours has now been discontinued.

PBr7 BURNT SIENNA (P. 212)

HEALTH	ASTM	RATING
✕ INFO	I L'FAST	★★ ★★

MAIMERI

STUDIO
FINE
WATER COLOR
2ND RANGE

BURNT SIENNA 622

A well produced Burnt Sienna. Of a quality superior to certain 'Artist' range paints. Very transparent.

PBr7 BURNT SIENNA (P. 212)

HEALTH	ASTM	RATING
✕ INFO	I L'FAST	★★

ROWNEY

GEORGIAN
WATER COLOUR
2ND RANGE

BURNT SIENNA 221

Not as rich or warm in hue as the 'Artist Quality' in this make. Nevertheless paint washes out well and is very transparent.

PBr7 BURNT SIENNA (P. 212)

HEALTH	ASTM	RATING
✓ INFO	I L'FAST	★ ★★

GRUMBACHER

ACADEMY
ARTISTS'
WATERCOLOUR
2ND RANGE

BURNT SIENNA 023

Sample was slightly gritty but brushed out reasonably well. Absolutely lightfast. Transparent.

PBr7 BURNT SIENNA (P. 212)

HEALTH	ASTM	RATING
✓ INFO	I L'FAST	★ ★★

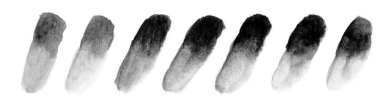

Being a neutralised orange it works very well with Ultramarine Blue. They will give a wide range of neutrals and greys. Worth experimenting.

7.3 Burnt Umber

Available from the earliest times, Burnt Sienna became increasingly popular from the early 1600's. It is produced by roasting Raw Umber. During heating it undergoes a series of changes. The final colour depends very much on the furnace operator and varies from a neutralised orange - brown to a rich reddish - brown.

Quite high in tinting strength, with good covering power. An excellent pigment, it is worth seeking out a variety that suits your way of working.

Before deciding on the possible results of mixing, it will be a useful exercise to paint out an area as a dilute wash. Such a thin application will reveal the undercolour and give mixing guidance. It is surprising how seldom we exploit the differences between the mass tone (heavier applications) and diluted washes.

Mixed with Ultramarine Blue it will give rich, deep colourful darks. If you wish to avoid the dulling effect of using black, such a blend will provide an excellent alternative.

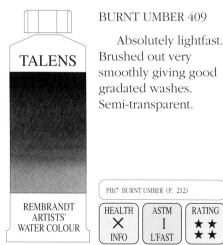

TALENS

REMBRANDT
ARTISTS'
WATER COLOUR

BURNT UMBER 409

Absolutely lightfast. Brushed out very smoothly giving good gradated washes. Semi-transparent.

PBr7 BURNT UMBER (P. 212)

HEALTH	ASTM	RATING
✕ INFO	I L'FAST	★★

OLD HOLLAND

CLASSIC
WATERCOLOURS

BURNT UMBER 445

Sample was slightly gritty but brushed out well. Exact ingredients not confirmed so I will not offer further guidance. Semi-transparent.

EARTH COLOURS

HEALTH
✕ INFO

MARTIN F.WEBER

PERMALBA
ARTIST'S
WATER COLOR
AQUARELLE

BURNT UMBER 2053

Handled well, giving a good series of values. Densely packed pigment. Absolutely lightfast. Semi-transparent.

PBr7 BURNT UMBER (P. 212)

HEALTH	ASTM	RATING
✓ INFO	I L'FAST	★★

BURNT UMBER 076 (009)

Dependable ingredients, quite unaffected by light. Washed out well over a good range. Semi-opaque.

WINSOR & NEWTON

ARTISTS' WATER COLOUR

PR101 MARS RED (P. 89)
PBr7 BURNT UMBER (P. 212)

HEALTH	ASTM	RATING
✕	I	★ ★
INFO	L'FAST	★ ★

BURNT UMBER 202

Gives reasonably good covering power as well as clear washes when well diluted. A quality watercolour.

SENNELIER

EXTRA-FINE ARTISTS' WATER COLOURS

PBr7 BURNT UMBER (P. 212)

HEALTH	ASTM	RATING
✕	I	★ ★
INFO	L'FAST	★ ★

BURNT UMBER 477

Very well ground paint giving smooth washes. Reasonably transparent when well diluted. Absolutely lightfast.

LEFRANC & BOURGEOIS

LINEL EXTRA-FINE ARTISTS' WATERCOLOUR

PBr7 BURNT UMBER (P. 212)

HEALTH	ASTM	RATING
✕	I	★ ★
INFO	L'FAST	★ ★

BURNT UMBER 024

A deep, rich colour. Covers well in heavier applications yet gives reasonably transparent washes. Semi-opaque.

GRUMBACHER

FINEST PROFESSIONAL WATERCOLORS

PBr7 BURNT UMBER (P. 212)

HEALTH	ASTM	RATING
✕	I	★ ★
INFO	L'FAST	★ ★

BURNT UMBER 148

A well produced watercolour paint. Gave smooth washes and a useful range of values. Absolutely lightfast. Semi-opaque.

BLOCKX

AQUARELLES ARTISTS' WATER COLOUR

PBr7 BURNT UMBER (P. 212)

HEALTH	ASTM	RATING
✕	I	★ ★
INFO	L'FAST	★ ★

BURNT UMBER 223

A deep velvety brown at full strength. Brushes out well and gives reasonably transparent washes when very dilute. Semi-opaque.

ROWNEY

ARTISTS' WATER COLOUR

PBr7 BURNT UMBER (P. 212)

HEALTH	ASTM	RATING
✕	I	★ ★
INFO	L'FAST	★ ★

BURNT UMBER 693

Very well produced. The paint flows smoothly in a wash and offers a good range of values, from a deep warm brown to a pale wash. Semi-opaque.

HOLBEIN

ARTISTS' WATER COLOR

PBr7 BURNT UMBER (P. 212)

HEALTH	ASTM	RATING
✕	I	★ ★
INFO	L'FAST	★ ★

BURNT UMBER 130

The ingredients give a colour close in hue to genuine Burnt Umber. To my eye the black content introduces a certain dullness. Semi-opaque.

PĒBĒO

FRAGONARD ARTISTS' WATER COLOUR

PR101 MARS RED (P. 89)
PBk7 CARBON BLACK (P. 256)

HEALTH	ASTM	RATING
✕	I	★
INFO	L'FAST	★ ★

BURNT UMBER 5702

Strictly speaking the pigment description fits Burnt Sienna. Brushed out well. Semi-opaque.

HUNTS

SPEEDBALL PROFESSIONAL WATERCOLOURS

CALCINED NATURAL IRON OXIDE

HEALTH	ASTM	RATING
✕	I	★
INFO	L'FAST	★ ★

BURNT UMBER 668

Sample was ground a little coarsely. Brushed out well however, over a useful range. Completely unaffected by light.

SCHMINCKE

HORADAM FINEST ARTISTS' WATER COLOURS

PBr7 BURNT UMBER (P. 212)

HEALTH	ASTM	RATING
✕	I	★
INFO	L'FAST	★ ★

BURNT UMBER 128

Does not have quite the intensity of hue of other examples, as if a little white had been added. Handled very smoothly. Semi-opaque.

BINNEY & SMITH

PROFESSIONAL ARTISTS' WATER COLOR

PBr7 BURNT UMBER (P. 212)

HEALTH	ASTM	RATING
✓	I	★
INFO	L'FAST	★ ★

BURNT UMBER 1111

This is not Burnt Umber at all but an imitation. Close in hue to the genuine article but lacking its richness. Semi-opaque.

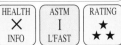

LUKAS

ARTISTS' WATER COLOUR

PY42 MARS YELLOW (P. 34)
PBk11 MARS BLACK (P. 257)

HEALTH	ASTM	RATING
✕	I	★
INFO	L'FAST	★ ★

BURNT UMBER 206

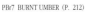

DA VINCI PAINTS

Re-formulated and now handles particularly well. Brushes out to give a reasonably wide range of values. Will not fade . Semi-opaque.

PBr7 BURNT UMBER (P. 212)

HEALTH	ASTM	RATING
✓ INFO	I L'FAST	★★ ★★

PERMANENT ARTISTS' WATER COLOR

BURNT UMBER 539

MAIMERI

A thoroughly reliable watercolour. Rich and deep in colour. Brushed out beautifully over a useful series of values. Semi-opaque.

PBr7 BURNT UMBER (P. 212)

HEALTH	ASTM	RATING
✗ INFO	I L'FAST	★★

ARTISTI EXTRA-FINE WATERCOLOURS

BURNT UMBER 223

ROWNEY

Superb. Brushed out particularly well giving smooth gradated washes. Covers well and provides quite transparent glazes. Lightfast.

PBr7 BURNT UMBER (P. 212)

HEALTH	ASTM	RATING
✓ INFO	I L'FAST	★★

GEORGIAN WATER COLOUR 2ND RANGE

BURNT UMBER 075

REEVES

Strong, deep colour in heavier application. When well diluted provides rather clear washes. Handles well. *This range of colours has now been discontinued.*

PBr7 BURNT UMBER (P. 212)

HEALTH	ASTM	RATING
✗ INFO	I L'FAST	★★ ★★

WATER COLOUR FOR ARTISTS 2ND RANGE

BURNT UMBER 076 (303)

WINSOR & NEWTON

If you need to make savings by purchasing 'Second Range' colours, look to the earths first. Absolutely lightfast and the equivalent of many 'Artist Quality' examples.

PBr7 BURNT UMBER (P. 212)

HEALTH	ASTM	RATING
✗ INFO	I L'FAST	★★ ★★

COTMAN WATER COLOUR 2ND RANGE

BURNT UMBER 620

MAIMERI

A velvety deep brown in heavier application. Washes out to give reasonably transparent glazes. Most reliable.

PBr7 BURNT UMBER (P. 212)

HEALTH	ASTM	RATING
✗ INFO	I L'FAST	★★ ★★

STUDIO FINE WATER COLOR 2ND RANGE

BURNT UMBER 409

TALENS

Rather warm in hue, closer to Burnt Sienna than the traditional Burnt Umber. Handles beautifully. Semi-opaque. *This range has now been discontinued.*

PBr7 BURNT UMBER (P. 212)

HEALTH	ASTM	RATING
✗ INFO	I L'FAST	★★ ★★

WATER COLOUR 2ND RANGE

BURNT UMBER 024

GRUMBACHER

An intense, deep brown at full strength. Handles very smoothly. A well produced watercolour. Semi-opaque.

PBr7 BURNT UMBER (P. 212)

HEALTH	ASTM	RATING
✓ INFO	I L'FAST	★★

ACADEMY ARTISTS' WATERCOLOUR 2ND RANGE

Considered by many to be the only true brown available. Other 'browns' being easily identified as neutralised orange, red or yellow.

7.4 English Red

A synthetic iron oxide, English or Light Red Oxide is distinguished from its cousins, Venetian Red, Indian Red and Mars Red, by colour alone. Much confusion was created in the past as the terms were used loosely to describe iron oxides, whether natural or synthetic.

The work of the ASTM committee on artists paints will hopefully lead to common descriptions.

As the colours are very similar in certain respects, many painters are undecided on which to select. The real difference between them is particularly noticeable in the undercolour. When deciding between the various colour names or even choosing between one make or another, wash out a small area and note the colour of the tint.

In this section I have emphasised the colour of the paint as a thin wash. It is

common for many artists to select a colour by opening a tube and looking at the full strength paint. When working later, the paint is often applied as a medium to thin wash where it changes in character. This applies to all colours but is particularly important when choosing from amongst the various PR101's on offer.

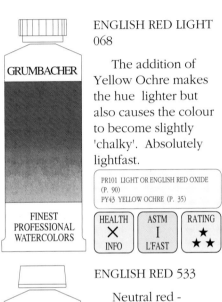

ENGLISH RED LIGHT 068

The addition of Yellow Ochre makes the hue lighter but also causes the colour to become slightly 'chalky'. Absolutely lightfast.

GRUMBACHER
FINEST PROFESSIONAL WATERCOLORS

PR101 LIGHT OR ENGLISH RED OXIDE (P. 90)
PY43 YELLOW OCHRE (P. 35)

HEALTH	ASTM	RATING
✕ INFO	I L'FAST	★ ★★

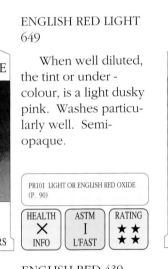

ENGLISH RED LIGHT 649

When well diluted, the tint or under-colour, is a light dusky pink. Washes particularly well. Semi-opaque.

SCHMINCKE
HORADAM FINEST ARTISTS' WATER COLOURS

PR101 LIGHT OR ENGLISH RED OXIDE (P. 90)

HEALTH	ASTM	RATING
✕ INFO	I L'FAST	★★

ENGLISH RED LIGHT 1054

The undercolour is a warm pink, mass tone a rich neutral red-orange. Wide range of values available. Superb. Semi-opaque.

LUKAS
ARTISTS' WATER COLOUR

PR101 LIGHT OR ENGLISH RED OXIDE (P. 90)

HEALTH	ASTM	RATING
✕ INFO	I L'FAST	★★

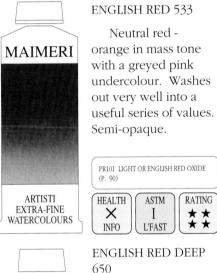

ENGLISH RED 533

Neutral red-orange in mass tone with a greyed pink undercolour. Washes out very well into a useful series of values. Semi-opaque.

MAIMERI
ARTISTI EXTRA-FINE WATERCOLOURS

PR101 LIGHT OR ENGLISH RED OXIDE (P. 90)

HEALTH	ASTM	RATING
✕ INFO	I L'FAST	★ ★★

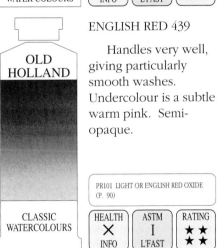

ENGLISH RED 439

Handles very well, giving particularly smooth washes. Undercolour is a subtle warm pink. Semi-opaque.

OLD HOLLAND
CLASSIC WATERCOLOURS

PR101 LIGHT OR ENGLISH RED OXIDE (P. 90)

HEALTH	ASTM	RATING
✕ INFO	I L'FAST	★★

ENGLISH RED DEEP 1055

Well produced watercolour paint, smoothly ground and densely packed. Undercolour is a slightly violet-pink.

LUKAS
ARTISTS' WATER COLOUR

PR101 LIGHT OR ENGLISH RED OXIDE (P. 90)

HEALTH	ASTM	RATING
✕ INFO	I L'FAST	★★

ENGLISH RED DEEP 650

An excellent water-colour, smoothly ground, absolutely lightfast and brushes superbly. Soft violet-pink undercolour.

SCHMINCKE
HORADAM FINEST ARTISTS' WATER COLOURS

PR101 LIGHT OR ENGLISH RED OXIDE (P. 90)
PY42 MARS YELLOW (P.34)

HEALTH	WG	RATING
✕ INFO	II L'FAST	★ ★★

A reliable, first class watercolour. Medium applications are semi-opaque but it washes out to give reasonably clear, very subtle tints.

7.5 Indian Red

The name was originally used for a naturally occurring red ochre imported from India. It is now employed to describe an artificially made red iron oxide of great durability.

Distinguished from other Pigment Red 101's by colour alone, Indian Red possesses a slightly violet undercolour.

As I suggest on page 223, the ideal method of determining between the different PR101's (or indeed when deciding which make of Indian Red to choose), is to paint out and note the undercolour. I have made special mention here of this factor, but all colours should be so examined. There can be considerable differences of basic hue between full strength applications and thin washes with any watercolour.

Treat as a neutralised violet - red when mixing and select a yellow - green as its partner.

INDIAN RED 523

Particularly well produced watercolour paint. Very smoothly ground and brushed out beautifully. Undercolour a soft salmon pink. Semi-opaque.

ROWNEY
ARTISTS' WATER COLOUR

PR101 INDIAN RED (P. 89)		
HEALTH ✕ INFO	ASTM I L'FAST	RATING ★★ ★★

INDIAN RED 694

Densely packed pigment, very finely ground. Brushed out particularly well giving rather transparent washes when very dilute. Soft pink undercolour.

HOLBEIN
ARTISTS' WATER COLOR

PR101 INDIAN RED (P. 89)		
HEALTH ✕ INFO	ASTM I L'FAST	RATING ★★

INDIAN RED 317 (023)

Undercolour is a delicate, greyed pink. Very well prepared and brushed out rather smoothly. Semi-opaque.

WINSOR & NEWTON
ARTISTS' WATER COLOUR

PR101 INDIAN RED (P. 89)		
HEALTH ✕ INFO	ASTM I L'FAST	RATING ★★

INDIAN RED 347

The inclusion of Alizarin Crimson lowers the overall lightfast rating. It gives the colour a slightly rosier look, for a while. An unnecessary addition. Semi-opaque.

TALENS
REMBRANDT ARTISTS' WATER COLOUR

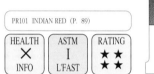

PR83:1 ALIZARIN CRIMSON (P. 88) PR101 INDIAN RED (P. 89)		
HEALTH ✕ INFO	ASTM IV L'FAST	RATING ★

INDIAN RED 240

Although semi-opaque at mid strength, it brushes out to give particularly transparent washes when very dilute. Excellent.

BINNEY & SMITH
PROFESSIONAL ARTISTS' WATER COLOR

PR101 INDIAN RED (P. 89)		
HEALTH ✓ INFO	ASTM I L'FAST	RATING ★★ ★★

INDIAN RED 110

Brushes out from full strength to the clearest wash very smoothly. A subtle, dusky pink undercolour. Absolutely lightfast.

GRUMBACHER
FINEST PROFESSIONAL WATERCOLORS

PR101 INDIAN RED (P. 89)		
HEALTH ✕ INFO	ASTM I L'FAST	RATING ★★

INDIAN RED 317 (318)

Not quite as smoothly ground as the 'Artist Quality' in this make. The pigment is quite unaffected by light, however strong and prolonged.

WINSOR & NEWTON
COTMAN WATER COLOUR 2ND RANGE

PR101 INDIAN RED (P. 89)		
HEALTH ✕ INFO	ASTM I L'FAST	RATING ★★

INDIAN RED (VENETIAN RED) 110

In both mass tone and undercolour is rather more orange than traditional Indian Red. This of course is due to the Yellow Ochre. Most reliable. Semi-opaque.

GRUMBACHER
ACADEMY ARTISTS' WATERCOLOUR 2ND RANGE

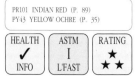

PR101 INDIAN RED (P. 89) PY43 YELLOW OCHRE (P. 35)		
HEALTH ✓ INFO	ASTM I L'FAST	RATING ★★

Wash out an area of paint to determine the undercolour. Such thin layers reveal the true nature of the colour. A knowledge of such 'hidden' colours will extend your range of available possibilities.

7.6 Light Red

A neutral orange to orange - red. Produced by heating naturally occurring Yellow Ochre. As with all pigments which alter as they are roasted, the final colour will depend very much on the furnace operator. The colour will tend to vary somewhat between batches but each manufacturer tries to produce a regular result.

Available from opaque to reasonably transparent. Most commonly semi-opaque but brushes out to give reasonably clear washes.

When mixing, treat as a neutral mid or red - orange, depending on your selection. As the complementary of orange is blue, experiment with the various blues to find the ideal partner.

LIGHT RED 362 (029)

A particularly well produced watercolour. Dense pigment, well ground and brushes out smoothly. Ingredients are completely lightfast.

PR101 LIGHT OR ENGLISH RED OXIDE (P. 90)
PY43 YELLOW OCHRE (P. 35)

WINSOR & NEWTON — ARTISTS' WATER COLOUR

HEALTH	ASTM	RATING
✕ INFO	I L'FAST	★★ ★★

LIGHT RED 695

Brushes out particularly well. Ranges from semi-opaque to transparent when very dilute. Undercolour is a warm neutral orange.

PR101 LIGHT OR ENGLISH RED OXIDE (P. 90)

HOLBEIN — ARTISTS' WATER COLOR

HEALTH	ASTM	RATING
✕ INFO	I L'FAST	★★

LIGHT RED 527

Smooth, well produced paint. Handles with great flexibility over a useful range of values. Subtle, greyed orange tint when very dilute. Semi-opaque.

PR101 LIGHT OR ENGLISH RED OXIDE (P. 90)
PY43 YELLOW OCHRE (P. 35)

ROWNEY — ARTISTS' WATER COLOUR

HEALTH	ASTM	RATING
✓ INFO	I L'FAST	★★

LIGHT RED 123

Sample was rather overbound, making handling difficult. Thin washes were fine. Absolutely lightfast. Semi-opaque.

PR101 LIGHT OR ENGLISH RED OXIDE (P. 90)

BLOCKX — AQUARELLES ARTISTS' WATER COLOUR

HEALTH	ASTM	RATING
✕ INFO	I L'FAST	★ ★★

LIGHT OXIDE RED 339

A well prepared watercolour paint. Brushed out very evenly at all strengths. Gives a salmon pink undercolour when very dilute. Excellent.

PR101 LIGHT OR ENGLISH RED OXIDE (P. 90)

TALENS — REMBRANDT ARTISTS' WATER COLOUR

HEALTH	ASTM	RATING
✕ INFO	I L'FAST	★★ ★★

LIGHT RED 362 (325)

Warmer in colour than the 'Artist Quality' in this make as there are no additions. Handled very well. Has a soft red - orange tint when diluted. Semi-transparent.

PR101 LIGHT OR ENGLISH RED OXIDE (P. 90)

WINSOR & NEWTON — COTMAN WATER COLOUR 2ND RANGE

HEALTH	ASTM	RATING
✓ INFO	I L'FAST	★★ ★★

LIGHT RED 527

Not Light Red at all but a close imitation. Dense pigment and washed out very well. When dilute, the tint is a light, neutral mid-orange. Semi-opaque.

PBr 6 MARS BROWN (P. 256)

ROWNEY — GEORGIAN WATER COLOUR 2ND RANGE

HEALTH	WG	RATING
✓ INFO	I L'FAST	★ ★★

LIGHT RED (ENGLISH RED LIGHT) 120

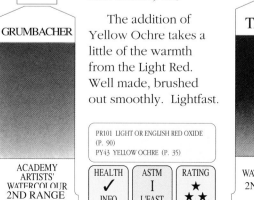

The addition of Yellow Ochre takes a little of the warmth from the Light Red. Well made, brushed out smoothly. Lightfast.

PR101 LIGHT OR ENGLISH RED OXIDE (P. 90)
PY43 YELLOW OCHRE (P. 35)

GRUMBACHER — ACADEMY ARTISTS' WATERCOLOUR 2ND RANGE

HEALTH	ASTM	RATING
✓ INFO	I L'FAST	★

LIGHT OXIDE RED 339

A well produced watercolour. Good covering power but strong enough to give reasonably clear washes when well diluted. *This range has been discontinued.*

PR101 LIGHT OR ENGLISH RED OXIDE (P. 90)

TALENS — WATER COLOUR 2ND RANGE

HEALTH	ASTM	RATING
✕ INFO	I L'FAST	★★ ★★

A thin wash will reveal the undercolour. Too often the paint is applied heavily and the available delicate tint ignored.

7.7 Ochres

The difference between the variously coloured iron oxides has not always been clear. At one time they were all described as Yellow Ochre whether they were yellow, red or brown. The descriptions have now generalised into yellow, gold, brown and red. As you will see the Gold or Golden Ochres are based on Yellow Ochre.

Rather than worry too much about the actual colour name I suggest that you note the ingredients and decide if you need the colour, have it already under another name, or can mix it with ease.

One company in particular, Old Holland, specialises in the supply of a range of ochres. They are very well ground and handled with ease.

Although I feel sure that each will be a lightfast iron oxide, I am unable to give full guidance as they are given only a general description regarding contents. Due to the nature of this book I cannot second guess actual ingredients.

BROWN OCHRE PALE 435

As the description 'earth colours' could conceivably include the fugitive Van Dyke Brown, I cannot offer assessments. Sample brushed out very well.

OLD HOLLAND

CLASSIC WATERCOLOURS

EARTH COLOURS

HEALTH ✗ INFO

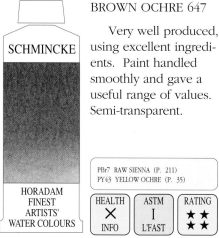

BROWN OCHRE 647

Very well produced, using excellent ingredients. Paint handled smoothly and gave a useful range of values. Semi-transparent.

SCHMINCKE

HORADAM FINEST ARTISTS' WATER COLOURS

PBr7 RAW SIENNA (P. 211)
PY43 YELLOW OCHRE (P. 35)

HEALTH ✗ INFO | ASTM I L'FAST | RATING ★★ ★★

BROWN OCHRE DEEP 442

Very well produced and brushed out smoothly. Clear washes are obtained when well diluted. Without exact details on ingredients I cannot offer assessments.

OLD HOLLAND

CLASSIC WATERCOLOURS

EARTH COLOURS

HEALTH ✗ INFO

DEEP OCHRE 443

It is a pity that full details of ingredients were not provided as this company produce a good range of ochres. They are most probably all lightfast but I cannot offer assessments.

OLD HOLLAND

CLASSIC WATERCOLOURS

EARTH COLOURS

HEALTH ✗ INFO

GOLD OCHRE 113

Yellow Ochre under another name. A well produced watercolour which brushed out beautifully, giving clear washes. Absolutely lightfast. Semi-transparent.

BLOCKX

AQUARELLES ARTISTS' WATER COLOUR

PY43 YELLOW OCHRE (P. 35)

HEALTH ✗ INFO | ASTM I L'FAST | RATING ★★

GOLD OCHRE 231

The PR101 is unspecified but will be lightfast. Sample handled very well and gave rather clear, even washes when applied dilute. Excellent. Semi-transparent.

TALENS

REMBRANDT ARTISTS' WATER COLOUR

PR101
PY43 YELLOW OCHRE

HEALTH ✗ INFO | ASTM I L'FAST | RATING ★★ ★★

GOLD OCHRE 257

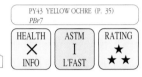

SENNELIER

EXTRA-FINE
ARTISTS'
WATER COLOURS

A rather dark version of Yellow Ochre. Sample brushed out very well giving a wide range of values. Absolutely lightfast. Semi-transparent.

PY43 YELLOW OCHRE (P. 35)
PBr7

HEALTH	ASTM	RATING
✕	I	★
INFO	L'FAST	★★

GOLD OCHRE 432

OLD HOLLAND

CLASSIC
WATERCOLOURS

Once again, I cannot offer assessments without full and accurate information on the ingredients. Very well produced paint which washed out beautifully.

EARTH COLOURS

HEALTH		
✕		
INFO		

GOLD OCHRE 1023

LUKAS

ARTISTS'
WATER COLOUR

A useful convenience colour. The ingredients are all absolutely lightfast and made into a watercolour which brushed out very smoothly. Semi-opaque.

PBk11 MARS BLACK (P. 257)
PR101 INDIAN RED (P. 89)
PY43 YELLOW OCHRE (P. 35)

HEALTH	ASTM	RATING
✕	I	★★
INFO	L'FAST	★★

GOLDEN OCHRE 651

SCHMINCKE

HORADAM
FINEST
ARTISTS'
WATER COLOURS

Sample was rather overbound, making heavier application difficult. Thinner washes were fine and reasonably clear. Semi-transparent.

PY42 MARS YELLOW (P.34)
PBr7 RAW SIENNA (P. 211)
PY43 YELLOW OCHRE (P. 35)

HEALTH	WG	RATING
✕	II	★
INFO	L'FAST	★★

GOLDEN OCHRE 529

MAIMERI

ARTISTI
EXTRA-FINE
WATERCOLOURS

The sample provided was rather dark for Yellow Ochre. Brushed out particularly well and gave smooth gradated washes. Semi-transparent.

PY43 YELLOW OCHRE (P. 35)

HEALTH	ASTM	RATING
✕	I	★
INFO	L'FAST	★★

GOLDEN OCHRE 614

MAIMERI

STUDIO
FINE
WATER COLOR
2ND RANGE

Washed out very smoothly across a wide range of strengths. Reasonably clear washes when dilute. Rather dark for the ingredients. Semi-transparent.

PY43 YELLOW OCHRE (P. 35)

HEALTH	ASTM	RATING
✕	I	★
INFO	L'FAST	★★

RED OCHRE 437

OLD HOLLAND

CLASSIC
WATERCOLOURS

This company offers a good range of Ochres but failed to give exact information on the ingredients. As I cannot be too careful I will not make assessments.

EARTH COLOURS

HEALTH		
✕		
INFO		

RED OCHRE 306

LEFRANC & BOURGEOIS

LINEL
EXTRA-FINE
ARTISTS'
WATERCOLOUR

Brushed out beautifully, from a rich red - brown to a light neutral orange. Should ideally be called Light Red as that is what it is. Semi-transparent.

PR102 LIGHT RED (P. 90)

HEALTH	ASTM	RATING
✓	I	★
INFO	L'FAST	★★

RED OCHRE 259

SENNELIER

EXTRA-FINE
ARTISTS'
WATER COLOURS

The sample provided for the first edition of this book was particularly gritty. The colour is now very much improved. Gave clear, smooth washes over a wide range. Excellent.

PR102 LIGHT RED (P. 90)

HEALTH	ASTM	RATING
✕	I	★★
INFO	L'FAST	★★

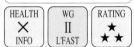

7.8 Raw Sienna

A naturally occurring iron oxide, Raw Sienna has been in use since painting began on cave walls. The name came into general use after a particularly fine variety at one time dug from deposits near Sienna, Tuscany. An ideal pigment with an admirable range of characteristics. A good quality Raw Sienna lies between Yellow Ochre and Burnt Sienna in colour. It has become very common to offer darker versions of Yellow Ochre under this name. To my mind this is a poor practice. If the two pigments were identical in make-up, colour and handling they would long ago have merged under the one common name. Raw Sienna has colour characteristics of its own and is usually slightly more transparent.

For mixing purposes it can be considered to be a neutral orange - yellow. Through experimentation you will find a blue - violet that will act as a mixing partner.

RAW SIENNA 690

HOLBEIN
ARTISTS' WATER COLOR

Virtually identical to the Yellow Ochre produced by this company. Not surprising really as they are both Yellow Ochre. Semi-transparent.

PY43 YELLOW OCHRE (P. 35)

HEALTH	ASTM	RATING
✕ INFO	I L'FAST	★ ★ ★

RAW SIENNA 552 (040)

WINSOR & NEWTON
ARTISTS' WATER COLOUR

An absolutely lightfast colour which brushes out very well. Thin washes are clear and bright. Semi-transparent.

PY43 YELLOW OCHRE (P. 35)

HEALTH	ASTM	RATING
✕ INFO	I L'FAST	★ ★ ★

RAW SIENNA 171

GRUMBACHER
FINEST PROFESSIONAL WATERCOLORS

A rather deeper version than is usual. Handled particularly well over the full range. Quality watercolour paint using genuine ingredients. Semi-transparent.

PBr7 RAW SIENNA (P. 211)

HEALTH	ASTM	RATING
✕ INFO	I L'FAST	★ ★ ★

RAW SIENNA 1039

LUKAS
ARTISTS' WATER COLOUR

If you already have the Yellow Ochre produced by Lukas, you will not need it a second time. Semi-transparent.

PY43 YELLOW OCHRE (P. 35)

HEALTH	ASTM	RATING
✕ INFO	I L'FAST	★ ★ ★

RAW SIENNA 5730

HUNTS
SPEEDBALL PROFESSIONAL WATERCOLOURS

Without exact and confirmed pigment information I am not willing to commit myself to assessments.

PURIFIED EARTH COLOUR

HEALTH		
✕ INFO		

RAW SIENNA 135

PĒBĒO
FRAGONARD ARTISTS' WATER COLOUR

Sample brushed out very poorly and contained debris. An imitation which resembled Raw S rather than Raw Sienna.

PR101 MARS RED (P. 89)
PY42 MARS YELLOW (P. 34)

HEALTH	ASTM	RATING
✕ INFO	I L'FAST	★

RAW SIENA 273

DA VINCI PAINTS
PERMANENT ARTISTS' WATER COLOR

A rare substance, Raw Sienna which actually is Raw Sienna, (however the company spell it). Handled particularly well giving smooth even washes. Absolutely lightfast. Semi- transparent.

PBr7 RAW SIENNA (P. 211)

HEALTH	ASTM	RATING
✓ INFO	I L'FAST	★ ★ ★ ★

RAW SIENNA 433

OLD HOLLAND
CLASSIC WATERCOLOURS

Assessments are not possible without accurate and confirmed information.

EARTH COLOURS

HEALTH		
✕ INFO		

RAW SIENNA 667

ROWNEY
ARTISTS' WATER COLOUR

Good quality Raw Sienna has its own unique qualities of hue and handling. This is yet another simple imitation.

PY43 YELLOW OCHRE (P. 35)

HEALTH	ASTM	RATING
✓ INFO	I L'FAST	★ ★

TALENS

REMBRANDT
ARTISTS'
WATER COLOUR

RAW SIENNA 234

A well produced watercolour. Handled fine but lacks the distinctive colour characteristics of the genuine article.

PY43 YELLOW OCHRE (P. 35)

HEALTH	ASTM	RATING
✗ INFO	I L'FAST	★ ★

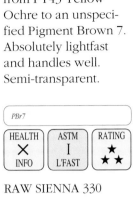

SENNELIER

EXTRA-FINE
ARTISTS'
WATER COLOURS

RAW SIENNA 208

The pigment has recently been changed from PY43 Yellow Ochre to an unspecified Pigment Brown 7. Absolutely lightfast and handles well. Semi-transparent.

PBr7

HEALTH	ASTM	RATING
✗ INFO	I L'FAST	★ ★

MARTIN F. WEBER

PERMALBA
ARTIST'S
WATER COLOR
AQUARELLE

RAW SIENNA 2060

The PY43 previously used in the make up of this colour has been changed to an unspecified PBr7. Lightfast and handles very well. Semi-transparent.

PBr7

HEALTH	ASTM	RATING
✓ INFO	I L'FAST	★ ★

LEFRANC & BOURGEOIS

LINEL
EXTRA-FINE
ARTISTS'
WATERCOLOUR

RAW SIENNA 482

Not one company marketing Yellow Ochre as Raw Sienna describes the colour as Raw Sienna Hue. This would at least identify it as an imitation.

PY43 YELLOW OCHRE (P. 35)

HEALTH	ASTM	RATING
✓ INFO	I L'FAST	★ ★

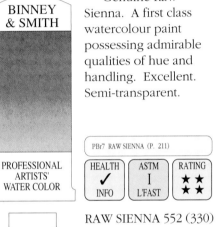

BINNEY & SMITH

PROFESSIONAL
ARTISTS'
WATER COLOR

RAW SIENNA 330

Genuine Raw Sienna. A first class watercolour paint possessing admirable qualities of hue and handling. Excellent. Semi-transparent.

PBr7 RAW SIENNA (P. 211)

HEALTH	ASTM	RATING
✓ INFO	I L'FAST	★ ★ ★ ★

MAIMERI

ARTISTI
EXTRA-FINE
WATERCOLOURS

RAW SIENNA 540

A well produced watercolour paint. Genuine ingredients have been used. Brushed out smoothly and gave a useful range of values. Semi-transparent.

PBr7 RAW SIENNA (P. 211)

HEALTH	ASTM	RATING
✗ INFO	I L'FAST	★ ★ ★ ★

SCHMINCKE

HORADAM
FINEST
ARTISTS'
WATER COLOURS

RAW SIENNA 660

Smooth, clear washes are available when well diluted. Brushed out particularly well. Absolutely lightfast. Semi-transparent.

PBr7 RAW SIENNA (P. 211)

HEALTH	ASTM	RATING
✗ INFO	I L'FAST	★ ★ ★ ★

WINSOR & NEWTON

COTMAN
WATER COLOUR
2ND RANGE

RAW SIENNA 552 (330)

A very reliable colour which will never fade. Sample brushed out very smoothly over a good range of values. Semi-transparent.

PY43 YELLOW OCHRE (P. 35)

HEALTH	ASTM	RATING
✓ INFO	I L'FAST	★ ★

TALENS

WATER COLOUR
2ND RANGE

RAW SIENNA 234

A simple imitation of Raw Sienna although the title does not make this clear. Absolutely lightfast. Semi-transparent. *This range of colours has now been discontinued.*

PY43 YELLOW OCHRE (P. 35)

HEALTH	ASTM	RATING
✓ INFO	I L'FAST	★ ★

ROWNEY

GEORGIAN
WATER COLOUR
2ND RANGE

RAW SIENNA 667

Absolutely lightfast, handles well over a useful range of values but it is not Raw Sienna. Semi-transparent.

PY43 YELLOW OCHRE (P. 35)

HEALTH	ASTM	RATING
✓ INFO	I L'FAST	★ ★

MAIMERI

STUDIO
FINE
WATER COLOR
2ND RANGE

RAW SIENNA 621

An excellent all round watercolour. As lightfast as the 'Artist Quality' and superior to many. First class. Semi-transparent.

PBr7 RAW SIENNA (P. 211)

HEALTH	ASTM	RATING
✗ INFO	I L'FAST	★ ★ ★ ★

REEVES

WATER COLOUR
FOR ARTISTS
2ND RANGE

RAW SIENNA 552

Yellow Ochre passed off as Raw Sienna. An excellent all round watercolour which would ideally be called 'Raw Sienna Hue'. Semi-transparent. *This range has now been discontinued.*

PY43 YELLOW OCHRE (P. 35)

HEALTH	ASTM	RATING
✗ INFO	I L'FAST	★ ★

RAW SIENNA 171

GRUMBACHER

A mix which is somewhat 'heavier' in colour than unadulterated Raw Sienna. Dependable and washed out well. Semi-transparent.

| PBr7 RAW SIENNA (P. 211) |
| PY42 MARS YELLOW (P. 34) |

HEALTH	ASTM	RATING
✓ INFO	I L'FAST	★★

ACADEMY ARTISTS' WATERCOLOUR 2ND RANGE

Raw Sienna has long been valued as a glazing colour. The better qualities are particularly transparent and wash out very smoothly.

7.9 Raw Umber

Believed to have been in use from the earliest times although its employment was not mentioned in easel painting until the 11th Century. Since then it has gained in popularity and is now widely used.

There are two schools of thought concerning the origins of the name. Some say it originated from a production site at Umbria, in Italy, although very little was produced there. The second version is that it is derived from the Latin 'Ombra' meaning shadow or shade.

A very pleasant, cool brown. The better qualities lean towards green. Not particularly transparent, although some grades give quite clear washes.

As far as its use in mixing is concerned I would suggest that it is used without further addition. It is a delicate colour which will soon lose its true character. Darken with a blue such as Ultramarine. Experiment first to suit your particular selection.

RAW UMBER 538

MAIMERI

A watercolour paint which handles particularly well. Quite strong in tinting power and covers well. Excellent. Semi-opaque.

| PBr 7 RAW UMBER (P. 211) |

HEALTH	ASTM	RATING
✗ INFO	I L'FAST	★★ ★★

ARTISTI EXTRA-FINE WATERCOLOURS

RAW UMBER 1110

LUKAS

This was previously made up using PY43 Yellow Ochre. Now reformulated to give a colour which resembles genuine Raw Umber. Let down by the inclusion of the unreliable PY74.

| PR176 BENZIMID. CARMINE (P.94) |
| PY74 ARYLIDE YELLOW (P.36) |
| PBk7 CARBON BLACK (P.256) |

ARTISTS' WATER COLOUR

HEALTH	ASTM	RATING
✗ INFO	III L'FAST	★★

RAW UMBER 691

HOLBEIN

Superb. Washes out smoothly, has good covering power but gives clear washes. Absolutely lightfast and well ground. Semi-opaque.

| PBr 7 RAW UMBER (P. 211) |

ARTISTS' WATER COLOR

HEALTH	ASTM	RATING
✗ INFO	I L'FAST	★★

RAW UMBER 554 (041)

WINSOR & NEWTON

Sample was rather overbound making only very light washes possible. Absolutely lightfast.

| PBr 7 RAW UMBER (P. 211) |

ARTISTS' WATER COLOUR

HEALTH	ASTM	RATING
✗ INFO	I L'FAST	★★

RAW UMBER 667

SCHMINCKE

Rather overbound but handled well in thinner application. Medium layers dried with a distinct shine. Lightfast.

| PBr 7 RAW UMBER (P. 211) |
| PY43 YELLOW OCHRE (P. 35) |

HORADAM FINEST ARTISTS' WATER COLOURS

HEALTH	ASTM	RATING
✗ INFO	I L'FAST	★★

RAW UMBER 478

LEFRANC & BOURGEOIS

Brushed out beautifully, a fine example of this colour. Has good covering power yet will give reasonably clear washes. First class. Semi-opaque.

| PBr 7 RAW UMBER (P. 211) |

LINEL EXTRA-FINE ARTISTS' WATERCOLOUR

HEALTH	ASTM	RATING
✓ INFO	I L'FAST	★★

RAW UMBER 247

A dark, dense velvety brown washing to a light, neutral tint. Handles very smoothly over the entire range. Semi-opaque.

PBr 7 RAW UMBER (P. 211)

ROWNEY

ARTISTS' WATER COLOUR

HEALTH	ASTM	RATING
✓	I	★★
INFO	L'FAST	★★

RAW UMBER 331

Medium applications are rich in colour and possess good covering power. Washes out well to give reasonably clear tints. Well labelled. Superb all round watercolour.

PBr 7 RAW UMBER (P. 211)

BINNEY & SMITH

PROFESSIONAL ARTISTS' WATER COLOR

HEALTH	ASTM	RATING
✓	I	★★
INFO	L'FAST	★★

RAW UMBER 2061

The sample provided was rather weak with a low pigment to gum ratio. Difficult to wash out smoothly. Lightfast. Semi-transparent.

PBr 7 RAW UMBER (P. 211)

MARTIN F. WEBER

PERMALBA ARTIST'S WATER COLOR AQUARELLE

HEALTH	ASTM	RATING
✓	I	★★
INFO	L'FAST	

RAW UMBER 444

Without full information I cannot offer assessments. The pigment description could conceivably include the unreliable Van Dyke Brown. Every effort was made to obtain accurate detail.

EARTH COLOURS

OLD HOLLAND

CLASSIC WATERCOLOURS

HEALTH	
✗	
INFO	

RAW UMBER 205

At full strength it is a rich, deep brown with good covering power. Washed out to give fairly clear tints. An excellent water-colour. Semi-opaque.

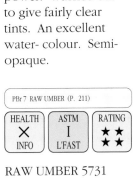

PBr 7 RAW UMBER (P. 211)

SENNELIER

EXTRA-FINE ARTISTS' WATER COLOURS

HEALTH	ASTM	RATING
✗	I	★★
INFO	L'FAST	★★

RAW UMBER 408

Rather overbound which made handling difficult. Very thin washes only were possible from the sample.

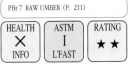

PBr 7 RAW UMBER (P. 211)

TALENS

REMBRANDT ARTISTS' WATER COLOUR

HEALTH	ASTM	RATING
✗	I	★★
INFO	L'FAST	

RAW UMBER 172

A particularly dark version of the colour due to the inclusion of Burnt Sienna. Reliable ingredients but a mongrel colour.

PBr7 BURNT SIENNA (P. 212)
PBr 7 RAW UMBER (P. 211)
PY42 MARS YELLOW (P. 34)

GRUMBACHER

FINEST PROFESSIONAL WATERCOLORS

HEALTH	ASTM	RATING
✗	I	★
INFO	L'FAST	★★

RAW UMBER 5731

If the company decide to co-operate on the next edition, I will bring you further information and give assessments.

PURIFIED EARTH COLOUR

HUNTS

SPEEDBALL PROFESSIONAL WATERCOLOURS

HEALTH	
✗	
INFO	

RAW UMBER 131

This paint has no relation to Raw Umber, either in composition or colour. Raw Umber, with untold centuries of proven value, deserves better than this. My rating refers to the final paint.

PR101 MARS RED (P. 89)
PY42 MARS YELLOW (P. 34)
PG10 GREEN GOLD (P. 178)
PBk7 CARBON BLACK (P. 256)

PĒBĒO

FRAGONARD ARTISTS' WATER COLOUR

HEALTH	WG	RATING
✗	II	★
INFO	L'FAST	★★

RAW UMBER 172

The addition of further pigments moves the colour away from its true position. Personally I cannot see how Raw Umber can be improved upon. Semi-opaque.

PBr7 BURNT SIENNA (P. 212)
PY42 MARS YELLOW (P. 34)
PBr 7 RAW UMBER (P. 211)

GRUMBACHER

ACADEMY ARTISTS' WATERCOLOUR 2ND RANGE

HEALTH	ASTM	RATING
✓	I	★
INFO	L'FAST	★★

RAW UMBER 619

A well ground watercolour paint. Reasonably good covering power and fairly clear tints. Most reliable. Many 'Second Range' paints in general are as lightfast as the 'Artist Quality'.

PBr 7 RAW UMBER (P. 211)

MAIMERI

STUDIO FINE WATER COLOR 2ND RANGE

HEALTH	ASTM	RATING
✗	I	★★
INFO	L'FAST	

RAW UMBER 554

Superior to many 'Artist Quality' versions of this colour. It is also closer in colour to the traditional characteristics of Raw Umber. Excellent. Semi-opaque. *Range now discontinued.*

PBr 7 RAW UMBER (P. 211)

REEVES

WATER COLOUR FOR ARTISTS 2ND RANGE

HEALTH	ASTM	RATING
✗	I	★★
INFO	L'FAST	★★

RAW UMBER 247

ROWNEY

Slightly gritty in texture. Sample did not wash out particularly well. Reliable. Semi-opaque.

GEORGIAN WATER COLOUR 2ND RANGE

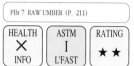

PBr 7 RAW UMBER (P. 211)

HEALTH	ASTM	RATING
✕ INFO	I L'FAST	★★

RAW UMBER 554 (331)

WINSOR & NEWTON

A well produced watercolour, preferable to many 'Artist Quality' Raw Umbers. Covered well and gave reasonably clear washes. Semi-opaque.

COTMAN WATER COLOUR 2ND RANGE

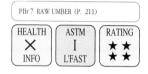

PBr 7 RAW UMBER (P. 211)

HEALTH	ASTM	RATING
✕ INFO	I L'FAST	★★ ★★

RAW UMBER 408

TALENS

Sample was rather gum laden making application difficult. Lightfast.

This range of colours has recently been discontinued.

WATER COLOUR 2ND RANGE

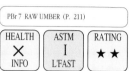

PBr 7 RAW UMBER (P. 211)

HEALTH	ASTM	RATING
✕ INFO	I L'FAST	★★

RAW UMBER

PAILLARD

Promised co-operation did not materialise. Without information I cannot offer guidance. The label and literature tell us that it is Raw Umber, no more.

LOUVRE AQUARELLE ARTISTS' COLOUR 2ND RANGE

HEALTH		
✕ INFO		

The very poor practise of adding further pigments such as Burnt Sienna and Mars Yellow persists. There are two disadvantages to this. On the one hand, genuine Raw Umber has its own unique range of characteristics which can only be altered by other pigments. On the other, there will be many painters, loyal to the one make, who have yet

to experience the subtlties of a well produced, unadulterated Raw Umber. If they do not experience the genuine colour they will not appreciate it or seek it out. One more step away from the true craft of painting.

7.10 Sepia

Originally prepared from the dried ink sac of the cuttlefish or squid. It was a semi-transparent blackish - brown with good tinting strength. The contents of just one ink sac will make 1,000 gallons of water opaque in just a few seconds, it is that strong.

Genuine Sepia is fairly permanent but thin washes are liable to fade in sunlight. In use since classical times as

a drawing ink it became popular as a watercolour towards the end of the 18th Century.

The colour so named today is a simple mix of just about anything which will give a blackish - brown. It is as if each manufacturer feels that their range will be incomplete unless it contains a 'Sepia'. Amazingly some find it possible to produce a blackish -brown which is

less than lightfast. Amazing because of the wide range of inexpensive lightfast blacks and browns which are readily available.

Let the name slip into obscurity by mixing such colours yourself.

SEPIA 696

HOLBEIN

Smooth, even washes, over a wide range of values. Typical, even traditional, ingredients for the modern version of 'Sepia'. Lightfast. Semi-opaque.

ARTISTS' WATER COLOR

PBr7 BURNT SIENNA (P. 212)
PBk6 LAMP BLACK (P. 256)

HEALTH	ASTM	RATING
✕ INFO	I L'FAST	★ ★★

SEPIA 609 (045)

WINSOR & NEWTON

Recently reformulated from a blend of Burnt Sienna and Lamp Black to a variety of PR101 and black. Absolutely lightfast. Semi-opaque.

ARTISTS' WATER COLOUR

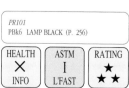

PR101
PBk6 LAMP BLACK (P. 256)

HEALTH	ASTM	RATING
✕ INFO	I L'FAST	★ ★★

RAW SEPIA 443

SENNELIER

This paint has been re-formulated and improved beyond recognition. Now handles particularly well, giving smooth, even washes. Absolutely lightfast.

EXTRA-FINE ARTISTS' WATER COLOURS

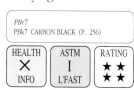

PBr7
PBk7 CARBON BLACK (P. 256)

HEALTH	ASTM	RATING
✕ INFO	I L'FAST	★★ ★★

MAIMERI

ARTISTI
EXTRA-FINE
WATERCOLOURS

SEPIA 535

Rather a concoction, but all ingredients are reliable and blend into a paint which handled quite well. Semi-opaque.

PBk9 IVORY BLACK (P. 257)
PBr 7 RAW UMBER (P. 211)
PBr7 BURNT UMBER (P. 212)
PBr7 BURNT SIENNA (P. 212)

HEALTH ✕ INFO | ASTM I L'FAST | RATING ★ ★★

BLOCKX

AQUARELLES
ARTISTS'
WATER COLOUR

SEPIA 144

The ingredients have not been made clear enough for me to give confident assessments or guidance. All companies were asked to provide full and accurate information.

PBr7
PBk

HEALTH ✕ INFO

PĒBĒO

FRAGONARD
ARTISTS'
WATER COLOUR

SEPIA 133

Dependable ingredients give a paint which handles well and provides a useful range of values. Semi-opaque.

PR101 MARS RED (P. 89)
PY42 MARS YELLOW (P. 34)
PBk7 CARBON BLACK (P. 256)

HEALTH ✕ INFO | ASTM I L'FAST | RATING ★ ★★

LUKAS

ARTISTS'
WATER COLOUR

SEPIA 1106

The particularly unreliable PY12 once included is no longer involved. Completely re-formulated but let down by the inclusion of PY74. A pity is was added.

PR176 BENZIM. CARMINE (P.94)
PY74 ARYLIDE YELL. (P.36)
PBk7 CARBON BLACK (P.256)

HEALTH ✕ INFO | ASTM III L'FAST | RATING ★★

MARTIN F. WEBER

PERMALBA
ARTIST'S
WATER COLOR
AQUARELLE

SEPIA 2086

Quite unlike the usual 'Sepia' in colour. The sample supplied was a little overbound and brushed out with some difficulty. Thinner washes were fine. Transparent.

PBr7 BURNT UMBER (P. 212)
PY42 MARS YELLOW (P. 34)

HEALTH ✓ INFO | ASTM I L'FAST | RATING ★ ★★

HUNTS

SPEEDBALL
PROFESSIONAL
WATERCOLOURS

SEPIA 5716

Without accurate pigment descriptions, the caring artist cannot select with confidence. Assessments are not possible.

PURIFIED EARTH COLOUR

HEALTH ✕ INFO

SCHMINCKE

HORADAM
FINEST
ARTISTS'
WATER COLOURS

SEPIA BROWN 663

The fugitive PB66 Indigo Blue once used has been replaced by dependable Phthalocyanine Blue. A definite step in the right direction. Recommended. Semi-opaque.

PB15:1 PHTHALOCYANINE BLUE (P.147)
PBr7 RAW SIENNA (P. 211)
PBk9 IVORY BLACK (P. 257)

HEALTH ✕ INFO | ASTM II L'FAST | RATING ★ ★★

SCHMINCKE

HORADAM
FINEST
ARTISTS'
WATER COLOURS

SEPIA BROWN TONE 662

A slightly reddish dark brown. Washed out well into quite clear washes when very dilute. Good covering power. Semi-opaque.

PR166 DISAZO SCARLET (P. 93)
PBr7 RAW SIENNA (P. 211)
PBk9 IVORY BLACK (P. 257)

HEALTH ✕ INFO | WG II L'FAST | RATING ★ ★★

OLD HOLLAND

CLASSIC
WATERCOLOURS

SEPIA EXTRA 446

As the unreliable Van Dyke Brown could also be described as an 'earth colour', I cannot offer assessments. All manufacturers were asked repeatedly for clarification of ingredients.

EARTH COLOUR
PBk9 IVORY BLACK (P. 257)

HEALTH ✕ INFO

TALENS

REMBRANDT
ARTISTS'
WATER COLOUR

SEPIA MODERN 416

A touch of Ultramarine Blue added to the Burnt Sienna would give a similar but 'cleaner' colour. Handled well. Semi-opaque.

PBr7 BURNT SIENNA (P. 211)
PBk7 CARBON BLACK (P. 256)

HEALTH ✕ INFO | ASTM I L'FAST | RATING ★ ★★

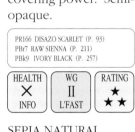

GRUMBACHER

FINEST
PROFESSIONAL
WATERCOLORS

SEPIA NATURAL (MINERAL) 193

An easily mixed convenience colour. Handled smoothly at all strengths and covered well. Semi-opaque.

PBr7 BURNT UMBER (P. 212)
PBk6 LAMP BLACK (P. 256)

HEALTH ✕ INFO | ASTM I L'FAST | RATING ★ ★★

DA VINCI PAINTS

PERMANENT
ARTISTS'
WATER COLOR

SEPIA NATURAL 278

Another mix of standard ingredients which are easy to stir together on the palette. Washed out well. Semi-opaque.

PBr 7 RAW UMBER (P. 211)
PBk6 LAMP BLACK (P. 256)

HEALTH ✓ INFO | ASTM I L'FAST | RATING ★ ★★

PERMANENT SEPIA 251

The only 'Permanent Sepia' on the market and it isn't. On exposure, changes to the PR4 are liable to affect the colour.

ROWNEY

ARTISTS' WATER COLOUR

| PR4 CHLORINATED PARA RED (P. 81) |
| PBk7 CARBON BLACK (P. 256) |
| PBr7 RAW SIENNA (P. 211) |

HEALTH	WG	RATING
✓	V	★
INFO	L'FAST	

RAW SEPIA 121

The sample was particularly overbound and very gritty. Most unpleasant and difficult to use. (Make your own sandpaper perhaps).

LEFRANC & BOURGEOIS

LINEL EXTRA-FINE ARTISTS' WATERCOLOUR

| PBr 7 BURNT UMBER (P. 212) |
| PBk9 IVORY BLACK (P. 257) |

HEALTH	ASTM	RATING
✗	I	★
INFO	L'FAST	

SEPIA WARM (MINERAL) 194

A dark velvety brown. Such colours are easily produced on the palette. Reliable and handles smoothly. Semi-opaque.

GRUMBACHER

FINEST PROFESSIONAL WATERCOLORS

| PBr7 BURNT UMBER (P. 212) |
| PBr7 BURNT SIENNA (P. 212) |
| PBk6 LAMP BLACK (P. 256) |

HEALTH	ASTM	RATING
✗	I	★★
INFO	L'FAST	

WARM SEPIA 613 (046)

The type of PR101 is unspecified but it will be lightfast. Gave good gradated washes. Easily mixed. Semi-opaque.

WINSOR & NEWTON

ARTISTS' WATER COLOUR

| *PR101* |
| PBk6 LAMP BLACK (P. 256) |

HEALTH	ASTM	RATING
✗	I	★★
INFO	L'FAST	

WARM SEPIA 120

Straight forward Ivory Black, produced from charred animal bones. Ivory Black has a natural leaning towards brown, this is particularly so in this example. Semi-opaque.

LEFRANC & BOURGEOIS

LINEL EXTRA-FINE ARTISTS' WATERCOLOUR

| PBk9 IVORY BLACK (P. 257) |

HEALTH	ASTM	RATING
✗	I	★
INFO	L'FAST	

WARM SEPIA 250

With basic colour mixing skills you will be able to produce this, (as well as all other 'Sepias') with ease. Lightfast. Semi-opaque.

ROWNEY

ARTISTS' WATER COLOUR

| PBr 7 RAW UMBER (P. 211) |
| PR101 VENETIAN RED (P. 90) |
| PBk11 MARS BLACK (P. 257) |

HEALTH	ASTM	RATING
✓	I	★★
INFO	L'FAST	

SEPIA UMBER 360

Ranges from a dark, dense brown at full strength to a light grey brown when very dilute. Reliable and easily mixed. Semi-opaque.

BINNEY & SMITH

PROFESSIONAL ARTISTS' WATER COLOR

| PBr7 BURNT UMBER (P. 212) |
| PBk6 LAMP BLACK (P. 256) |
| PY43 YELLOW OCHRE (P. 35) |

HEALTH	ASTM	RATING
✓	I	★★
INFO	L'FAST	

SEPIA HUE 192

We waited until the last moment before going to press, but the promised sample did not materialise. Assessment deferred.

GRUMBACHER

ACADEMY ARTISTS' WATERCOLOUR 2ND RANGE

| PBr7 BURNT SIENNA (P. 212) |
| PY42 MARS YELLOW (P. 34) |
| PBk6 LAMP BLACK (P. 256) |

HEALTH	ASTM	
✗	I	
INFO	L'FAST	

SEPIA 631

A convenience colour which handles well. Smoothly ground paint, covers economically and gives quite clear washes. Semi-opaque.

MAIMERI

STUDIO FINE WATER COLOR 2ND RANGE

| PBr7 BURNT SIENNA (P. 212) |
| PBk9 IVORY BLACK (P. 257) |
| PBk7 CARBON BLACK (P. 256) |

HEALTH	ASTM	RATING
✗	I	★★
INFO	L'FAST	

SEPIA (MODERN) 416

Reliable ingredients giving a paint which covers well and gives even washes. Absolutely lightfast. Semi-opaque.
This range has recently been discontinued.

TALENS

WATER COLOUR 2ND RANGE

| PBr7 BURNT SIENNA (P. 212) |
| PBk7 CARBON BLACK (P. 256) |

HEALTH	ASTM	RATING
✗	I	★★
INFO	L'FAST	

SEPIA 609 (335)

Sample brushed out well over a wide range of values. A convenience colour easily mixed. Semi-opaque.

WINSOR & NEWTON

COTMAN WATER COLOUR 2ND RANGE

| PBr7 BURNT UMBER (P. 212) |
| PBk7 CARBON BLACK (P. 256) |

HEALTH	ASTM	RATING
✗	I	★★
INFO	L'FAST	

SEPIA (HUE) 251

Had the PR4 not been added this could have been a reliable colour. Washed out well. Semi-opaque.

ROWNEY

GEORGIAN WATER COLOUR 2ND RANGE

| PR4 CHLORINATED PARA RED (P. 82) |
| PY43 YELLOW OCHRE (P. 35) |
| PBk7 CARBON BLACK (P. 256) |

HEALTH	WG	RATING
✓	V	★
INFO	L'FAST	

7.11 Van Dyke Brown

A peat like substance formed by long decayed wood and other vegetable matter. The pits from which it is dug can be considered similar to ancient compost heaps, this is the best way to think of them considering the final product.

Varies between transparent and semi-transparent, this quality led to its wide spread use as a glazing colour. As a watercolour it will change to a dull, cold grey-brown after a relatively short exposure to light. This change can be seen on many finished watercolours within a short time of their completion. It is especially fugitive if applied as a thin wash. This of course will be the most common use for a transparent watercolour.

Named after the artist who was particularly fond of using it. Knowledgeable painters have avoided it for centuries.

I have approached several manufacturers and asked why they still offer it. The predictable answer is always 'because of demand'. That it sells well to the unwary artist is a poor reason for its continuation.

Often imitated by simple mixes of readily available colours, it is not worth considering.

VANDYCK BROWN 407

SENNELIER
EXTRA-FINE ARTISTS' WATER COLOURS

Natural Brown 8, Van Dyke Brown, will deteriorate rapidly on exposure to light. Most unreliable. Semi-transparent, becoming more so.

NBr8 VAN DYKE BROWN (P. 212)
PY43 YELLOW OCHRE (P. 35)

HEALTH	WG	RATING
✕ INFO	IV L'FAST	★

VANDYKE BROWN 509

MAIMERI
ARTISTI EXTRA-FINE WATERCOLOURS

Rose Madder Alizarin was once added making the colour unreliable in thinner washes. Now removed to give a lightfast colour.

PBk9 IVORY BLACK (P. 257)
PBr7 BURNT SIENNA (P. 212)
PREVIOUSLY ALSO CONTAINED PR83
ROSE MADDER ALIZARIN (P. 87)

HEALTH	ASTM	RATING
✕ INFO	I L'FAST	★★

VANDYCK BROWN 403

TALENS
REMBRANDT ARTISTS' WATER COLOUR

A simple mix giving a name to add to the colour chart. Same ingredients as Talens Sepia but with less black. Semi-opaque.

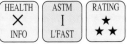
PBr7 BURNT SIENNA (P. 212)
PBk7 CARBON BLACK (P. 256)

HEALTH	ASTM	RATING
✕ INFO	I L'FAST	★★

VAN DYKE BROWN 390

BINNEY & SMITH
PROFESSIONAL ARTISTS' WATER COLOR

If the name Van Dyke Brown were to be universally abandoned, such mixtures need not be put together. Reliable.

PBr7 BURNT UMBER (P. 212)
PY43 YELLOW OCHRE (P. 35)
PBk6 LAMP BLACK (P. 256)

HEALTH	ASTM	RATING
✓ INFO	I L'FAST	★★

VANDYKE BROWN 697

HOLBEIN
ARTISTS' WATER COLOR

On exposure our sample changed from a rich warm brown to a cold grey-brown. Certain impurities did not fade and gave a speckled finish to the 'new' colour.

NBr8 VAN DYKE BROWN (P. 212)

HEALTH	WG	RATING
✕ INFO	IV L'FAST	★

VANDYKE BROWN 263

ROWNEY
ARTISTS' WATER COLOUR

The company inform me that Natural Brown 8 is no longer available. When present stocks are exhausted they will reformulate. This is good news as our sample faded dramatically.

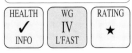
NBr8 VAN DYKE BROWN (P. 212)

HEALTH	WG	RATING
✓ INFO	IV L'FAST	★

VAN DYCKE BROWN 447

OLD HOLLAND
CLASSIC WATERCOLOURS

If the name must be retained at least reliable ingredients such as these should be used. Handled very well. Semi-opaque.

PR101 VENETIAN RED (P. 90)
PBk9 IVORY BLACK (P. 257)

HEALTH	ASTM	RATING
✕ INFO	I L'FAST	★★

VANDYKE BROWN 142

BLOCKX
AQUARELLES ARTISTS' WATER COLOUR

Reliable ingredients giving a paint which handled well. The PBr7 is unspecified. Semi-opaque.

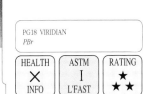
PG18 VIRIDIAN
PBr

HEALTH	ASTM	RATING
✕ INFO	I L'FAST	★★

VAN DYCK BROWN 222

GRUMBACHER
FINEST PROFESSIONAL WATERCOLORS

The disastrous substance, NBr8 Van Dyke Brown, once used has been discarded. Now produced using lightfast pigments.

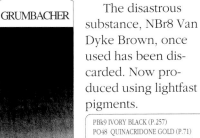
PBk9 IVORY BLACK (P.257)
PO48 QUINACRIDONE GOLD (P.71)
PR101 LIGHT OR ENGLISH RED OX. (P.90)

HEALTH	WG	RATING
✕ INFO	II L'FAST	★★

VAN DYKE BROWN 1112

LUKAS

Some confusion here. Lukas insist the colorant is Pigment Black 8, Brown Coal. NBr 8, Van Dyke Brown, is often called Brown Coal, PBk 8 is Charcoal Black. Whatever the pigment it quickly became a light, dull violet on exposure.

PBk8 BROWN COAL

ARTISTS' WATER COLOUR

HEALTH	WG	RATING
✕	IV	★
INFO	L'FAST	

VAN DYCK BROWN 122

PĒBĒO

Personally I would sooner see the name fade away as most of the examples do. If it must be retained then ingredients such as these should be employed.

PR101 MARS RED (P. 89)
PY42 MARS YELLOW (P. 34)
PBk7 CARBON BLACK (P. 256)

FRAGONARD ARTISTS' WATER COLOUR

HEALTH	ASTM	RATING
✕	I	★ ★
INFO	L'FAST	

VANDYKE BROWN 669

SCHMINCKE

Re-formulated to give a reliable deep brown. Handles well over a useful range of values.

PBk7 CARBON BLACK (P. 256)
PBr 7 RAW UMBER (P. 211)
PY153 NICKEL DIOXINE YELL (P.38)
PREVIOUSLY ALSO CONTAINED PBr23
AND PY129 (P. 39)

HORADAM FINEST ARTISTS' WATER COLOURS

HEALTH	WG	RATING
✕	II	★ ★
INFO	L'FAST	

VANDYKE BROWN 676 (050)

WINSOR & NEWTON

The PR101 is described as a synthetic equivalent of Burnt Sienna. Our sample faded severely thanks to the inclusion of NBr 8. Semi-opaque.

PR101
NBr8 VAN DYKE BROWN (P. 212)

ARTISTS' WATER COLOUR

HEALTH	WG	RATING
✕	IV	★
INFO	L'FAST	

VANDYCK BROWN 111

LEFRANC & BOURGEOIS

Our sample faded to a marked extent suggesting that PBr8 is unreliable. Washed out reasonably well. Semi-transparent.

PBr 8 MANGANESE BROWN (P. 213)

LINEL EXTRA-FINE ARTISTS' WATERCOLOUR

HEALTH	WG	RATING
✓	IV	★
INFO	L'FAST	

VAN DYKE BROWN 403

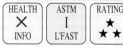

TALENS

Similar in colour to genuine Van Dyke Brown but reliable. An easily mixed convenience colour but far superior to the real thing. *Discontinued.*

PBr7 BURNT SIENNA (P. 212)
PBk7 CARBON BLACK (P. 256)

WATER COLOUR 2ND RANGE

HEALTH	ASTM	RATING
✕	I	★ ★
INFO	L'FAST	

VANDYKE BROWN 676 (338)

WINSOR & NEWTON

Slightly cooler than the actual paint Burnt Umber available in this range, but nevertheless the same pigment. Superior to their 'Artist Quality' Van Dyke Brown.

PBr7 BURNT UMBER (P. 212)

COTMAN WATER COLOUR 2ND RANGE

HEALTH	ASTM	RATING
✕	I	★ ★
INFO	L'FAST	

VANDYKE BROWN 676

REEVES

Burnt Umber varies in colour from an orange to a reddish - brown. If you have it in your range you will not need to make a second purchase. *Range discontinued.*

PBr7 BURNT UMBER (P. 212)

WATER COLOUR FOR ARTISTS 2ND RANGE

HEALTH	ASTM	RATING
✕	I	★ ★
INFO	L'FAST	

VANDYKE BROWN 605

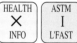

MAIMERI

The very unreliable PR83 Rose Madder Alizarin has now been removed giving a lightfast colour which handles well. Semi-transparent.

PBr7 BURNT SIENNA (P. 212)
PBk9 IVORY BLACK (P. 257)
PREVIOUSLY ALSO CONTAINED PR83
ROSE MADDER ALIZARIN (P. 87)

STUDIO FINE WATER COLOR 2ND RANGE

HEALTH	ASTM	RATING
✕	I	★ ★
INFO	L'FAST	

VANDYKE BROWN (HUE) 263

ROWNEY

A simple mix giving a close imitation of genuine Van Dyke Brown. At least it is reliable. Superior to the 'Artist' version of this make. Semi-opaque.

PBk7 CARBON BLACK (P. 256)
PBr7 BURNT UMBER (P. 212)

GEORGIAN WATER COLOUR 2ND RANGE

HEALTH	ASTM	RATING
✓	I	★ ★
INFO	L'FAST	

VAN DYCK BROWN 222

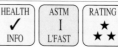

GRUMBACHER

Slightly gritty but brushed out well. Reliable imitation which is superior to the 'Artist' version of this make. Semi-opaque.

PBr7 BURNT SIENNA (P. 212)
PBr7 BURNT UMBER (P. 212)
PBk6 LAMP BLACK (P. 256)

ACADEMY ARTISTS' WATERCOLOUR 2ND RANGE

HEALTH	ASTM	RATING
✓	I	★ ★
INFO	L'FAST	

During testing it was found that raw Van Dyke Brown pigment burnt quite well. I am tempted to suggest that the entire stock be so tested. Help to make it another obsolete colour and give your work a better chance of survival.

7.12 Venetian Red

Originally the name for a native earth colour, it is now coming into general use for a synthetic iron oxide with a leaning towards orange.

The various artificial oxides which come under the description Pigment Red 101 are separated only by the general colour. Not all manufacturers work to the same guidelines. It is possible to find Venetian reds more like Indian Red. Light Reds identical to Venetian Red and so on. Check for colour type carefully. At least they are all equally lightfast.

When mixing, it can be considered as a neutralised red - orange. Mixing partner will be one or other of the green - blues. It is also worth experimenting with Ultramarine, a violet - blue for further possibilities.

VENITIAN RED 623

SENNELIER

The addition of Yellow Ochre tends to dull the colour somewhat. Washed out very smoothly. Both pigments are completely lightfast. Semi-opaque.

EXTRA-FINE ARTISTS' WATER COLOURS

PY43 YELLOW OCHRE (P. 35)
PR101 VENETIAN RED (P. 90)

HEALTH INFO	ASTM L'FAST	RATING
✗	I	★★

VENETIAN RED 583

ROWNEY

A well produced watercolour. Washed out beautifully giving a range varying from a deep neutral orange to a salmon pink. Excellent. Semi-opaque.

ARTISTS' WATER COLOUR

PR101 VENETIAN RED (P. 90)

HEALTH INFO	ASTM L'FAST	RATING
✓	I	★★ ★★

VENETIAN RED 295

BINNEY & SMITH

Ranges from a deep brown orange at full strength to a fiery neutral orange at mid value. Further dilution gives a delicate pink. Superb. Semi-opaque.

PROFESSIONAL ARTISTS' WATER COLOR

PR101 VENETIAN RED (P. 90)

HEALTH INFO	ASTM L'FAST	RATING
✓	I	★★

VENETIAN RED 440

OLD HOLLAND

Moving towards violet - red in hue. This is particularly noticeable in the thinner washes. An excellent all round watercolour.

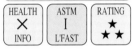

CLASSIC WATERCOLOURS

PR101 VENETIAN RED (P. 90)

HEALTH INFO	ASTM L'FAST	RATING
✗	I	★★ ★★

VENETIAN RED 121

BLOCKX

Whereas I feel that this will either be one of the PBr7's or a PR101 I do not feel able to offer assessments. Washed out very well.

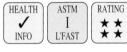

NATURAL PURE EARTH

AQUARELLES ARTISTS' WATER COLOUR

HEALTH INFO
✗

VENETIAN RED 678 (051)

WINSOR & NEWTON

Superb. An excellent range of values is offered from a deep velvety neutral orange to a subtle pale pink. Dense pigment. Semi-opaque.

ARTISTS' WATER COLOUR

PR101 VENETIAN RED (P. 90)

HEALTH INFO	ASTM L'FAST	RATING
✗	I	★★ ★★

VENETIAN RED 392

LEFRANC & BOURGEOIS

Gradated washes run smoothly from one strength to another. A first class watercolour in every respect. Warm pink tints. Semi-opaque.

LINEL EXTRA-FINE ARTISTS' WATERCOLOUR

PR101 VENETIAN RED (P. 90)

HEALTH INFO	ASTM L'FAST	RATING
✗	I	★★ ★★

VENICIAN RED 132

PĒBĒO

An imitation which is rather too red to be realistic. Handled well, giving smooth washes. Resisted light during our testing but the PR 122 is less than reliable. Semi-opaque.

FRAGONARD ARTISTS' WATER COLOUR

PR101 MARS RED (P. 89)
PR122 QUINACRIDONE MAGENTA (P. 92)

HEALTH INFO	ASTM L'FAST	RATING
✗	III	★★

VENETIAN RED 288

DA VINCI PAINTS

Was previously a dull and 'heavy' colour. Now reformulated and greatly improved. A brighter, 'cleaner' colour. Absolutely lightfast. Semi-opaque.

PERMANENT ARTISTS' WATER COLOR

PR101 VENETIAN RED (P. 90)

HEALTH INFO	ASTM L'FAST	RATING
✗	I	★★ ★★

7.13 Yellow Ochre

Applied, as it was found, by the early cave painter. Yellow Ochre is one of the oldest inorganic pigments still in use.

Mined from open cast pits as a coloured clay, it is ground, washed and settled into tanks. Deposits are found all over the world.

The most important and widely used of the ochres, it is a soft golden yellow which brushes and mixes very well.

Good qualities are reasonably opaque but do brush out into clear washes when well diluted. Mars Yellow, which can be considered to be a synthetic Yellow Ochre, is often sold under this name. Although virtually identical in colour, many consider it to be a little harsh when compared to the more muted colour of genuine Yellow Ochre.

For mixing purposes treat it as a neutralised orange - yellow and use accordingly. Complementary partner will be a blue - violet.

LUKAS — YELLOW OCHRE LIGHT 1031

Mars Yellow, the pigment used, can be considered to be a synthetic version of Yellow Ochre, which is a naturally occurring colorant. Well produced.

PY42 MARS YELLOW (P. 34)

HEALTH	ASTM	RATING
✗ INFO	I L'FAST	★★

ARTISTS' WATER COLOUR

OLD HOLLAND — YELLOW OCHRE LIGHT 430

By appearance this is probably either Yellow Ochre or Mars Yellow. I cannot offer assessments without full and detailed information on ingredients.

EARTH COLOURS

HEALTH		
✗ INFO		

CLASSIC WATERCOLOURS

BINNEY & SMITH — YELLOW OCHRE 413

Reasonably strong in mixes and covers quite well. Becomes very transparent when washed out thinly. Absolutely lightfast. Genuine ingredients.

PY43 YELLOW OCHRE (P. 35)

HEALTH	ASTM	RATING
✓ INFO	I L'FAST	★★ ★★

PROFESSIONAL ARTISTS' WATER COLOR

DA VINCI PAINTS — YELLOW OCHRE 292

Washed out beautifully over a very useful range of values. An ancient pigment which is still of vital importance today. Semi-opaque.

PY43 YELLOW OCHRE (P. 35)

HEALTH	ASTM	RATING
✓ INFO	I L'FAST	★★ ★★

PERMANENT ARTISTS' WATER COLOR

HUNTS — YELLOW OCHRE 5736

The obtained sample did not brush out particularly well, giving rather streaky washes. Assessments cannot be offered on such a general pigment description.

PURIFIED EARTH COLOUR

HEALTH		
✗ INFO		

SPEEDBALL PROFESSIONAL WATERCOLOURS

TALENS — YELLOW OCHRE 227

Mars Yellow, a superb all round pigment, should surely be sold under its own name. Handled very well. Semi-opaque.

PY42 MARS YELLOW (P. 34)

HEALTH	ASTM	RATING
✗ INFO	I L'FAST	★ ★★

REMBRANDT ARTISTS' WATER COLOUR

ROWNEY — YELLOW OCHRE 663

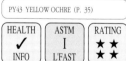

Yellow Ochre is considered by many to be a little less brash than its artificial equivalent, Mars Yellow. This is a superb example. Semi-opaque.

PY43 YELLOW OCHRE (P. 35)

HEALTH	ASTM	RATING
✓ INFO	I L'FAST	★★ ★★

ARTISTS' WATER COLOUR

WINSOR & NEWTON — YELLOW OCHRE 744 (059)

A first class watercolour paint. Washed out very smoothly, covered well and gave transparent washes. Genuine ingredients. Semi-opaque.

PY43 YELLOW OCHRE (P. 35)

HEALTH	ASTM	RATING
✗ INFO	I L'FAST	★★ ★★

ARTISTS' WATER COLOUR

MARTIN F. WEBER — YELLOW OCHRE 2066

Mars Yellow is used here as an imitation Yellow Ochre. Virtually identical in colour to the genuine article. Semi-transparent.

PY42 MARS YELLOW (P. 34)

HEALTH	ASTM	RATING
✓ INFO	I L'FAST	★★

PERMALBA ARTIST'S WATER COLOR AQUARELLE

YELLOW OCHRE 111

BLOCKX

Mars Yellow sold under another name. Although considered to be a synthetic version of genuine Yellow Ochre, certain subtleties of hue can be lost.

AQUARELLES ARTISTS' WATER COLOUR

PY42 MARS YELLOW (P. 34)

HEALTH	ASTM	RATING
✗ INFO	I L'FAST	★ ★

YELLOW OCHRE 302

LEFRANC & BOURGEOIS

Genuine ingredients give a superb all round watercolour. A neutralised yellow - orange with an excellent range of values.

LINEL EXTRA-FINE ARTISTS' WATERCOLOUR

PY43 YELLOW OCHRE (P. 35)

HEALTH	ASTM	RATING
✓ INFO	I L'FAST	★ ★

YELLOW OCHRE 242

GRUMBACHER

The subtlety of hue available from a quality Yellow Ochre is lost in this imitation. Mars Yellow is one thing but this mix rather oversteps the margins.

FINEST PROFESSIONAL WATERCOLORS

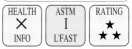

PBr7 RAW SIENNA (P. 211)
PY42 MARS YELLOW (P. 34)

HEALTH	ASTM	RATING
✗ INFO	I L'FAST	★ ★

YELLOW OCHRE 646

HOLBEIN

Genuine Yellow Ochre has a certain softness of hue, this is usually brought about by a small clay content. Mars Yellow lacks this softness.

ARTISTS' WATER COLOR

PY42 MARS YELLOW (P. 34)

HEALTH	ASTM	RATING
✗ INFO	I L'FAST	★ ★

YELLOW OCHRE 1
655

SCHMINCKE

PY119 (page 39) was given as the pgt. in the last edition. An error made by the manufacture. Mars Yellow is a superb pigment. Handles very well and is permanent.

HORADAM FINEST ARTISTS' WATER COLOURS

PY42 MARS YELLOW (P. 34)

HEALTH	ASTM	RATING
✗ INFO	I L'FAST	★ ★

YELLOW OCHRE 2
656

SCHMINCKE

Slightly yellower than the No1 version. If you have either, the other will be superfluous. A lightfast, very well produced watercolour paint. Semi-opaque.

HORADAM FINEST ARTISTS' WATER COLOURS

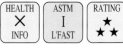

PY42 MARS YELLOW (P. 34)
PY43 YELLOW OCHRE (P. 35)

HEALTH	ASTM	RATING
✗ INFO	I L'FAST	★ ★

YELLOW OCHRE 530

MAIMERI

A synthetically produced alternative to Yellow Ochre. Both are superb pigments but there are subtle differences of hue. Semi-opaque.

ARTISTI EXTRA-FINE WATERCOLOURS

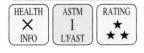

PY42 MARS YELLOW (P. 34)

HEALTH	ASTM	RATING
✗ INFO	I L'FAST	★ ★

YELLOW OCHRE 129

PÉBÉO

To my eyes, Mars Yellow lacks the subtley available from a quality Yellow Ochre. Nevertheless it makes an excellent watercolour. Semi-opaque.

FRAGONARD ARTISTS' WATER COLOUR

PY42 MARS YELLOW (P. 34)

HEALTH	ASTM	RATING
✗ INFO	I L'FAST	★ ★

YELLOW OCHRE DEEP 431

OLD HOLLAND

I am afraid that 'earth colours' does not give me a lot to go on when it comes to making assessments. Washed out particularly well.

CLASSIC WATERCOLOURS

EARTH COLOURS

HEALTH		
✗ INFO		

YELLOW OCHRE BURNT 436

OLD HOLLAND

A well produced watercolour, washed out well and has a good range of strengths. But what is it? The given ingredients do not give much away. Assessments not offered.

CLASSIC WATERCOLOURS

EARTH COLOURS

HEALTH		
✗ INFO		

BURNT YELLOW OCHRE 657

SCHMINCKE

When Yellow Ochre is burnt it does not turn into a mix of PY42 and PR101. Such colours are easily produced on the palette. Semi-opaque.

HORADAM FINEST ARTISTS' WATER COLOURS

PY42 MARS YELLOW (P. 34)
PR101 MARS RED (P. 89)

HEALTH	ASTM	RATING
✗ INFO	I L'FAST	★ ★

YELLOW OCHRE HALF BURNT 434

OLD HOLLAND

It might be Half Burnt Yellow Ochre or it might be something quite different. The stated and confirmed ingredients offer few clues. Not assessed in this edition.

CLASSIC WATERCOLOURS

EARTH COLOURS

HEALTH		
✗ INFO		

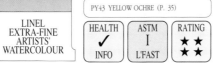

YELLOW OCHRE 252

A well produced watercolour paint. Smoothly ground, densely packed pigment. Covered well but also gave very clear washes. Semi-opaque.

SENNELIER

EXTRA-FINE ARTISTS' WATER COLOURS

PY43 YELLOW OCHRE (P. 35)

HEALTH	ASTM	RATING
✗	I	★ ★
INFO	L'FAST	★ ★

YELLOW OCHRE 242

Mars Yellow, being artificially produced, tends to be more predictable in colour between batches. But it is not Yellow Ochre. Semi-opaque.

GRUMBACHER

ACADEMY ARTISTS' WATERCOLOUR 2ND RANGE

PY42 MARS YELLOW (P. 34)

HEALTH	ASTM	RATING
✓	I	★ ★
INFO	L'FAST	★ ★

YELLOW OCHRE 663

As reliable as the 'Artist Quality' and virtually identical. Smoothly ground and washed out very well. Semi-opaque.

ROWNEY

GEORGIAN WATER COLOUR 2ND RANGE

PY43 YELLOW OCHRE (P. 35)

HEALTH	ASTM	RATING
✓	I	★ ★
INFO	L'FAST	★ ★

YELLOW OCHRE 744

Washed out well at all strengths. Will not be affected by light of any strength or duration. An artificial version of Yellow Ochre. Semi-opaque. *The range has now been discontinued.*

REEVES

WATER COLOUR FOR ARTISTS 2ND RANGE

PY42 MARS YELLOW (P. 34)

HEALTH	ASTM	RATING
✗	I	★
INFO	L'FAST	★ ★

YELLOW OCHRE 744 (341)

Absolutely lightfast. Can be regarded as the synthetic equivalent of genuine Yellow Ochre. Semi-opaque.

WINSOR & NEWTON

COTMAN WATER COLOUR 2ND RANGE

PY42 MARS YELLOW (P. 34)

HEALTH	ASTM	RATING
✗	I	★
INFO	L'FAST	★ ★

YELLOW OCHRE 227

Mars Yellow, regarded as the synthetic equivalent of Yellow Ochre, is equally reliable but lacks a certain subtlety. Semi-opaque. *This range has now been discontinued.*

TALENS

WATER COLOUR 2ND RANGE

PY42 MARS YELLOW (P. 34)

HEALTH	ASTM	RATING
✗	I	★
INFO	L'FAST	★ ★

YELLOW OCHRE 613

An excellent range of values are offered from this superb pigment. It is not, however, genuine Yellow Ochre. Semi-opaque.

MAIMERI

STUDIO FINE WATER COLOR 2ND RANGE

PY42 MARS YELLOW (P. 34)

HEALTH	ASTM	RATING
✗	I	★
INFO	L'FAST	★ ★

YELLOW OCHRE

As the promised information was not provided, I can show the colour but not offer any information.

PAILLARD

LOUVRE AQUARELLE ARTISTS' COLOUR 2ND RANGE

HEALTH		
✗		
INFO		

Yellow Ochre offers a wide range of useful values. Heavier layers are a brownish yellow which covers well. Medium applications a reasonably bright neutral yellow and thin washes a very delicate soft yellow.

7.14 Miscellaneous Browns

A rather motley collection which adds little value to the overall range of available browns. Many of the names used are extracted from the distant past and refer to paints which at one time would mostly have been avoided.

Bitume was an originally an oil paint produced from bitumen or tar. It never really dried and has destroyed or damaged just about every painting on which it was employed. Bitume water-colour was sold in bottles in the 19th Century. The word pink has come to mean a light red only quite recently. It was originally used as a noun to describe a yellow pigment. Usually produced from unripe Buckthorn berries it was particularly fugitive. The name Brown Pink has survived to describe the mixed colours shown here.

Caput Mortuum is a Latin name once used to describe a violet - brown produced from an industrial by-product. It has now lost all real meaning and is used loosely to describe synthetic iron oxides of similar hue.

Dragons Blood, my favourite colour title, is an ancient name used to describe a resinous substance which looks like dried blood. It was said to be the mingled blood of an elephant and a dragon as they fought to the death. Where did all the elephants come from?

TRANSPARENT BROWN 435

SENNELIER

Previously named 'Bitume' (Asphalt). A reliable colour, if easily mixed. Washed out well, giving a useful range of values. Semi-opaque.

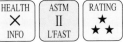

PR101
PBr7 RAW UMBER (P. 211)
PY3 ARYLIDE YELLOW 10G (P. 29)

EXTRA-FINE ARTISTS' WATER COLOURS

HEALTH	ASTM	RATING
✕ INFO	II L'FAST	★★

BROWN PINK 445

SENNELIER

Previously faded as a tint and darkened in mass tone. Now reformulated using reliable pigments. An excellent watercolour paint. Semi-opaque.

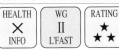

'G7 PHTHALOCYANINE GREEN (P. 177)
PO49 QUINACRIDONE DEEP GOLD (P.70)
PW21 BLANC FIXE (P.272)
VAS PY43 (P 35) PG7 (P 177) & PY83 (P.36)

EXTRA-FINE ARTISTS' WATER COLOURS

HEALTH	WG	RATING
✕ INFO	II L'FAST	★★

BROWN PINK 215

ROWNEY

PY100 failed ASTM testing in a big way. It is well known to be a fugitive pigment. Its use as an ingredient will spoil the colour when exposed to light. Semi-transparent.

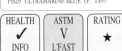

PY100 TARTRAZINE LAKE (P. 37)
PBk9 IVORY BLACK (P. 257)
PB29 ULTRAMARINE BLUE (P. 149)

ARTISTS' WATER COLOUR

HEALTH	ASTM	RATING
✓ INFO	V L'FAST	★

BROWN PINK 664

SCHMINCKE

Did not brush out particularly well unless in thin applications. All ingredients are absolutely lightfast. An unimportant colour easily duplicated.

PBr7 RAW SIENNA (P. 211)
PY42 MARS YELLOW (P. 34)
PBk9 IVORY BLACK (P. 257)

HORADAM FINEST ARTISTS' WATER COLOURS

HEALTH	ASTM	RATING
✕ INFO	I L'FAST	★★

BROWN STIL DE GRAIN 536

MAIMERI

Our sample started off as brown, became pink as the yellow faded and then a light grey as the Alizarin Crimson departed. *Name now changed from Brown Pink.*

PY17 DIARYLIDE YELLOW AO (P. 31)
PR83:1 ALIZARIN CRIMSON (P. 88)
PG18 VIRIDIAN (P. 179)

ARTISTI EXTRA-FINE WATERCOLOURS

HEALTH	WG	RATING
✕ INFO	V L'FAST	★

BURNT GREEN EARTH 653

SCHMINCKE

Burnt Umber is Burnt Umber, it is not Burnt Green Earth. Semi-transparent.

PBr7 BURNT UMBER (P. 212)

HORADAM FINEST ARTISTS' WATER COLOURS

HEALTH	ASTM	RATING
✕ INFO	I L'FAST	★★

BURNT GREEN EARTH 1104

LUKAS

As the name suggests this was originally calcined Green Earth (Terre Verte). Here we have a simple mix giving a basic brown. Semi-opaque.

PR101 LIGHT OR ENGLISH RED OXIDE (P. 90)
PY42 MARS YELLOW (P. 34)
PBk11 MARS BLACK (P. 257)

ARTISTS' WATER COLOUR

HEALTH	ASTM	RATING
✕ INFO	I L'FAST	★★

CAPUT MORTUUM 645

SCHMINCKE

A Latin name which went out of general use several hundred years ago. The pigment would have been similar to Mars Violet in hue and make up. Dependable.

PR101 MARS VIOLET (P. 89)

HORADAM FINEST ARTISTS' WATER COLOURS

HEALTH	ASTM	RATING
✕ INFO	I L'FAST	★★

CAPUT MORTUUM DEEP 1052

LUKAS

Strong, deep, neutral violet - brown. Washed out beautifully from one strength to another. Absolutely lightfast. An ancient name used for a similar pigment.

PR101 INDIAN RED (P. 89)

ARTISTS' WATER COLOUR

HEALTH	ASTM	RATING
✕ INFO	I L'FAST	★★

DRAGON'S BLOOD 534

MAIMERI

Originally said to come from the mingled blood of an Elephant and a Dragon as they fought to the death. Now a lightfast colour easily mixed on the palette.

PR 209 QUINACRIDONE RED Y (P.96)
PBr7
WAS PREVIOUSLY AN UNRELIABLE MIX OF PY17 (P.31) - PR83 (P. 87) - PG18 (P. 179) & PR81 (P. 87)

ARTISTI EXTRA-FINE WATERCOLOURS

HEALTH	ASTM	RATING
✕ INFO	I L'FAST	★★

ITALIAN EARTH 117

BLOCKX

The name was at one time used to describe Raw Sienna. With such a vague pigment description I have no idea what this is and do not care to guess. Assessments not offered.

NATURAL PURE EARTH

AQUARELLES ARTISTS' WATER COLOUR

HEALTH		
✕ INFO		

PERSIAN RED 441

OLD HOLLAND

An unspecified PR101. As the various versions are based on colour type alone, it can be classed as lightfast. Washed out smoothly.

PR101

CLASSIC WATERCOLOURS

HEALTH	ASTM	RATING
✕ INFO	I L'FAST	★★

POZZUOLI EARTH 532

MAIMERI

Originally a native iron oxide of volcanic origin, from Pozzuoli, near Naples. This is a simple mix. Both ingredients are reliable. Neither is specified exactly. Semi-opaque.

PR101
PBr7

ARTISTI EXTRA-FINE WATERCOLOURS

HEALTH	ASTM	RATING
✕ INFO	I L'FAST	★

POZZUOLI EARTH 666

SCHMINCKE

An ancient name used to market Mars Red. Washes out very smoothly and is completely fast to light. Semi-opaque, but gives quite clear washes.

PR101 MARS RED (P. 89)

HORADAM FINEST ARTISTS' WATER COLOURS

HEALTH	ASTM	RATING
✕ INFO	I L'FAST	★★

POZZUOLI EARTH 1083

LUKAS

If Indian Red, Light Red, Mars Red and Venetian Red were marketed under their correct titles, artists would become more familiar with them. Lightfast. Semi-opaque, washes well.

PR101 INDIAN RED (P. 89)

ARTISTS' WATER COLOUR

HEALTH	ASTM	RATING
✕ INFO	I L'FAST	★★

POZZUOLI EARTH 617

MAIMERI

A simple mix of lightfast ingredients. Relies heavily on Venetian Red for main colorant. Easily mixed. Semi-opaque but gives clear washes.

PR101 VENETIAN RED (P. 90)
PBr 7 RAW UMBER (P. 211)
PBr7 RAW SIENNA (P. 211)

STUDIO FINE WATER COLOR 2ND RANGE

HEALTH	ASTM	RATING
✕ INFO	I L'FAST	★

TRANSPARENT BROWN 110

LEFRANC & BOURGEOIS

PY83 cannot be depended on. Thin washes are particularly vulnerable. Keep finished work in subdued light if possible or the colour will become greyer. Semi-transparent.

PY83 DIARYLIDE YELLOW HR70 (P. 36)
PBk7 CARBON BLACK (P. 256)

LINEL EXTRA-FINE ARTISTS' WATERCOLOUR

HEALTH	WG	RATING
✕ INFO	III L'FAST	★★

TRANSPARENT OXIDE BROWN 426

TALENS

An unspecified variety of PR101. It will be particularly lightfast. Washed out very smoothly. Semi-transparent.

PR101

REMBRANDT ARTISTS' WATER COLOUR

HEALTH	ASTM	RATING
✕ INFO	I L'FAST	★

TRANSPARENT OXIDE RED 378

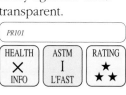

TALENS

The type of PR101 is unspecified. As the various versions are usually described by colour type, we can be sure that this is absolutely lightfast. Semi-transparent.

PR101

REMBRANDT ARTISTS' WATER COLOUR

HEALTH	ASTM	RATING
✕ INFO	I L'FAST	★

TRANSPARENT OXIDE YELLOW 265

TALENS

Mars Yellow under another name. Sample rather gummy. Thinner washes are fine. Lightfast.

PY42 MARS YELLOW (P. 34)

REMBRANDT ARTISTS' WATER COLOUR

HEALTH	ASTM	RATING
✕ INFO	I L'FAST	★★

RED BROWN 405

SENNELIER

Neither the PBr7 or PR101 is specified but both will be absolutely lightfast. Sample was rather gritty but washed out reasonably well. Semi-opaque.

PBr7 AND PR101 PREVIOUSLY ALSO CONTAINED PY43 YELLOW OCHRE (P. 35)

EXTRA-FINE ARTISTS' WATER COLOURS

HEALTH	ASTM	RATING
✕ INFO	I L'FAST	★★

GREYS

History of Grey Pigments

A wide range of subtle coloured greys can be produced on the palette by mixing complementary colours. Unfortunately many of todays artists do not realise the incredible range available by this method and reach instead for a pre-mixed grey.

Charcoal has long been used to give a dark blackish grey. It is difficult to produce a satisfactory watercolour paint from it and the colour has often been bolstered by other pigments. The better qualities come from Willow.

Modern greys are crude when compared to the vast range available to the skilled colour mixer.

Earlier artists often had a quite different approach. A mixed neutral grey, set within warm colours was frequently used in place of blue for example. The grey was than surrounded by warm colours, which, through the effect of after image, caused the grey to move towards a very subtle soft blue.

Our use of greys is invariably rather crude in comparison. We tend to rely on a limited number of greys and neutrals which have been blended by the colourmen for us. A painter with colour mixing skills would have little use for any of the modern greys.

GREY
WATERCOLOURS

GREY WATERCOLOURS

8.1 Davy's Grey

A mid-grey which often has a slightly greenish bias. At one time the colour was mainly based on powdered slate. Nowadays it is a simple mix involving a variety of ingredients which are usually standard, and found in most paint boxes.

I have described several paints, such as Naples Yellow, as convenience colours. Although they can be mixed on the palette, many artists find it more convenient to have them ready prepared. I do not regard any of the ready blended greys to be in this category, for the following reasons:

Virtually all of them include black amongst the ingredients. To my eye the use of black always leads to rather 'dirty' colours when mixed further. My main objection to them however is that they lead to limitations in colour mixing and understanding. This in turn leads to work of a limited nature. An understanding of the way in which complementaries behave when mixed will give you a range of neutrals and greys which can be made to harmonise readily, giving vastly improved colour work. A vast range of greys which are simple to mix and will work smoothly with neighbouring colours is available to the artist able to control mixing.

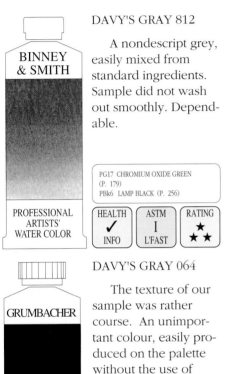

DAVY'S GRAY 812

A nondescript grey, easily mixed from standard ingredients. Sample did not wash out smoothly. Dependable.

PG17 CHROMIUM OXIDE GREEN (P. 179)
PBk6 LAMP BLACK (P. 256)

HEALTH	ASTM	RATING
✓ INFO	I L'FAST	★ ★★

BINNEY & SMITH
PROFESSIONAL ARTISTS' WATER COLOR

DAVY'S GRAY 217 (019)

The company supplied incorrect information which gave a lower rating in the first edition. Now rectified here. Brushed out poorly.

PG17 CHROMIUM OXIDE GREEN (P.179)
PBk19 GRAY HYDRATED ALUMINUM SILICATE (P. 258)
PBk6 LAMP BLACK (P. 256)

HEALTH	ASTM	RATING
✗ INFO	I L'FAST	★★

WINSOR & NEWTON
ARTISTS' WATER COLOUR

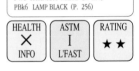

DAVY'S GREY 712

Particularly weak and brushed out poorly. Reliable ingredients but easily produced on the palette.

PBr7
PW6 TITANIUM WHITE (P. 271)
PBk6 LAMP BLACK (P. 256)

HEALTH	ASTM	RATING
✗ INFO	I L'FAST	★★

HOLBEIN
ARTISTS' WATER COLOR

DAVY'S GRAY 064

The texture of our sample was rather course. An unimportant colour, easily produced on the palette without the use of Black.

PB15 PHTHALOCYANINE BLUE (P. 147)
PBr7
PBk9 IVORY BLACK (P. 257)

HEALTH	ASTM	RATING
✗ INFO	II L'FAST	★ ★★

GRUMBACHER
FINEST PROFESSIONAL WATERCOLORS

DAVIES GRAY 2078

Sample was particularly overbound and had a decidedly greasy texture. If you really need this colour it is easy to mix. Semi-transparent.

PG7 PHTHALOCYANINE GREEN (P. 177)
PBr 7 RAW UMBER (P. 211)
PBk6 LAMP BLACK (P. 256)
PW4 ZINC WHITE (P. 270)

HEALTH	ASTM	RATING
✓ INFO	I L'FAST	★★

MARTIN F. WEBER
PERMALBA ARTIST'S WATER COLOR AQUARELLE

DAVY'S GREY 066

Give me wet, raw pastry any day over this substance. Impossible to use unless in very thin washes, poor texture and overbound.

PBk19 GRAY HYDRATED ALUMINUM SILICATE (P. 258)
PBk11 MARS BLACK (P. 257)

HEALTH	ASTM	RATING
✓ INFO	I L'FAST	★★

ROWNEY
ARTISTS' WATER COLOUR

DAVY'S GREY 064

Black with a hint of green. Such colours are easily mixed without using black. Viridian or Phthalocyanine Green with a transparent violet - red will come close.

PB15 PHTHALOCYANINE BLUE (P. 147)
PBr7
PBk9 IVORY BLACK (P. 257)

HEALTH	ASTM	RATING
✓ INFO	II L'FAST	★ ★★

GRUMBACHER
ACADEMY ARTISTS' WATERCOLOUR 2ND RANGE

8.2 Neutral Tint

A quick glance at the range of 'Neutral Tints' on the market will show that it is simply a name to add to a list in order to sell yet another simple, nondescript colour.

It cannot be argued that the name fits any particular colour description. As you can see, it ranges from a blackish-blue through dull violet to a straight-forward black. As I have said

elsewhere, the colour ranges to take seriously are those with a limited number of well produced and well labelled quality colours.

Any company offering a huge range of colours will have amongst them many that are unreliable or are simple mixes.

For too long now the race has been on to offer yet one more colour under

yet another fancy or irrelevant name. Do not join those who feel ill equipped to work unless they have a paint box requiring wheels.

NEUTRAL TINT 063

ROWNEY

ARTISTS' WATER COLOUR

You will not get much more neutral than black, which is all this is. If you already have a black watercolour you will probably not require another.

PBk11 MARS BLACK (P. 257)

HEALTH	ASTM	RATING
✓ INFO	I L'FAST	★★

NEUTRAL TINT 136

PĒBĒO

FRAGONARD ARTISTS' WATER COLOUR

To my mind this is a rather pointless mix of blacks sold under a meaningless name. Perhaps I am missing the point somehow.

PBk9 IVORY BLACK (P. 257)
PBk7 CARBON BLACK (P. 256)

HEALTH	ASTM	RATING
✗ INFO	I L'FAST	★★

NEUTRAL TINT 430 (032)

WINSOR & NEWTON

ARTISTS' WATER COLOUR

A blackish - blue. Easy to mix if you really need it. All ingredients are lightfast. Washed out well. Semi-opaque.

PBk6 LAMP BLACK (P. 256)
PV19 QUINACRIDONE RED (P. 130)
PB15 PHTHALOCYANINE BLUE (P. 147)

HEALTH	ASTM	RATING
✗ INFO	II L'FAST	★★

NEUTRAL TINT 620

LEFRANC & BOURGEOIS

LINEL EXTRA-FINE ARTISTS' WATERCOLOUR

Blackish - violet. The PV23 BS will tend to resist light quite well for some time but will eventually fade. Semi-opaque.

PV23BS DIOXAZINE PURPLE (P. 131)
PBk7 CARBON BLACK (P. 256)

HEALTH	ASTM	RATING
✓ INFO	V L'FAST	★

NEUTRAL TINT 714

HOLBEIN

ARTISTS' WATER COLOR

The inclusion of Pigment Red 23, a fugitive substance, brings the overall lightfast rating down from a possible ASTM II. A nondescript blackish - blue.

PR23 NAPHTHOL RED (P. 84)
PB29 ULTRAMARINE BLUE (P. 149)
PBk6 LAMP BLACK (P. 256)

HEALTH	WG	RATING
✗ INFO	V L'FAST	★

NEUTRAL TINT 782

SCHMINCKE

HORADAM FINEST ARTISTS' WATER COLOURS

The fugitive PB66, Indigo Blue once added has been discarded. Now Re-formulated using reliable pigments. Semi-opaque.

PB15 ULTRAMARINE RED/VIOLET (P.147)
PV19 QUINACRIDONE RED (P.130)
PBk7 CARBON BLACK (P. 256)
PREV. ALSO PR170 (P. 94) & PB66 (P. 150)

HEALTH	ASTM	RATING
✗ INFO	I L'FAST	★★

NEUTRAL TINT 177

BLOCKX

AQUARELLES ARTISTS' WATER COLOUR

Crimson Alizarin certainly creeps in here and there. Wherever it does so it causes damage to the overall colour, particularly in thinner washes.

BLACK
PB15 PHTHALOCYANINE BLUE (P. 147)
PR83:1 ALIZARIN CRIMSON (P. 88)

HEALTH	ASTM	RATING
✗ INFO	IV L'FAST	★

NEUTRAL TINT 448

OLD HOLLAND

CLASSIC WATERCOLOURS

An amazing paint. The pigment had separated and came out as two distinct colours, roughly intermingled. They go back together when diluted. Novelty value perhaps.

PB27 PRUSSIAN BLUE (P. 148)
PBr7 BURNT SIENNA (P. 212)

HEALTH	ASTM	RATING
✗ INFO	I L'FAST	★★

NEUTRAL TINT 931

SENNELIER

EXTRA-FINE ARTISTS' WATER COLOURS

Previously contained the unreliable Crimson Alizarin. The colour has now been re-formulated using reliable ingredients throughout. Washed out well.

Bk7 CARBON BLACK (P.256) - PB60
INDANTHRONE BLUE (P.150) & PR209
QUINAC. RED (P.96) PREVIOUSLY PR83:1
(P. 88) - PB60 (P. 150) & PBk9 (P. 257)

HEALTH	WG	RATING
✗ INFO	II L'FAST	★★

NEUTRAL TINT 1186

The overall lightfast rating was once lowered by the use of PG8, Hooker's Green. This has now been removed and the colour re-formulated. Lightfast ingredients are now used.

PG7 PHTHALOCYANINE GREEN (P.177)
PR122 QUINACRIDONE MAGENTA (P. 92)
PY83 DIARYLIDE YELLOW (P.36)
PBk7 CARBON BLACK (P. 256)
PB15 PHTHALOCYANINE BLUE (P.147)

HEALTH	WG	RATING
✕	II	★
INFO	L'FAST	★ ★

NEUTRAL TINT 715

Will move towards black even more as the PV23 fades on exposure. If you need the final colour why not simply start off with black.

PV23 BS DIOXAZINE PURPLE (P. 131)
PBk7 CARBON BLACK (P. 256)

HEALTH	ASTM	RATING
✕	V	★
INFO	L'FAST	

NEUTRAL COLOR 543

As you can see, a variety of concoctions can be marketed under this rather vague name. This is yet another. Reliable.

PBr7
PB29 ULTRAMARINE BLUE (P. 149)
PBk7 CARBON BLACK (P. 256)

HEALTH	ASTM	RATING
✕	I	★
INFO	L'FAST	★ ★

NEUTRAL TINT 624

Virtually the same as the 'Artist Quality'. A tip in case you wish to make savings and are desperate for this near black.

PB29 ULTRAMARINE BLUE (P. 149)
PBr7 BURNT UMBER (P. 212)
PBk7 CARBON BLACK (P. 256)

HEALTH	ASTM	RATING
✕	I	★
INFO	L'FAST	★ ★

8.3 Payne's Grey

A very popular blackish - blue produced from standard colours. Although it can be easily duplicated on the palette, many artists find it convenient to purchase the ready prepared paint. Perhaps it is because they do not quite realise the simple make up of the colour.

If you do need this rather dull 'heavy' colour and your brand is mixed from, say, Ultramarine and Ivory Black, try taking a moment to mix the two paints together yourself. You will end up with exactly the same colour for a few moments of paint stirring. It will be one less colour to worry about. Alternatively, and this is by far the better way to work, mix the colour from the complementary pair, Burnt Sienna and Ultramarine Blue. This way you will have a wide range of 'Payne's Greys' as you will have control over the amount of each colour. You will also have a result that does not include black but will be rich in both colour and intrigue.

PAYNE'S GREY 553

The standard Payne's Grey. Ultramarine and Black. A convenience colour which is easy to mix on the palette. Semi-opaque.

PB29 ULTRAMARINE BLUE (P. 149)
PBk9 IVORY BLACK (P. 257)

HEALTH	ASTM	RATING
✕	I	★
INFO	L'FAST	★ ★

PAYNE'S GREY 703

The unreliable PBk1, once added, has been removed and the colour re-formulated using lightfast pigments throughout. Sample gave very smooth, even washes.

PBk7 CARBON BLACK (P.256)
PB15:3 PHTHALOCYANINE BLUE (P.147)
PV19 QUINACRIDONE RED (P.130)

HEALTH	ASTM	RATING
✕	II	★
INFO	L'FAST	★ ★

PAYNE'S GREY 708

There can be little of the blue or violet involved as the colour is all but black. Reliable ingredients. Washes out well. Semi-opaque.

PV19 QUINACRIDONE VIOLET (P. 130)
PBk7 CARBON BLACK (P. 256)
PB15 PHTHALOCYANINE BLUE (P. 147)

HEALTH	ASTM	RATING
✕	II	★
INFO	L'FAST	★ ★

PAYNE'S GREY 175

BLOCKX

Black with the slightest hint of green. Reliable ingredients but as close to black as would seem possible. The black is unspecified. Semi-opaque.

AQUARELLES
ARTISTS'
WATER COLOUR

BLACK
PB29 ULTRAMARINE BLUE (P. 149)
PB15 PHTHALOCYANINE BLUE (P. 147)

HEALTH	ASTM	RATING
✕ INFO	II L'FAST	★ ★★

PAYNE'S GREY 065

ROWNEY

I wonder whether certain of these Payne's Greys are really worth considering. They are so close to black that they could only be used as such. Reliable. Opaque.

ARTISTS'
WATER COLOUR

PB29 ULTRAMARINE BLUE (P. 149)
PBk7 CARBON BLACK (P. 256)

HEALTH	ASTM	RATING
✓ INFO	I L'FAST	★ ★★

PAYNE'S GREY 123

PĒBĒO

In appearance it is black with the slightest hint of brown, and it is slight! Reliable and well produced. Semi-opaque.

PR88 MRS THIOINDIGOID VIOLET (P. 88)
PBk7 CARBON BLACK (P. 256)
PB15 PHTHALOCYANINE BLUE (P. 147)

FRAGONARD
ARTISTS'
WATER COLOUR

HEALTH	ASTM	RATING
✕ INFO	II L'FAST	★ ★★

PAYNE'S GREY 783

SCHMINCKE

A slightly 'warm' black. Recently reformulated using reliable ingredients throughout. A lightfast colour easily duplicated on the palette.

PR101 MARS RED (P.91)
PB29 ULTRAMARINE BLUE (P.149)
PBk7 CARBON BLACK (P. 256)
ONCE ALSO PB15:3 (P.147) & PV5:1 (P.129)

HORADAM
FINEST
ARTISTS'
WATER COLOURS

HEALTH	ASTM	RATING
✕ INFO	I L'FAST	★ ★★

PAYNE'S GRAY 156

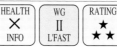

The blue content is noticeable in mid to light washes. A velvety black in heavier application. The PR88 is a recent addition. Lightfast. Semi-opaque.

PBk9 IVORY BLACK (P. 257)
PB29 ULTRAMARINE BLUE (P. 149)
PR88 THIOINDIGOID VIOLET (P.250)

FINEST
PROFESSIONAL
WATERCOLORS

HEALTH	WG	RATING
✕ INFO	II L'FAST	★ ★★

PAYNE'S GREY 1184

LUKAS

Very thin applications have the slightest hint of blue about them. Otherwise treat as black. Semi-opaque.

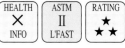

PB15 PHTHALOCYANINE BLUE (P. 147)
PBk7 CARBON BLACK (P. 256)

ARTISTS'
WATER COLOUR

HEALTH	ASTM	RATING
✕ INFO	II L'FAST	★ ★★

PAYNE'S GRAY 261

DA VINCI PAINTS

A blackish green - blue. Heavier applications can take on a reddish overlay, visible at certain angles. This is due to the 'bronzing' which Prussian Blue is particularly susceptible to.

PBk6 LAMP BLACK (P. 256)
PB27 PRUSSIAN BLUE (P. 148)

PERMANENT
ARTISTS'
WATER COLOR

HEALTH	ASTM	RATING
✓ INFO	I L'FAST	★ ★★

PAYNE'S GRAY 5737

HUNTS

Reliable ingredients give a black with a hint of blue. Washed out reasonably well. Semi-opaque.

PURE BONE BLACK AND ULTRAMARINE PIGMENT

SPEEDBALL
PROFESSIONAL
WATERCOLOURS

HEALTH	ASTM	RATING
✕ INFO	I L'FAST	★ ★★

PAYNE'S GREY 713

HOLBEIN

The blue content is obvious, making this a possible convenience colour. Unfortunately the addition of PR83 lowers the overall assessment, even if its eventual fading will make little difference to the colour. Semi-opaque.

PR83 ROSE MADDER ALIZARIN (P. 88)
PB29 ULTRAMARINE BLUE (P. 149)
PB27 PRUSSIAN BLUE (P. 148)
PBk7 CARBON BLACK (P. 256)

ARTISTS'
WATER COLOR

HEALTH	ASTM	RATING
✕ INFO	IV L'FAST	★★

PAYNE'S GRAY 465 (034)

WINSOR & NEWTON

Reliable ingredients giving a possible convenience colour. The blue content is quite obvious in mid to light washes. Washed out well. Semi-opaque.

PB15 PHTHALOCYANINE BLUE (P. 147)
PBk6 LAMP BLACK (P. 256)
PV19 QUINACRIDONE RED (P. 130)

ARTISTS'
WATER COLOUR

HEALTH	ASTM	RATING
✕ INFO	II L'FAST	★ ★★

PAYNE'S GRAY 2057

MARTIN F.WEBER

The Ultramarine Blue once added has been replaced by the less than reliable PR122. This has lowered the lightfast rating. Washed out well. Opaque.

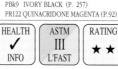

PB15 PHTHALOCYANINE BLUE (P. 147)
PBk9 IVORY BLACK (P. 257)
PR122 QUINACRIDONE MAGENTA (P.92)

PERMALBA
ARTIST'S
WATER COLOR
AQUARELLE

HEALTH	ASTM	RATING
✓ INFO	III L'FAST	★★

PAYNE'S GRAY 310

BINNEY & SMITH

The 'traditional' mix giving a dark blue - black. Washes out very smoothly over a useful range of values.

PB29 ULTRAMARINE BLUE (P. 149)
PBk9 IVORY BLACK (P. 257)

PROFESSIONAL
ARTISTS'
WATER COLOR

HEALTH	ASTM	RATING
✓ INFO	I L'FAST	★ ★★

PAYNE'S GREY 261

LEFRANC & BOURGEOIS

In the thinnest washes there is possibly a hint of blueness. Otherwise use simply as a black watercolour. Handles well and is reliable. Semi-opaque.

PB60 INDANTHRONE BLUE (P. 150)
PBk7 CARBON BLACK (P. 256)

LINEL
EXTRA-FINE
ARTISTS'
WATERCOLOUR

HEALTH	WG	RATING
✓	II	★
INFO	L'FAST	★ ★

PAYNE'S GREY 065

ROWNEY

A neutral black - grey with the faintest hint of blue in the tint. Little removed from a straightforward black.

PBk7 CARBON BLACK (P. 256)
PB29 ULTRAMARINE BLUE (P. 149)

GEORGIAN
WATER COLOUR
2ND RANGE

HEALTH	ASTM	RATING
✓	I	★
INFO	L'FAST	★ ★

PAYNE'S GREY

PAILLARD

A greyed blue. I cannot give the ingredients as they were withheld, not from me but from you. Semi-opaque.

LOUVRE
AQUARELLE
ARTISTS' COLOUR
2ND RANGE

HEALTH		
✗		
INFO		

PAYNE'S GREY 708

TALENS

Treat as a black watercolour rather than the traditional blackish-blue. I am sure the other pigments are in there somewhere, just a bit shy. *Discontinued.*

PB15 PHTHALOCYANINE BLUE (P. 147)
PBk7 CARBON BLACK (P. 256)
PV19 QUINACRIDONE RED (P. 130)

WATER COLOUR
2ND RANGE

HEALTH	ASTM	RATING
✗	II	★
INFO	L'FAST	★ ★

PAYNE'S GREY 465

REEVES

A variety of ingredients giving in effect just another black watercolour. Semi-opaque.
This range of colours has now been discontinued.

PB15 PHTHALOCYANINE BLUE (P. 147)
PB29 ULTRAMARINE BLUE (P. 149)
PBk7 CARBON BLACK (P. 256)

WATER COLOUR
FOR ARTISTS
2ND RANGE

HEALTH	ASTM	RATING
✗	II	★
INFO	L'FAST	★ ★

PAYNE'S GRAY 465 (327)

WINSOR & NEWTON

The blue content is visible in mid to light washes. Dependable ingredients, washes out well. Semi-opaque.

PB15 PHTHALOCYANINE BLUE (P. 147)
PBk7 CARBON BLACK (P. 256)
PB29 ULTRAMARINE BLUE (P. 149)

COTMAN
WATER COLOUR
2ND RANGE

HEALTH	ASTM	RATING
✗	II	★
INFO	L'FAST	★ ★

PAYNE'S GRAY 156

GRUMBACHER

The 'traditional' blue for Payne's Grey is Ultramarine, a violet - blue, rather than a green - blue such as Phthalocyanine. Semi-opaque.

PB15 PHTHALOCYANINE BLUE (P. 147)
PBk6 LAMP BLACK (P. 256)

ACADEMY
ARTISTS'
WATERCOLOUR
2ND RANGE

HEALTH	ASTM	RATING
✓	II	★
INFO	L'FAST	★ ★

When Burnt Sienna is added to Ultramarine Blue it will darken it very successfully and produce a range of 'Payne's Greys'. Other types of greys and neutral can also be produced this way. Both are close as complementaries and are also transparent. Worth trying.

8.4 Miscellaneous Greys

What can I say? If any of these greys or blacks are vital to your way of working than go ahead. My view is that they are added onto lists in order to provide yet another colour name and are of very limited worth as individual colours.

TALENS

REMBRANDT
ARTISTS'
WATER COLOUR

CHARCOAL GREY 726

A nondescript black leaning towards brown. To my mind a rather pointless mix of two black pigments. Semi-opaque.

PBk9 IVORY BLACK (P. 257)
PBk7 CARBON BLACK (P. 256)

HEALTH	ASTM	RATING
✕	I	★
INFO	L'FAST	★ ★

WINSOR
& NEWTON

ARTISTS'
WATER COLOUR

CHARCOAL GREY 142 (010)

Sample was rather gritty but brushed out reasonably well. Treat as a general black rather than anything special. Lightfast. Semi-opaque.

PBk8 CHARCOAL BLACK (P. 257)

HEALTH	WG	RATING
✕	I	★
INFO	L'FAST	★

GRUMBACHER

ACADEMY
ARTISTS'
WATERCOLOUR
2ND RANGE

CHARCOAL GRAY 042

If you also purchase the actual Lamp Black available in this range, you will have a matching pair, in every respect. Do not buy the same thing twice unless you collect paint names.

PBk6 LAMP BLACK (P. 256)

HEALTH	ASTM	RATING
✓	I	★
INFO	L'FAST	★ ★

HOLBEIN

ARTISTS'
WATER COLOR

GREY OF GREY 705

Cracks readily even when applied at mid strength. PBk1 is less than reliable. If you need this colour, add white to black and stir. Semi-opaque.

PBk1 ANILINE BLACK (P. 256)
PW6 TITANIUM WHITE (P. 271)

HEALTH	WG	RATING
✕	III	★
INFO	L'FAST	★ ★

BLACKS

History of Black Pigments

The first paint ever used was almost certainly soot, either rubbed directly onto the surface or mixed with a binder such as animal fat or blood.

A wide variety of substances have been burnt for their soot or charred to give black pigments. Many have been greasy and difficult to use.

Soot from the cave man's fire was probably the first material ever to be employed as a pigment. It was either rubbed onto the cave wall or made into a rough paint with a binder such as animal fat, sap, blood or a similar sticky substance.
The basic material is still with us as Lamp Black.

Lamp Black was one of the standard black pigments of the Middle Ages, its main drawback was the fact that it was often greasy and tended to 'dirty' mixes. An advantage was its ease of manufacture and low cost if purchased ready prepared.

Most of the black pigments available today are still produced from carbon obtained by burning various materials. Such blacks are either almost pure carbon obtained from the soot of burnt oils and tars, or the slightly impure carbons derived form animal or vegetable origins.

Certain charcoals of high quality were valued by the Medieval artist. One of the more common, Vine Black, being made from charred grape vines.

Vine Black and other vegetable blacks tended to be rather brownish and had an unpleasant consistency. Some particularly fine blacks were obtained from

charred fruit stones, especially peach. Willow charcoal was often made into a paint, but was found to be rather greyish and difficult to work with.

An extremely permanent black made from charred animal bones has been in use since earliest times and is still with us, masquerading as Ivory Black. Nowadays the paint sold as Ivory Black is in fact Bone Black, an inferior product. Genuine Ivory Black, made from charred ivory is, thankfully, no longer available. As far as the source of the ivory is concerned that is.

A recent addition has been Mars Black, an artificial mineral pigment. Dense and reliable, the better qualities have been generally welcomed by today's artists.

MODERN BLACK PIGMENTS

ANILINE BLACK

This is a rather unusual black to find in artists' watercolours. It is well known that it will tend to fade as a tint. Watercolours of course are often applied thinly, where they are particularly vulnerable to the light. Why a black, which is less than reliable, is ever employed is rather mysterious. After all, there is a reasonably wide selection of absolutely lightfast products available. Semi-opaque. Rarely used in artists' watercolours.

The first 'coal tar dye'. By reputation and our own testing rated WG III. Unreliable and unnecessary.

LAMP BLACK

Produced by burning mineral oil, pitch or tar in brick chambers and collecting the soot which is given off. Any oily residues are then removed by heat treatment. Has been used since the dawn of civilisation. A very fine, light pigment, it tends to float on the surface of a wash and settle elsewhere. High in tinting strength, it should be handled with some care. Excellent hiding power. Reasonably transparent when well diluted.

Absolutely lightfast, with an ASTM rating of I as a watercolour. On the list of recommended colours. A cool bluish - black.

CARBON BLACK

Carbon blacks have been produced by charring a wide variety of materials. Today it is usually made by burning natural gas and allowing the flame to impinge onto a metal plate. The resultant soot can be made into a paint without further process. Being very light, the pigment tends to float to the edges of a very wet wash. Opaque, with excellent hiding power. Transparent only when well diluted. An intense velvety black.

Tested ASTM I as a watercolour. Absolutely lightfast, it will never alter in colour. On the ASTM list of approved pigments.

CHARCOAL BLACK

A grey - black powder made from charcoal. The better qualities come from charred Willow, but other materials can be used, such as twigs from the vine. Usually considered to make an inferior pigment as far as brushability is concerned. However, when blended with other pigments this drawback is largely overcome. The denser charcoals produce the better pigment. Semi-opaque. PBk8 is seldom found in modern watercolours, more in cement and concrete as a colorant.

Charcoal Black has an excellent reputation for reliability. I do not have test results to back this up but carbon is unaffected by light.

Also called Bideford Black.

IVORY BLACK

Originally obtained by charring ivory scraps in sealed crucibles. The resultant black material was ground into a intense, velvety black. This pigment was sold alongside an inferior black made from charred animal bones (Bone Black). When the supply of ivory dried up, the name Ivory Black was simply switched to Bone Black. Modern Ivory Black is still made from animal bones. Semi-opaque with brownish tints. Sometimes darkened with other pigments.

Completely lightfast. ASTM I in watercolour and on the list of approved pigments.

MARS BLACK

Mars Black varies in colour from a dark bluish - grey to black. Opaque, with very good hiding power. When applied very dilute it can settle out into small pockets of colour. PBk11 has a similar chemical make up to PR101 - PR102 -PBr7 and PBr6. High in tinting strength it will quickly influence virtually all other colours when mixed. Varies in quality between pigment manufacturers. The better grades are good value for money.

An excellent dense blue - grey to black. Absolutely lightfast, with an ASTM rating of I. On the list of approved pigments. Has valuable qualities.

Also called Iron Oxide Black.

GRAY HYDRATED ALUMINUM SILICATE

PBk19 has many industrial uses - is often found as an inert extender in cheap paints of various types. It is also used in grey fillers and stoppers and to colour artificial stone and cement. Mid Grey.

Excellent lightfastness. ASTM I as a watercolour and on the list of approved pigments.

Also called Slate Grey.

BLACK
WATERCOLOURS

BLACK WATERCOLOURS

9.1 Ivory Black

Produced by charring animal bones in closed crucibles. The bones are first boiled to remove fat and gristle. It is not known for certain when this material was first employed as a pigment, although we can be fairly sure that it was one of the earliest materials used for painting.

The original Ivory Black was produced by charring ivory scraps, usually off-cuts from the comb making trade or similar. It was a rich velvety black, in great demand. Bone Black, an inferior pigment was also offered to the less discerning. When the supply of reasonably cheap ivory dried up, the Colourmen were left with a dilemma. Genuine Ivory Black was in wide demand and sold for a good price, but the pigment could not be supplied.

To make everyone happy (particularly the Colourmen) they simply switched names and called Bone Black Ivory Black.

The colour of the product has changed over recent years. Normally possessing a warm brown undercolour, manufacturers now strive to produce a darker, more neutral black. Modern Bone Black, sorry, Ivory Black, is of a far better quality than it used to be as all the fat is now removed during manufacture.

IVORY BLACK 528

Absolutely lightfast. Well produced watercolour paint which handles well, giving smooth washes. Semi-opaque.

MAIMERI — ARTISTI EXTRA-FINE WATERCOLOURS

PBk9 IVORY BLACK (P. 257)

HEALTH	ASTM	RATING
INFO ✗	L'FAST I	★★ ★★

IVORY BLACK 700

An intense velvety black. Particularly well produced watercolour paint, it washed out well over a wide range of values. Semi-opaque.

HOLBEIN — ARTISTS' WATER COLOR

PBk9 IVORY BLACK (P. 257)

HEALTH	ASTM	RATING
INFO ✗	L'FAST I	★★ ★★

IVORY BLACK 331 (026)

A warm black with a hint of brown in the tints. Gave smooth washes over the full range of strengths. Semi-opaque.

WINSOR & NEWTON — ARTISTS' WATER COLOUR

PBk9 IVORY BLACK (P. 257)

HEALTH	ASTM	RATING
INFO ✗	L'FAST I	★★ ★★

IVORY BLACK 450

Well produced paint, dense pigment and smoothly ground. Washed out very well over a useful range of values. Semi-opaque.

OLD HOLLAND — CLASSIC WATERCOLOURS

PBk9 IVORY BLACK (P. 257)

HEALTH	ASTM	RATING
INFO ✗	L'FAST I	★★ ★★

IVORY BLACK 034

Rich, velvety black at full strength, brushing out to light mid - greys when dilute. Handled well. Semi-opaque.

ROWNEY — ARTISTS' WATER COLOUR

PBk9 IVORY BLACK (P. 257)

HEALTH	ASTM	RATING
INFO ✓	L'FAST I	★★ ★★

IVORY BLACK 171

A neutral black, leaning neither towards brown or blue. Washed out well over an extensive range of strengths. Semi-opaque.

BLOCKX — AQUARELLES ARTISTS' WATER COLOUR

PBk9 IVORY BLACK (P. 257)

HEALTH	ASTM	RATING
INFO ✗	L'FAST I	★★ ★★

IVORY BLACK 2070

Sample was a little overbound and brushed out rather streaky. Absolutely lightfast. Opaque.

MARTIN F.WEBER — PERMALBA ARTIST'S WATER COLOR AQUARELLE

PBk9 IVORY BLACK (P. 257)

HEALTH	ASTM	RATING
INFO ✓	L'FAST I	★ ★★

IVORY BLACK 269

Ivory Black is semi-opaque and covers well. It is strong enough however, to give reasonably clear washes when fully diluted. Handles well.

LEFRANC & BOURGEOIS — LINEL EXTRA-FINE ARTISTS' WATERCOLOUR

PBk9 IVORY BLACK (P. 257)

HEALTH	ASTM	RATING
INFO ✓	L'FAST I	★★ ★★

IVORY BLACK 244

Without a doubt this company lead the field when it comes to clear and informative labelling. A well produced Ivory Black. Semi-opaque.

BINNEY & SMITH — PROFESSIONAL ARTISTS' WATER COLOR

PBk9 IVORY BLACK (P. 257)

HEALTH	ASTM	RATING
INFO ✓	L'FAST I	★★ ★★

IVORY BLACK 701

The addition of Carbon Black removes the soft brown undercolour associated with a well produced Ivory Black. Absolutely lightfast.

TALENS

REMBRANDT ARTISTS' WATER COLOUR

| PBk9 IVORY BLACK (P. 257) |
| PBk7 CARBON BLACK (P. 256) |

HEALTH	ASTM	RATING
✕ INFO	I L'FAST	★★

IVORY BLACK 1 128

Opaque, with excellent covering power. Gives reasonable washes when very dilute. An imitation Ivory Black.

PÉBÉO

FRAGONARD ARTISTS' WATER COLOUR

| PBk7 CARBON BLACK (P. 256) |

HEALTH	ASTM	RATING
✕ INFO	I L'FAST	★★

IVORY BLACK 115

Full strength applications dry as a soft velvety matt black. Washed out well over a particularly wide range of values.

GRUMBACHER

FINEST PROFESSIONAL WATERCOLORS

| PBk9 IVORY BLACK (P. 257) |

HEALTH	ASTM	RATING
✕ INFO	I L'FAST	★★

IVORY BLACK 5739

Densely packed pigment. A well produced watercolour paint which handled well. Good covering power and quite strong tinctorialy. Semi-opaque.

HUNTS

SPEEDBALL PROFESSIONAL WATERCOLOURS

| *PURE BONE BLACK* |

HEALTH	ASTM	RATING
✕ INFO	I L'FAST	★★ ★★

IVORY BLACK 1182

This should ideally be described as 'Ivory Black Hue' as it is an imitation. Carbon Black has its own particular characteristics of handling and hue. Opaque.

LUKAS

ARTISTS' WATER COLOUR

| PBk7 CARBON BLACK (P. 256) |

HEALTH	ASTM	RATING
✕ INFO	I L'FAST	★★

IVORY BLACK 780

A particularly dense black at full strength. Washes out well and has good covering power.

SCHMINCKE

HORADAM FINEST ARTISTS' WATER COLOURS

| PBk9 IVORY BLACK (P. 257) |

HEALTH	ASTM	RATING
✕ INFO	I L'FAST	★★

IVORY BLACK

Rather weak grey - black which dried out with a grainy appearance. As information on ingredients was withheld I cannot offer assessments.

PAILLARD

LOUVRE AQUARELLE ARTISTS' COLOUR 2ND RANGE

HEALTH
✕ INFO

IVORY BLACK 331

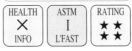

As lightfast and well produced as 'Artist Quality' Ivory Blacks. Washed out well. Semi-opaque. *This range of colours has recently been discontinued.*

REEVES

WATER COLOUR FOR ARTISTS 2ND RANGE

| PBk9 IVORY BLACK (P. 257) |

HEALTH	ASTM	RATING
✕ INFO	I L'FAST	★★ ★★

IVORY BLACK 331 (322)

If you need to make savings this is as reliable as any 'Artist Quality' Ivory Black. Handled well. Semi-opaque.

WINSOR & NEWTON

COTMAN WATER COLOUR 2ND RANGE

| PBk9 IVORY BLACK (P. 257) |

HEALTH	ASTM	RATING
✕ INFO	I L'FAST	★★

IVORY BLACK 034

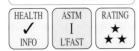

Sample was rather overbound and brushed out with difficulty unless well diluted. Absolutely lightfast. Semi-opaque.

ROWNEY

GEORGIAN WATER COLOUR 2ND RANGE

| PBk9 IVORY BLACK (P. 257) |

HEALTH	ASTM	RATING
✓ INFO	I L'FAST	★★

IVORY BLACK 701

Does not have the brown undercolour associated with unadulterated Ivory Black. Reliable. Semi-opaque. *This range of colours has recently been discontinued.*

TALENS

WATER COLOUR 2ND RANGE

| PBk9 IVORY BLACK (P. 257) |
| PBk7 CARBON BLACK (P. 256) |

HEALTH	ASTM	RATING
✕ INFO	I L'FAST	★★

IVORY BLACK 115

A soft, warm black which handles very well. Unaffected by light of any strength and duration.

GRUMBACHER

ACADEMY ARTISTS' WATERCOLOUR 2ND RANGE

| PBk9 IVORY BLACK (P. 257) |

HEALTH	ASTM	RATING
✓ INFO	I L'FAST	★★

9.2 Lamp Black

Mineral oil, tar, pitch or a similar substance is burnt in brick chambers and the soot is collected. Oily residues are normally present, these are removed by heat treatment. Being a fine, soft powder it does not require further grinding.

Soot given off from the fire was probably the first pigment ever to be used, either rubbed onto the wall of the cave or possibly mixed with animal fats. Lamp Black, produced by burning a wide variety of substances, has been in use ever since.

Used extensively for Chinese ink work from the earliest times, it was usually made by burning resinous pine wood or Tung oil nuts and cake.

A cool mid - black, often with a very slight blue bias. Very high in tinting strength and covering power it should be handled with some care. Washes out to give reasonably clear tints.

The pigment is particularly light and fluffy. When applied in a very wet layer it is apt to float on the surface of the film and settle near the edges, causing a dark band around the wash. This is especially noticeable in small areas.

LAMP BLACK 753

The pigment previously used was Carbon Black rather than Lamp Black. Now reformulated. Brushed out well. Absolutely lightfast. Opaque.

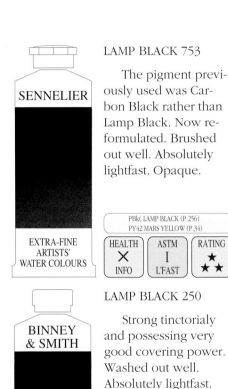

SENNELIER
EXTRA-FINE ARTISTS' WATER COLOURS

PBk(LAMP BLACK (P.256)
PY42 MARS YELLOW (P.34)

HEALTH	ASTM	RATING
✕ INFO	I L'FAST	★★

LAMP BLACK 251

Lamp Black is very high in tinting strength and will quickly influence other colours in a mix. Covers well but gives reasonably clear washes.

DA VINCI PAINTS
PERMANENT ARTISTS' WATER COLOR

PBk6 LAMP BLACK (P. 256)

HEALTH	ASTM	RATING
✓ INFO	I L'FAST	★★ ★★

LAMP BLACK 702

A particularly dense black at full strength. Washes out well over an extensive range of values. Excellent. Opaque.

TALENS
REMBRANDT ARTISTS' WATER COLOUR

PBk7 CARBON BLACK (P. 256)

HEALTH	ASTM	RATING
✕ INFO	I L'FAST	★★ ★★

LAMP BLACK 250

Strong tinctorialy and possessing very good covering power. Washed out well. Absolutely lightfast.

BINNEY & SMITH
PROFESSIONAL ARTISTS' WATER COLOR

PBk6 LAMP BLACK (P. 256)

HEALTH	ASTM	RATING
✓ INFO	I L'FAST	★★ ★★

LAMP BLACK 702

At full strength is a particularly dense, smooth, matt black. Handled well but should be used with care due to its high strength. Opaque.

HOLBEIN
ARTISTS' WATER COLOR

PBk6 LAMP BLACK (P. 256)

HEALTH	ASTM	RATING
✕ INFO	I L'FAST	★★ ★★

LAMP BLACK 337 (028)

Being a very fine pigment it makes into a paint which washes out well, giving smooth even washes. Most reliable. Opaque.

WINSOR & NEWTON
ARTISTS' WATER COLOUR

PBk6 LAMP BLACK (P. 256)

HEALTH	ASTM	RATING
✕ INFO	I L'FAST	★★ ★★

LAMP BLACK 035

Ranges in value from an intense deep black to a pale mid - grey in a wash. Covers very well and washes evenly. Opaque.

ROWNEY
ARTISTS' WATER COLOUR

PBk6 LAMP BLACK (P. 256)

HEALTH	ASTM	RATING
✓ INFO	I L'FAST	★★ ★★

LAMP BLACK 781

Recently re-formulated from a rather complicated mix containing the unreliable PBk1 to an absolutely lightfast, dense black. Opaque.

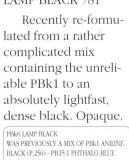
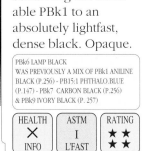

SCHMINCKE
HORADAM FINEST ARTISTS' WATER COLOURS

PBk6 LAMP BLACK
WAS PREVIOUSLY A MIX OF PBk1 ANILINE BLACK (P.256) - PB15:1 PHTHALO.BLUE (P.147) - PBk7 CARBON BLACK (P.256) & PBk9 IVORY BLACK (P. 257)

HEALTH	ASTM	RATING
✕ INFO	I L'FAST	★★ ★★

LAMP BLACK 266

Carbon Black is virtually the same as Lamp Black in hue and handling characteristics. Absolutely lightfast.

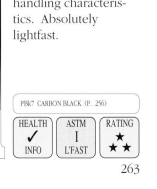

LEFRANC & BOURGEOIS
LINEL EXTRA-FINE ARTISTS' WATERCOLOUR

PBk7 CARBON BLACK (P. 256)

HEALTH	ASTM	RATING
✓ INFO	I L'FAST	★ ★★

LAMP BLACK 127

Has a soft, warm undercolour as apposed to the rather hard tint which is more common. Washed out very smoothly. Opaque.

PĒBĒO

FRAGONARD
ARTISTS'
WATER COLOUR

PBk7 CARBON BLACK (P. 256)		
HEALTH ✕ INFO	ASTM I L'FAST	RATING ★★

LAMP BLACK 116

At full strength is a very dense black with excellent covering power. Washes out smoothly giving reasonably clear washes. Opaque.

GRUMBACHER

FINEST
PROFESSIONAL
WATERCOLORS

PBk6 LAMP BLACK (P. 256)		
HEALTH ✕ INFO	ASTM I L'FAST	RATING ★★

LAMP BLACK 337

Unaffected by light of any strength or duration. Certainly as reliable as any 'Artist Quality' Lamp Black. Handled well. Opaque. *This range has now been discontinued.*

REEVES

WATER COLOUR
FOR ARTISTS
2ND RANGE

PBk6 LAMP BLACK (P. 256)		
HEALTH ✕ INFO	ASTM I L'FAST	RATING ★★

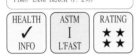

LAMP BLACK 035

Why purchase the 'Artist Quality' version when this will be less expensive but as well produced and reliable. Opaque.

ROWNEY

GEORGIAN
WATER COLOUR
2ND RANGE

PBk6 LAMP BLACK (P. 256)		
HEALTH ✓ INFO	ASTM I L'FAST	RATING ★★

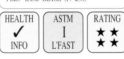

LAMP BLACK 337 (323)

A wide range of values are available, from a particularly dense black at full strength, to soft, light grey washes when diluted. Opaque.

WINSOR & NEWTON

COTMAN
WATER COLOUR
2ND RANGE

PBk6 LAMP BLACK (P. 256)		
HEALTH ✓ INFO	ASTM I L'FAST	RATING ★★

LAMP BLACK 116

Soft, matt black at full strength with very good covering power. Handles well. Why pay more for the 'Artist Quality'? Most reliable. Opaque.

GRUMBACHER

ACADEMY
ARTISTS'
WATERCOLOUR
2ND RANGE

PBk6 LAMP BLACK (P. 256)		
HEALTH ✓ INFO	ASTM I L'FAST	RATING ★★

9.3 Miscellaneous Blacks

As you will see, these are either very simple mixes or standard blacks sold under another name. Be careful that you do not purchase the same colour twice. With a little imagination a basic black such as Ivory Black could be given another five or six names and all be sold to the unwary. Perhaps it might also be called Bone Black again, or is that going too far?

MAIMERI

STUDIO
FINE
WATER COLOR
2ND RANGE

BLACK 612

A simple name for a simple mix of two standard blacks. Soft, slightly warm under-colour. Handled well. Opaque.

PBk9 IVORY BLACK (P. 257)
PBk7 CARBON BLACK (P. 256)

HEALTH	ASTM	RATING
✗ INFO	I L'FAST	★ ★★

WINSOR & NEWTON

ARTISTS'
WATER COLOUR

BLUE BLACK 034 (004)

I could not detect any real difference between this 'Lamp Black' and the actual Lamp Black offered by the company. The latter maintain that this is 'bluish' compared to the 'brownish' Lamp Black.

PBk6 LAMP BLACK (P. 256)

HEALTH	ASTM	RATING
✗ INFO	I L'FAST	★ ★★

OLD HOLLAND

CLASSIC
WATERCOLOURS

BLUE BLACK 449

A simple mix giving a blackish green - blue. Handled well. Easily mixed using either Prussian or Phthalo-cyanine Blue. Semi-opaque.

PBk9 IVORY BLACK (P. 257)
PB27 PRUSSIAN BLUE (P. 148)

HEALTH	ASTM	RATING
✗ INFO	I L'FAST	★ ★★

SENNELIER

EXTRA-FINE
ARTISTS'
WATER COLOURS

PEACH BLACK 757

The name was originally used for a black produced from charred peach stones. In this case it is a simple mix. Used to contain the unreliabe PBk1. Now produced using lightfast pigments.

PBk7 CARBON BLACK (P.256)
PB29 ULTRAMARINE BLUE (P.149)
WAS PBk1 (P. 256) & PBk9 (P. 257)

HEALTH	ASTM	RATING
✗ INFO	I L'FAST	★ ★★

LEFRANC & BOURGEOIS

LINEL
EXTRA-FINE
ARTISTS'
WATERCOLOUR

PEACH BLACK 272

The company already market this pigment under its correct name, Ivory Black. I could detect no difference between the two. Do not purchase the same paint twice unless that's how you get your kicks.

PBk9 IVORY BLACK (P. 257)

HEALTH	ASTM	RATING
✓ INFO	I L'FAST	★ ★★

HOLBEIN

ARTISTS'
WATER COLOR

PEACH BLACK 701

PBk1 is less than reliable and can have added little to the final colour. Washed out well.

PBk1 ANILINE BLACK (P. 256)
PBk6 LAMP BLACK (P. 256)

HEALTH	WG	RATING
✗ INFO	III L'FAST	★★

SCHMINCKE

HORADAM
FINEST
ARTISTS'
WATER COLOURS

VINE BLACK 784

The inclusion of PB66, a fugitive substance, once lowered the overall rating. This has now been removed. An absolutely lightfast, velvety black. Opaque.

PBk6 LAMP BLACK (P. 256)
PBk9 IVORY BLACK (P. 257)
PREVIOUSLY ALSO CONTAINED PB66
(P. 150) & PBk11 (P. 257)

HEALTH	ASTM	RATING
✗ INFO	I L'FAST	★ ★★

WHITES

History of White Pigments

The advancement of the technique of oil painting owes its success largely to the use of Lead White. The fine brushing quality, opacity and warmth have made it popular with artists for many hundreds of years. This fine pigment is unfortunately not suitable for use in watercolours as it darkens when exposed to the Hydrogen Sulphide of the atmosphere. (Amazingly this has not prevented its use by at least one watercolour manufacturer)

Various substances have been used in water based colours to give a white. Calcined chicken bones have been employed to make an inferior white colorant which brushed out poorly.

Burnt and ground egg shells gave another poor pigment.

Chalk has been used since the cave painter, either in lump form, or ground for use as a coarse paint.

Oyster shells, burnt and crushed into a fine powder provided a white of great importance to early Japanese painting.

A particularly dense type of Zinc White is employed in the manufacture of Chinese White. It is absolutely lightfast.

Titanium White, the whitest of the whites, makes a particularly useful watercolour. Unfortunately it is often sold under other names.

Oyster shells, burnt and powdered, provided a white which was widely used throughout Japan and China. It became one of the standard pigments. Oyster Shell White was also used to some extent in Medieval England.

Zinc White was suggested in 1746 as a possible alternative to Lead White in oil paints. It was non toxic and unaffected by sulphur fumes. Produced first as a watercolour, it is still widely available, usually under the name Chinese White.

Titanium White, used more extensively in other mediums, makes a perfectly reliable watercolour white.

The watercolourist is well served with the range of whites available today.

MODERN WHITE PIGMENTS

FLAKE WHITE

Produced by various methods of corroding lead. Flake White or White Lead is one of the earliest manufactured pigments on record. Very opaque and brushes out well. It has been known for centuries that it cannot successfully be used as a watercolour. The Hydrogen Sulphide of the atmosphere will react with the pigment and darken it to a marked extent. I am absolutely amazed that it should actually be used in a watercolour.

Sample darkened within a short time. It will spoil any colour that has been mixed with it. A most unsuitable pigment for use in watercolour.

Also called White Lead.

ZINC WHITE

First produced on a commercial scale in the 1830's. A major advantage of the pigment was that it did not darken on exposure to the atmosphere, as did Flake White. It soon became the most important white watercolour. A very cold, pure white with good reducing power, (will lighten other colours economically). The prepared watercolour pigment is a specially produced, very dense type of zinc oxide with greater covering power than the oils version.

Rated ASTM I as a watercolour and on the list of recommended pigments. Thoroughly reliable.

Also called Chinese White.

LITHOPONE

A semi-opaque to opaque white, widely used as an extender or filler. Possesses excellent lightfastness. Its use can damage the clarity of an otherwise transparent paint.

TITANIUM WHITE

The whitest of the whites. Absolutely inert and unaffected by other pigments, light, weak acids or alkalis. Earlier problems of yellowing and chalking were overcome and commercial production had started by 1920. Since then it has become a popular addition to the palette, although not as widely available as Zinc or Chinese White. This brilliant white is strong and possesses great covering power. Titanium White makes a very satisfactory watercolour pigment.

Possesses excellent lightfastness. Rated ASTM I as a watercolour and is on the list of approved pigments. A first class pigment.

ZINC SULPHIDE

Semi-opaque, with excellent lightfastness. This pigment reflects in the ultra - violet, making it appear luminous. It is seldom found in watercolours.

CHALK

Varies in colour from a reasonably clean white to a pale grey. Opaque and with excellent lightfastness, it is widely used as an extender in a variety of paints. Overuse can reduce the transparency of the parent pigment to which it is added.

SILICA

Widely used as an extender in a variety of paints, and as a base for lake colours where transparency is required. If used simply as a filler, it can tend to 'cloud' colours, reducing their transparency.

L/FAST W/GUIDE I

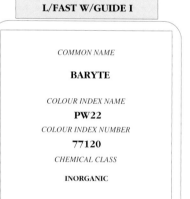

COMMON NAME

SILICA

COLOUR INDEX NAME

PW27

COLOUR INDEX NUMBER

77811

CHEMICAL CLASS

INORGANIC

BARYTE

A heavy white, to greyish white, powder, obtained from the mineral Baryte. Particularly inert, it is unaffected by light and chemicals. Used extensively as a filler for cheaper paints or as a base for certain 'lake' colours. Rarely used alone as a pigment. Opaque.

Absolutely lightfast.

L/FAST W/GUIDE I

COMMON NAME

BARYTE

COLOUR INDEX NAME

PW22

COLOUR INDEX NUMBER

77120

CHEMICAL CLASS

INORGANIC

The following pigment was recently introduced by manufacturers covered in this publication. Insufficient notice was given for full research to be carried out.

BLANC FIXE
Colour Index Name PW 21

Colour Index Number - 77120. Chemical Class 'Inorganic. Precipitated Barium Sulfate'. Also called Process White and Permanent White.

A synthetic extender. A bright white which is inert to acids, alkalies, light and heat. This pigment is usually used as a filler to reduce the cost of a paint or as an extender to improve handling qualities. Not subjected to ASTM testing as a watercolour paint and will not need to be. I will rate it as WG I for this edition.

Lightfast Category WG I

WHITE
WATERCOLOURS

WHITE WATERCOLOURS

10.1 Chinese White

The vapour given off from molten metallic zinc is burnt in a draft of air, the resultant smoke is collected into chambers and compressed into powder whilst still hot. Chinese White is a specially produced, very dense type of Zinc Oxide with greater covering power than the Zinc White of the oil painter.

As the technique of the watercolourist allows for the use of the paper to give tints and untouched paper the whites, there should be little or no call for a white watercolour. However, Chinese White outsells many other colours. It should be born in mind that the use of a white in mixing will both dull and cool any other colour. Bright tints are best created through thin washes. Having said that, it must be emphasised that there is no such thing as an 'incorrect' colour. If you wish to lighten with white and are happy with the results then who is to say otherwise.

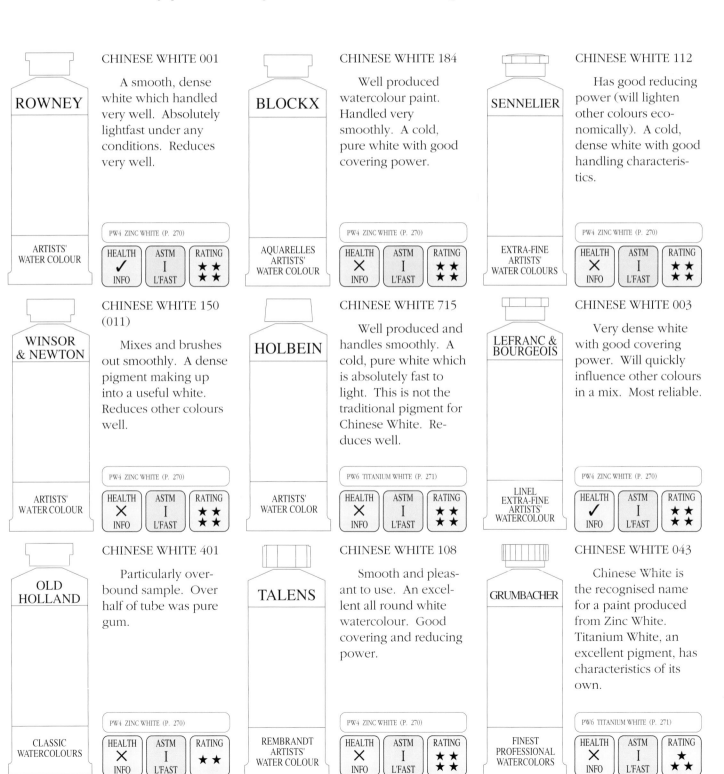

CHINESE WHITE 001 — ROWNEY — A smooth, dense white which handled very well. Absolutely lightfast under any conditions. Reduces very well.
ARTISTS' WATER COLOUR
PW4 ZINC WHITE (P. 270) — HEALTH INFO ✓ — ASTM L'FAST I — RATING ★★ ★★

CHINESE WHITE 184 — BLOCKX — Well produced watercolour paint. Handled very smoothly. A cold, pure white with good covering power.
AQUARELLES ARTISTS' WATER COLOUR
PW4 ZINC WHITE (P. 270) — HEALTH INFO ✕ — ASTM L'FAST I — RATING ★★ ★★

CHINESE WHITE 112 — SENNELIER — Has good reducing power (will lighten other colours economically). A cold, dense white with good handling characteristics.
EXTRA-FINE ARTISTS' WATER COLOURS
PW4 ZINC WHITE (P. 270) — HEALTH INFO ✕ — ASTM L'FAST I — RATING ★★ ★★

CHINESE WHITE 150 (011) — WINSOR & NEWTON — Mixes and brushes out smoothly. A dense pigment making up into a useful white. Reduces other colours well.
ARTISTS' WATER COLOUR
PW4 ZINC WHITE (P. 270) — HEALTH INFO ✕ — ASTM L'FAST I — RATING ★★ ★★

CHINESE WHITE 715 — HOLBEIN — Well produced and handles smoothly. A cold, pure white which is absolutely fast to light. This is not the traditional pigment for Chinese White. Reduces well.
ARTISTS' WATER COLOR
PW6 TITANIUM WHITE (P. 271) — HEALTH INFO ✕ — ASTM L'FAST I — RATING ★★ ★★

CHINESE WHITE 003 — LEFRANC & BOURGEOIS — Very dense white with good covering power. Will quickly influence other colours in a mix. Most reliable.
LINEL EXTRA-FINE ARTISTS' WATERCOLOUR
PW4 ZINC WHITE (P. 270) — HEALTH INFO ✓ — ASTM L'FAST I — RATING ★★ ★★

CHINESE WHITE 401 — OLD HOLLAND — Particularly over-bound sample. Over half of tube was pure gum.
CLASSIC WATERCOLOURS
PW4 ZINC WHITE (P. 270) — HEALTH INFO ✕ — ASTM L'FAST I — RATING ★★

CHINESE WHITE 108 — TALENS — Smooth and pleasant to use. An excellent all round white watercolour. Good covering and reducing power.
REMBRANDT ARTISTS' WATER COLOUR
PW4 ZINC WHITE (P. 270) — HEALTH INFO ✕ — ASTM L'FAST I — RATING ★★ ★★

CHINESE WHITE 043 — GRUMBACHER — Chinese White is the recognised name for a paint produced from Zinc White. Titanium White, an excellent pigment, has characteristics of its own.
FINEST PROFESSIONAL WATERCOLORS
PW6 TITANIUM WHITE (P. 271) — HEALTH INFO ✕ — ASTM L'FAST I — RATING ★

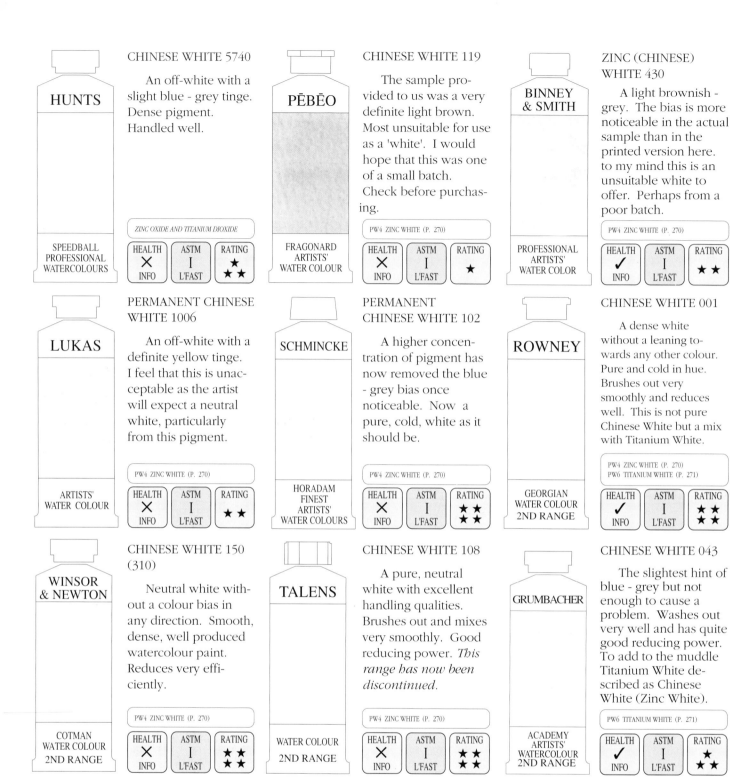

HUNTS
SPEEDBALL
PROFESSIONAL
WATERCOLOURS

CHINESE WHITE 5740

An off-white with a slight blue - grey tinge. Dense pigment. Handled well.

ZINC OXIDE AND TITANIUM DIOXIDE

HEALTH	ASTM	RATING
✕	I	★★
INFO	L'FAST	

PĒBĒO
FRAGONARD
ARTISTS'
WATER COLOUR

CHINESE WHITE 119

The sample provided to us was a very definite light brown. Most unsuitable for use as a 'white'. I would hope that this was one of a small batch. Check before purchasing.

PW4 ZINC WHITE (P. 270)

HEALTH	ASTM	RATING
✕	I	★
INFO	L'FAST	

BINNEY & SMITH
PROFESSIONAL
ARTISTS'
WATER COLOR

ZINC (CHINESE) WHITE 430

A light brownish - grey. The bias is more noticeable in the actual sample than in the printed version here. to my mind this is an unsuitable white to offer. Perhaps from a poor batch.

PW4 ZINC WHITE (P. 270)

HEALTH	ASTM	RATING
✓	I	★★
INFO	L'FAST	

LUKAS
ARTISTS'
WATER COLOUR

PERMANENT CHINESE WHITE 1006

An off-white with a definite yellow tinge. I feel that this is unacceptable as the artist will expect a neutral white, particularly from this pigment.

PW4 ZINC WHITE (P. 270)

HEALTH	ASTM	RATING
✕	I	★★
INFO	L'FAST	

SCHMINCKE
HORADAM
FINEST
ARTISTS'
WATER COLOURS

PERMANENT CHINESE WHITE 102

A higher concentration of pigment has now removed the blue - grey bias once noticeable. Now a pure, cold, white as it should be.

PW4 ZINC WHITE (P. 270)

HEALTH	ASTM	RATING
✕	I	★★
INFO	L'FAST	

ROWNEY
GEORGIAN
WATER COLOUR
2ND RANGE

CHINESE WHITE 001

A dense white without a leaning towards any other colour. Pure and cold in hue. Brushes out very smoothly and reduces well. This is not pure Chinese White but a mix with Titanium White.

PW4 ZINC WHITE (P. 270)
PW6 TITANIUM WHITE (P. 271)

HEALTH	ASTM	RATING
✓	I	★★
INFO	L'FAST	

WINSOR & NEWTON
COTMAN
WATER COLOUR
2ND RANGE

CHINESE WHITE 150 (310)

Neutral white without a colour bias in any direction. Smooth, dense, well produced watercolour paint. Reduces very efficiently.

PW4 ZINC WHITE (P. 270)

HEALTH	ASTM	RATING
✕	I	★★
INFO	L'FAST	

TALENS
WATER COLOUR
2ND RANGE

CHINESE WHITE 108

A pure, neutral white with excellent handling qualities. Brushes out and mixes very smoothly. Good reducing power. *This range has now been discontinued.*

PW4 ZINC WHITE (P. 270)

HEALTH	ASTM	RATING
✕	I	★★
INFO	L'FAST	

GRUMBACHER
ACADEMY
ARTISTS'
WATERCOLOUR
2ND RANGE

CHINESE WHITE 043

The slightest hint of blue - grey but not enough to cause a problem. Washes out very well and has quite good reducing power. To add to the muddle Titanium White described as Chinese White (Zinc White).

PW6 TITANIUM WHITE (P. 271)

HEALTH	ASTM	RATING
✓	I	★★
INFO	L'FAST	

10.2 Miscellaneous Whites

The most unexpected of these is Flake White produced from genuine Flake or Lead White. Confirmation on its use was sought and given. It has been common knowledge for centuries that it is most unsuitable for use as a watercolour. To offer a pigment which will darken when exposed to the atmosphere and is also poisonous to the unwary, is nothing short of reckless, in fact it is outrageous. If you have the substance may I suggest that you either dispose of it safely or return it to the retailer and ask for a full refund. Whatever you do please do not use it in an airbrush without wearing a mask and do not lick your brush into shape. It should also be kept off the skin.

As you will see from my comments, I feel that if Titanium White were described as such we would all benefit. A little of the confusion would be cleared up, artists would come to recognise its qualities and demand it for sound reasons.

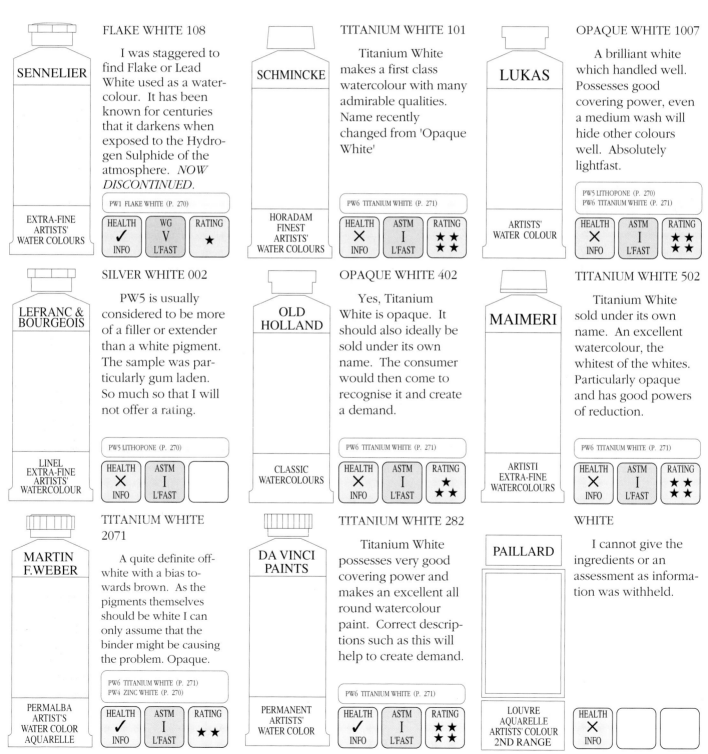

FLAKE WHITE 108
SENNELIER
EXTRA-FINE ARTISTS' WATER COLOURS

I was staggered to find Flake or Lead White used as a watercolour. It has been known for centuries that it darkens when exposed to the Hydrogen Sulphide of the atmosphere. *NOW DISCONTINUED.*

PW1 FLAKE WHITE (P. 270)

HEALTH INFO ✓ | WG L'FAST V | RATING ★

TITANIUM WHITE 101
SCHMINCKE
HORADAM FINEST ARTISTS' WATER COLOURS

Titanium White makes a first class watercolour with many admirable qualities. Name recently changed from 'Opaque White'

PW6 TITANIUM WHITE (P. 271)

HEALTH INFO ✗ | ASTM L'FAST I | RATING ★★ ★★

OPAQUE WHITE 1007
LUKAS
ARTISTS' WATER COLOUR

A brilliant white which handled well. Possesses good covering power, even a medium wash will hide other colours well. Absolutely lightfast.

PW5 LITHOPONE (P. 270)
PW6 TITANIUM WHITE (P. 271)

HEALTH INFO ✗ | ASTM L'FAST I | RATING ★★

SILVER WHITE 002
LEFRANC & BOURGEOIS
LINEL EXTRA-FINE ARTISTS' WATERCOLOUR

PW5 is usually considered to be more of a filler or extender than a white pigment. The sample was particularly gum laden. So much so that I will not offer a rating.

PW5 LITHOPONE (P. 270)

HEALTH INFO ✗ | ASTM L'FAST I

OPAQUE WHITE 402
OLD HOLLAND
CLASSIC WATERCOLOURS

Yes, Titanium White is opaque. It should also ideally be sold under its own name. The consumer would then come to recognise it and create a demand.

PW6 TITANIUM WHITE (P. 271)

HEALTH INFO ✗ | ASTM L'FAST I | RATING ★ ★★

TITANIUM WHITE 502
MAIMERI
ARTISTI EXTRA-FINE WATERCOLOURS

Titanium White sold under its own name. An excellent watercolour, the whitest of the whites. Particularly opaque and has good powers of reduction.

PW6 TITANIUM WHITE (P. 271)

HEALTH INFO ✗ | ASTM L'FAST I | RATING ★★ ★★

TITANIUM WHITE 2071
MARTIN F.WEBER
PERMALBA ARTIST'S WATER COLOR AQUARELLE

A quite definite off-white with a bias towards brown. As the pigments themselves should be white I can only assume that the binder might be causing the problem. Opaque.

PW6 TITANIUM WHITE (P. 271)
PW4 ZINC WHITE (P. 270)

HEALTH INFO ✓ | ASTM L'FAST I | RATING ★★

TITANIUM WHITE 282
DA VINCI PAINTS
PERMANENT ARTISTS' WATER COLOR

Titanium White possesses very good covering power and makes an excellent all round watercolour paint. Correct descriptions such as this will help to create demand.

PW6 TITANIUM WHITE (P. 271)

HEALTH INFO ✓ | ASTM L'FAST I | RATING ★★ ★★

WHITE
PAILLARD
LOUVRE AQUARELLE ARTISTS' COLOUR 2ND RANGE

I cannot give the ingredients or an assessment as information was withheld.

HEALTH INFO ✗

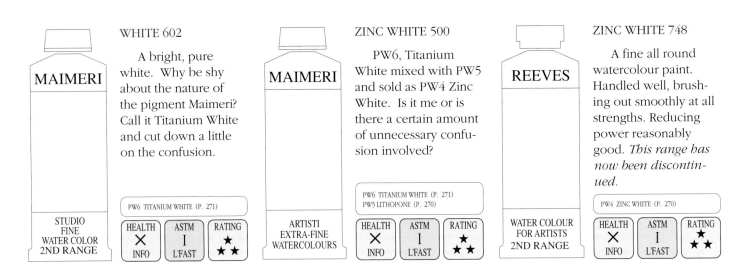

WHITE 602

A bright, pure white. Why be shy about the nature of the pigment Maimeri? Call it Titanium White and cut down a little on the confusion.

PW6 TITANIUM WHITE (P. 271)

MAIMERI

STUDIO
FINE
WATER COLOR
2ND RANGE

HEALTH ✗ INFO

ASTM I L'FAST

RATING ★ ★★

ZINC WHITE 500

PW6, Titanium White mixed with PW5 and sold as PW4 Zinc White. Is it me or is there a certain amount of unnecessary confusion involved?

PW6 TITANIUM WHITE (P. 271)
PW5 LITHOPONE (P. 270)

MAIMERI

ARTISTI
EXTRA-FINE
WATERCOLOURS

HEALTH ✗ INFO

ASTM I L'FAST

RATING ★ ★★

ZINC WHITE 748

A fine all round watercolour paint. Handled well, brushing out smoothly at all strengths. Reducing power reasonably good. *This range has now been discontinued.*

PW4 ZINC WHITE (P. 270)

REEVES

WATER COLOUR
FOR ARTISTS
2ND RANGE

HEALTH ✗ INFO

ASTM I L'FAST

RATING ★ ★★

U.S.A.

M. Grumbacher Inc.
30 Englehard Drive
Cranbury,
NJ 08512

Da Vinci Paint Co. Inc.
11 Goodyear Street
Irvine
California 92718

Martin/F. Weber Company
2727 Southhampton Road
Philadelphia PA. 19154

Binney & Smith Inc.
1100 Church Lane
PO Box 431
Easton PA 18044-0431

Hunt International Co.
230 South Broad Street
Philadelphia PA 19102

UNITED KINGDOM

Reeves Paints
Whitefriars Avenue
Wealdstone
Harrow, Middlesex HA3 5RH

Winsor & Newton
Whitefriars Avenue
Wealdstone
Harrow, Middlesex HA3 5RH

Daler-Rowney & Co. Ltd.
PO Box 10
Bracknell, Berkshire RG12 4ST

HOLLAND

Old Holland
Nijendal 36
3972 KC Driebergen

Royal Talens BV
PO Box 4
NL 7300 AA Apeldoorn

FRANCE

Sennelier Beaux-Arts Distr.
Rue du Moulin a Cailloux
Senia 408 Orly 94567
Rungis Cedex

Lefranc & Bourgeois
Zone Industrielle Nord
B.P. 337-72007
Le Mans Cedex

Pebeo
St-Marcel BP 12-13367
Marseille Cedex 11

J.M. Paillard
Societe Nouvelle
B.P. No.2-60250 Mouy

GERMANY

Schmincke & Co.
GMBH & Co. KG.
Otto-Hahn-Str.2
PO Box 3120
4006-Erkrath

Lukas-Kunstlerfarben-Und
Maltuchfabrik
Dr.Fr. Schoenfeld & Co.
Postfach 7427
4000 Dusseldorf 1

BELGIUM

J. Blockx Fils S.P.R.L.
B 5291 Terwagne

ITALY

F.lli Maimeri & C.sri
Strada Vecchia
Paullese
20060 Bettolino Dl
Mediglia
Milano

JAPAN

Holbein Art Materials Inc.
2-2-5 Ueshio Chuo-Ku
Osaka 542

OTHER USEFUL ADDRESSES.

ASTM Standards on artists paints
can be obtained from:

ASTM, 1916 Race Street
Philadelphia
PA 19103-1187
Tel: 215-299-5400

Questions about health hazards
from art materials:

Art & Craft Materials Institute
715 Boylston Street
Boston, MA 02116
Tel: 617-266-6800

To join Artists Equity or ask
questions about health hazards
and/or quality labeling of art
materials and Federal legislation
affecting artists:

National Artists Equity
Association
PO Box 28068, Washington,
DC 20038

Executive Director,
Catherine Auth

Chairwoman of Materials
Research Committee,
Joy Luke

Colour Mixing

Our Present Method of Working: 'The Three Primary System.'

Although many ingenious theories have been put forward to explain the nature of colour, little attention has been paid to formalising colour mixing. The notion that there existed three 'primary' colours, from which all others could be mixed, was first put forward in 1731.

But it was not until 1776, some forty years later that the first practical colour mixing wheel was produced. Mosses Harris, the publisher, declared that red, yellow and blue, the 'primitive' (primary) colours gave rise, through mixing, to the 'prismatic' (secondary) colours, orange, green and violet. And so it has remained ever since. It was in fact an invention rather than a natural way of working.

The use of the three primary system has gained universal acceptance and now forms the basis of colour mixing teaching throughout the world.

The heavy and almost total reliance on this system cannot be claimed, however, to have led to generations of skilled colour mixers.

On the contrary, it has led to muddled, confused frustration. We would probably have been far better off if the three primary system had never been invented. It is a method of working which will always fail us because it is scientifically unsound. It seems to work but it never does, as anyone who has ever tried to paint a traditional colour mixing wheel from any three colours will testify.

Like countless others I have spent many years trying to mix the exact colours that I wanted. All too often I would produce dull 'muddy' hues. This meant:

1. I wasted a lot of time that could have been better spent painting.

2. A great deal of expensive paint was turned into 'mud' and a lot of unnecessary colours were purchased.

3. Most importantly I ended up mixing and using colours that were not quite those I had in mind, but they had to suffice. My work inevitably suffered.

I have probably outlined some of the frustrations felt by countless other colour users.

During a study of light physics I came to the conclusion that it is scientifically unsound to say that mixtures of red, yellow and blue create new colours. This is because all colours, no matter how pure they may appear, contain impurities; elements of every other colour in the white light spectrum. When colours are mixed - as in the case of blue and yellow to make green - we end up with a colour comprised of these hidden impurities.

The reality is that blue and yellow obliterate each other or cancel each other out, leaving only the hidden green they each contained. A pure yellow and blue, for example, would not make green but black, while a pure red and blue would produce not violet but black again.

These findings led me to develop the approach to colour mixing explained in my book 'Blue and Yellow Don't Make Green'.

Behind the book is the certain knowledge that the 'primaries' do not create new colours when mixed; that pure red, yellow and blue do not exist and that they would be almost useless to us were they to exist.

The Colour Bias Wheel

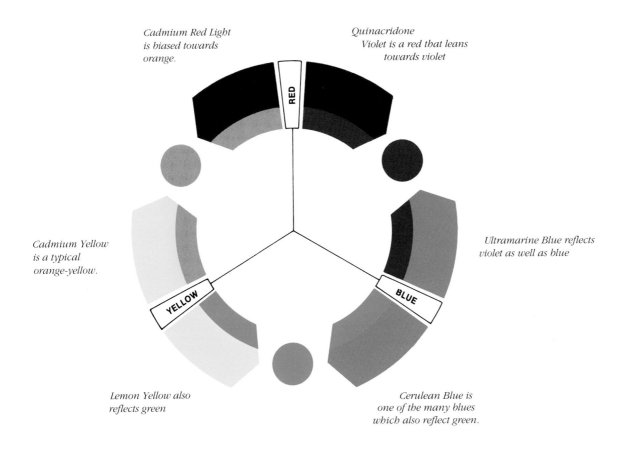

Cadmium Red Light is biased towards orange.

Quinacridone Violet is a red that leans towards violet

Cadmium Yellow is a typical orange-yellow.

Ultramarine Blue reflects violet as well as blue

Lemon Yellow also reflects green

Cerulean Blue is one of the many blues which also reflect green.

The Colour Bias Wheel is the basic guide to accurate colour mixing. There are, of course, many different colour mixing wheels in existence.

This is not yet another one. It has to be said that all other mixing wheels have now become obsolete as they support a method of working which is also now obsolete— the three primary system.

The most dramatic difference is that the Bias Wheel does not offer 'primary' colours. You will notice that the red, yellow and blue positions are left blank. These colours, in a pure form, simply do not exist, if they did they would be quite useless for mixing purposes.

Every red available in pigment form will either be a violet-red or an orange-red. Every blue you will ever come across is either a green-blue or a violet-blue. In the same way every yellow is either an orange-yellow or a green-yellow.

The basic make-up of these hues is shown here with an example for each colour type.

The colours can now be merged to show the six colour types that replace the traditional three colours. These six are the *minimum* number of colours needed for a wide range of mixes. Each of the colour types lean or are biased towards a 'secondary' colour and this bias is emphasised by forming the colours into 'arrows'.

The Palette

The palette takes its basic design from the Bias Wheel, which is the backbone of the system.

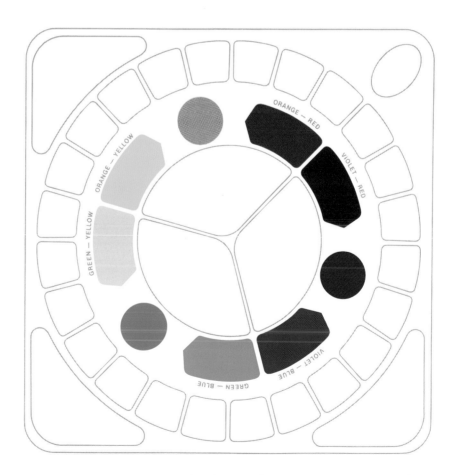

In this diagram the two are merged to show their relationship.

Each of the six colour-types is embossed alongside the rele--vent paint well.

The Watercolour Palette

There are two types of palette, one for 'wet' media, the other mainly for oils. I will refer to the former as the 'watercolour palette'.

The watercolour palette is intended for water-based or water-soluble mediums such as watercolour, gouache, casein, water-based inks and dyes and diluted acrylic.

Intended as a guide towards accurate colour mixing, the palette will also point the way towards effective colour contrast and harmony.

Colour Mixing Workbook

A workbook has been designed to enable the user to become familiar with the full potential of the chosen media. An invaluable colour reference is created for either studio work or field trips. Colours which might previously have been difficult to work with can give surprising results.

Paint Selection Workbook

To be used in conjunction with this book. The workbook will enable the user to compile a reference of the chosen paint range. The characteristics of your own paints can be studied in detail and recorded. Samples can also be taken of the colours used by fellow artists for comparison.

One of the work sheets is illustrated here. On completion they are placed in protective sleeves.

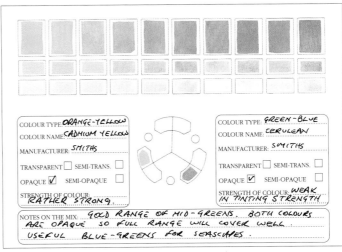

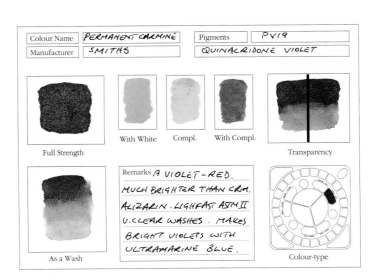

Overall Aim

Earlier artists had many difficulties to overcome. Reliable pigments were in short supply and invariably expensive. Information on technique was often kept secret, either by the individual painter or the local Guild. Common knowledge on the nature of colour and light was inaccurate and misleading. Yet they produced some wonderful work.

The main advantage that these early painters had over us today is that they had a thorough and very lengthy training. Many served apprenticeships of 15-16 years.

Over the years the trainee would become very familiar with the materials and techniques of the Master. Those who eventually became Masters in their own right, also understood their craft and practised it diligently.

The 'secrets' of the Old Masters are largely known to us. Despite this wealth of information on technique and the superb materials at our disposal, we produce work of a temporary nature. The average five year old painting is in a worse condition than most that are five hundred years old. We have inherited a rich collection of paintings, yet will pass on few of our own. Despite our advanced knowledge and the inspiration of the Impressionists, most users of colour have little understanding of this most powerful element.

I believe that this has all come about because for most of this century we have been moving away from the craft of painting. Art for art's sake has been the cry and we are now paying the price.

'The School of Colour' was formed to encourage a return to the true craft of painting. By bringing art and science together and incorporating knowledge from the past, it should be possible to put right the muddle of centuries.

If the artist can select his or her materials with confidence, mix colours with accuracy and apply the colour with meaning, then creativity will be released and not stifled.

Information is the essential back up required for inspiration.

The Michael Wilcox School of Colour

A range of products has been designed and books and courses published to help bring about a fuller understanding of colour. Accurate mixing will be concentrated on at first, followed by other areas of colour use, harmony, theory, contrast etc.

Our Paints

We have our own, specially formulated paint ranges (watercolours, oils, acrylics, designer's gouache and artist's gouache). These are intended for the use of those following our approach to colour mixing. I felt that it would be inappropriate to include the watercolours in this book. They will not be available in art stores.

To overcome possible problems associated with commenting on as well as offering watercolour paints, I will, in the future, be working with others on the guidance books.

Our Courses

Home study courses on colour mixing are also available. Guidance is offered by video and the lessons are completed in specialist workbooks.

An advanced course is also available.

Updates

This book will be updated on a regular basis as changes take place within the art materials industry.

All proceeds from the sale of this book will go towards further research.

If you wish to be sent details of our products, books, courses and paints please contact any 'School of Colour' office.

The Michael Wilcox School of Colour USA
P.O. Box 50760
Irvine, CA 92619-0760

The Michael Wilcox School of Colour UK
P.O. Box 3518
London SE24 9LW
Fax: 0171 274 9160
Tel: 0171 738 7751

The Michael Wilcox School of Colour Australia
P.O. Box 358 Kelmscott
Western Australia 6111
Tel: (09) 466 1053

Correspondence is always welcomed, your comments and ideas are vital to our undertaking. If we work together a lot can be accomplished.

INDEX OF COLOURS

The following range has been introduced by Martin/F. Weber Co. Samples have been supplied but there was insufficient time to carry out a full examination before going to print. The page numbers given refer to information on the pigments used, rather than the actual colours. It pays to check the ingredients used when considering a purchase.